Donald & Isobel
MACKENZIE 1992

The Prado

General Editor: José Antonio de Urbina

The Prado

Alfonso E. Pérez Sánchez (Director)
Manuela Mena Marqués (Assistant Director)
Matías Díaz Padrón
Juan José Luna
Joaquín de la Puente

Scala Books
in association with
Sotheby's

© 1988 Scala Publications Ltd

First published in 1988 by
Scala Publications Ltd
26 Litchfield Street
London WC2H 9NJ

Distributed in the USA by
Harper & Row, Publishers
10 East 53rd Street
New York, NY 10022

ISBN 1 870248 05 8 (UK)
ISBN 0 935748 75 X (US)
LC 87–060272

Photographs by Gonzalo de la Serna
Designed by Alan Bartram
Produced by Scala Publications
Filmset by August Filmsetting, England
Printed and bound in Spain
by Heraclio Fournier, SA

Contents

ACKNOWLEDGEMENTS
The Publishers would like to record their grati-
tude to Edmund Peel of Sotheby's Madrid to
whose unremitting efforts in the early stages this
book largely owes its existence.
 They would also like to acknowledge the
valuable assistance of the Friends of the Prado in
bringing it to publication.

A chronology of principal events in the history of the building of the Prado and the creation of the Museum

1785 Charles III commissions the architect Juan de Villanueva to draw up the first plans for the Museum of Natural History.

1809 Joseph Bonaparte issues a Royal Decree with the aim of founding a Museum of Paintings.

1810 Joseph Bonaparte issues a Royal Decree installing a gallery at the Buenavista Palace, originally the property of the Duchess of Alba and later of Godoy, Prime Minister of Charles IV.

1811 Death of Juan de Villanueva; the building of the Prado is almost completed.

1814 At the suggestion of Queen Maria Isabel de Braganza and Isidoro Montenegro, Ferdinand VII decides to set up a gallery in the empty building on the Prado Promenade.

1819 Official opening of the Royal Museum by Ferdinand VII.

1819–29 The main part of the Royal Collection is transferred to the Prado.

1829 The Duke of San Fernando makes the first donation: *Christ on the Cross* by Velázquez.

1835 The Disentailment of the properties of the Church by Mendizabal; many paintings taken from churches and monasteries are transferred to the Convent of the Trinity which becomes a temporary gallery.

1838 A large number of paintings from the Escorial are transferred to the Prado, due to the threat of civil war.

1843 1,949 paintings are listed in the Catalogue of the Prado.

1868 The Royal Museum is nationalized after the dethronement of Isabel II.

1870 The contents of the Museum of the Trinity and the Goya tapestry cartoons from the Royal Palace in Madrid are transferred to the Prado.

1881 Donation of Goya's *Pinturas Negras* by Baron d'Erlanger.

1883–89 Additions are made to the building and new rooms are opened.

1889 Donation of more than 200 paintings by the Duchess of Pastrana.

1898 Inauguration of the Museum of Modern Art.

1912 The Patronage of the Museum is established.

1914–30 New wings are built providing additional exhibition space.

1915 A group of important paintings is bequeathed by Don Pablo Bosch.

1930 A group of important paintings is bequeathed by Don Pedro Fernández Durán.

1936–39 Directorship of Pablo Picasso. During the Civil War the major paintings are removed from the Museum. Supported by an International Council assembled to protect the art treasures of Spain they were transferred from Valencia to France.

1939 Exhibition at the Museum of Art and History in Geneva of a selection of paintings from the Prado; the paintings sent to France are returned to Spain.

1940 A group of paintings is donated by Don Francisco Cambó.

1955–56 New extension to the exhibition galleries.

1980 The Foundation of the Friends of the Prado is set up.

1981 Installation of Picasso's *Guernica* and accompanying sketches at the Casón del Buen Retiro.

The Spanish Collection

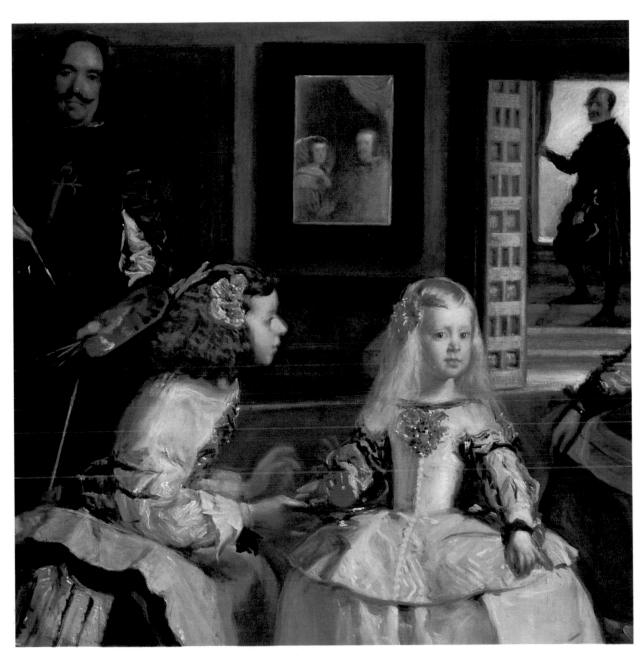

Velázquez, *Las Meninas* (detail)

Introduction

The Prado owes its existence to the collecting passions of the Spanish Kings and Queens; the Royal Collection is the backbone, and the Spanish collection is the spirit of the museum. It is this which accounts for the significant presence of those artists who were connected, in one capacity or another, with the Spanish Court. There are Court painters and official portraitists ranging from Sánchez Coello at the Court of Philip II, to Goya at the Court of Charles IV. Moreover, the Court acquired many works in accordance with the changes in fashion and taste, even if the artists worked far from Madrid. Queen Isabel de Farnesio, for example, sought out the work of Murillo in Seville in 1729, successfully obtaining four canvases. The work of the regional schools and almost all medieval painting, on the other hand, were not to the Court's liking, and so were either excluded from royal collections or, at best, only partially represented.

When the contents of the Museum of the Trinity were incorporated into the Royal Museum in 1872, many religious works of the Madrid and Toledo schools were added to the Prado collection along with a number of important works of the Primitive schools. Nevertheless, large gaps in the collection remained and it is only recently that these have begun to be filled. It was not until 1946, for example, that certain Romanesque works were installed in the Prado even though Romanesque art had figured prominently in the museum at Barcelona from 1926. Primitive works from the Aragonese, the Catalonian and the Valencian schools have also been acquired in recent years. Similarly, the most outstanding examples of the baroque schools of Valencia, Cordoba, Granada and Seville (apart from Murillo) have come from acquisitions and donations made during the last thirty years.

From the Primitives to El Greco

The frescos of San Baudilio de Berlanga and Santa Cruz de Maderuelo, the oldest works which the Prado contains, serve as excellent examples of the severe figurative order of the Spanish Romanesque, full of Byzantine and Oriental allusions and with an almost abstract taste for simple tonality and linear repetition. To these, in recent years, have been added a number of paintings, mostly altar panels, which illustrate the movement in the thirteenth century towards a more emotive style of pictorial narrative; notably, one frontal representation of Saint Stephen and one altarpiece of Saint Christopher. They display a manner which is already Gothic yet still expressed through the simple forms and outlines of the Romanesque. The Gothic world proper is represented in the Prado by some outstanding panels in the International Gothic style, which fuse Sienese and French motifs. The result is a delightful combination of calligraphic forms, elegant postures and lively details which carry the atmosphere of Chivalric romance into religious narrative. Works such as the Catalonian panels by the Serra brothers and the huge altarpiece by Nicolás Francés date from this period of outstanding elegance.

From the beginning of the second half of the fifteenth century, the influence of Netherlandish realism, stemming from the Van Eycks, made itself felt with insistence in Spanish painting and contributed to the formation of the first Spanish artists of any universal significance. The relentless objectivity of such painters as Jan van Eyck and Robert Campin acquired in the work of some Spanish artists a poetic, almost expressionistic spirit. However, the vigour and harshness, and the Oriental profusion of gilding, make the links with the earlier Primitive Masters unmistakable. As well as various anonymous masterpieces, the Prado possesses important works by two of the greatest masters of this period, the Castilian, Fernando Gallego, and the Cordoban, Bartolomé Bermejo, who worked in Aragon.

Pedro Berruguete, who also owed much to the Netherlandish influence then prevailing in Castile, deserves separate consideration. His journey to Italy during the early Renaissance, where he came to know the work of Piero della Francesca and Melozzo da Forlì, introduced him to a new awareness of space and rhythm, and also to the use of decorative details from a classical repertoire which opened the way to the Renaissance in Castile. Elsewhere in Spain there was a parallel development, possibly hastened by the presence of Italian artists. For instance, in Valencia, the anonymous Master of the Knight of Montesa, who was almost certainly the Italian Paolo de San Leocadio, marks a further step in the conquest of the plastic sense of space.

In the first years of the sixteenth century, at the same time as this tentative incorporation of new elements, we find in Valencia the work of Fernando Yáñez de la Almedina emerging with its vivid echoes of Leonardo da Vinci blended with a Venetian wealth of colour. The Prado possesses, among other pieces by Yáñez, the exquisite *Saint Catherine*. The century which opened in such a promising manner did not, however, produce anything comparable later on, and it remains one of the least distinguished periods in the history of Spanish painting. In fact, the Prado is almost entirely lacking in Andalucian painting, which had, especially during the second half of the century, close connections with the Italian world. Nevertheless, the period is represented by Pedro Machuca who studied in Italy and assimilated many of the refinements of mannerism. Roughly contemporary are the Valencians, Vicente Masip and his son Juan de Juanes, details of whose

works reflect Florentine and Roman forms from the High Renaissance – lucid and pure in the work of the father, softened in the work of the son.

During the same years the Estremaduran Luis de Morales formed his personal style, blending Flemish and Leonardesque elements; while, at the Court of Philip II, the visit of the Dutch artist Anthonis Mor van Dashorst helped to create a school of official portraitists of which Sánchez Coello was the most distinguished. Coello's portraits combine consistent objectivity with a sober elegance in the pose of the sitter, and a degree of Venetian influence. They left an important stylistic legacy to his successors, notably Bartolomé González, which continued almost until the time of Velázquez.

At this time El Greco was also working in Toledo but was somewhat isolated from the circles at court. He had arrived in Spain in 1577 attracted, probably, by the chance of work offered by the decoration of the Escorial. Although he failed to find employment there, there remains in the Escorial the remarkable *Martyrdom of St Maurice*, which was commissioned by Philip II but subsequently rejected even though it had been generously paid for. In the passionate and somewhat pessimistic intellectual climate of Toledo, El Greco created an individual pictorial world of unparalleled mannerist intensity, which gives him a strong claim to be considered one of the most original artists of his adopted country. The Royal Collection contained only a few of El Greco's portraits, and these are known to have been highly esteemed by Velázquez. When the contents of the Museum of the Trinity were transferred to the Prado, a number of religious compositions were added to the El Greco collection, and further acquisitions and donations since then have made the Prado a haven for the study of the individual aesthetic of the great Cretan in all its aspects.

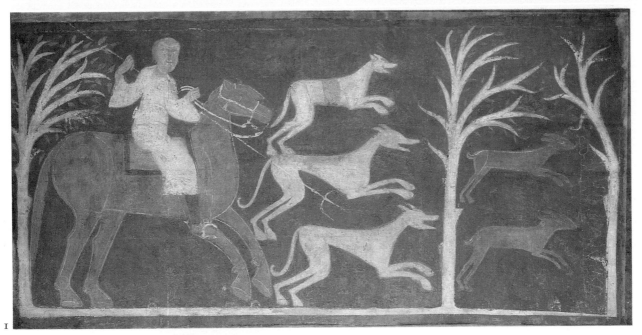

1

Anonymous master, known as the Master of Berlanga
Active in Soria at the beginning of the twelfth century
A Huntsman
Fresco transferred to canvas,
290 × 134 cm
From the Hermitage of Saint Baudilio in Berlanga; on loan from the Metropolitan Museum of Art, New York. Entered the Prado in 1957; without Cat No.

2

Anonymous master of the Castilian school
Active in Castile in the fourteenth century
Altarpiece, showing *St Christopher and the infant Christ*, *The Deposition*, and *Scenes from the Lives of the Saints*
Panel, 270 × 149 cm
Donated in 1969 by Don José Luis Várez Fisa; Cat No. 3150

1
Anonymous master, known as the Master of Archbishop Don Sancho Rojas
Active in Castile during the first quarter of the fifteenth century
Panel, 150 × 82 cm, from an altarpiece, showing *The Virgin and Child with Angels, Dominican Saints and two donors*
From the Church of Saint Benedict in Valladolid; Cat No. 1321

2
Nicolás Francés
Active in Leon from before 1424 to 1468
Left wing of an altarpiece, showing *Scenes from the Life of St Francis*
Panel, 360 × 186 cm (size of detail)
From the Chapel of La Esteva de Las Delicias in La Bañeza, Leon. Entered the Prado between 1930 and 1932; Cat No. 2545

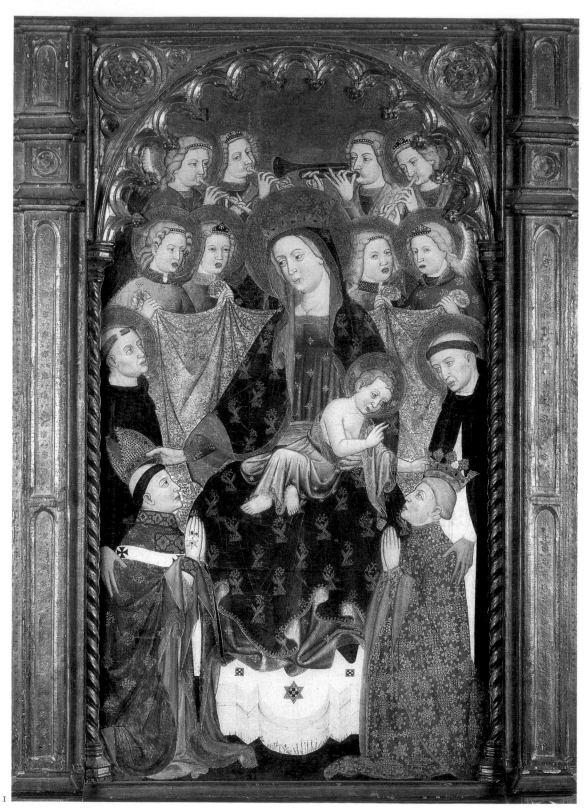

1

2

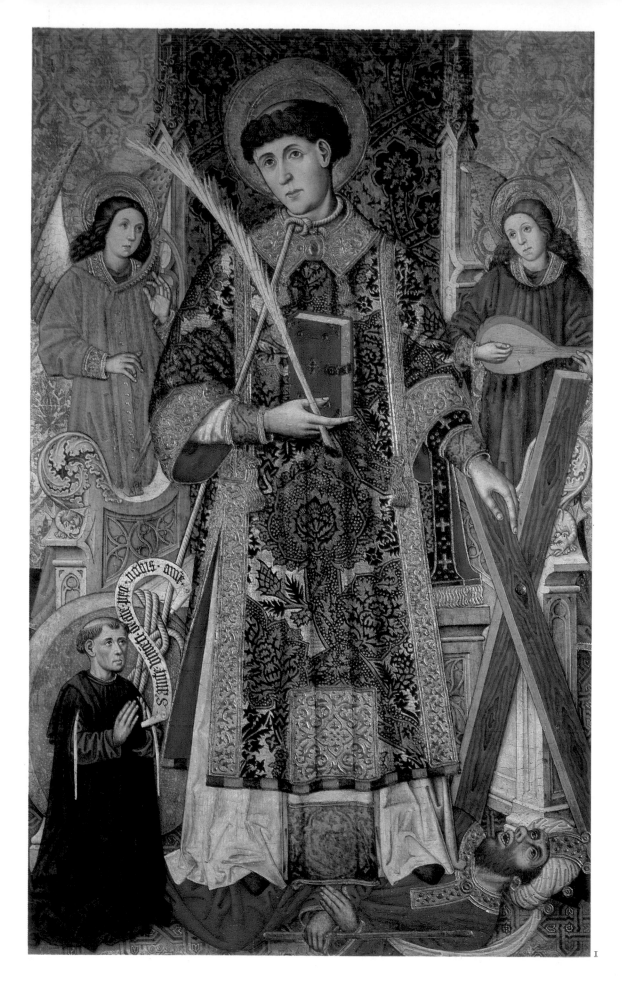

1
**Anonymous master, known as the Master
of Archbishop Dalmau of Mur**
Active in Aragon during the second half
of the fifteenth century
St Vincent and a donor
Panel, 185 × 117 cm
Entered the Prado in 1920; Cat No. 1334

2
**Hispano-Flemish master, known as the
Master of the Luna Chapel**
Active during the last quarter of the
fifteenth century
*The Entombment of Christ (The Seventh
Sorrow of the Virgin Mary)*
Panel, 105 × 71 cm
From the Museum of the Trinity; Cat No.
2425

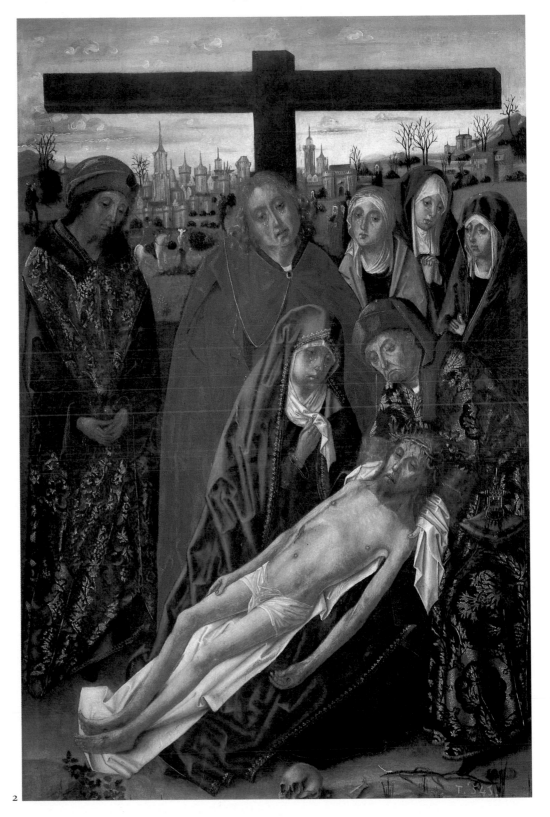

2

1

Rodrigo de Osona the Younger
Active in Valencia between 1505 and
1530
The Adoration of the Shepherds
Panel, 78 × 44 cm
Entered the Prado in 1941; Cat No. 2834

2

Valencian master, known as the Master of
Perea
Active towards the end of the fifteenth
century
The Visitation
Panel, 126 × 155 cm
Bequeathed by Don Pablo Bosch in 1915;
Cat No. 2678

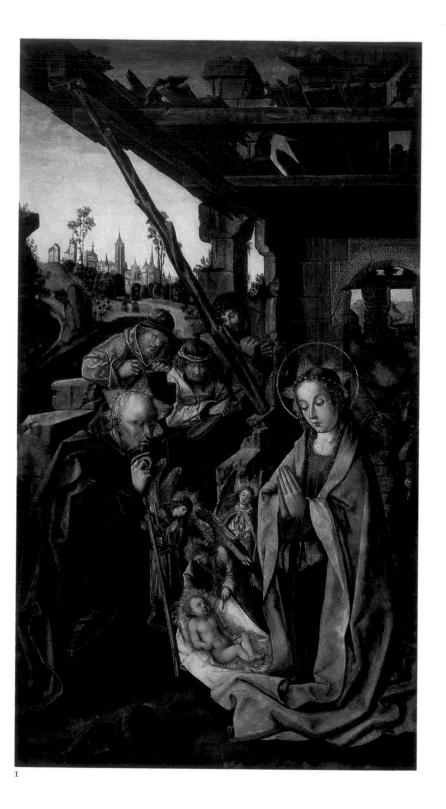

1

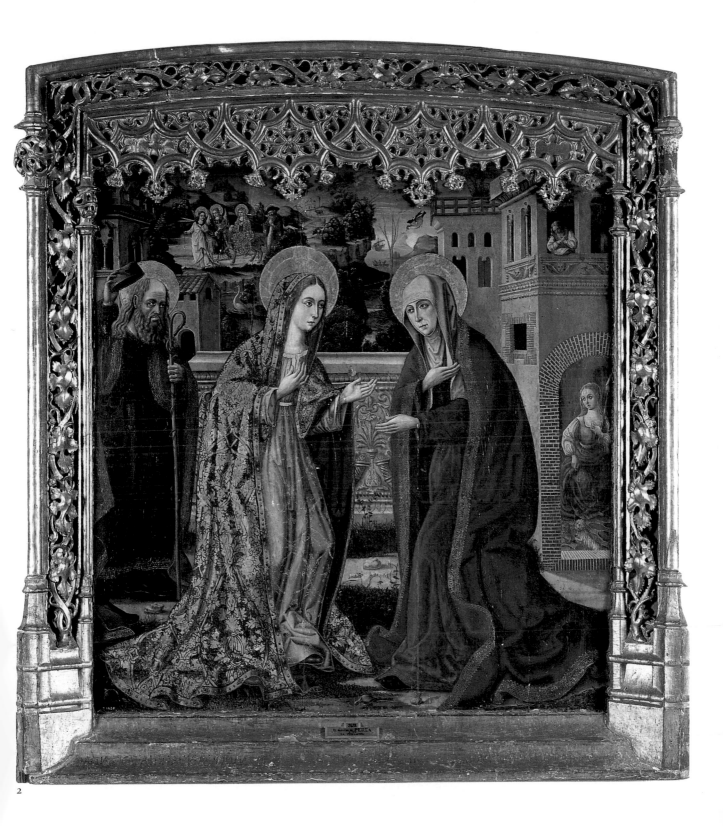

2

1
**Hispano-Flemish master, known as the
Master of La Sisla
Active in Castile towards the end of the
fifteenth century**
The Death of the Virgin
Panel transferred to canvas,
212 × 113 cm
From the Monastery of La Sisla in Toledo;
Cat No. 1259

2
**Bartolomé Bermejo
Born in Cordoba; active between 1474
and 1495**
St Dominic (?) enthroned in glory,
*c.*1474/77
Panel, 242 × 130 cm
Entered the Prado in 1920; Cat No. 1323

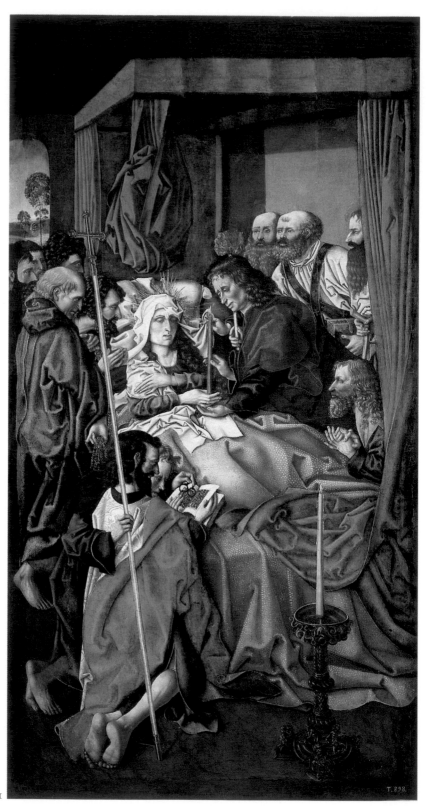

1

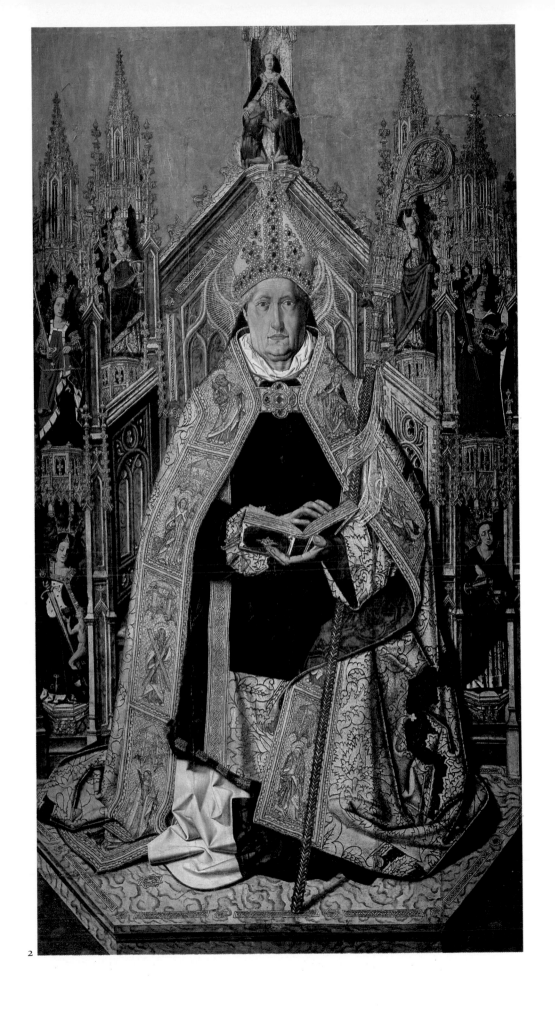

2

1

Juan de Flandes
Born *c.*1465(?); died 1519 in Palencia
The Raising of Lazarus
Panel, 110 × 84 cm
From the Church of Saint Lazarus in
Palencia; later in the Kress collection.
Purchased in 1952; Cat No. 2935

2

Juan de Flandes
Born *c.*1465(?); died 1519 in Palencia
Pentecost
Panel, 110 × 84 cm
From the Church of Saint Lazarus in
Palencia; later in the Kress collection.
Purchased in 1952; Cat No. 2938

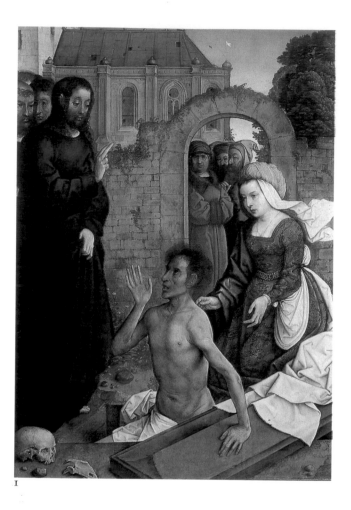

1

2

3

Fernando Gallego
Hispano-Flemish master
**Known to be active between 1466 and
1507**
Pietà, with two donors
Panel, 118 × 102 cm
From the Weibel collection in Madrid.
Purchased in 1959; Cat No. 2998

The influence of fifteenth-century Nether-
landish painting is clearly evident in this
work, bearing the signature of Fernando
Gallego. It is visible particularly in the
rigid pose of Christ's body and the sorrow-
ful expression of the Virgin, and in the
landscape with its carefully depicted town.
The fantastic rock formations and minute
donors are not specifically Netherlandish,
but typical of altarpieces all over Europe
in the late Middle Ages.

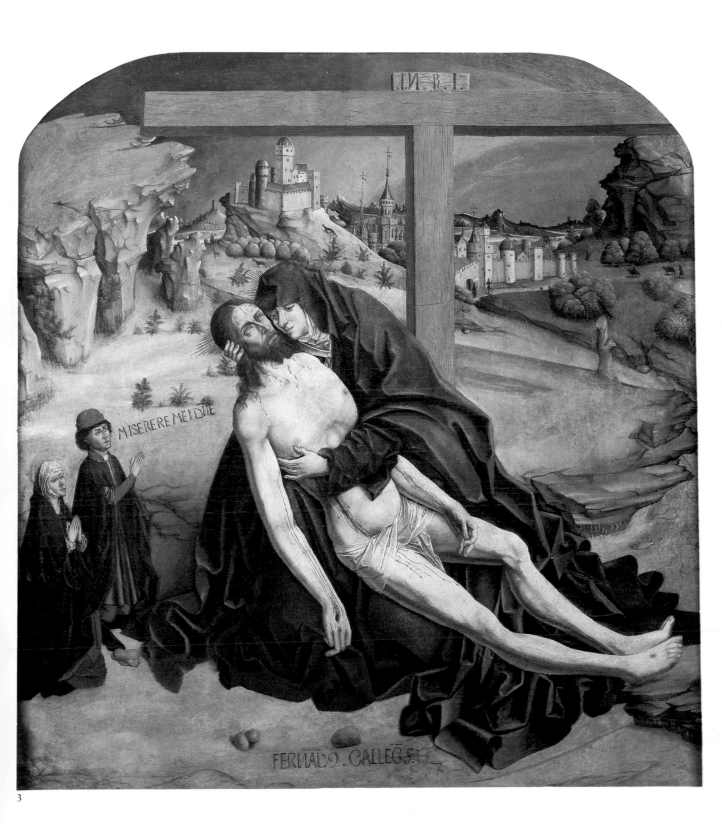

3

1
Juan Correa de Vivar
Died in Toledo in 1566
The Adoration of the Child, c.1533/35
Panel, 228 × 183 cm
Believed to be from the Monastery of
Guisando in Avila; Cat No. 690

2
León Picardo
Active in Burgos 1514–1530; died 1547
The Presentation of Christ in the Temple
Panel, 170 × 139 cm
From the Monastery of Támara in Palencia. Purchased in 1947; Cat No. 2172

3
Pedro Berruguete
**Born in Paredes de Navas(?) c.1450; died
before 1504**
*St Dominic presides over the burning of
heretics*
Panel, 154 × 92 cm
From the Church of St Thomas in Avila.
Purchased in 1867; Cat No. 618

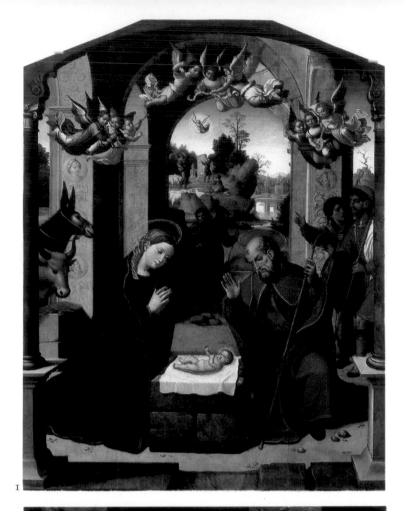

1

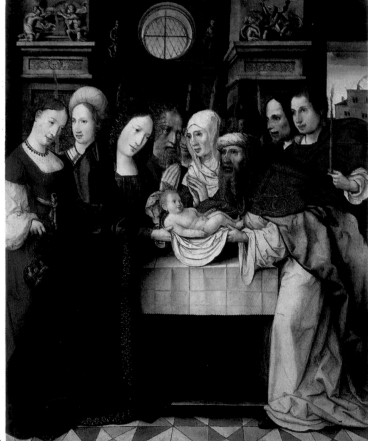

2

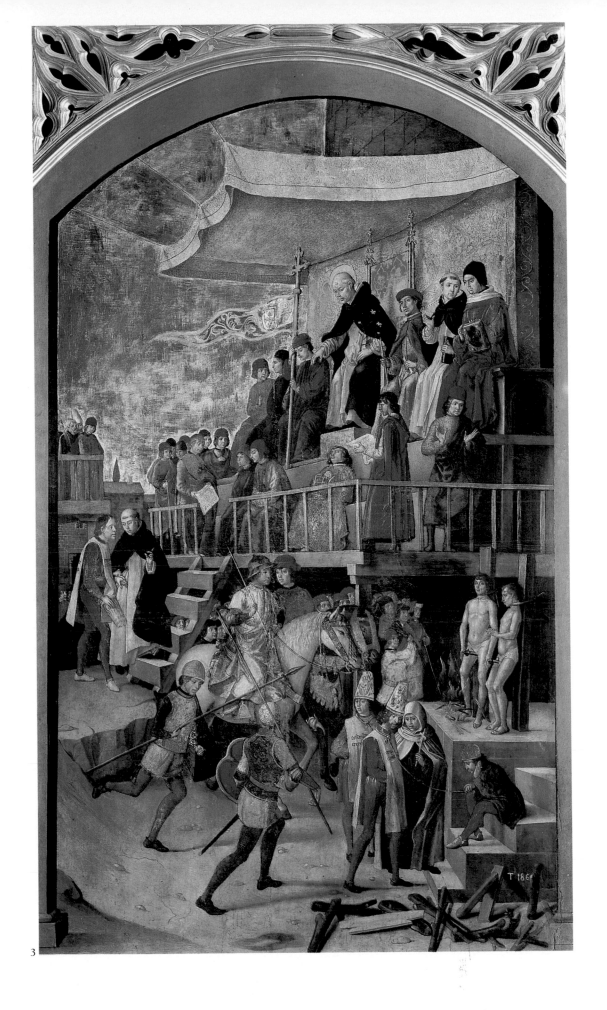

3

Pedro Berruguete
Born in Paredes de Navas(?) c.1450; died
before 1504
The Virgin and Child
Panel, 58 × 43 cm
Bequeathed by Don Pablo Bosch in 1915;
Cat No. 2709

Alejo Fernández
Cordoba, c.1475 – Granada, c.1545/46
The Scourging of Christ
Panel, 42 × 35 cm
In the collection of Queen Isabel de
Farnesio by 1746; Cat No. 1925

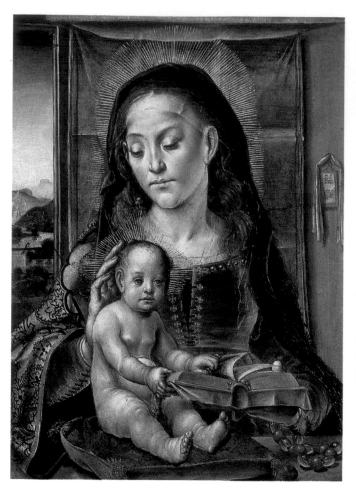

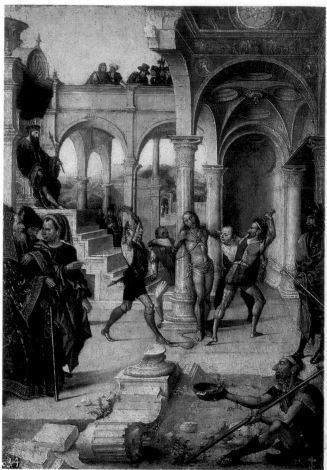

Vicente Masip
Born c.1475; died in Valencia, 1545
The Visitation
Panel, diameter 60 cm
From the Convent of St Julian in Valencia;
later in the collection of the Marquis of
Jura Real, Purchased in 1826; Cat No.
851

18

Vicente Juan Masip, called Juan de Juanes
Fuenta La Higuera(?), 1523 – Bocairente,
1579
The Last Supper (The Institution of the
Eucharist)
Panel, 116 × 191 cm
From the Church of St Stephen in Valencia. Entered the Prado in 1818; Cat No.
846

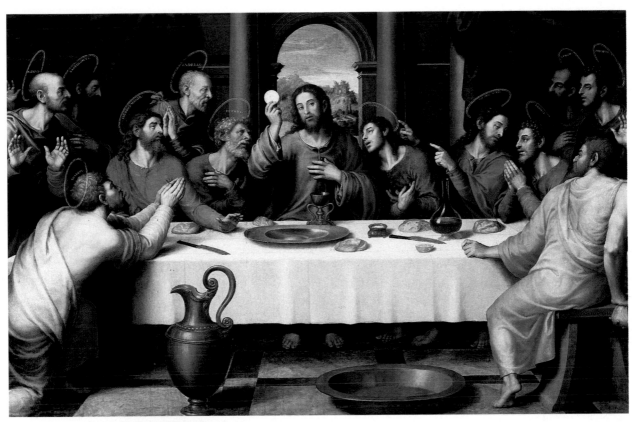

1
Fernando Yáñez de La Almedina
Active 1501–1531 in Valencia
St Catherine of Alexandria
Panel, 212 × 112 cm
From the collection of the Marquis of
Casa-Argudín. Purchased in 1946; Cat
No. 2902

2
**Paolo de San Leocadio (formerly known
as the Master of the Knight of Montesa)**
Born in Italy; active in Valencia
1472–1514
*The Virgin and Child ('The Virgin of the
Knight of Montesa')*
Panel, 102 × 96 cm
Purchased in 1919; Cat No. 1335

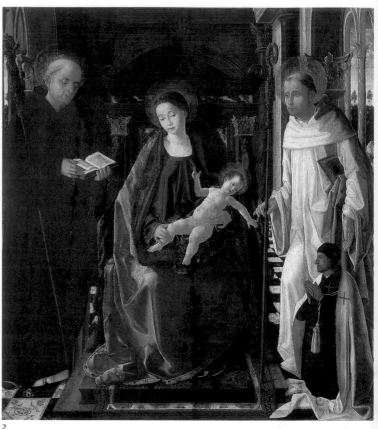

2

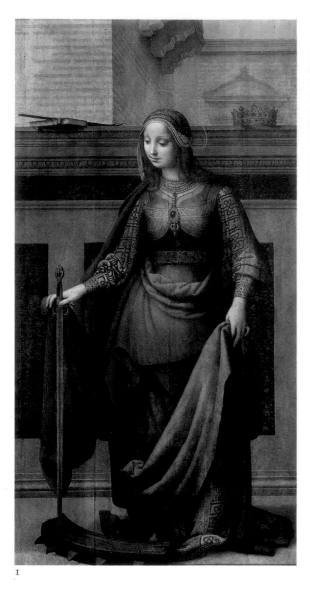

1

3
Luis de Morales, called El Divino
Badajoz, c.1500 – Badajoz, 1586
St Stephen
Panel, 67 × 50 cm
Donated in 1915 by the descendants of
the Countess of Castañeda; Cat No. 948a

4
Luis de Morales, called El Divino
Badajoz, c.1500 – Badajoz, 1586
The Virgin and Child
Panel, 84 × 64 cm
Bequeathed by Don Pablo Bosch in 1915;
Cat No. 2656

5
Pedro Machuca
**Toledo, end of the fifteenth century; died
in Granada in 1550**
The Descent from the Cross
Panel, 141 × 128 cm (including frame)
Purchased in 1961; Cat No. 3017

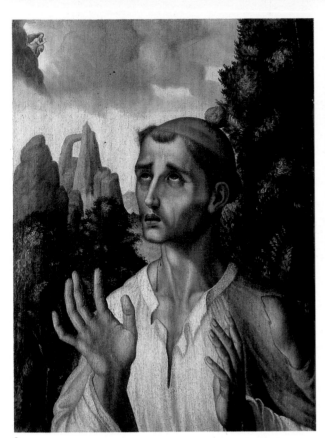

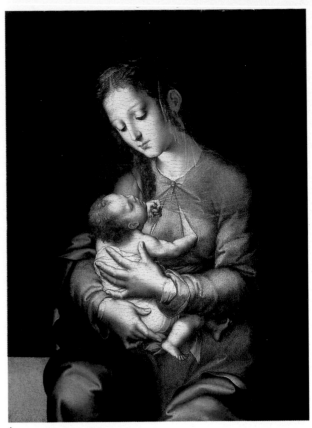

3

4

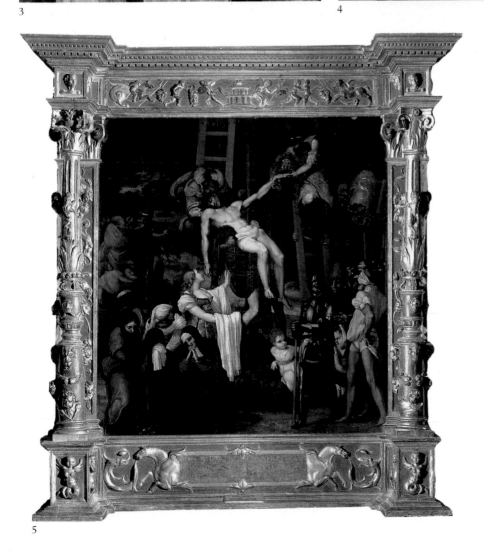

5

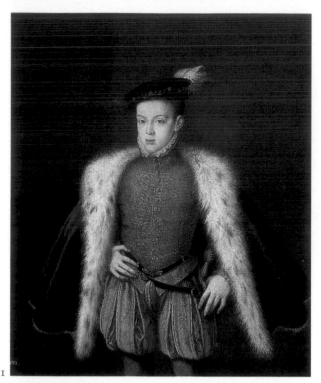

1

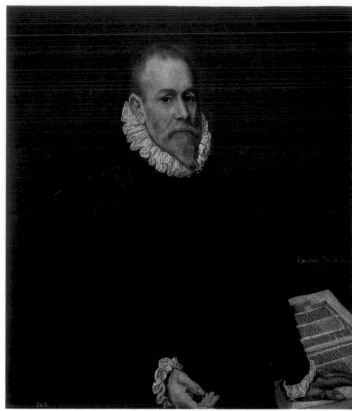

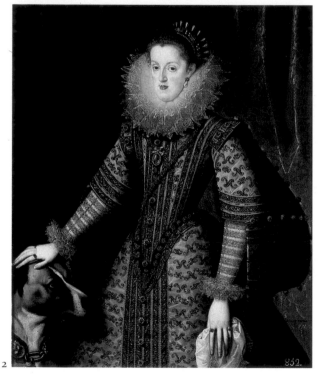

2

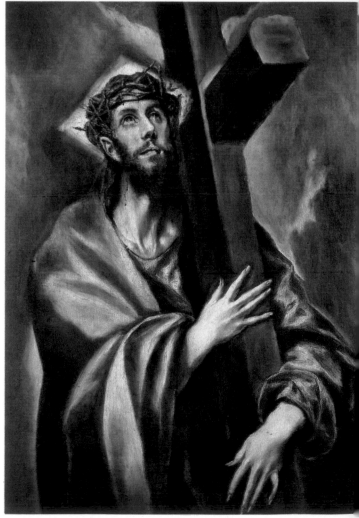

1
Alonso Sánchez Coello
Valencia, *c*.1531/32 – Madrid, 1588
Prince Don Carlos of Austria
Canvas, 109 × 95 cm
Collection of Philip II; Cat No. 1136

2
Bartolomé González
Valladolid, 1564 – Madrid, 1627
Queen Margarita of Austria, 1609
Canvas, 116 × 100 cm
Provenance unknown; Cat No. 716

3
**Domenikos Theotokopoulos, called
El Greco**
Kameia, *c*.1540/41 – Toledo, 1614
Doctor Rodrigo de La Fuente (?),
before 1598
Canvas, 93 × 82 cm
Collection of Philip IV; Cat No. 807

4
**Domenikos Theotokopoulos, called
El Greco**
Kameia, *c*.1540/41 – Toledo, 1614
*Christ carrying the Cross, c.*1600/10
Canvas, 108 × 78 cm
Entered the Prado in 1877; Cat No. 822

5
**Domenikos Theotokopoulos, called
El Greco**
Kameia, *c*.1540/41 – Toledo, 1614
*Portrait of a nobleman with his hand on his
chest, c.*1577/84
Canvas, 81 × 66 cm
Royal Collection; Cat No. 809

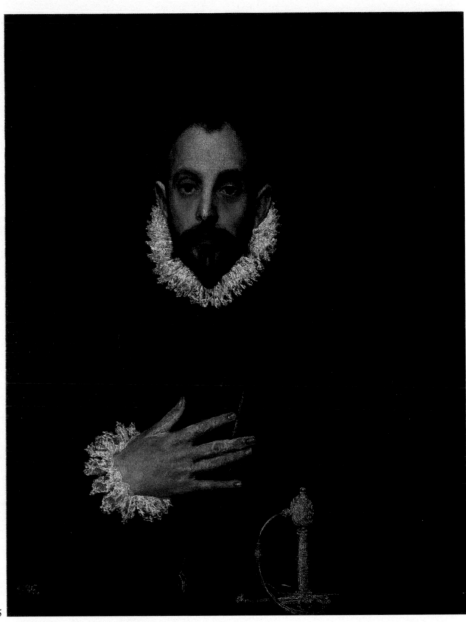

5

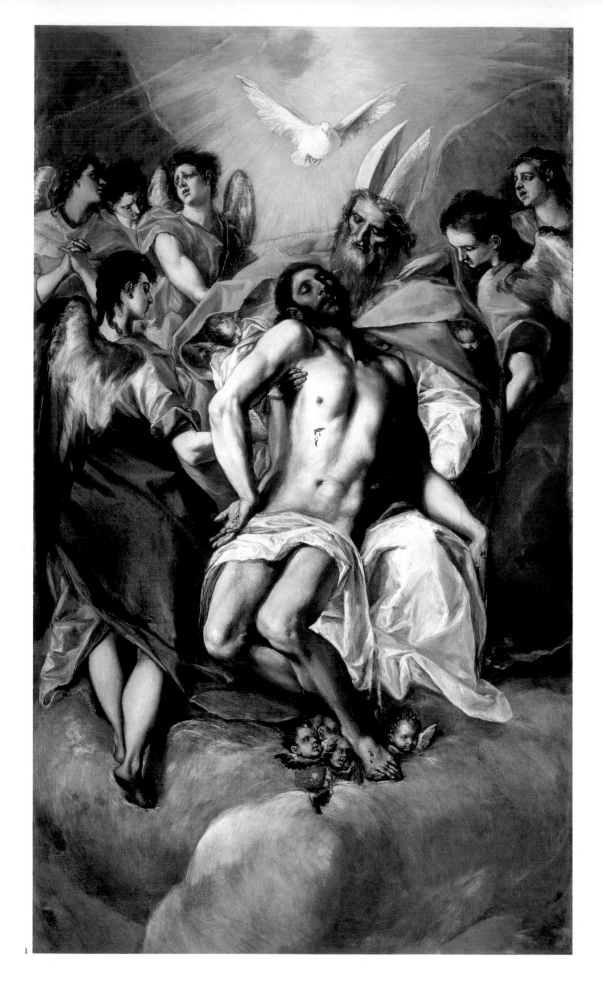

1

**Domenikos Theotokopoulos, called
El Greco**
Kameia, *c.*1540/41 – Toledo, 1614
*The Holy Trinity, c.*1577/79
Canvas, 300 × 179 cm
Purchased in 1827; Cat No. 824

This work was painted as the main
altarpiece for the Old Church of St
Dominic (Santo Domingo El Antiguo), and
was El Greco's first commission upon his
arrival in Toledo in 1577. It gained great
fame in Toledo, which was artistically
rather archaic and provincial, and es-
tablished a successful career for El Greco
in the town. The general composition is
based on an engraving by Dürer, but for
the figure of Christ the artist probably also
drew inspiration from Michelangelo's
Pietà for Vittoria Colonna. The stress on
the dead body of Christ, together with the
clamorous mannerist colours and the
rather loose composition of the figures,
produces a feverish pathos.

2

**Domenikos Theotokopoulos, called
El Greco**
Kameia, *c.*1540/41 – Toledo, 1614
*The Resurrection, c.*1596/1610
Canvas, 275 × 127 cm
From the College of Doña María de
Aragón in Madrid; Cat No. 825

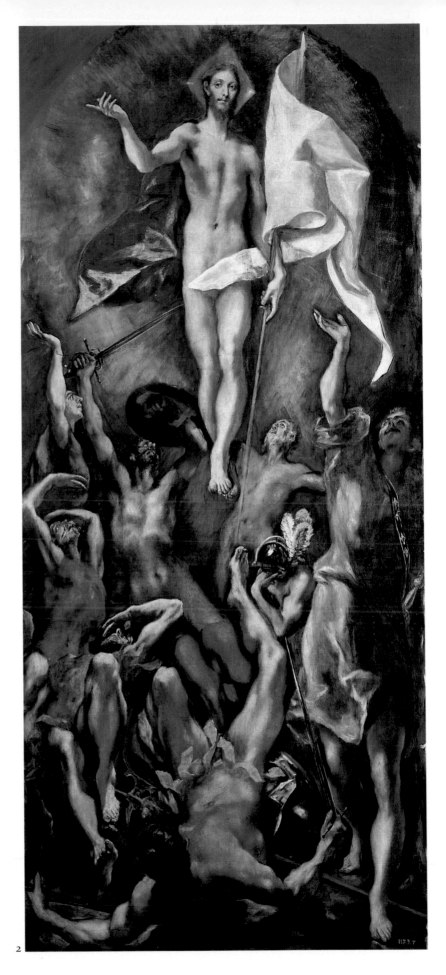

2

Domenikos Theotokopoulos, called El Greco
Kameia, *c*.1540/41 – Toledo, 1614
The Adoration of the Shepherds,
c.1614
Canvas, 319 × 180 cm
Entered the Prado in 1954;
Cat No. 2988

This *Nativity*, painted by El Greco for his own burial chapel in the Old Church of St Dominic (Santo Domingo El Antiguo) in Toledo, provides an excellent example of the artist's late style. The elongated bodies seem almost without substance; the cold, vibrant colours are accentuated by a nervous brushwork; the exaggerated attitudes of the figures communicate a palpable spirituality.

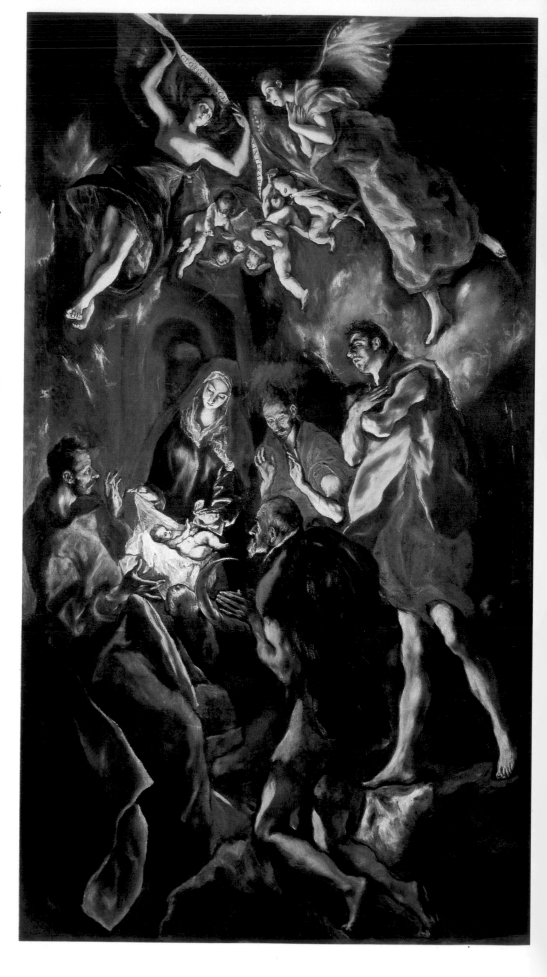

Velázquez and the Seventeenth Century

When El Greco died in 1614, the first signs were already appearing in Spain of the style known as 'naturalist tenebrism' which brought with it a new vision of pictorial reality. Details like folds, creases, or subtle physical characteristics were picked out beneath harsh pictorial lighting with an almost theatrical emphasis, isolating and magnifying them under its expressive glare in order to achieve the maximum effect on the spectator. This early naturalism, which owed much to Italian models, was perhaps already implied in the return to a sense of order, clarity and immediacy tentatively indicated in the work of some of the artists employed at the Escorial, for example, Federico Zuccaro, Luca Cambiaso, Bartolomé Carducho and Francisco Ribalta.

Ribalta, a Catalonian from Solsona who was trained in Castile but settled in Valencia, opened his work to the influence of naturalism without totally renouncing the lucid forms of the Renaissance; the Prado possesses important examples of his work. At the same time in Castile, the various followers of artists hired by Philip II at the Escorial began to move back towards forms of realism. The work of these artists, notably Vicente Carducho and Juan Bautista Maino, is also well represented in the museum. In Seville, from under the shadow of the timid naturalism of older masters such as Pacheco and Roelas, whose work is barely represented in the Prado, there emerged younger artists such as Cano, Velázquez and Zurbarán, who were to produce masterpieces within the confines of a stricter naturalism.

Before describing the mature work of these artists, the work of the Valencian painter Jusepe de Ribera, should also be mentioned. Ribera emigrated to Italy when very young and never returned to Spain, yet his work is considered as important in the history of Spanish painting as it is in that of Italian. He established himself in Naples in 1616 and created an individual style, delighting in grand compositions and a naturalistic and sensual treatment of the human form which is regarded as being among the most powerful expressions of European baroque. Ribera was enthusiastically patronised by the Spanish viceroys in Naples, and a large part of his artistic production was sent to Madrid where it was kept in the royal palaces until it was eventually transferred to the Prado. Ribera might be said to mark the beginning of the Golden Age of Spanish painting.

Zurbarán, who attempted only fitfully to gain acceptance at Court, divided his working life between his birthplace in Estremadura and Seville, spending his final years in Madrid. The essential part of the work of Zurbarán remains outside the Prado, though there is an important selection of his paintings on view. These works are perhaps the most representative of the monastic world of Counter-Reformation Spain, a world of 'broken bread, wine and serge', as Rafael Alberti aptly defined it, which is perfectly embodied in his still lifes.

Velázquez, of an entirely different character, established himself at Court from 1623 onwards and was closely connected with all forms of courtly life. In these surroundings, with access to the outstanding collections of Venetian and Flemish painting housed in the palaces of Madrid, Velázquez soon forgot the sober tenebrist style of his youth in Seville. He was thus able to develop his mature manner which is characterized by an inimitable lightness of brushwork, the taste for a cold range of colours (as shown in his use of harmonized grey tones), and a supreme sense of composition and the posing of his subjects. The œuvre of Velázquez, the courtly painter *par excellence*, remained virtually intact while in the Royal Palace, and the Prado is proud to have in its possession more than a third of his entire production, from which the visitor can carry out a comprehensive study of his work as a whole. Understandably, paintings from his naturalist period in Seville are missing from the collection, but *The Adoration of the Kings* and a few portraits go some way to represent his earlier manner. The mature phases of Velázquez' art are all displayed: the portraits of kings, princes, royal favourites and buffoons; the mythological subjects; the historical pictures, like *The Surrender of Breda*, with their great dignity of composition; the later religious works with their silent elegance; the landscapes, such as those of the Medici Gardens in Rome, where a more melancholy and reticent side to the artist's sensibility can be sensed; and the magnificent *Las Meninas*, that astonishing symbol of the relationship which exists in all paintings between appearance and reality and yet mysteriously withholds its meaning.

The wave of high baroque works in Madrid during this period was produced largely for monastic and ecclesiastical decorative schemes. As a result of the disestablishment of Mendizábal and the transfer of the contents of the Museum of the Trinity to the Prado, many of these works are now in the possession of the museum; the collection has in some cases been increased by later purchases and donations. The following artists from this period are all well represented: Antonio de Pereda, who remains close to naturalism in his greatest works; Carreño de Miranda, whose portraiture inherits something of the distinction of Velázquez; Herrera the Younger, whose work shows both decorative and dynamic elements; Antolínez and Cerezo, delicate colourists,

both of whom died in their prime; and Claudio Coello, with his spacious pictorial rhetoric and masterly immediacy.

In the second half of the seventeenth century two highly significant artists emerged in Seville. The first, Murillo, enjoyed great popularity during the eighteenth and nineteenth centuries, although his reputation has since been somewhat tarnished on account of what, to modern taste, appears to be the sentimentality of his work. This image is partly due to the vulgarization of his original compositions by many of his followers and imitators, and more recently to poor mass reproduction. Murillo, who is technically a painter of great quality, an elegant draughtsman and a refined colourist, absorbed the realistic tradition of the religious painting of the Counter-Reformation and transformed it through the study of Flemish art, in particular the work of Van Dyck. The result of the process was an emotional, decorative style which, although considered superficial and effeminate by some, reflected a genuine piety and exerted an authentic popular appeal for over two centuries. Murillo developed a familiar, accessible and tender manner of pictorial expression, which manages to evade the portrayal of crude and distasteful elements even in those pictures in which degradation and the misery of *picaros* and beggars is represented. In this sense, Murillo might fairly be described as a sentimentalist, yet his work retains its great quality and its historical importance in art history despite its modern categorization. The Prado possesses an important series of Murillo's paintings thanks, above all, to the purchases of Queen Isabel de Farnesio in Seville, but also to later acquisitions. Unfortunately, the pictures of *picaros* and young beggars which procured an especial popularity for Murillo's work are lacking from the collection and must be studied outside Spain.

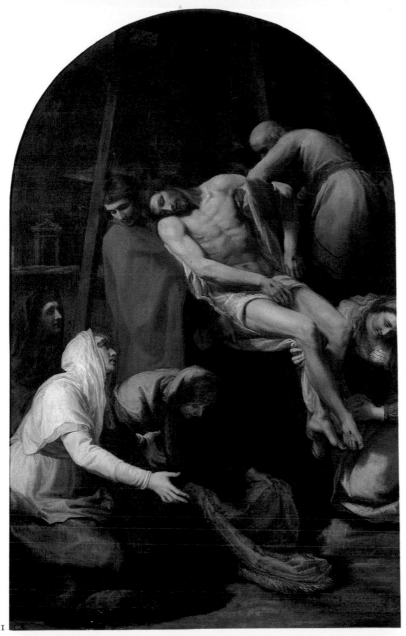

1

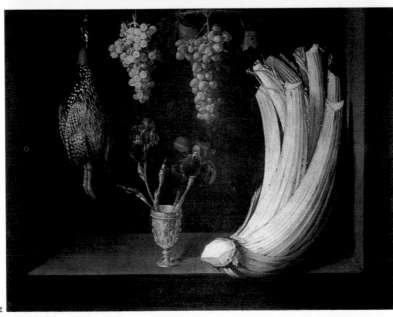

2

1
Bartolomé Carducho
Florence, 1554 – Madrid, 1608
The Descent from the Cross, 1595
Canvas, 263 × 181 cm
Painted for the Royal Church of Saint
Philip (San Felipe el Real) in Madrid; Cat
No. 66

2
Felipe Ramírez
Active probably in Toledo during the first
third of the seventeenth century
Still life
Canvas, 72 × 92 cm
Purchased in 1940 with a bequest of the
Count of Cartagena; Cat No. 2802

1
Juan van der Hamen
Madrid, 1596 – Madrid, 1631
Flora, 1627
Canvas, 216 × 140 cm
Bequeathed in 1944 by the Count of La
Cimera; Cat No. 2877

2
Fray Juan Bautista Maino
Pastrana, 1581 – Madrid, 1649
The Adoration of the Kings, 1612
Canvas, 315 × 174 cm
From the Church of St Peter Martyr in
Toledo; Cat No. 886

3
Fray Juan Bautista Maino
Pastrana, 1581 – Madrid, 1649
The Adoration of the Shepherds, 1612
Canvas, 315 × 174 cm
From the Church of St Peter Martyr in
Toledo; Cat No. 3227

These two works were painted as
altarpieces for the Convent of St Peter
Martyr in Toledo. Maino comes close to
what we now term 'superrealism' in some
sections of the pictures. He achieved this
effect by careful control of the texture,
shape and volume of the objects together
with a very cold but bright lighting,
which reveals the influence of Orazio
Gentileschi and the Italian baroque. Many
aspects of the compositions derive instead
from El Greco, whose works were so
numerous in Toledo.

1

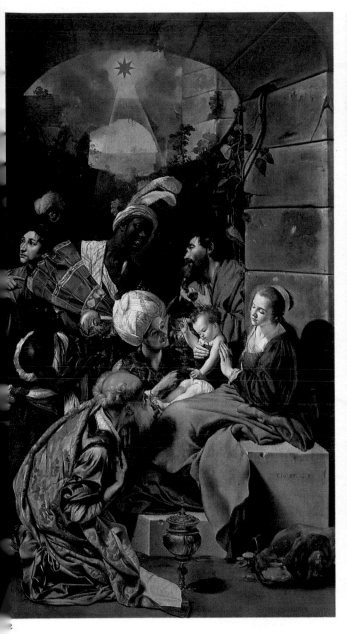

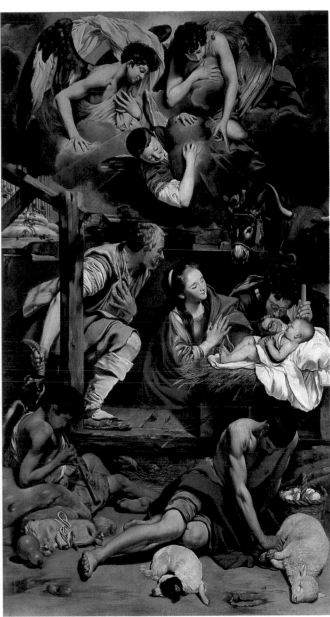

3

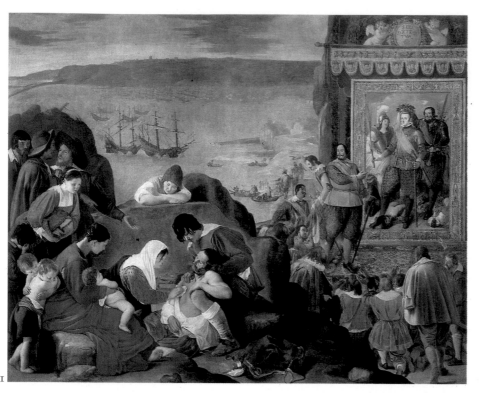

I

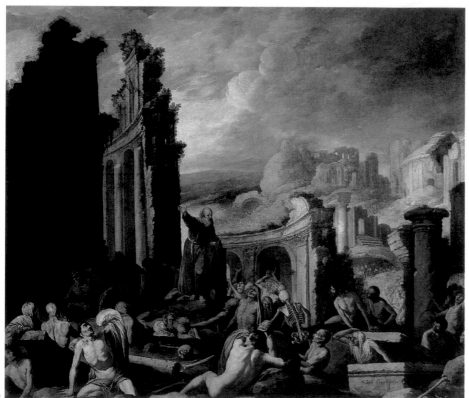

2

1
Fray Juan Bautista Maino
Pastrana, 1581 – Madrid, 1649
The Recovery of Bahia in 1625, c.1634/35
Canvas, 309 × 381 cm
From the Hall of the Realms in the Buen
Retiro Palace. Entered the Prado in 1827;
Cat No. 885

2
Francisco Collantes
Madrid, 1599 – Madrid, 1656
The Vision of Ezechiel, 1630
Canvas, 177 × 205 cm
Collection of Philip IV. Entered the Prado
in 1827; Cat No. 666

3
Francisco Collantes
Madrid, 1599 – Madrid, 1656
St Onuphrius
Canvas, 168 × 108 cm
Collection of Queen Isabel de Farnesio; Cat
No. 3027

4
Fray Juan Andrés Rizi
Madrid, 1600 – Monte Cassino, 1681
Don Tiburcio de Redin
Canvas, 203 × 124 cm
Collection of Charles IV; Cat No. 887

5
Diego Polo
Burgos, c.1610 – Madrid, 1665
The Fall of Manna
Canvas, 187 × 238 cm
From the collection of the Infante Don
Sebastian Gabriel de Borbón. Entered the
Prado in 1982; Cat No. 6775

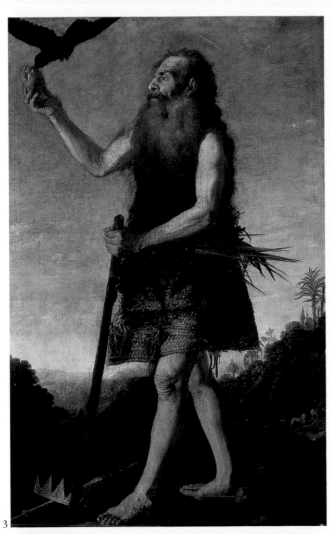

3

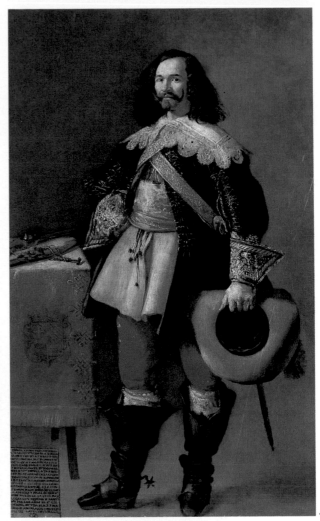

4

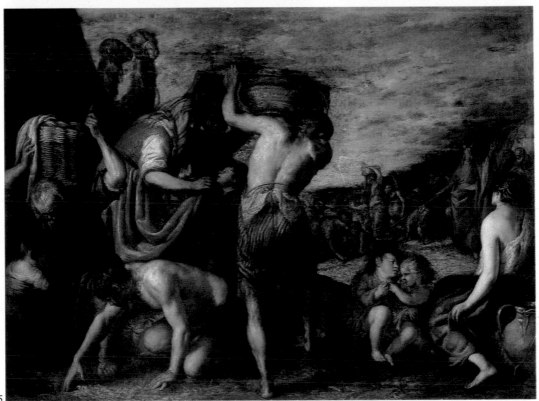

5

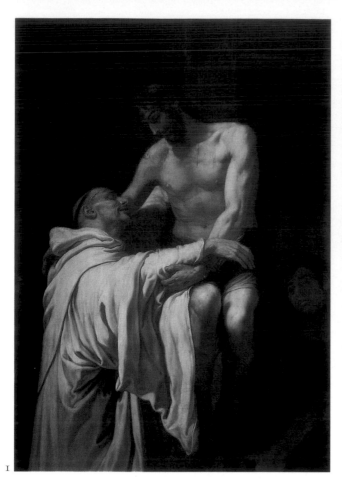

1

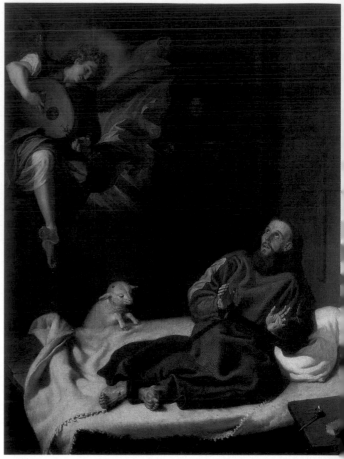

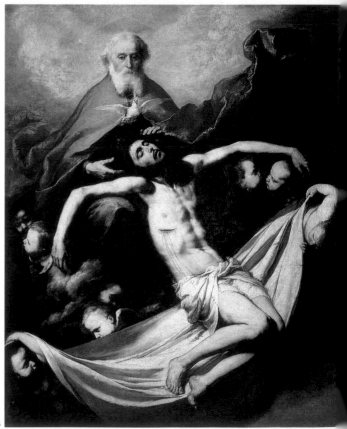

1
Francisco Ribalta
Solsona, 1565 – Valencia, 1628
Christ embracing St Bernard
Canvas, 158 × 113 cm
Purchased in 1940 with a donation
bequeathed by the Count of Cartagena:
Cat No. 2804

2
Francisco Ribalta
Solsona, 1565 – Valencia, 1628
St Francis comforted by an Angel
Canvas, 204 × 158 cm
Collection of Charles IV; Cat No. 1062

3
Jusepe de Ribera
Játiva, 1591 – Naples, 1652
The Holy Trinity, c.1635/36
Canvas, 226 × 181 cm
Purchased in 1820; Cat No. 1069

3

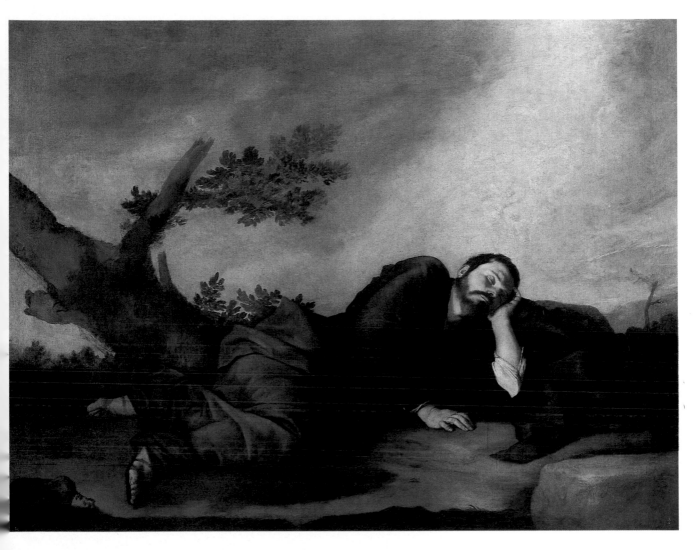

Jusepe de Ribera
Játiva, 1591 – Naples, 1652
Jacob's Dream, 1639
Canvas, 179 × 233 cm
In the collection of Queen Isabel de
Farnesio by 1746. Entered the Prado in
1827; Cat No. 1117

This work by Ribera has particular inter-
est because it conspicuously avoids the
usual iconography of Jacob's dream,
involving a ladder. Instead, the dream is
suggested merely by vaporous, golden
figures who might almost be part of the
real sky. But the setting of the dreamer,
and the play of light on his sleeping face,
impart a portentous and mysterious mood
to the scene.

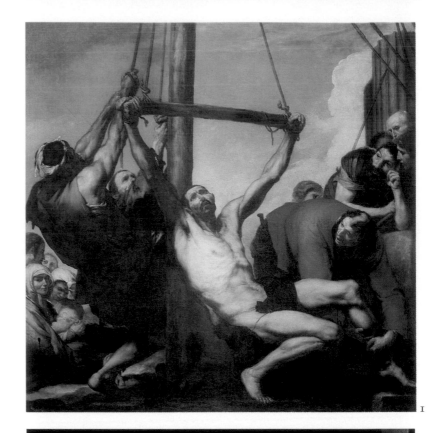

1

Jusepe de Ribera
Játiva, 1591 – Naples, 1652
The Martyrdom of St Philip, 1639 (?)
Canvas, 234 × 234 cm
Collection of Philip IV; Cat No. 1101

2

Jusepe de Ribera
Játiva, 1591 – Naples, 1652
*St Andrew, c.*1630/32
Canvas, 123 × 95 cm
Previously in the Escorial. Entered the
Prado in 1838; Cat No. 1078

3

Jusepe de Ribera
Játiva, 1591 – Naples, 1652
Jacob receives Isaac's Blessing, 1637
Canvas, 129 × 289 cm
Collection of Charles II of Spain; Cat No.
1118

4

Jusepe de Ribera
Játiva, 1591 – Naples, 1652
Mary Magdalene (or St Thais?) in the desert,
*c.*1640/41
Canvas, 181 × 195 cm
From the collection of the Marquis of Los
Llanos; at the Royal Palace, Madrid, by
1772; Cat No. 1103

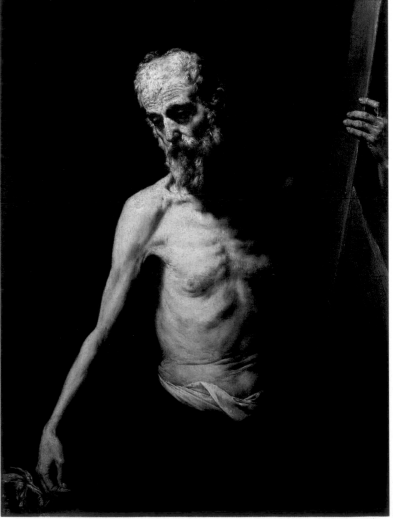

2

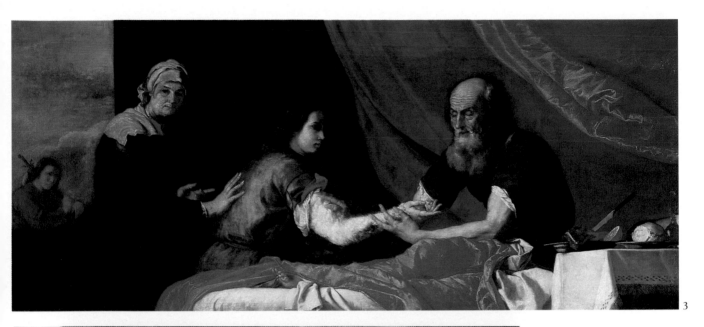

3

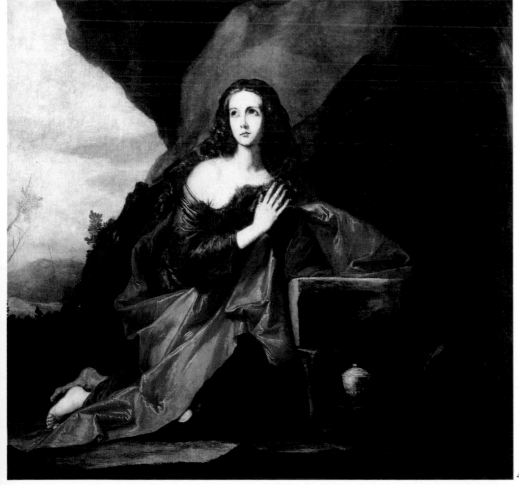

4

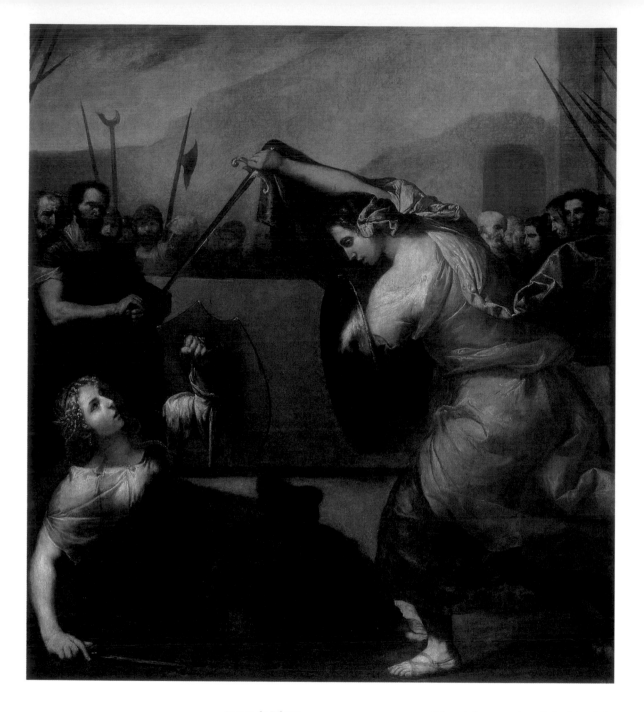

Jusepe de Ribera
Játiva, 1591 – Naples, 1652
The Duel of Isabella de Carazzi and Diambra
de Pettinella, 1636
Canvas, 235 × 212 cm
Collection of Philip IV (?); Cat No. 1124

Ribera is known primarily for his religious subjects, but he painted a number of mythological and historical scenes. This painting represents a true story, a duel between two women, Isabella de Carazzi and Diambra de Pettinella, for the love of Fabio de Zeresola. Probably the unusual or grotesque nature of the story attracted Ribera; alternatively he wished to satirize duels for honour, a common phenomenon in the Naples of his time. Ribera employs the warm colouring typical of his mature work.

Jusepe de Ribera
Játiva, 1591 – Naples, 1652
St Peter freed from Prison by an Angel,
1639
Canvas, 177 × 232 cm
In the collection of Queen Isabel de
Farnesio by 1746; Cat No. 1073

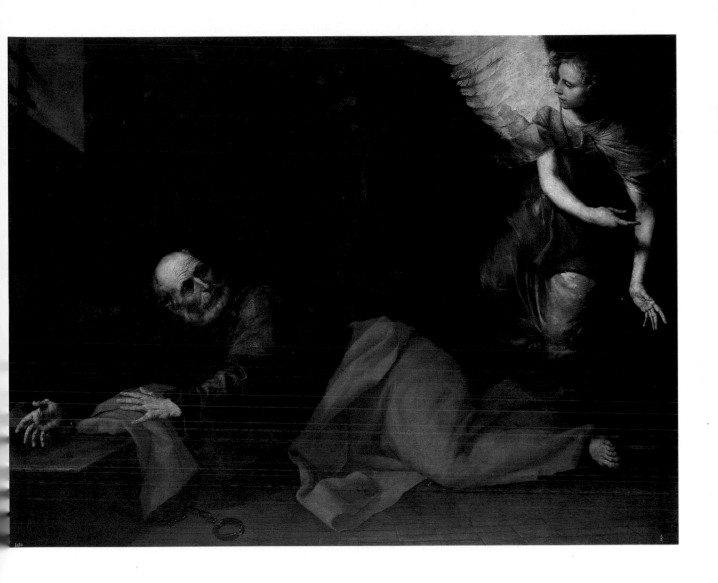

1
Antonio de Pereda
Valladolid, 1611 – Madrid, 1678
St Jerome, 1643
Canvas, 105 × 84 cm
From the Palace of Aranjuez; Cat No.
1046

2
Antonio de Pereda
Valladolid, 1611 – Madrid, 1678
Christ the Man of Sorrows, 1641
Canvas, 97 × 78 cm
From the Museum of the Trinity; Cat No.
1047

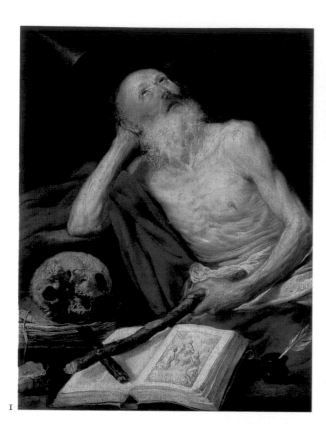

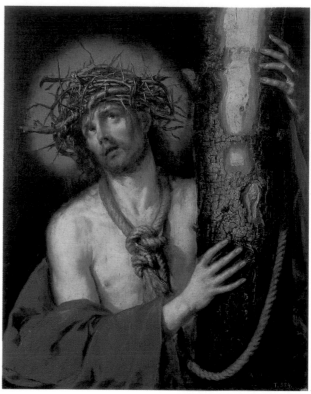

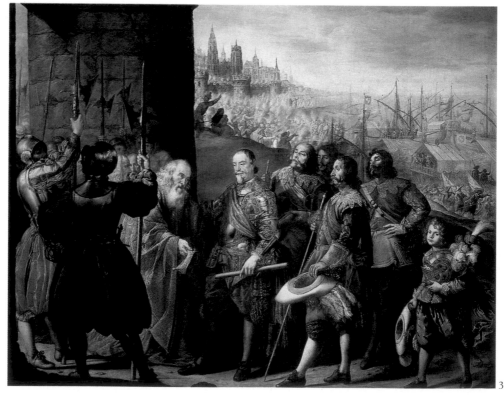

1
Antonio de Pereda
Valladolid, 1611 – Madrid, 1678
St Jerome, 1643
Canvas, 105 × 84 cm
From the Palace of Aranjuez; Cat No.
1046

2
Antonio de Pereda
Valladolid, 1611 – Madrid, 1678
Christ the Man of Sorrows, 1641
Canvas, 97 × 78 cm
From the Museum of the Trinity; Cat No.
1047

3
Antonio de Pereda
Valladolid, 1611 – Madrid, 1678
The Relief of Genoa, c.1634/35
Canvas, 290 × 370 cm
From the Hall of the Realms in the Buen
Retiro Palace. Presented to the Prado in
1912 by Marzel de Nemes; Cat No. 1317

4
Jusepe Leonardo
Calatayud, 1601 – Zaragoza, before 1653
The Birth of the Virgin, 1640
Canvas, 180 × 122 cm
Entered the Museum of the Trinity in
1864; Cat No. 860

5
Jusepe Leonardo
Calatayud, 1601 – Zaragoza, before 1653
St Sebastian
Canvas, 192 × 58 cm
In the collection of Queen Isabel de
Farnesio by 1746; Cat No. 67

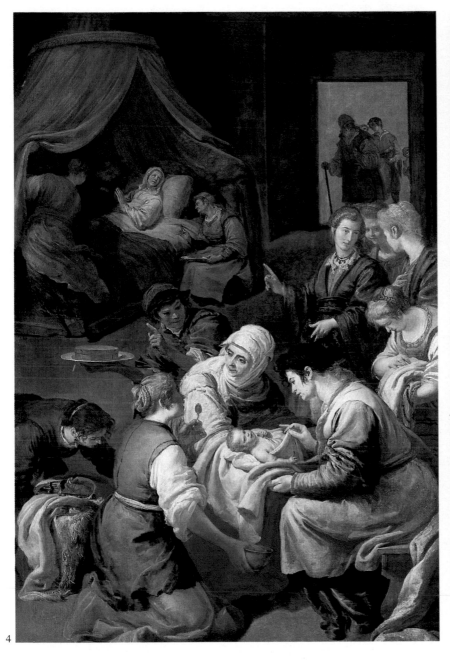

4

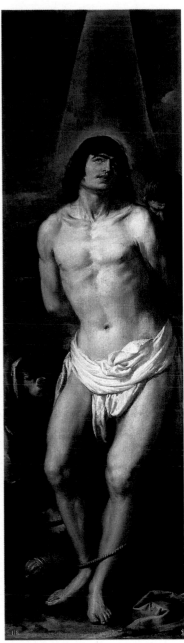

5

1
Diego Velázquez de Silva
Seville, 1599 – Madrid, 1660
The Topers (The Rule of Bacchus), 1628
Canvas, 165 × 225 cm
Collection of Philip IV; Cat No. 1170

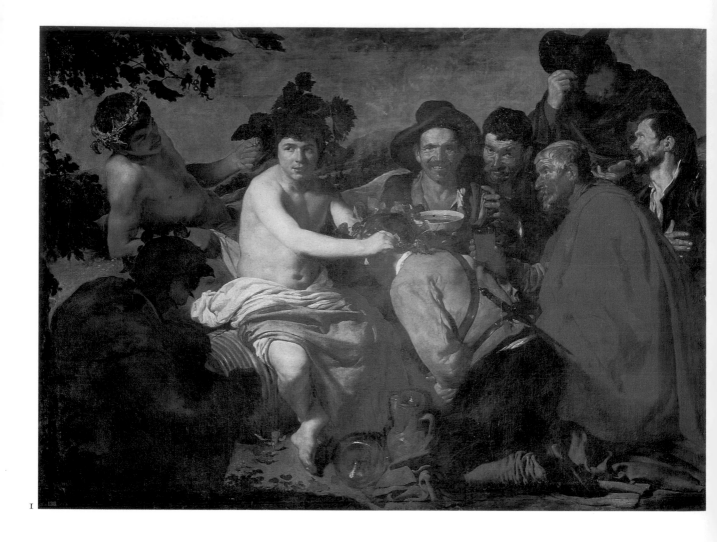

I

2
Diego Velázquez de Silva
Seville, 1599 – Madrid, 1660
Apollo at the Forge of Vulcan, 1630
Canvas, 223 × 290 cm
Purchased for Philip IV in 1634; Cat No. 1171

3
Diego Velázquez de Silva
Seville, 1599 – Madrid, 1660
The Gardens of the Villa Medici in Rome,
*c.*1650/51
Canvas, 48 × 42 cm
Collection of Philip IV; Cat No. 1210

4
Diego Velázquez de Silva
Seville, 1599 – Madrid, 1660
The Gardens of the Villa Medici in Rome,
*c.*1650/51
Canvas, 44 × 38 cm
Collection of Philip IV; Cat No. 1211

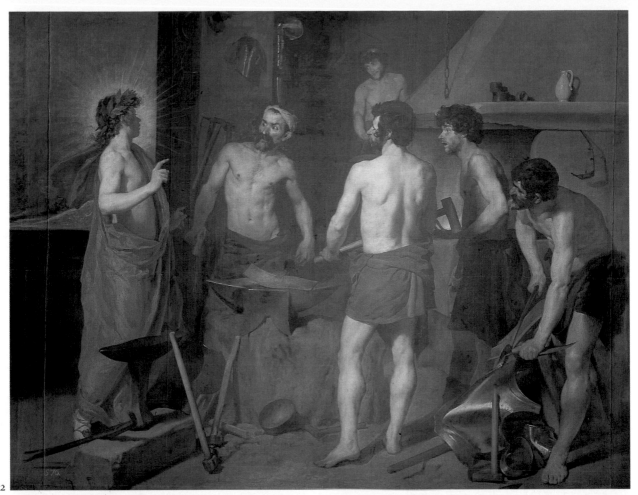

2

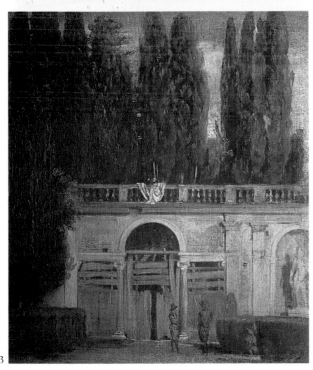

3

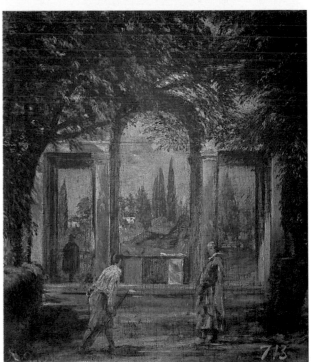

713

4

43

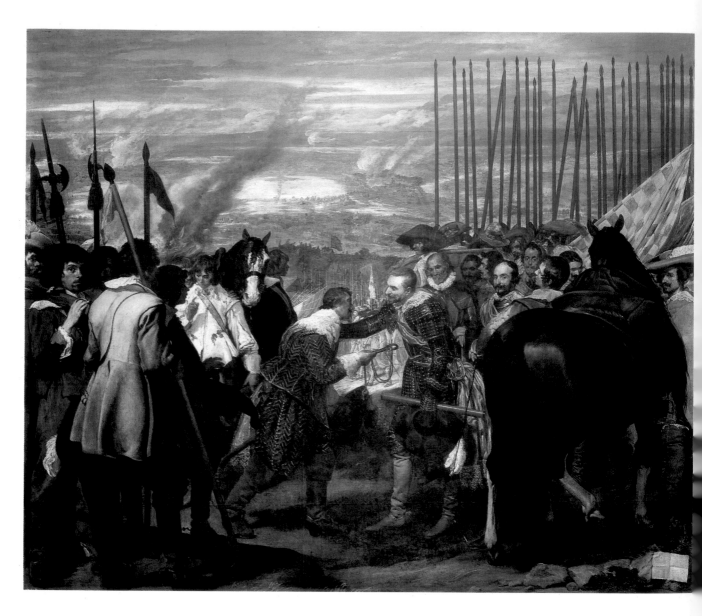

Diego Velázquez de Silva
Seville, 1599 – Madrid, 1660
The Surrender of Breda, before 1635
Canvas, 307 × 367 cm
From the Hall of the Realms in the Buen
Retiro Palace; Cat No. 1172

Velázquez was not himself present at the
Surrender of the town of Breda, but he
had access to an engraving by Jacques
Callot executed shortly after the Battle (in
1625), and also he met the beseiging
general, Spinola, on his first trip to Italy in
1629. The painting is noticeably un-
touched by the sensationalism and
dramatization current in baroque history
painting of the time, and makes a striking
contrast to a work such as Rubens' *Meet-
ing of the Cardinal-Infante Don Fernando and
the King of Hungary at Nördlingen*.

The device by which the landscape is
handled, laid out like a map behind the

protagonists, recalls the work of Peeter
Snayers. But, though recognizable, it lacks
the topographical precision of some of the
other contributions to the Hall of the
Realms, and provides no more than a
blurred background to the figures. The
clearing sky and trailing smoke are per-
haps intended to suggest the recent battle.
The compositional variety and inventive
liveliness of the bystanders recreate the
scene with extraordinary conviction and
convey the impression of its happening
now, as if the spectator were present with
the artist: this looks forward to the theme
of *Las Meninas*.

Diego Velázquez de Silva
Seville, 1599 – Madrid, 1660
Prince Baltasar Carlos on horseback,
c.1635/36
Canvas, 209 × 173 cm
From the Hall of the Realms in the Buen
Retiro Palace; Cat No. 1180

Together with four more equestrian portraits by Velázquez, a cycle of 13 battle scenes by Cajés, Velázquez, Maino, Zurbarán, Carducho, Castello, Leonardo and Pereda, and a series of the Labours of Hercules by Zurbarán, this picture was an element in the colossal decorative scheme of the Hall of the Realms in the Buen

Retiro Palace. The scheme was organized by the Count-Duke of Olivares, with the aim of affirming the glory of the Spanish Monarchy during what was in fact a period of decline. The portrait, though highly conventional, is painted by Velázquez with his usual conviction, and with brilliantly suggestive strokes of impasto.

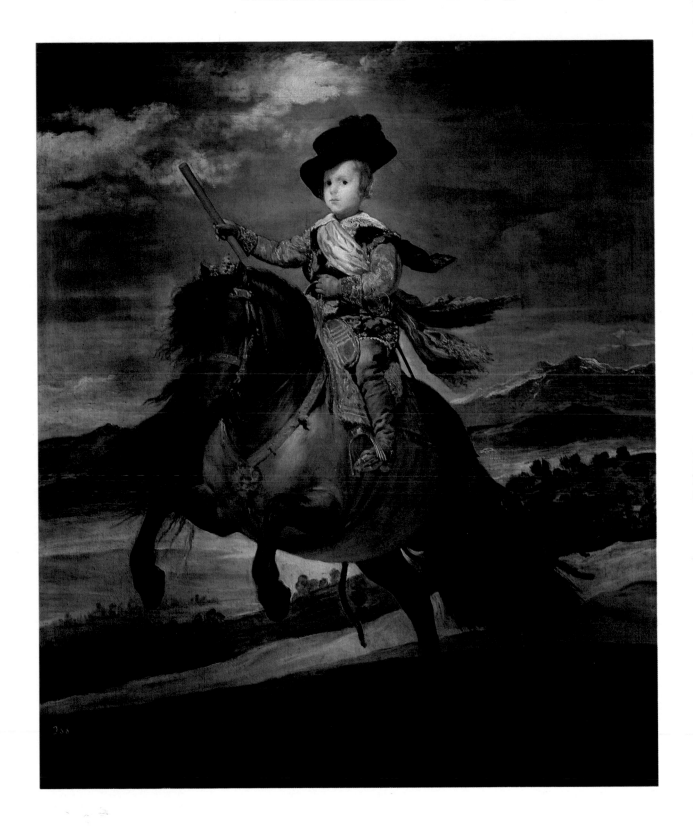

1

Diego Velázquez de Silva
Seville, 1599 – Madrid, 1660
Queen Doña Mariana of Austria, c.1652/53
Canvas, 231 × 131 cm
Collection of Philip IV; Cat No. 1191

2

Diego Velázquez de Silva
Seville, 1599 – Madrid, 1660
Pablo de Valladolid, c.1632
Canvas, 209 × 123 cm
Collection of Philip IV (from the apart-
ment of the Queen in the Buen Retiro
Palace); Cat No. 1198

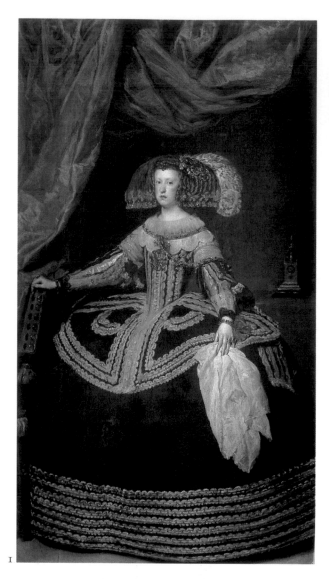

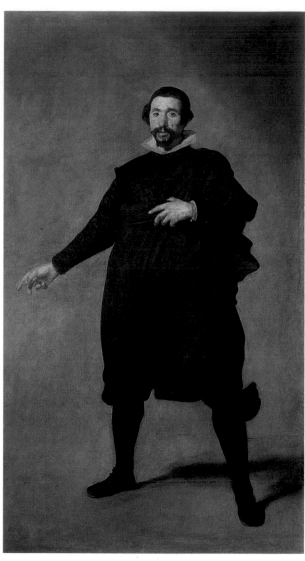

1

2

3

Diego Velázquez de Silva
Seville, 1599 – Madrid, 1660
Las Meninas, 1656
Canvas, 316 × 276 cm
Collection of Philip IV; Cat No. 1174

Las Meninas ('The Maids of Honour') is
more than a portrait, or even a portrait of
a portraitist at work. It may be read as a
statement in paint of the intellectual
dignity of art. We know that Velázquez
was always concerned about his status at
court and that he must have assimilated
much of his father-in-law's treatise on the
nobility of painting, *Arte de la Pintura* by
Francisco Pacheco. Therefore he shows
the King and Queen, who, though rather
ambiguously, are clearly present, witness-
ing the painter in the creative act. The
artist shows himself pausing, to prove
that painting involves thinking as well as
acting.

The figures in the painting seem to be
caught between one position and the next
with the kind of instantaneity that the
Impressionists, especially Degas, sought so
earnestly 200 years later. Other painters
would attempt to rival the extraordinary
illusionism of the space in which they
stand. Velázquez' power to evoke space
was already apparent in earlier works
such as *The Topers* and *The Surrender of
Breda*; here, with the device of setting the
King and Queen to loom in a mirror, he
extended the spatial order of the picture
into the realm of the spectator. The paint-
ing is a supreme example of baroque
spatial fiction or illusionism, and a re-
markable statement of the power of art
both to convey the real and to imagine
what is not in nature.

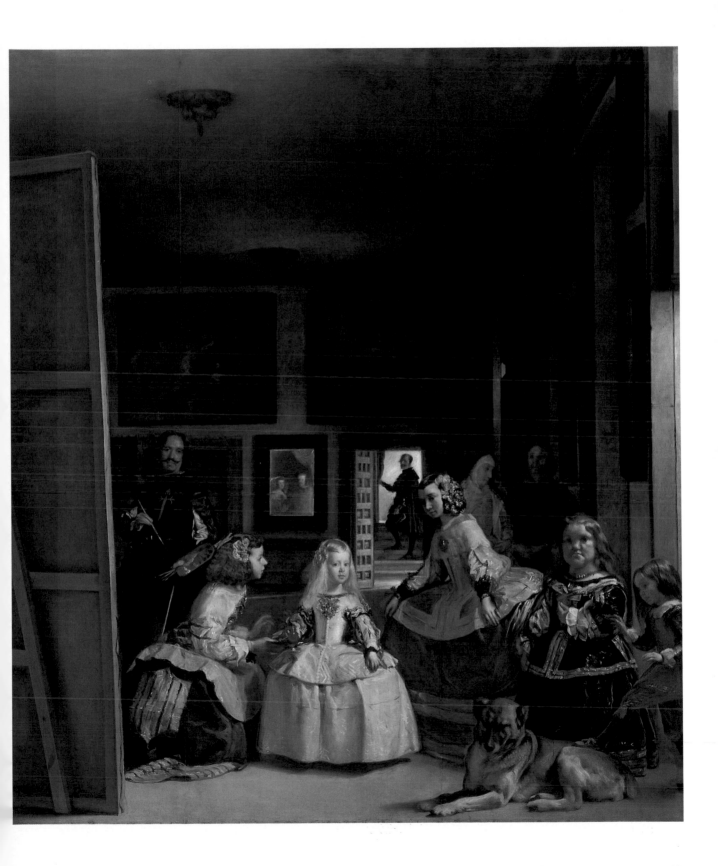

Diego Velázquez de Silva
Seville, 1599 – Madrid, 1660
The Count-Duke of Olivares on horseback,
*c.*1634
Canvas, 313 × 239 cm
Bought for Charles III in 1769 from the
collection of the Marquis of La Ensenada;
Cat No. 1181

Diego Velázquez de Silva
Seville, 1599 – Madrid, 1660
King Philip IV of Spain, before 1628
Canvas, 201 × 102 cm
Collection of Philip IV; Cat No. 1182

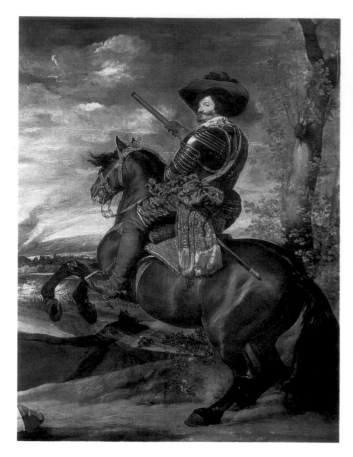

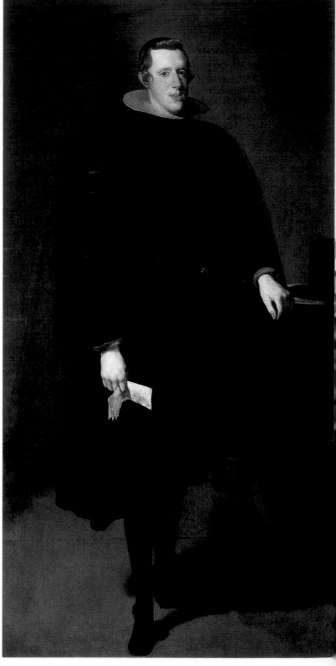

Diego Velázquez de Silva
Seville, 1599 – Madrid, 1660

Diego Velázquez de Silva
Seville, 1599 – Madrid, 1660

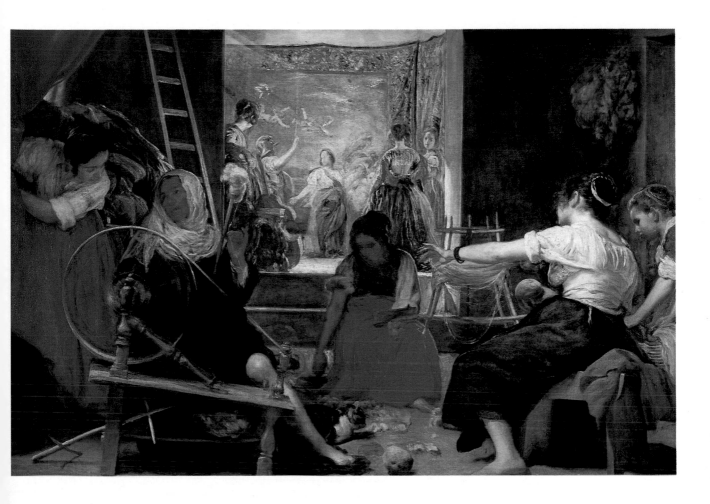

Diego Velázquez de Silva
Seville, 1599 – Madrid, 1660
*Las Hilanderas, c.*1657
Canvas, 220 × 289 cm
(Original dimensions, 164 × 250 cm)
In the collection of Don Pedro de Arce by
1664; later in the Royal Collection; Cat
No. 1173

There has been much discussion about
the meaning of *Las Hilanderas* ('The Spin-
ners'), but essentially the picture is clear
enough. Just as Velázquez in *The Topers* set
ordinary folk beside Bacchus, here he sets
Minerva, the goddess of weaving, and
Arachne, who rashly challenged her, in
the context of actual tapestry-makers. The
scene may reflect the disposition of the

Royal Tapestry Factory of St Elizabeth in
Madrid. Minerva is seen arriving in the
background, where Arachne is at work,
while other spinners in the foreground
concentrate on the business in hand.

Velázquez conveys their industry with
brilliant immediacy, seeming to mingle
the hum of their wheels with the shifts of
colour in the light. Nothing could be
further from the silent suspension and
frozen movement of *Las Meninas*. But *Las
Hilanderas* shares with *Las Meninas* and
certain early works by Velázquez an
ambiguity in the handling of space, with
which he deliberately fascinates the
viewer.

Diego Velázquez de Silva
Seville, 1599 – Madrid, 1660
*King Philip IV as a huntsman, c.*1634/35
Canvas, 191 × 126 cm
Commissioned by Philip IV for Torre de La
Parada; Cat No. 1184

Diego Velázquez de Silva
Seville, 1599 – Madrid, 1660
and
Juan Bautista Martínez del Mazo
Beteta (?), 1615 – Madrid, 1667
*The Infanta Doña Margarita de Austria,
c.*1660
Canvas, 212 × 147 cm
Collection of Philip IV; Cat No. 1192

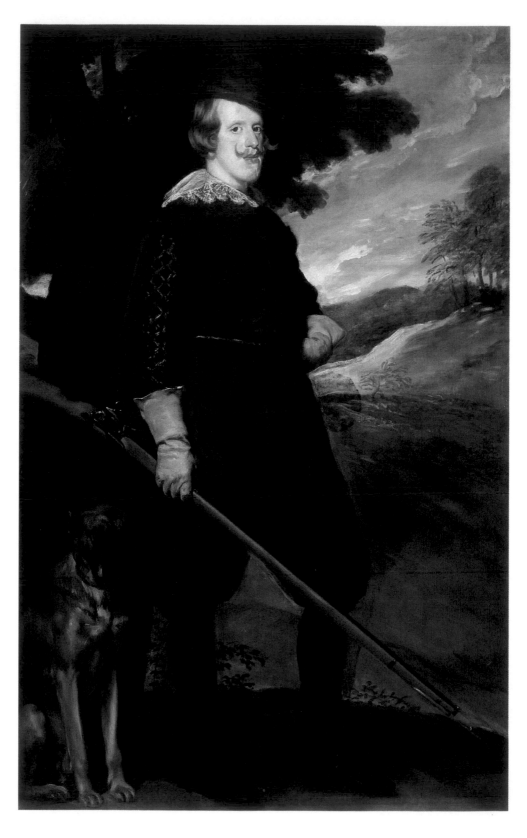

Diego Velázquez de Silva
Seville, 1599 – Madrid, 1660
*King Philip IV as a huntsman, c.*1634/35
Canvas, 191 × 126 cm
Commissioned by Philip IV for Torre de La
Parada; Cat No. 1184

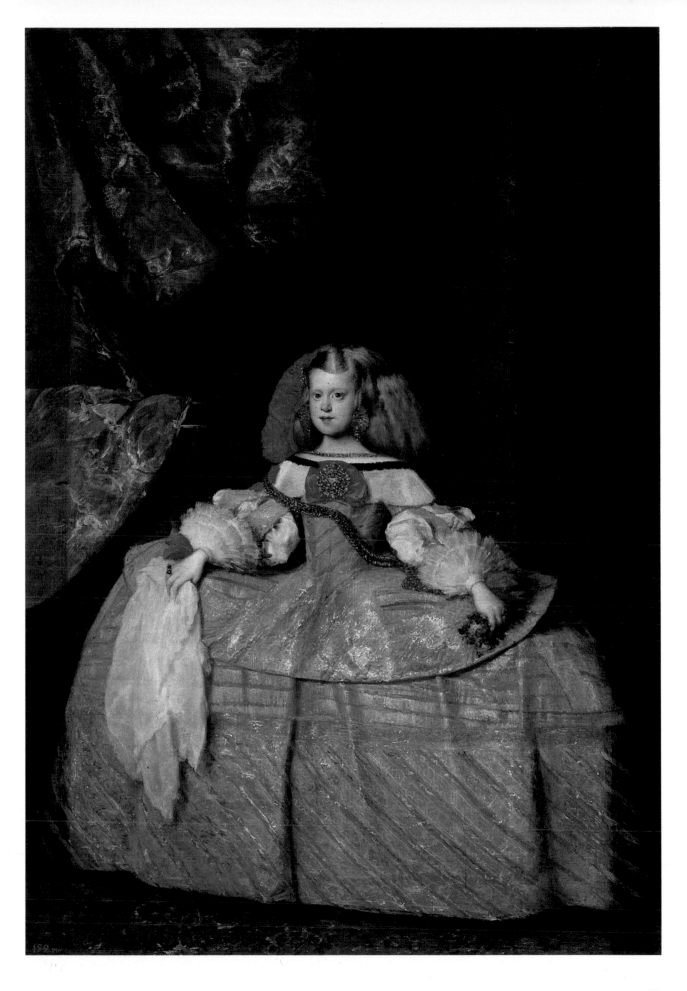

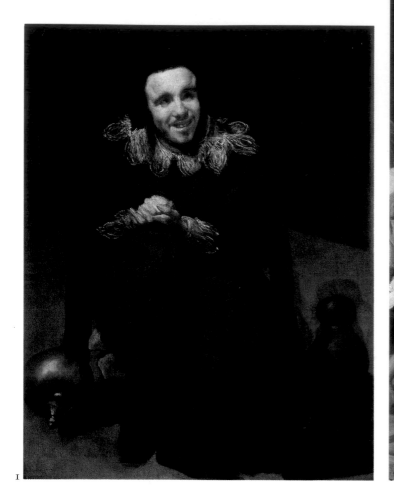

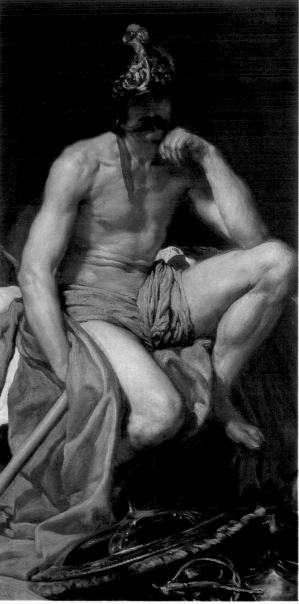

1

Diego Velázquez de Silva
Seville, 1599 – Madrid, 1660
*The Dwarf Don Juan Calabazas, called Cala-bacillas, c.*1639
Canvas, 106 × 83 cm
Collection of Philip IV (from the apartment of the Queen in the Buen Retiro Palace); Cat No. 1205

Dwarfs, fools and jesters were present in large numbers at the Court of Philip IV. They were maintained by the King according to a tradition extending back well into the Middle Ages. The tradition was motivated by charity, but many 'fools' came to be appreciated for their wit, arousing great affection and sometimes achieving great fame. Because they were not taken seriously, they were licensed to parody or flout the etiquette with which courtiers and royalty had to conform, which seems to have been especially appreciated at the rigid Court of Philip IV.

Velázquez has used a variety of subtle devices in portraying them: particularly interesting is the way the light flickers uncertainly over Calabacillas' grimace, suggesting his poor vision. Here Velázquez anticipates, or may have influenced, Goya's techniques of 160 years later.

2
Diego Velázquez de Silva
Seville, 1599 – Madrid, 1660
Mars, God of War, 1640
Canvas, 179 × 95 cm
Commissioned by Philip IV for Torre de La Parada. Entered the Prado after 1827; Cat No. 1208

3
Diego Velázquez de Silva
Seville, 1599 – Madrid, 1660
*Sts Paul the Hermit and Anthony Abbot, c.*1642
Canvas, 257 × 188 cm
Painted for the Hermitage of St Paul in the Buen Retiro Gardens; Cat No. 1169

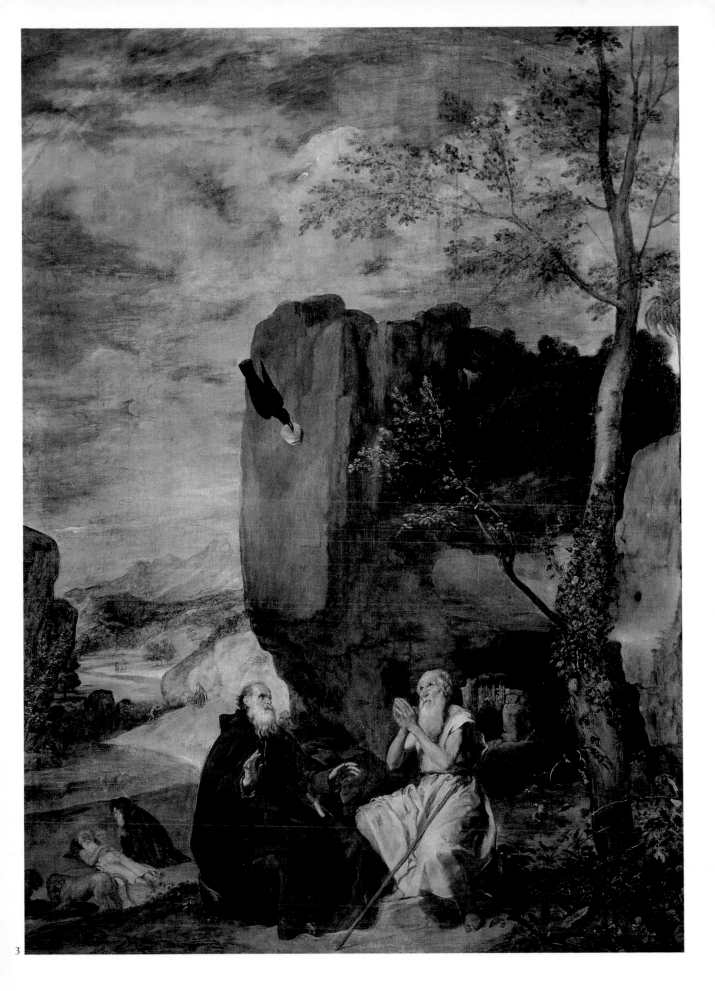

1

Diego Velázquez de Silva
Seville, 1599 – Madrid, 1660
The Jester Don Juan de Austria, c.1632/35
Canvas, 210 × 123 cm
Collection of Philip IV (from the apartment of the Queen in the Buen Retiro Palace); Cat No. 1200

2

Diego Velázquez de Silva
Seville, 1599 – Madrid, 1660
Aesop, 1640
Canvas, 179 × 94 cm
Commissioned by Philip IV for Torre de La Parada. Entered the Prado after 1827; Cat No. 1206

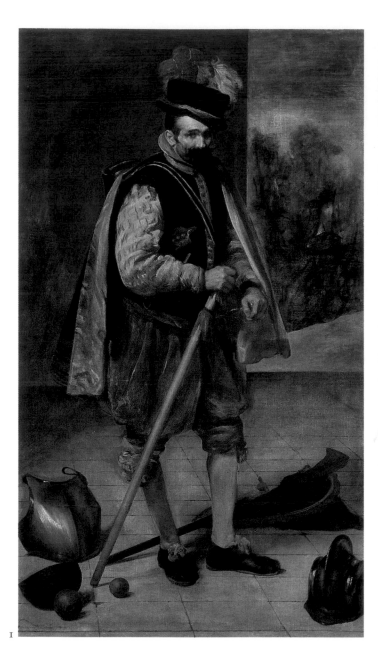

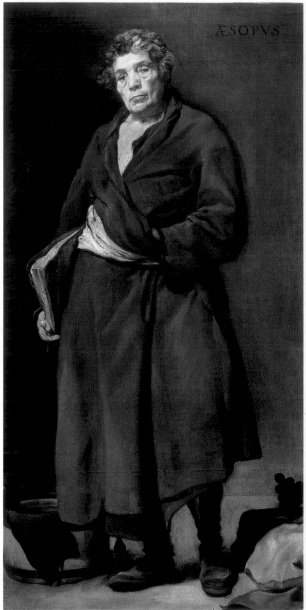

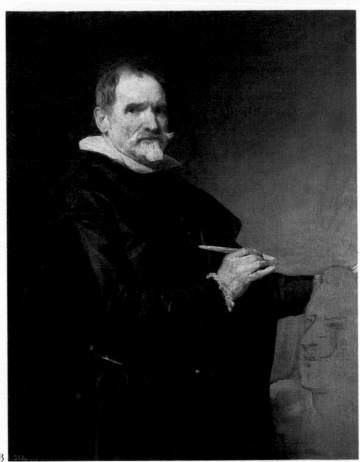

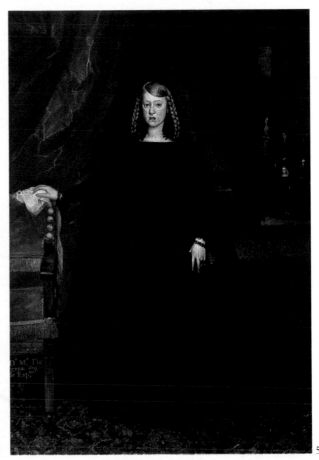

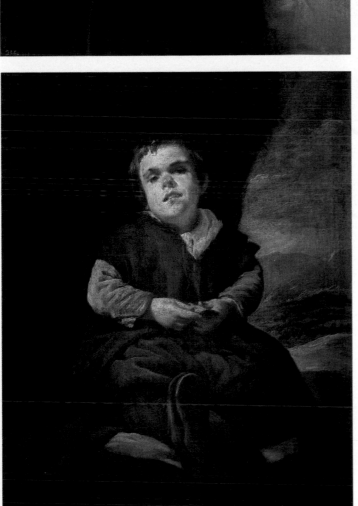

3
Diego Velázquez de Silva
Seville, 1599 – Madrid, 1660
Juan Martinez Montañes, c.1635
Canvas, 109 × 107 cm
In the Royal Collection by the eighteenth
century; at the Quinta del Duque del Arco
in 1794; Cat No. 1194

4
Diego Velázquez de Silva
Seville, 1599 – Madrid, 1660
Francisco Lezcano, known as El Niño de
Vallecas, c.1637
Canvas, 107 × 38 cm
Commissioned by Philip IV for the Torre
de la Parada. Entered the Prado after
1827; Cat No. 1204

5
Juan Bautista Martínez del Mazo
Beteta (?), 1615 – Madrid, 1667
The Empress Doña Margarita de Austria in
mourning dress, 1666
Canvas, 209 × 147 cm
Entered the Prado in 1847; Cat No. 888

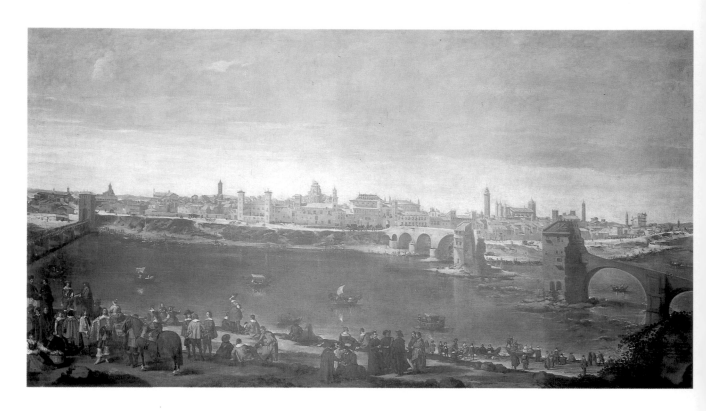

Juan Bautista Martínez del Mazo
Beteta(?), 1615 – Madrid, 1667
View of Saragossa, 1547(?)
Canvas, 181 × 331 cm
Commissioned by Prince Baltasar Carlos;
collection of Philip IV; Cat No. 889

1
Juan Martin Cabezalero
Almaden (Ciudad Real), 1633– Madrid, 1673
The Assumption of the Virgin
Canvas, 237 × 169 cm
From the Palace of Aranjuez; Cat No. 658

2
Mateo Cerezo
Burgos, c.1626 – Madrid, 1666
The Mystic Marriage of St Catherine, 1660
Canvas, 207 × 163 cm
Bought for Ferdinand VII from the collection of Don José Antonio Ruiz; Cat No. 659

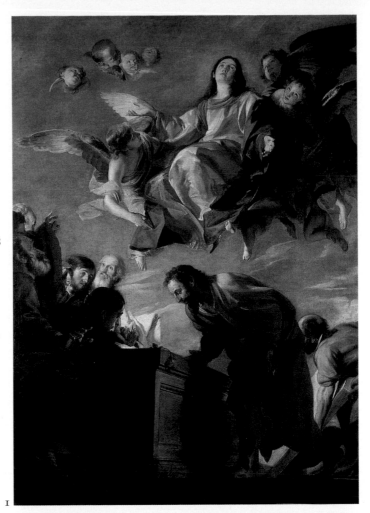

1

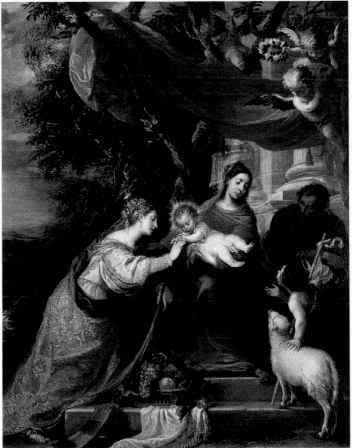

2

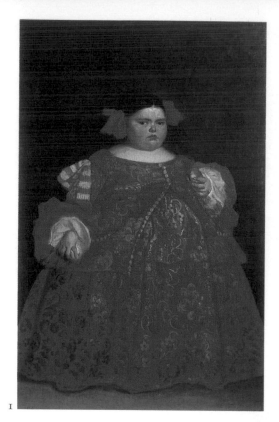

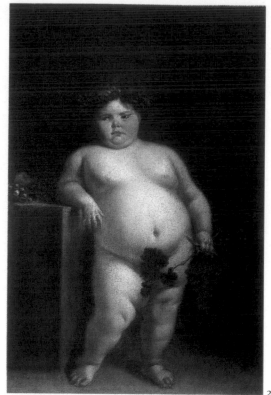

1
Juan Carreño de Miranda
Avilés, 1614 – Madrid, 1685
*Eugenia Martinez Vallejo, called La
Monstrua*
Canvas, 165 × 107 cm
Collection of Charles II of Spain; Cat No.
646

2
Juan Carreño de Miranda
Avilés, 1614 – Madrid, 1685
*La Monstrua Desnuda (Eugenia Martinez
Vallejo unclothed)*
Canvas, 165 × 108 cm
Collection of Charles II of Spain; Cat No.
2800

3
Juan Carreño de Miranda
Avilés, 1614 – Madrid, 1685
*The Russian Ambassador Piotr Ivanowitz
Potemkin, 1681*
Canvas, 204 × 120 cm
Collection of Charles II of Spain; Cat No.
645

4
Juan Carreño de Miranda
Avilés, 1614 – Madrid, 1685
The Duke of Pastrana
Canvas, 217 × 155 cm
Purchased in 1896 from the collection of
the Duke of Osuna; Cat No. 650

In this mature portrait by Carreño, the
impact of the dark and imposing, pyram-
idal figure of the Duke is counterbalanced
by very delicate and melancholy colour-
ing. Carreño's work here recalls the
portraiture of Van Dyck in England.

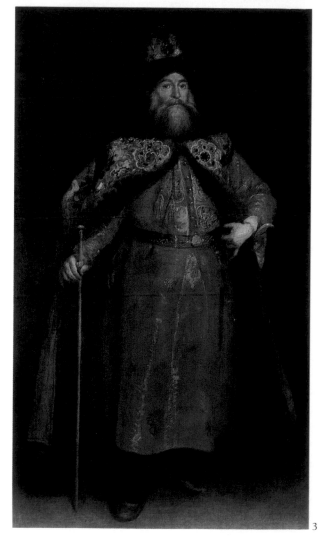

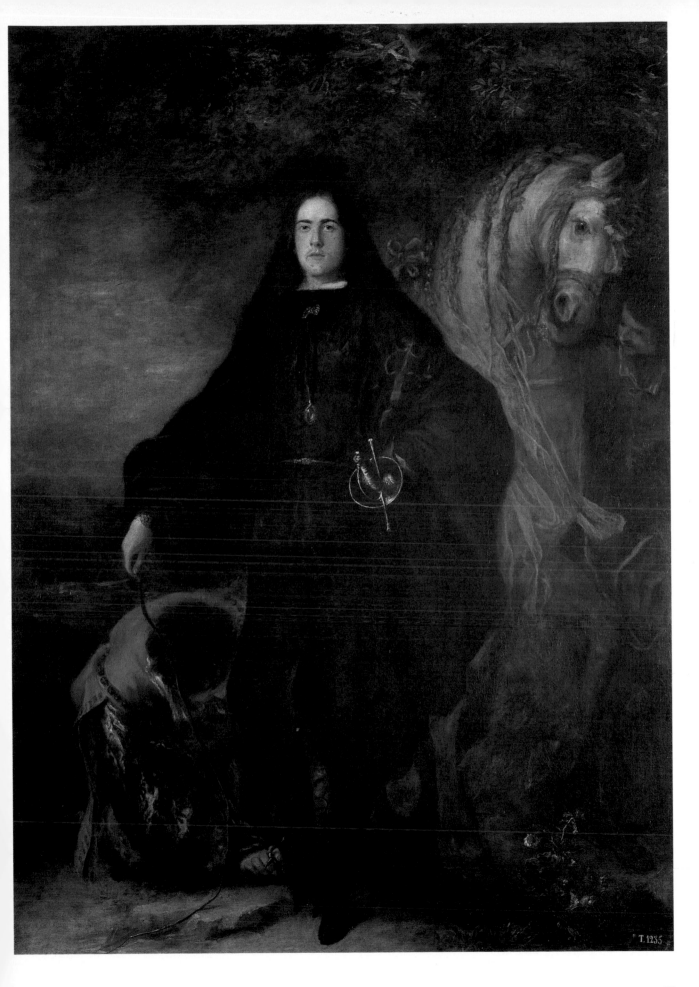

T. 1235

59

José Antolinez
Madrid, 1635 – Madrid, 1675
The Assumption of Mary Magdalene
Canvas, 205 × 163 cm
Purchased in 1829; Cat No. 591

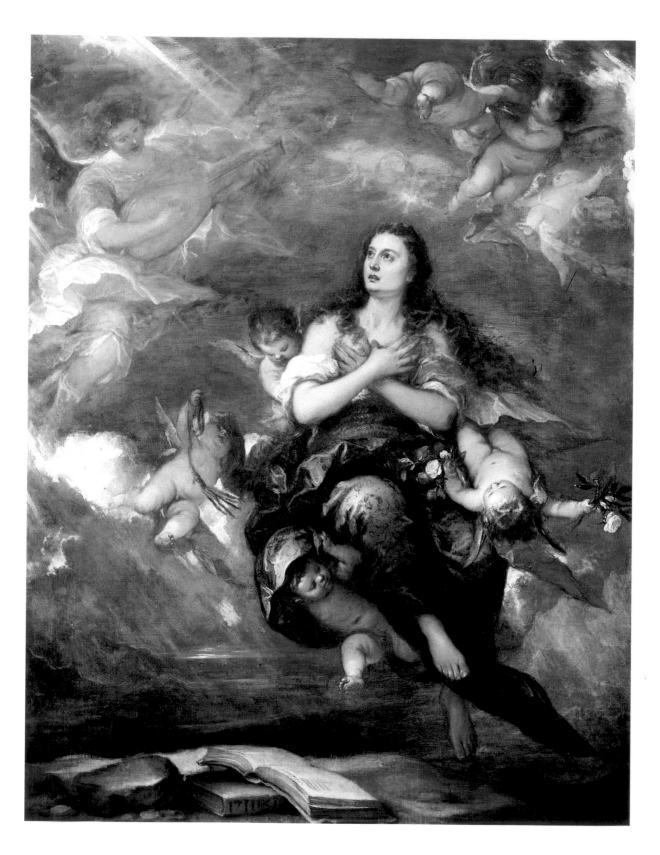

Claudio Coello
Madrid, 1642 – Madrid, 1693
The Triumph of St Augustine, 1664
Canvas, 271 × 203 cm
From the Convent of the Augustinian
Recollects in Alcalá de Henares. Entered
the Museum of the Trinity in 1836; Cat
No. 664

Coello, of Portuguese origin, became a
leading exponent of baroque painting in
seventeenth-century Madrid, having
assimilated the influence of Carreño and
Flemish painting. Typical in this large
work is the diagonal axis of the figures,
stressing the dynamic movement of the
saint, and the framing elements of clas-

sical architecture. The sensual and sump-
tuous colour recalls Rubens, whose
pictures in the Royal Collection Coello is
known to have studied.

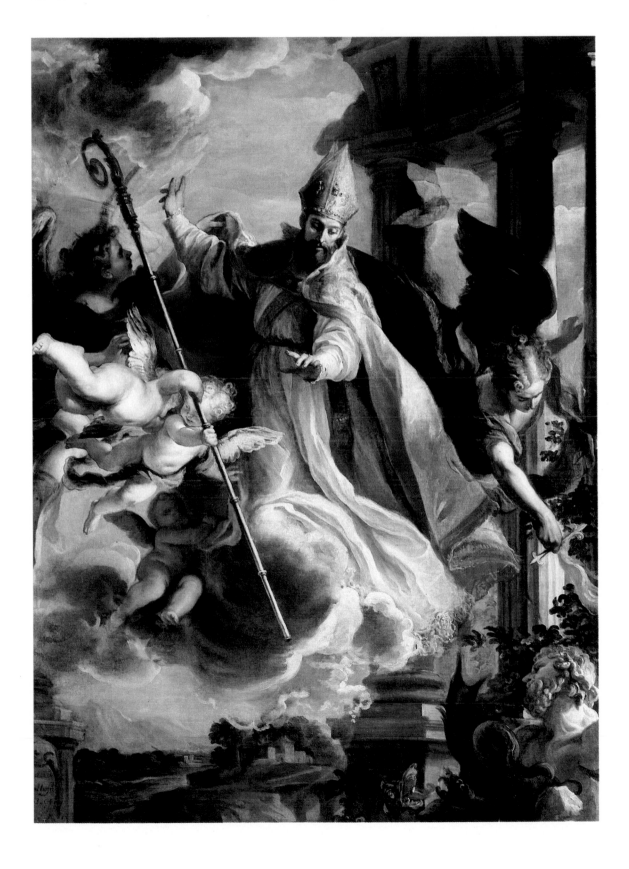

1
Francisco de Zurbarán
Fuente de Cantos, 1598 – Madrid, 1664
The Defence of Cadiz against the English,
1634
Canvas, 302 × 323 cm
From the Hall of the Realms in the Buen
Retiro Palace; Cat No. 656

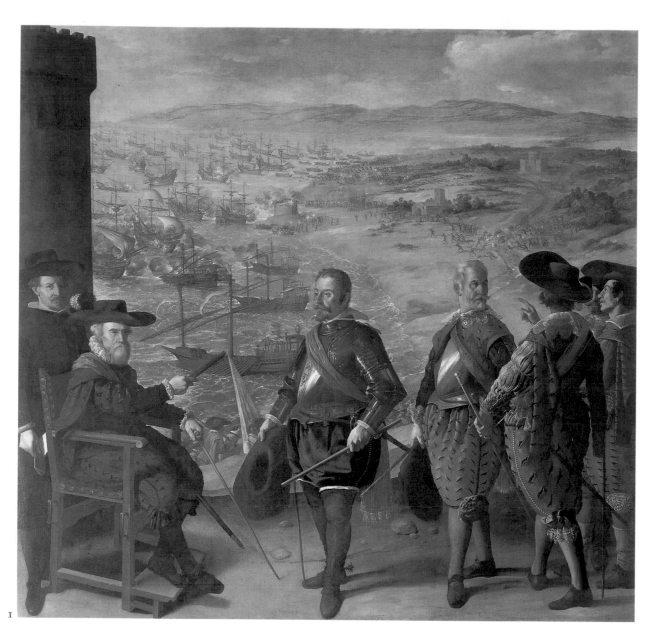

I

2
Francisco de Zurbarán
Fuente de Cantos, 1598 – Madrid, 1664
Still life
Canvas, 46 × 84 cm
Presented in 1940 by Don Francisco
Cambó; Cat No. 2803

3
Francisco de Zurbarán
Fuente de Cantos, 1598 – Madrid, 1664
St Casilda, 1640
Canvas, 184 × 90 cm
In the Royal Collection by the end of the
eighteenth century; Cat No. 1239

4
Francisco de Zurbarán
Fuente de Cantos, 1598 – Madrid, 1664
Our Lady of Immaculate Conception,
*c.*1630/35
Canvas, 139 × 104 cm
Purchased in 1956; Cat No. 2992

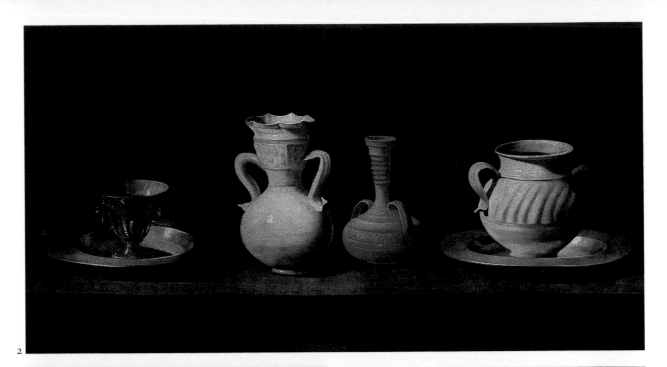

2

3

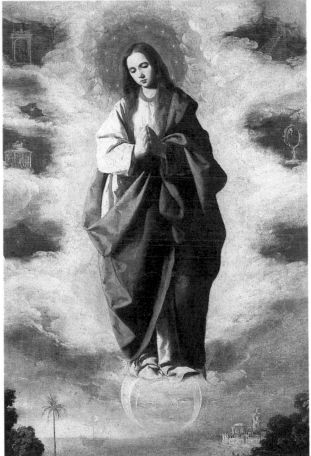

4

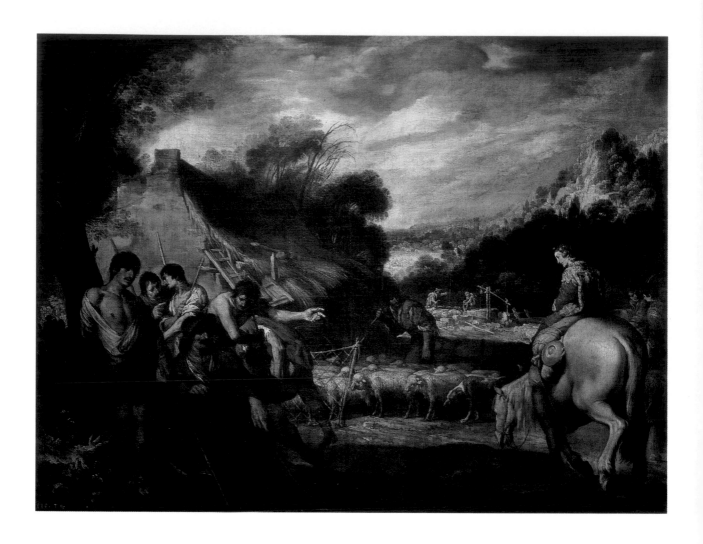

Alonso Cano
Granada, 1601 – Granada, 1667
The Dead Christ supported by an Angel,
*c.*1646/52
Canvas, 178 × 121 cm
Purchased for Charles III in 1769 from
the collection of the Marquis of La
Ensenada; Cat No. 629

Alonso Cano
Granada, 1601 – Granada, 1667
St Isidro saves a child that had fallen in a
*well, c.*1546/48
Canvas, 216 × 149 cm
Entered the Prado in 1941; Cat No. 2806

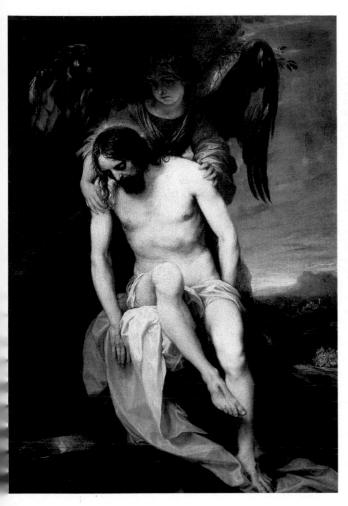

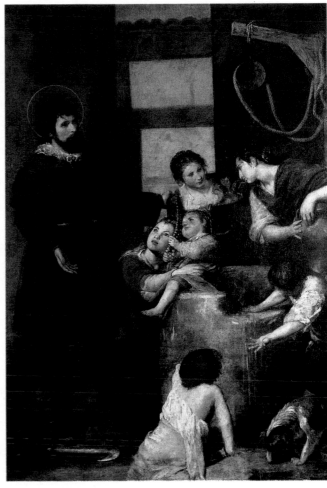

Alonso Cano
Granada, 1601 – Granada, 1667
The Dead Christ supported by an Angel,
*c.*1646/52
Canvas, 178 × 121 cm

Alonso Cano
Granada, 1601 – Granada, 1667
St Isidro saves a child that had fallen in a
*well, c.*1546/48

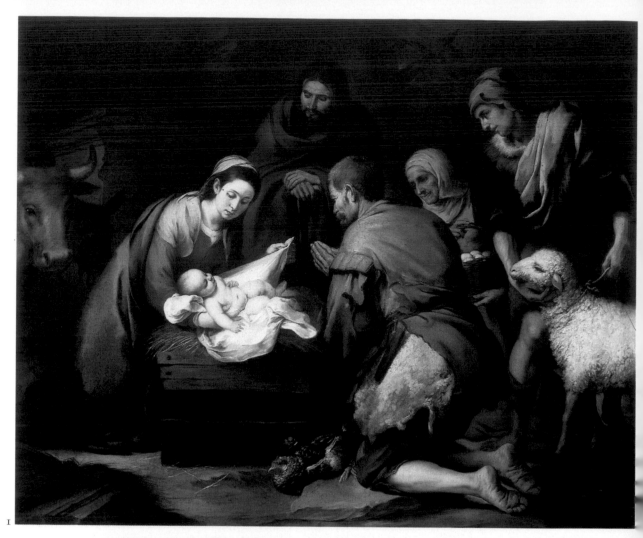

1

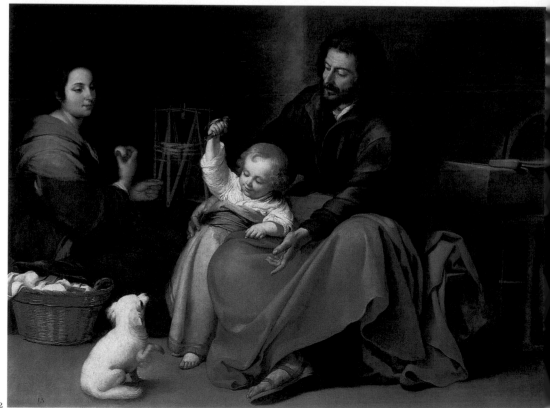

2

13

1

Bartolomé Esteban Murillo
Seville, 1618 – Seville, 1682
*The Adoration of the Shepherds, c.*1650/55
Canvas, 187 × 228 cm
Purchased in 1764 by Charles III from the
Kelly collection. Entered the Prado in
1819; Cat No. 961

Murillo, like Velázquez and Ribera, is one
of the few Spanish artists with an inter-
national reputation. In his own lifetime
Murillo's genre scenes were exported to
Flanders, but much greater interest was
aroused by his work in the early
nineteenth century, when, following the
Napoleonic invasion of Spain, the agents
of French and other collectors were able
to acquire and export pictures by him of
other kinds.

In this early painting the typical char-
acteristics of the Seville school, by which
he was formed, can be observed. There is
an accent on clear detail, emphasized by
the contrasts of light and shade. The
rather high viewpoint creates the im-
pression that one has just walked in on to
the scene represented: such effects of
intimacy and directness were typical of
the aims of Counter-Reformation baroque.

2

Bartolomé Esteban Murillo
Seville, 1618 – Seville, 1682
The Holy Family, before 1650
Canvas, 144 × 188 cm
In the collection of Queen Isabel de
Farnesio by 1746; Cat No. 960

3

Bartolomé Esteban Murillo
Seville, 1618 – Seville, 1682
*The Martyrdom of St Andrew, c.*1675/82
Canvas, 123 × 162 cm
Collection of Charles IV; Cat. No. 982

4

Bartolomé Esteban Murillo
Seville, 1618 – Seville, 1682
*Christ the Good Shepherd, c.*1660
Canvas, 123 × 161 cm
In the collection of Queen Isabel de
Farnesio by 1746; Cat No. 962

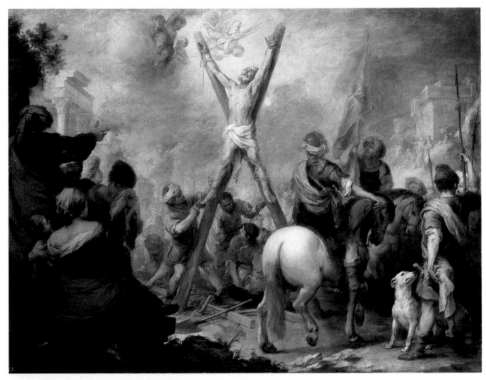

3

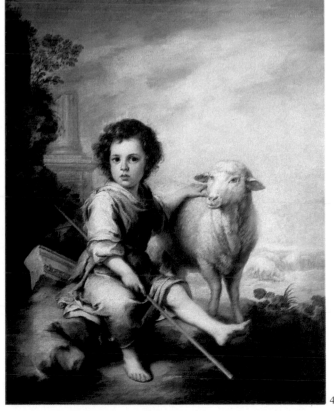

4

1

Bartolomé Esteban Murillo
Seville, 1618 – Seville, 1682
The Story of the Foundation of Santa Maria
Maggiore in Rome: The Patrician's Dream,
c.1662/65
Canvas, 232 × 522 cm
From the Church of St Mary the White
(Santa Maria La Blanca) in Seville.
Entered the Prado in 1901; Cat No. 994

2

Bartolomé Esteban Murillo
Seville, 1618 – Seville, 1682
The Story of the Foundation of Santa Maria
Maggiore in Rome: The Patrician reveals his
Dream to the Pope, c.1662/65
Canvas, 232 × 522 cm
From the Church of St Mary the White
(Santa María la Blanca) in Seville. Entered
the Prado in 1901; Cat No. 995

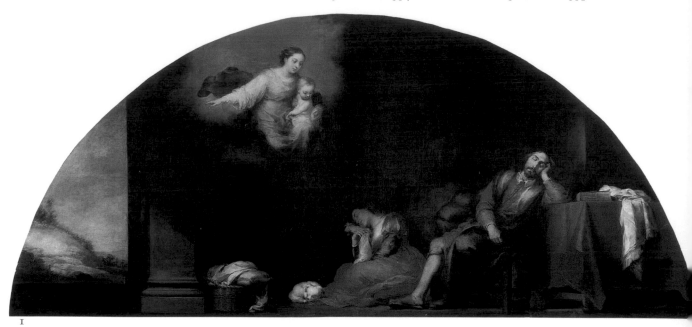

I

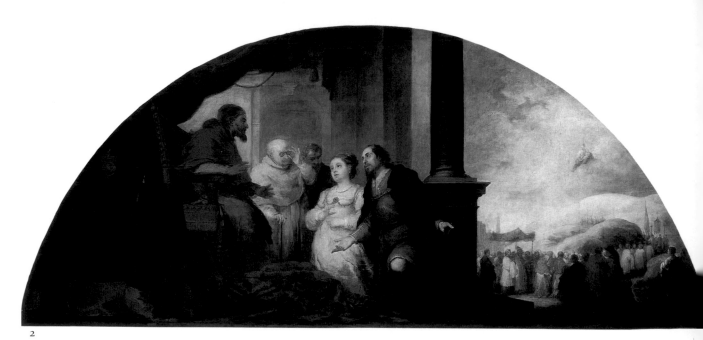

2

3

Bartolomé Esteban Murillo
Seville, 1618 – Seville, 1682
The Our Lady of the Immaculate Conception
(The Soult Immaculate Conception), c.1678
Canvas, 274 × 190 cm
From the Hospital of the Venerables in
Seville; taken to France in 1813 by Mar-
shal Soult. Returned to the Prado in
1941; Cat No. 2809

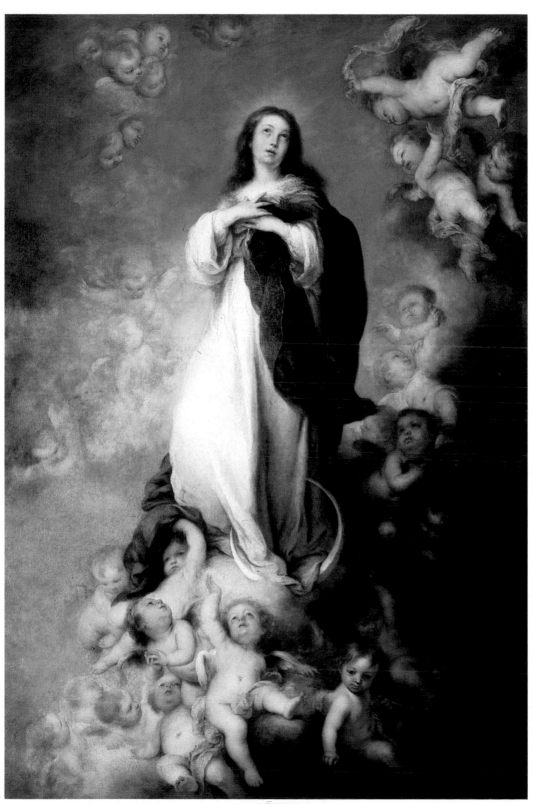

3

1
Bartolomé Esteban Murillo
Seville, 1618 – Seville, 1682
The Virgin and Child with a rosary,
c.1650/55
Canvas, 164 × 110 cm
Collection of Charles IV; Cat No. 975

2
Bartolomé Esteban Murillo
Seville, 1618 – Seville, 1682
Portrait of a gentleman in a ruff collar,
c.1670
Canvas, 198 × 127 cm
Purchased in 1941; Cat No. 2845

3
Ignacio Iriarte
Santa María de Azcoitia, 1621 – Seville,
1685
A landscape with a torrent, 1665
Canvas, 112 × 198 cm
Presented in 1952 by Mr Frederick Mont;
Cat No. 836

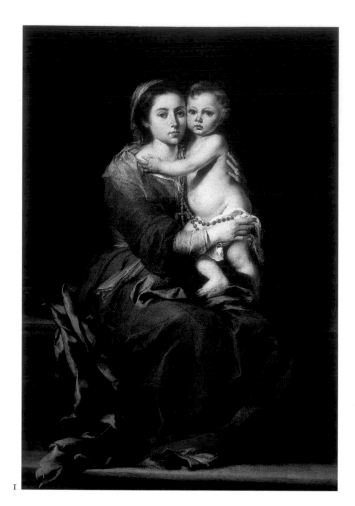

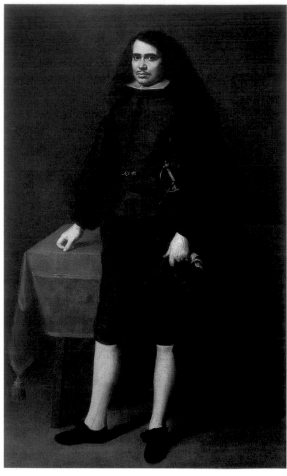

1

2

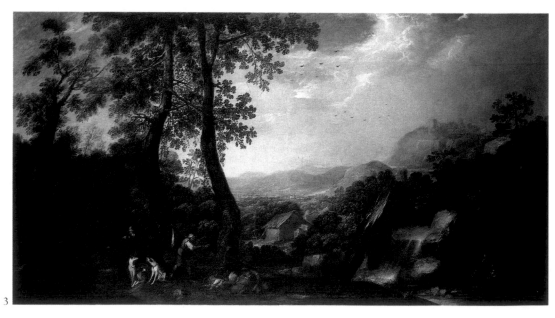

3

4
Francisco Herrera the Younger
Seville, 1622 – Madrid, 1685
The Triumph of St Hermengild
Canvas, 328 × 229 cm
From the Convent of the Discalced
Carmelites in Madrid. Entered the Prado
in 1832; Cat No. 833

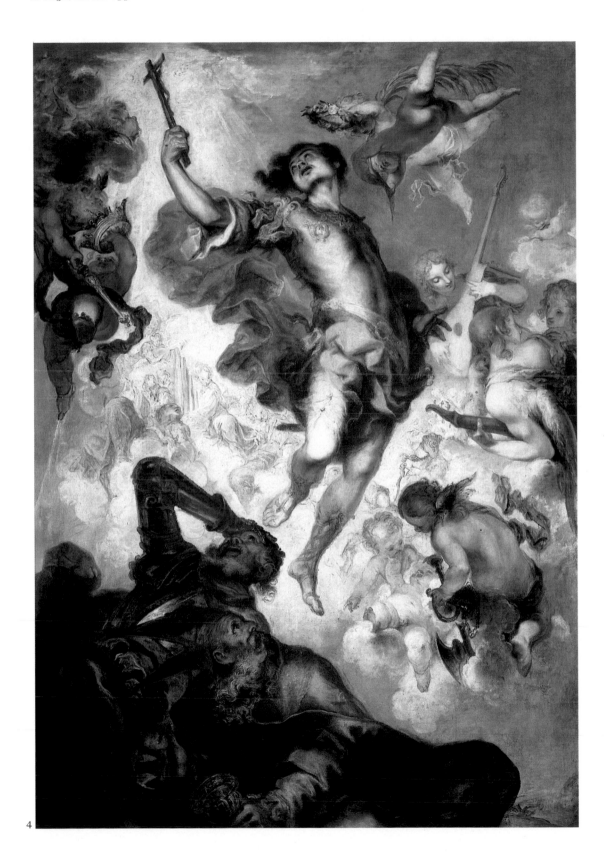

4

The Eighteenth Century and Goya

The eighteenth century has been considered until recently a period of lesser interest in Spanish painting. It begins with artists still working in the decorative baroque style of the previous century. The paintings of Palomino, better known as the great biographer of Spanish art, follow the manner of Coello and are somewhat influenced by Luca Giordano; they represent the work of the Madrid School at this time. The century continues with the powerful growth of the French and Italian artistic influence introduced by the Bourbon monarchies. This influence was initially limited to the milieu of the Court, but later, as a result of the creation of the academies which began with the foundation of the Royal Academy of San Fernando in 1753, encompassed all Spain. The academies institutionalized the journey to Rome and generally depersonalized the work of contemporary artists who, it must be confessed, did not show any great creative promise.

Before passing on to the phenomenon of Goya, which brings the century to a close in such an extraordinary manner, two other artists should be mentioned whose work stands out from the moderate accomplishments of their contemporaries. The first is the still-life painter Meléndez, in whose exquisite representations of pottery, created through a precise and almost obsessive pictorial objectivity, one can sense the legacy of the naturalism of the previous century. The second is Luis Paret, of French paternity, whose works have a porcelain-like fragility expressed in a lively miniaturist technique that blends the best elements of French and Italian rococo. A close contemporary of Goya, Paret's *œuvre* is made up of cabinet paintings, regional subjects and delicate courtly scenes which reflect a varied and enchanting sensibility; his work is well represented in the Prado.

The emergence of Francisco José Goya not only entirely redeems eighteenth-century Spanish painting, but anticipates some of the most interesting forms of modern art, as for instance surrealism and expressionism. Although Goya's training and early artistic development took place outside Madrid, his marriage to the sister of Francisco Bayeu, an artist who was much in favour at Court, and his nomination in 1785 as painter to the King, gave him the position of official palace portraitist. This special status of Goya at Court meant that the Prado automatically inherited an important part of Goya's corpus, including the official portraits and the historical paintings. The latter are drawn from an immediate experience of war and transcend the representation of patriotism and heroism to create a savage indictment of human cruelty.

The Prado also possesses the beautiful tapestry cartoons which form the most delightful and popular section of Goya's work and display great rococo elegance in their composition and colouring. Occasionally, this lightness of tone is combined with a mordant sense of humour, an acute observation of external reality, and touches of irony. Lastly, the Prado owns the famous 'Pinturas Negras' (Black Paintings), in which the old Goya, deaf and lonely at the age of seventy-two, expressed through the remorseless depiction of the futilities of human existence, his embittered pessimism in an age which destroyed its own progeny. Taken as a whole, the works of Goya form the most numerous and varied collection in the museum. It need hardly be pointed out that a study of this collection is crucial to any understanding of Goya's genius.

1
Luis Egidio Meléndez
Naples, 1716 – Madrid, 1780
Still life, 1772
Canvas, 42 × 62 cm
Collection of Charles III; Cat No. 902

2
Luis Paret
Madrid, 1746 – Madrid, 1798 or 1799
Still life of flowers
Canvas, 39 × 37 cm
Collection of Charles IV; Cat No. 1043

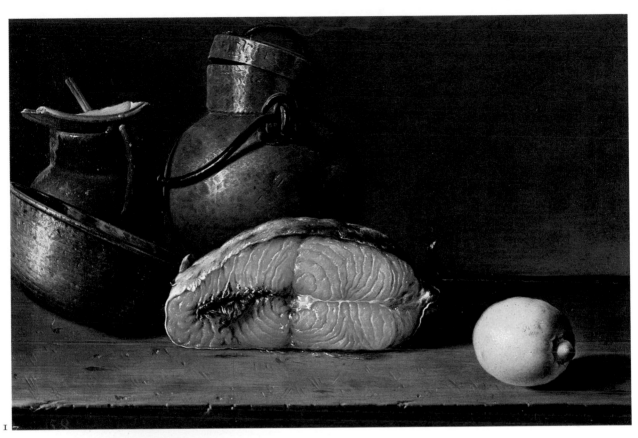

1

2

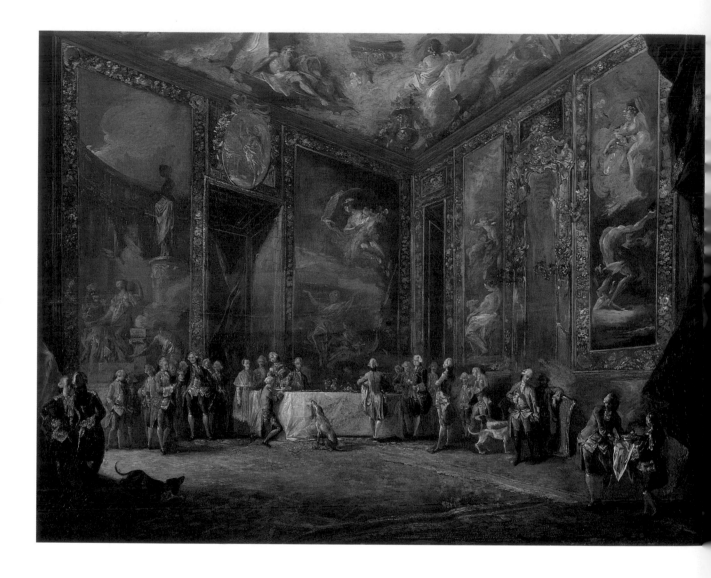

Luis Paret
Madrid, 1746 – Madrid, 1798 or 1799
Charles III lunching before his court, c.1770
Panel, 50 × 64 cm
From the Palace of Gatchina in Russia.
Bought with a donation bequeathed by
the Count of Cartagena; Cat No. 2422

Paret is the most distinguished representative of Spanish rococo. He portrays the aristocrats and *hauts bourgeois* of his day with calculated elegance and refinement. Influenced by the Venetian and French schools of the eighteenth century, he developed a personal technique combining glassy and precious textures with light, vaporous colouring. He presents his scenes and landscapes in a dreamy atmosphere faintly tinged with irony.

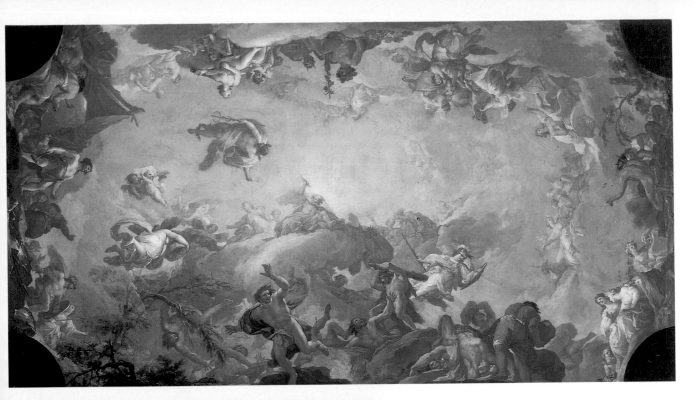

1
Francisco Bayeu
Zaragoza, 1734 – Madrid, 1795
The Fall of the Giants beseiging Olympus,
1764
Canvas, 68 × 123 cm
Purchased by Ferdinand VII for the Prado;
Cat No. 604

2
Luis Paret
Madrid, 1746 – Madrid, 1798 or 1799
Maria Nieves Micaela Fourdinies, the
Artist's Wife, c.1780
Copper, 37 × 28 cm
Purchased in 1974; Cat No. 3250

1
Antonio Carnicero
Salamanca, 1748 – Madrid, 1814
A Montgolfier balloon at Aranjuez, c.1764
Canvas, 170 × 284 cm
Purchased from the collection of the Duke
of Osuna in 1896; Cat No. 641

2
José Camaron
Segorbe, 1730 – Valencia, 1803
Dancing the 'bolero', c.1790
Canvas, 83 × 108 cm
Purchased in 1980 from the collection of
the Prince of Hohenlohe at El Quexigal in
Madrid; Cat No. 6732

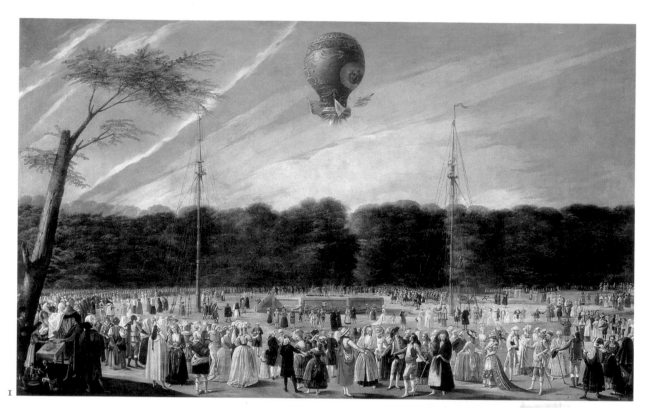

1

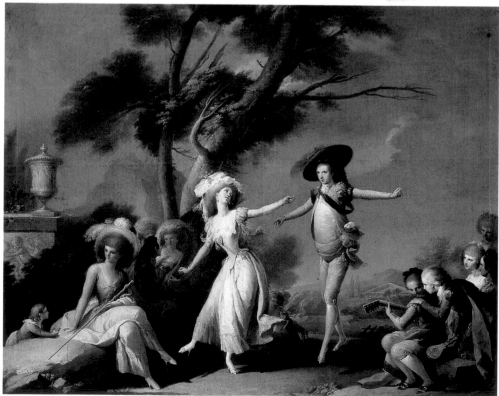

2

Francisco José de Goya
Fuendetodos, 1745 – Bordeaux, 1828
Self-portrait, 1815
Canvas, 46 × 35 cm
Purchased for the Museum of the Trinity
in 1866. Entered the Prado in 1872; Cat
No. 723

In this rigorous and melancholic vision
Goya seems to be trying to express his
forebearance in the face of suffering and
disillusionment.

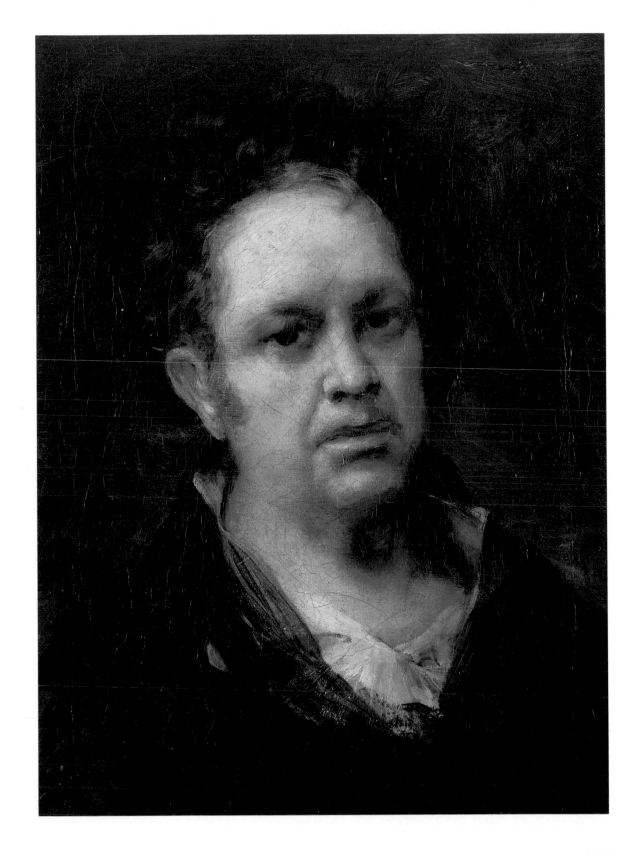

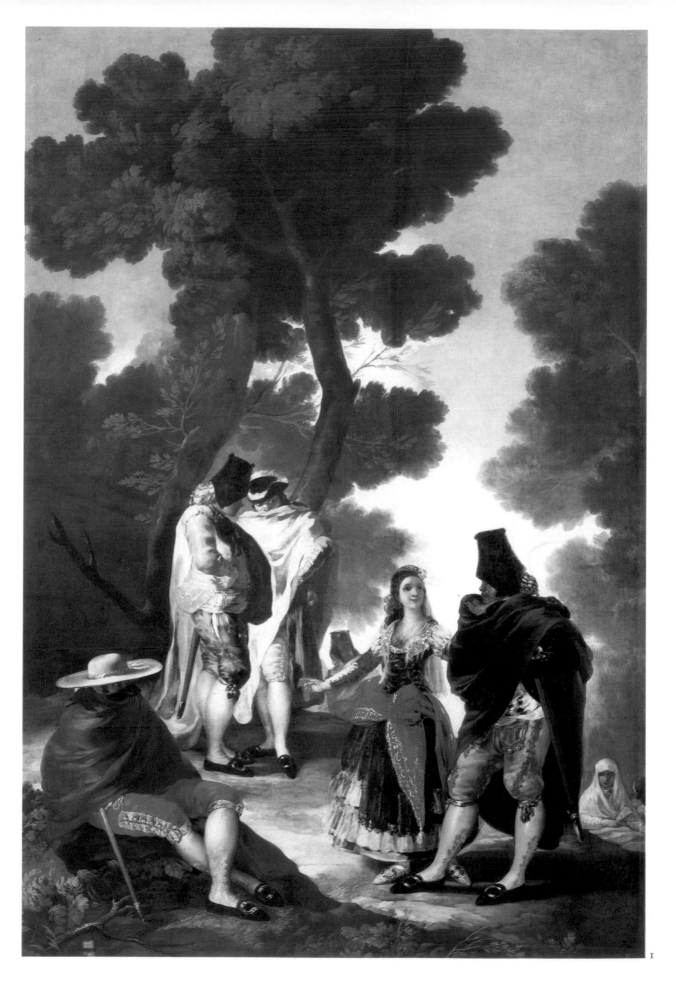

1
Francisco José de Goya
Fuendetodos, 1745 – Bordeaux, 1828
A 'maja' and gallants, 1777
Canvas, 275 × 190 cm
From the Royal Palace in Madrid. Entered
the Prado in 1870; Cat No. 771

2
Francisco José de Goya
Fuendetodos, 1745 – Bordeaux, 1828
A pottery vendor, 1779
Canvas, 259 × 220 cm
From the Royal Palace in Madrid. Entered
the Prado in 1870; Cat No. 780

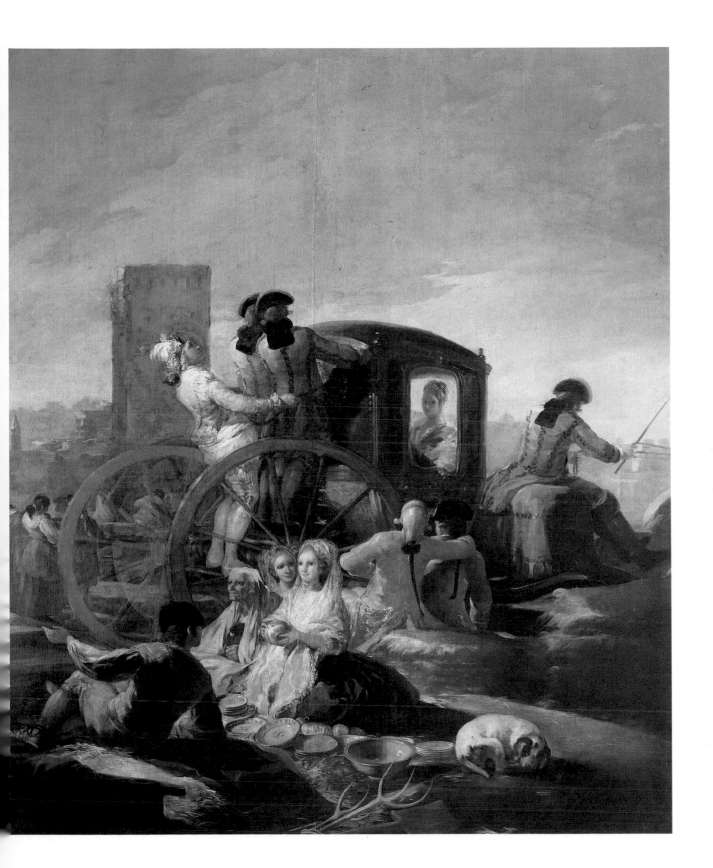

79

Francisco José de Goya
Fuendetodos, 1745 – Bordeaux, 1828
The Parasol, 1777
Canvas, 104 × 152 cm
From the Royal Palace in Madrid. Entered
the Prado in 1870; Cat No. 773

This canvas was painted as a cartoon for
a tapestry to hang over a door in the
Prince of Asturias' Dining Room in the El
Pardo Palace. For such commissions Goya
was employed repeatedly by the Royal
Tapestry Factory between 1775 and
1792. The series of cartoons he produced

enable us to trace the evolution of his art
from an orthodox, courtly presentation
appropriate to palace decoration towards
a more individualistic expression: the
artist subtly and gradually shifts from
delicate, mannered pleasantry to an overt
facetiousness laced with crude irony.

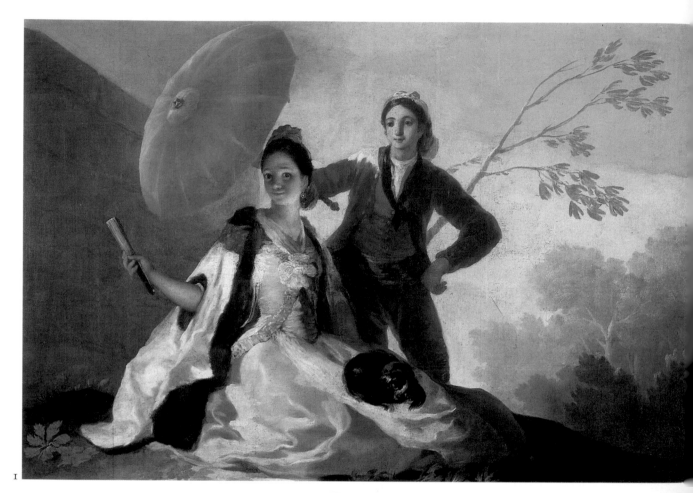

I

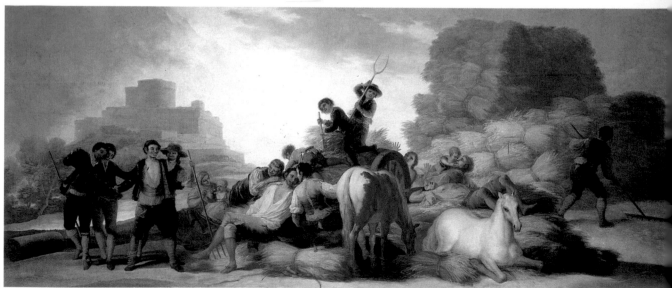

2

2
Francisco José de Goya
Fuendetodos, 1745 – Bordeaux, 1828
Summer, or the Harvest, 1786
Canvas, 276 × 641 cm
From the Royal Palace in Madrid. Entered
the Prado in 1870; Cat No. 794

3
Francisco José de Goya
Fuendetodos, 1745 – Bordeaux, 1828
Autumn, or the Vintage, 1786
Canvas, 275 × 190 cm
From the Royal Palace in Madrid. Entered
the Prado in 1870; Cat No. 795

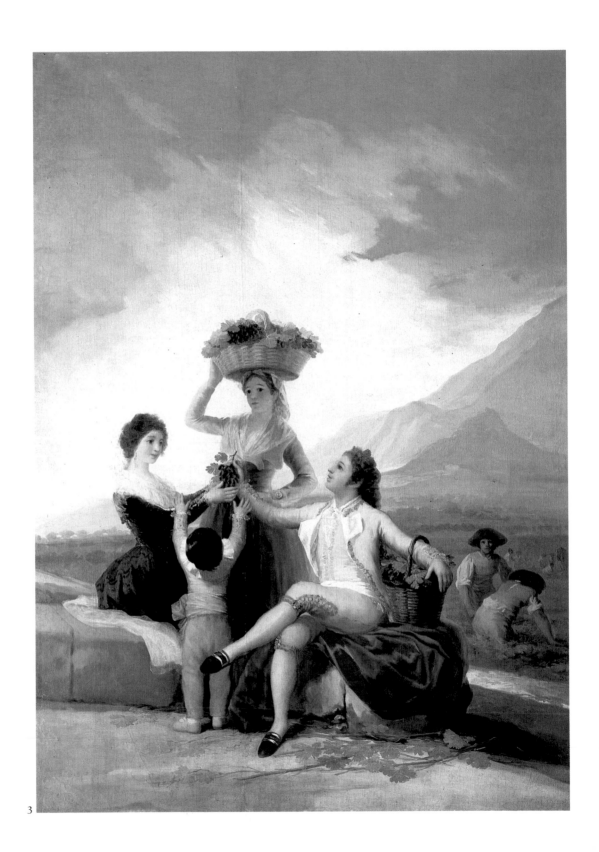

3

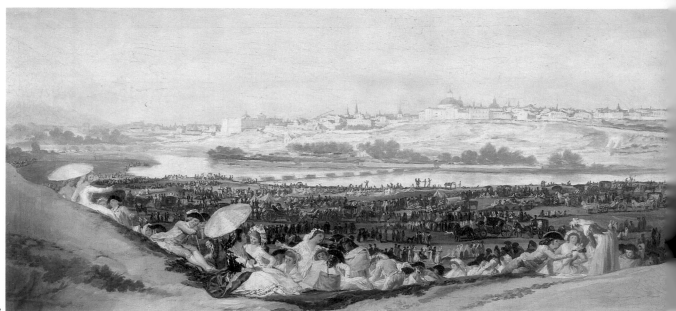

1

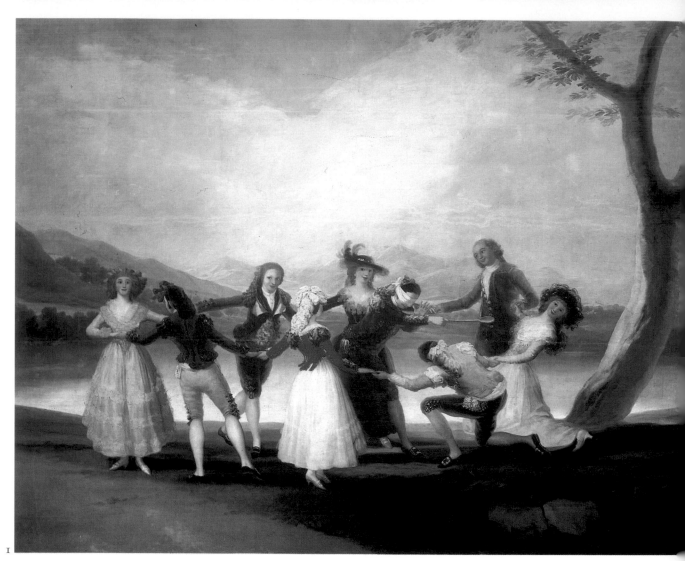

2

1
Francisco José de Goya
Fuendetodos, 1745 – Bordeaux, 1828
Blind man's buff, 1789
Canvas, 269 × 350 cm
From the Royal Palace in Madrid. Entered
the Prado in 1870; Cat No. 804

2
Francisco José de Goya
Fuendetodos, 1745 – Bordeaux, 1828
The meadow at San Isidro, 1788
Canvas, 44 × 94 cm
Purchased from the collection of the Duke
of Osuna in 1896; Cat No. 750

3
Francisco José de Goya
Fuendetodos, 1745 – Bordeaux, 1828
*Christ's Arrest in the Garden, c.*1788/98
Canvas, 40 × 23 cm
Purchased in 1966; Cat No. 3113

3

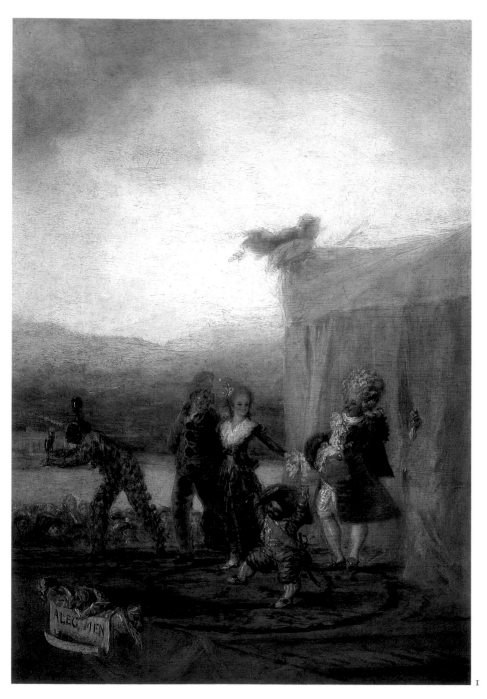

1

1

Francisco José de Goya
Fuendetodos, 1745 – Bordeaux, 1828
Travelling players, 1793 (?)
Tin-plate, 43 × 32 cm
Purchased in 1962; Cat No. 3045

2

Francisco José de Goya
Fuendetodos, 1745 – Bordeaux, 1828
The Duke of Osuna and his Family, 1788
Canvas, 225 × 174 cm
Presented to the Prado in 1897 by the
descendants of the Duke of Osuna; Cat N
739

Several great Spanish families commis-
sioned works from Goya, among them th
Osuna. Their group portrait shows
remarkable sensitivity and variety. The
children are depicted with great freshnes
(it may be of interest to note that the
seated child later became the Director of
the Prado). The neutral background and
easy composition tend to play down
courtly formality and encourage intimac
instead; the intimacy is also enhanced by
the delicate silvery-greys in the lighting.

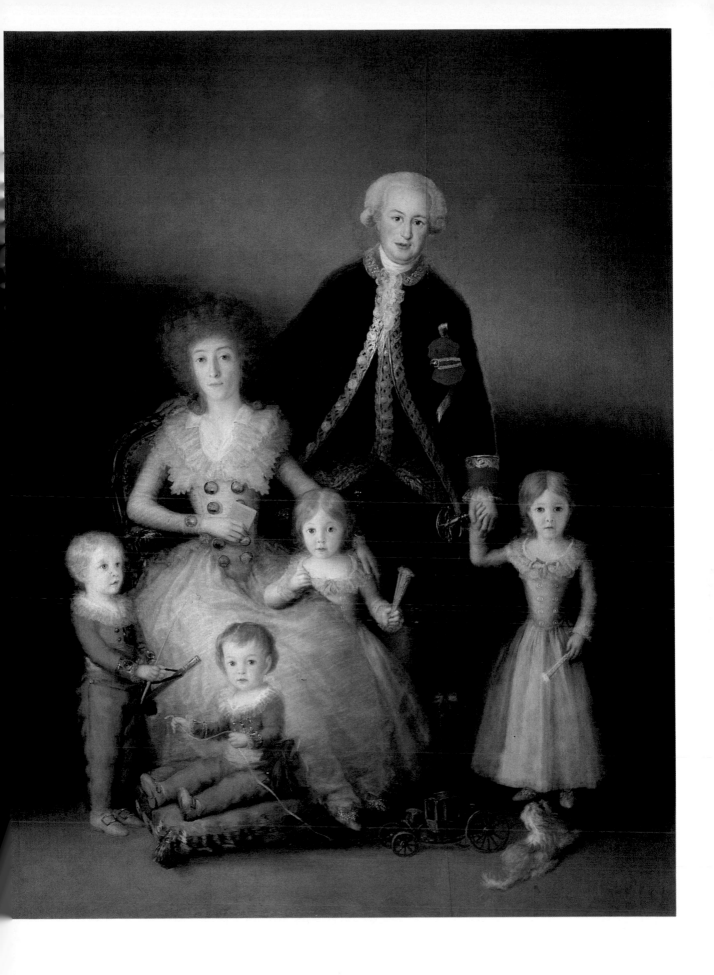

85

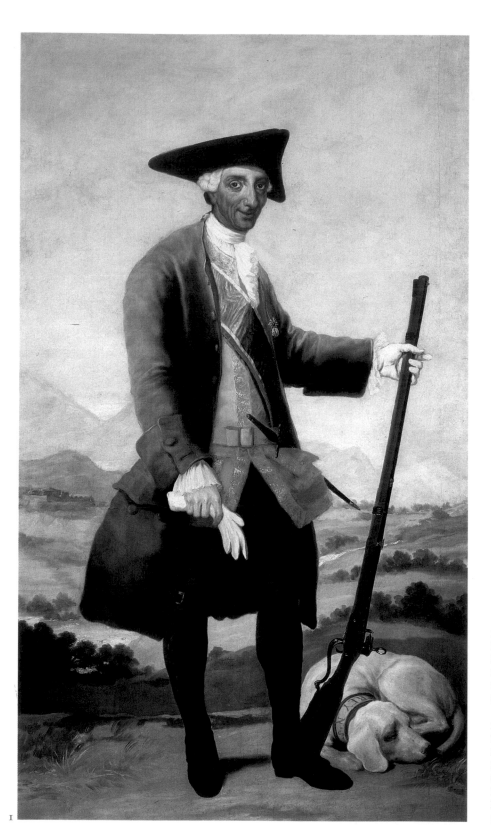

1

1
Francisco José de Goya
Fuendetodos, 1745 – Bordeaux, 1828
King Charles III as a huntsman, c.1786/88
Canvas, 210 × 127 cm
Collection of Charles III; Cat No. 737

2
Francisco José de Goya
Fuendetodos, 1745 – Bordeaux, 1828
Doña Tadea Arias de Enríquez, c.1793/94
Canvas, 190 × 106 cm
Presented to the Prado in 1896 by Doña
Luisa and Don Gabriel Enríquez; Cat No.
740

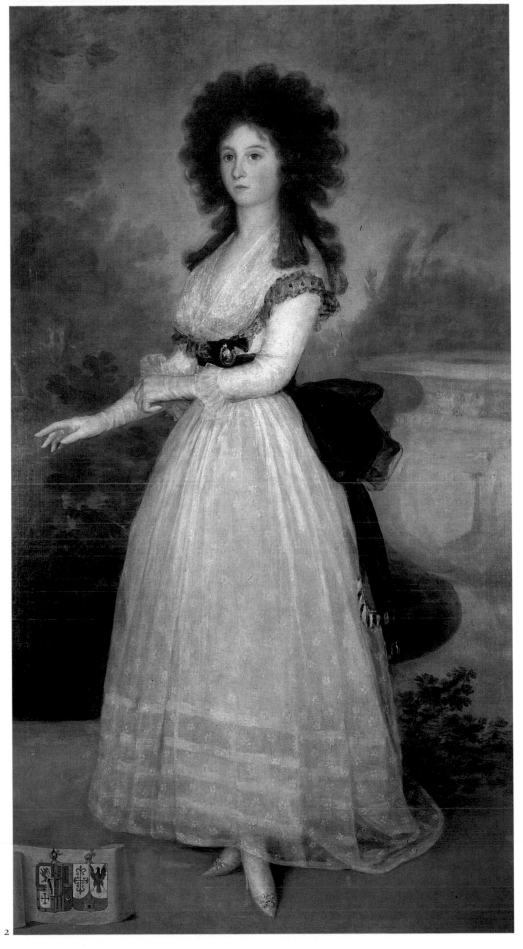

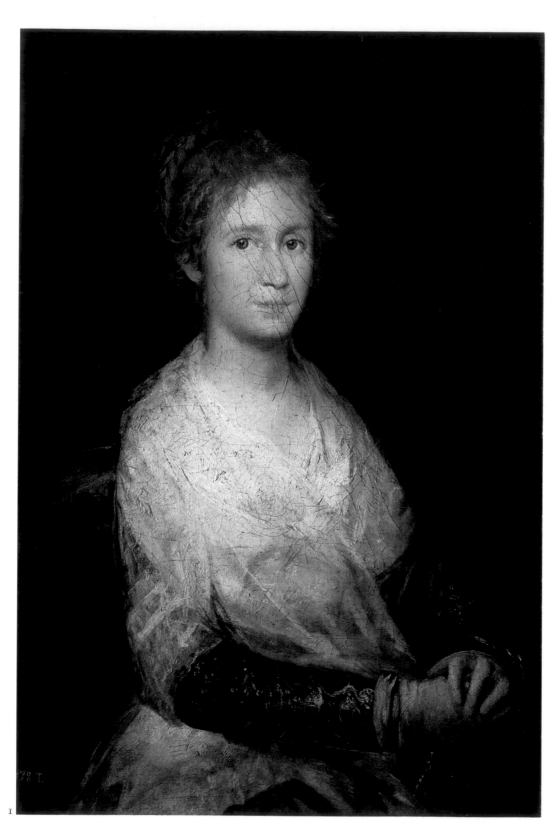

1

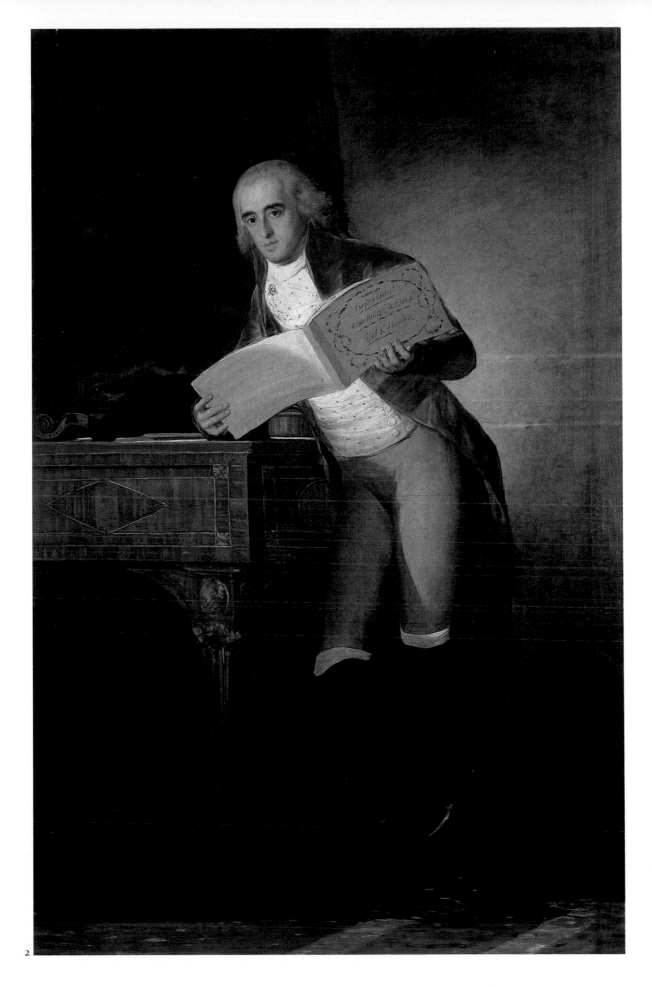

2

1
Francisco José de Goya
Fuendetodos, 1745 – Bordeaux, 1828
The Marchioness of Santa Cruz, 1805
Canvas, 125 × 207 cm
Purchased in 1986; Cat No. 7070

2
Francisco José de Goya
Fuendetodos, 1745 – Bordeaux, 1828
Still life, c.1808/12
Canvas, 45 × 63 cm
Purchased in 1900; Cat No. 751

3
Francisco José de Goya
Fuendetodos, 1745 – Bordeaux, 1828
Queen María Luisa wearing a 'mantilla',
1799
Canvas, 209 × 125 cm
In the Royal Collection by the early
nineteenth century; Cat No. 728

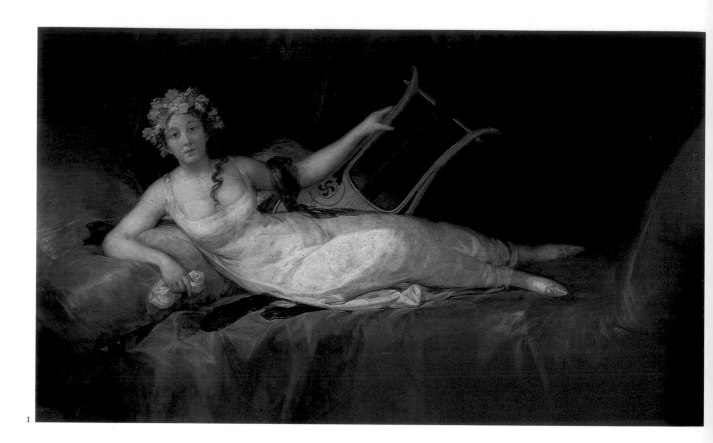

1

2

90

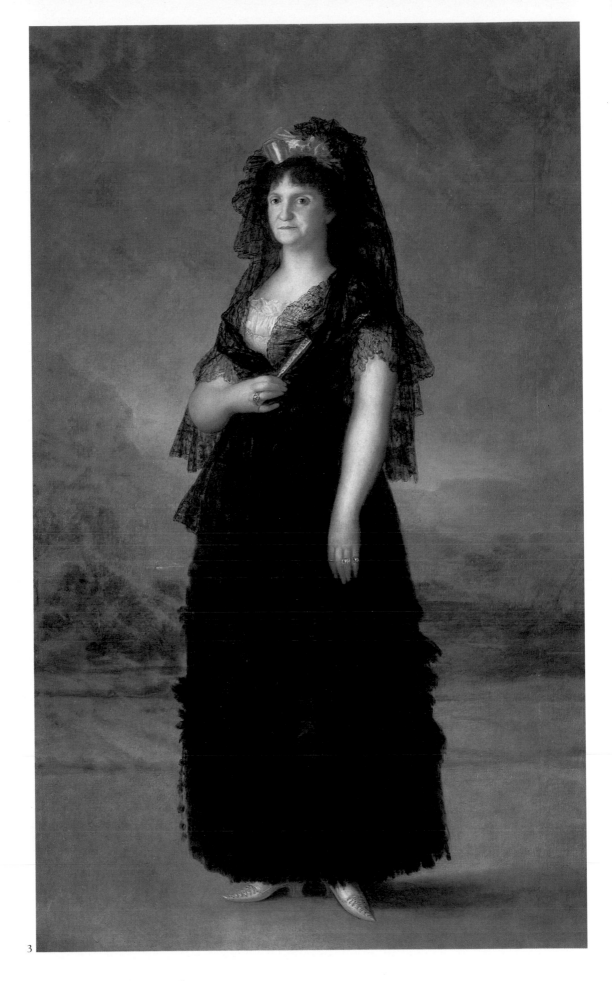

3

Francisco José de Goya
Fuendetodos, 1745 – Bordeaux, 1828
The Infante Don Francisco de Paula Antonio,
1800
Canvas, 74 × 60 cm
Collection of Charles IV; Cat No. 730

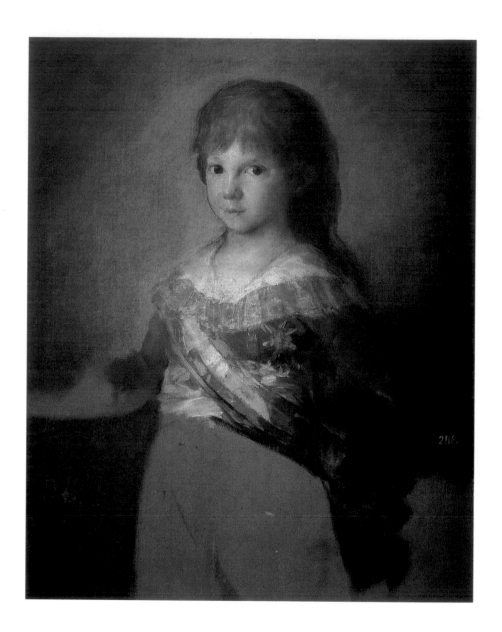

Francisco José de Goya
Fuendetodos, 1745 – Bordeaux, 1828
King Charles IV and his Family, 1800
Canvas, 280 × 336 cm
Collection of Charles IV; Cat No. 726

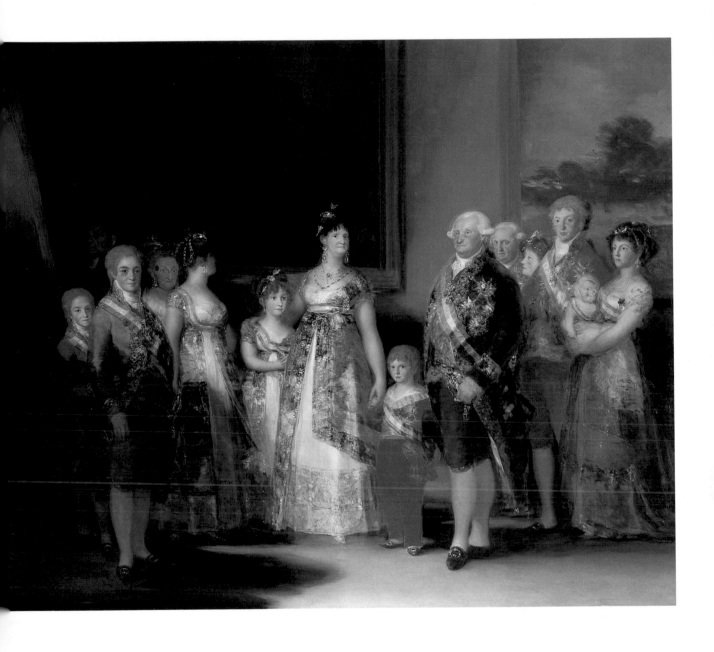

I

Francisco José de Goya
Fuendetodos, 1745 – Bordeaux, 1828
La Maja Desnuda (The 'maja' nude),
*c.*1800/03
Canvas, 97 × 190 cm
From the collection of the Royal Academy
of Fine Arts of San Fernando. Entered the
Prado in 1901; Cat No. 742

2

Francisco José de Goya
Fuendetodos, 1745 – Bordeaux, 1828
La Maja Vestida (The 'maja' clothed),
*c.*1800/03
Canvas, 95 × 190 cm
From the collection of the Royal Academy
of Fine Arts of San Fernando.
Entered the Prado in 1901; Cat No. 741

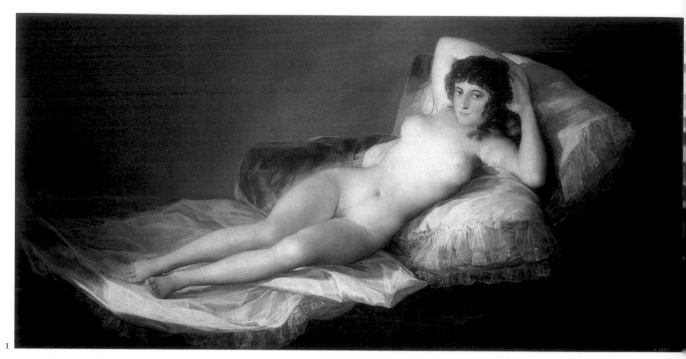

I

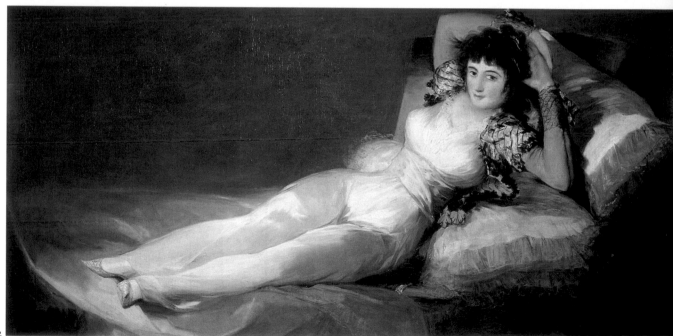

2

Francisco José de Goya
Fuendetodos, 1745 – Bordeaux, 1828
La Maja Desnuda (The 'maja' nude),
*c.*1800/03

Francisco José de Goya
Fuendetodos, 1745 – Bordeaux, 1828
La Maja Vestida (The 'maja' clothed),
*c.*1800/03

Francisco José de Goya
Fuendetodos, 1745 – Bordeaux, 1828
Don Gaspar Melchor de Jovellanos, c.1798
Canvas, 205 × 123 cm
Purchased in 1974; Cat No. 3236

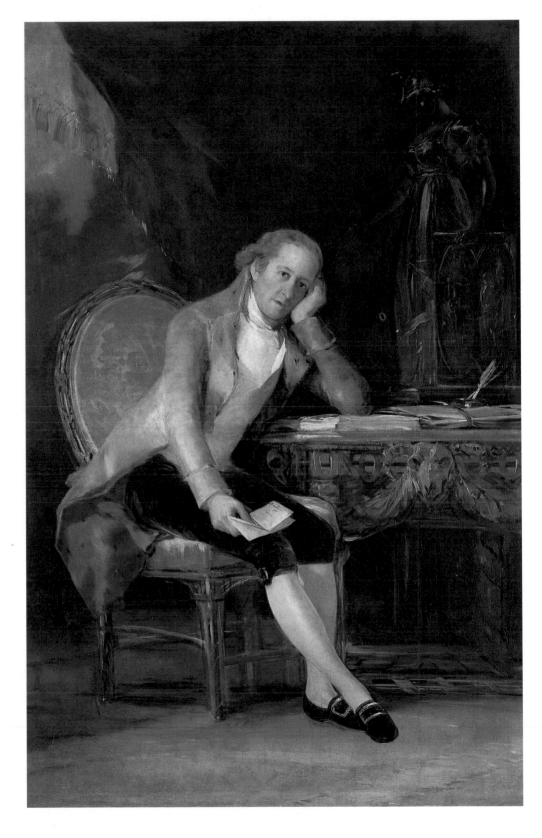

Francisco José de Goya
Fuendetodos, 1745 – Bordeaux, 1828
The Second of May, 1808: The Riot against
the Mameluke Mercenaries, 1814
Canvas, 266 × 345 cm
Collection of Ferdinand VII; Cat No. 748

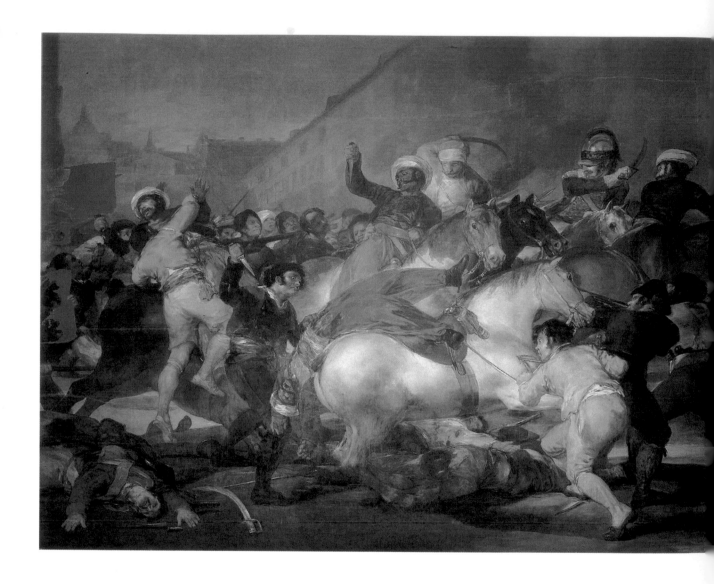

Francisco José de Goya
Fuendetodos, 1745 – Bordeaux, 1828
The Third of May, 1808: The Executions
on Principe Pio Hill, 1814
Canvas, 266 × 345 cm
Collection of Ferdinand VII; Cat No. 749

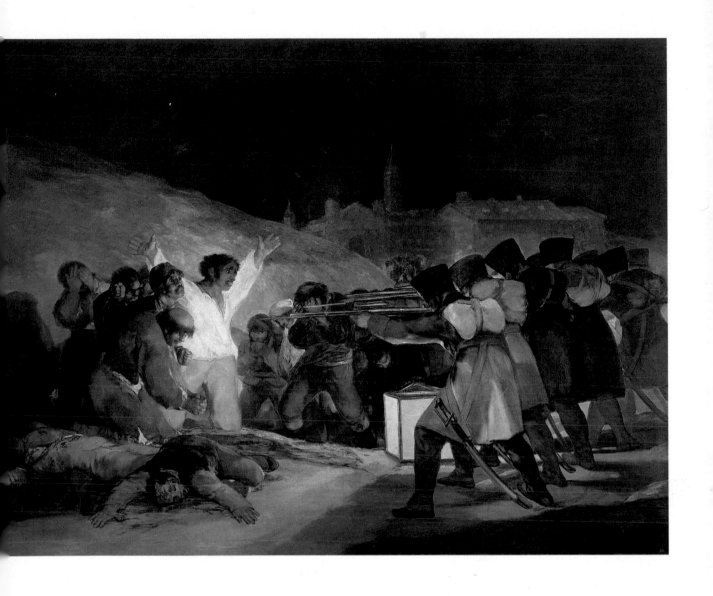

Francisco José de Goya
Fuendetodos, 1745 – Bordeaux, 1828
*The Colossus, c.*1808/12
Canvas, 116 × 105 cm
Bequeathed in 1930 by Don Pedro
Fernández Durán; Cat No. 2785

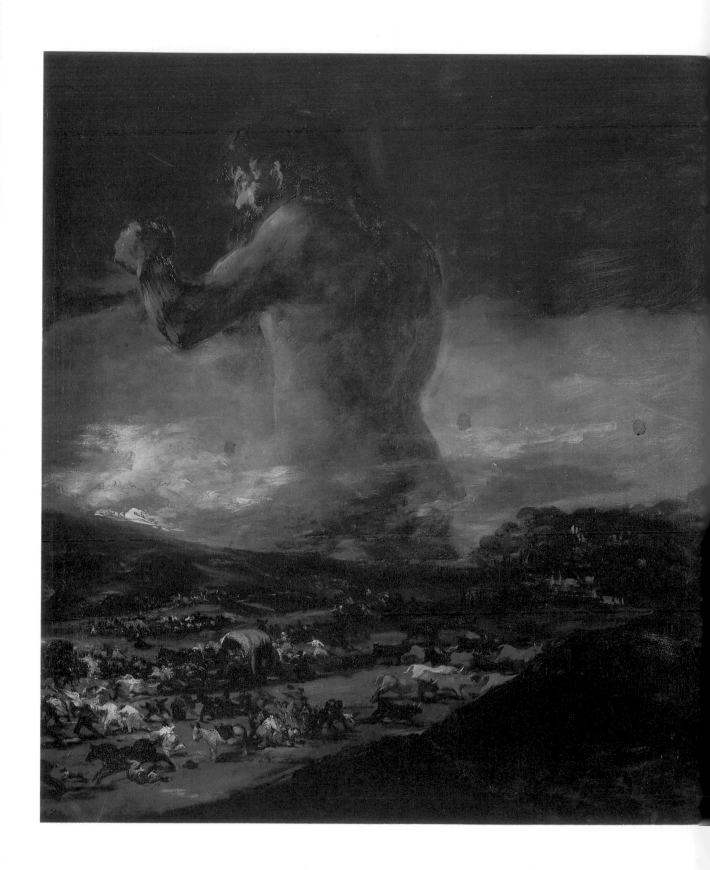

Goya's famous 'Pinturas Negras', or Black Paintings, are named after their grim content, not their colouring. Goya painted them on the interior walls of his house called La Quinta del Sordo ('The Manor of the Deaf Man') near the River Manzaranes. After their retrieval, they were transferred to canvas in 1873. They are highly personal, and overwhelmingly pessimistic. There are many different ways in which they can be interpreted in detail, but the idea of futile conflict and attrition emerges frequently. The aged artist shows a constant preoccupation with decomposition, the grotesque and the horrible.

Francisco José de Goya
Fuendetodos, 1745 – Bordeaux, 1828
La Leocadia (Leocadia Zorrilla, the artist's housekeeper), c.1821/23
Mural transferred to canvas,
147 × 132 cm
Presented in 1881 by Baron Emile d'Erlanger; Cat No. 754

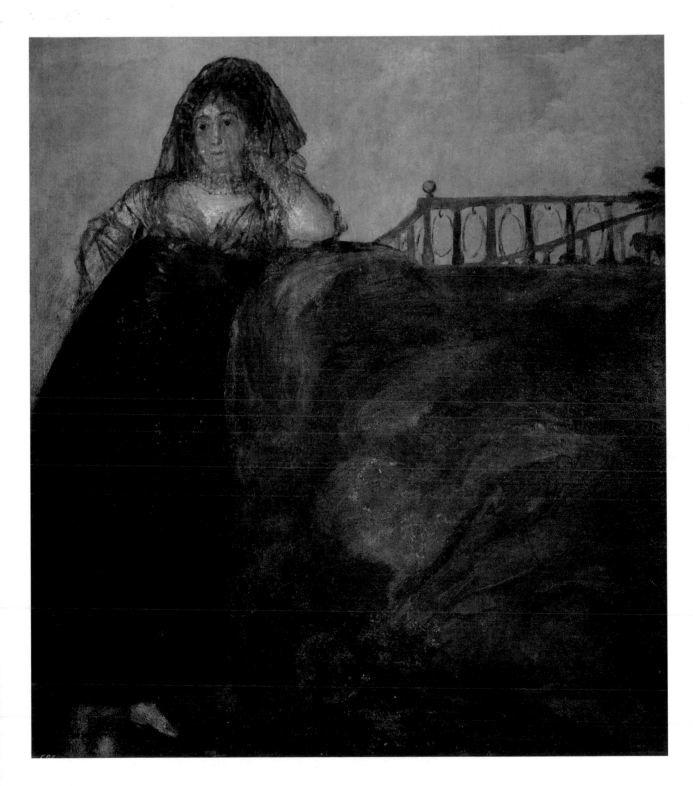

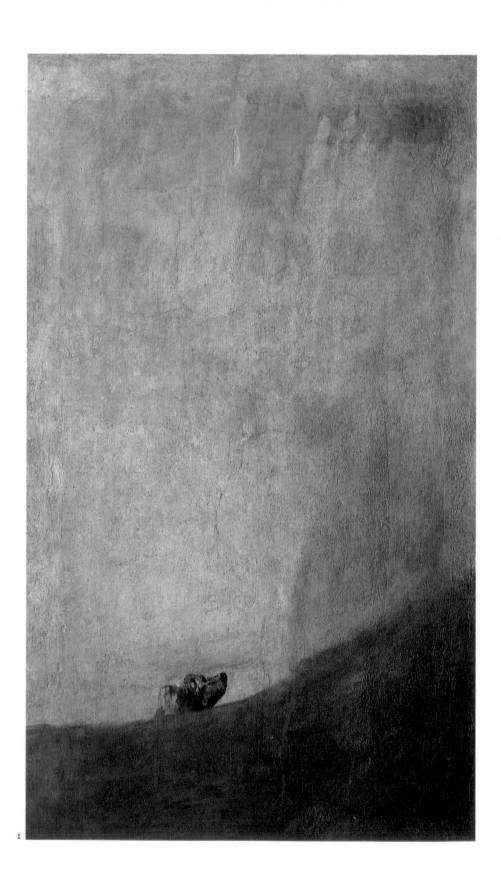

1

Francisco José de Goya
Fuendetodos, 1745 – Bordeaux, 1828
The Dog, c.1821/23
Mural transferred to canvas, 134 × 80 cm
Presented in 1881 by Baron Emile
d'Erlanger; Cat No. 767

Francisco José de Goya
Fuendetodos, 1745 – Bordeaux, 1828
Saturn, c.1821/23
Mural transferred to canvas, 146 × 83 cm
Presented in 1881 by Baron Emile
d'Erlanger; Cat No. 763

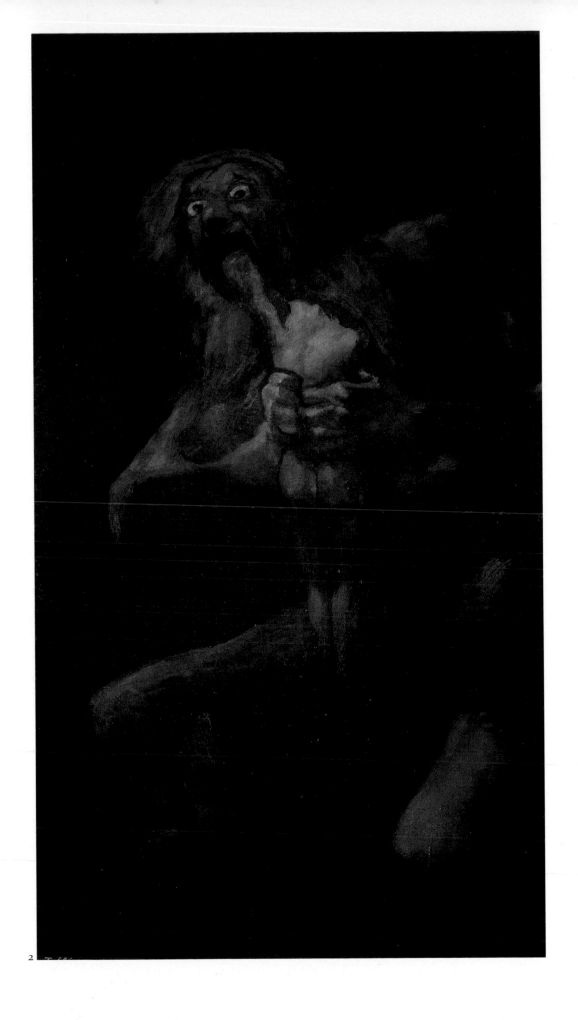

1
Francisco José de Goya
Fuendetodos, 1745 – Bordeaux, 1828
The Fates, c.1821/23
Mural transferred to canvas,
123 × 266 cm
Presented in 1881 by Baron Emile
d'Erlanger; Cat No. 757

2
Francisco José de Goya
Fuendetodos, 1745 – Bordeaux, 1828
The Witches' Sabbath, c.1821/23
Mural transferred to canvas,
140 × 438 cm
Presented in 1881 by Baron Emile
d'Erlanger; Cat No. 761

3
Francisco José de Goya
Fuendetodos, 1745 – Bordeaux, 1828
The pilgrimage to San Isidro, c.1821/23
Mural transferred to canvas,
146 × 438 cm
Presented in 1881 by Baron Emile
d'Erlanger; Cat No. 760

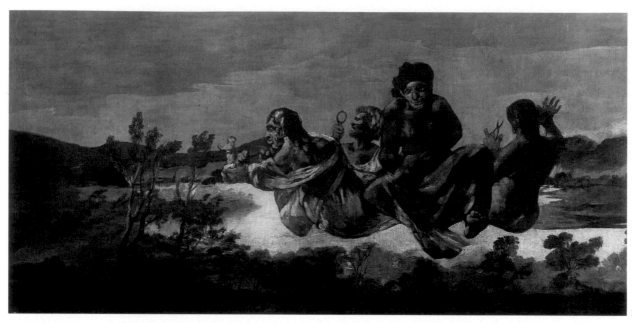

1

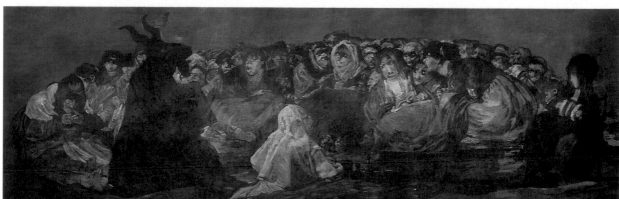

2

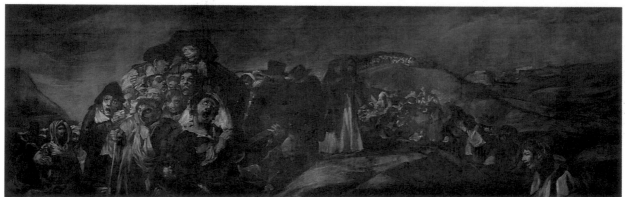

3

4
Francisco José de Goya
Fuendetodos, 1745 – Bordeaux, 1828
*A bullfight, c.*1825
Canvas, 38 × 46 cm
Presented in 1962 by Mr Thomas Harris;
Cat No. 3047

5
Francisco José de Goya
Fuendetodos, 1745 – Bordeaux, 1828
The Milkmaid of Bordeaux, 1827
Canvas, 74 × 68 cm
Bequeathed in 1946 by the Count of
Muguiro; Cat No. 2899

Painted by Goya in the year before he
died, this work is a tribute to his creative
vitality despite old age. Continuing to
experiment with new techniques, he
adopts a freer, more luminous palette,
using shorter brushstrokes and laying on
colours in a style that anticipates the
Impressionists.

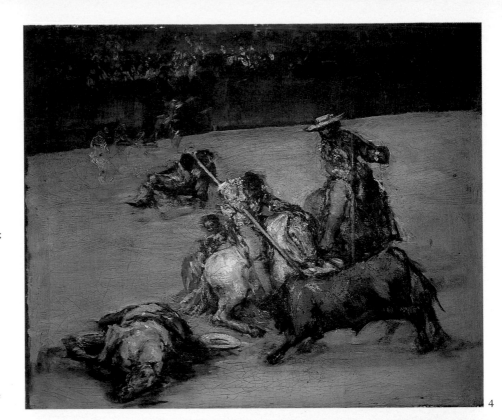

4

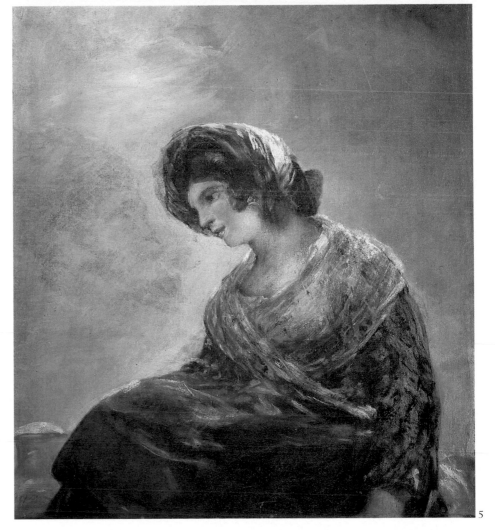

5

From the Nineteenth Century to Picasso

The romantic art of the nineteenth century is mainly housed in the Casón del Buen Retiro (the annex to the Prado), where extensive space is also given to the distinguished portraits of Federico de Madrazo, who followed Vicente López as the most important portraitist in Madrid. The Casón also displays the work of Antonio María Esquivel, with examples of his historical paintings, religious compositions, genre works and portraits, including *The Gathering of the Poets* which is of particular interest.

Three other artists of this period, Lucas, Alenza and Lameyer, are examples of what the historian Elias Tormo has termed 'the bold vein' (la Veta Brava), a recurring characteristic of Spanish painting from El Greco, through Goya, to Picasso. These artists might be described as 'romantic colourists', a form of Romanticism represented by Delacroix, for example, in French art, as distinct from the classicism of Ingres. Eugenio Lucas is far more than an imitator of Goya, although he certainly shows talent in assimilating the Goya 'black' manner, since he displays a much greater degree of intelligence and creative potential in his less derivative work. The Casón possesses an extensive collection of the paintings of Lucas, with works on many of his favourite themes – Inquisition scenes, witches' Sabbaths, bull fights and *majas* on balconies. Leonardo Alenza, a more important artist than Lucas, was also influenced by Goya, as can be seen in works such as the portrait of Pasutti and *The Beating*, the latter being a version of one of the *caprichos* entitled *If you break the jug....* Before encountering Goya, however, Alenza absorbed the influence of Teniers, through works which are now in the Prado, and his 'regional' style can be attributed to this pictorial context as much as to the later influence of Goya. Among this group of 'romantic colourists', Francisco Lameyer also stands out as a painter with a taste for African and Oriental subjects, a predilection which earned him the absurdly incongruous title of the 'Spanish Delacroix'.

Spanish 'regionalism' was made up of a number of varied and individual styles which were valued both in Spain and abroad. Four painters in the Casón del Buen Retiro principally represent 'regionalism': the delicate purist, Valeriano Bécquer; the almost naïf Manuel Cabral y Aguado Bejarano; the realist, Manuel Castellano; and Manuel Rodríguez de Guzmán. Through the influence of David

Roberts (1796–1864) on artists such as Luis Rigalt, a mode of landscape painting was established, still large in scale, from which a more realistic form of landscape painting would evolve. The most significant exponent of this form in Spain was Carlos de Haes who, although Belgian by birth, was brought up in Malaga and undoubtedly ended up more Spanish than Flemish.

Among the artists contemporary with the beginning of realist landscape painting in Spain is Martín Rico. Originally a Madrid painter, Rico finished by establishing himself in Venice, and his late manner shows a luminosity and a precise draughtsmanship partly influenced by Mariano Fortuny; another contemporary, Ramón Martí y Alsina, was highly influential in his native Catalonia. Amongst the collection of realist landscape painting in the Casón, the works of the following are also represented: Jaime Morera, one of the closest followers of Haes; Antonio Muñoz Degrain, who did not limit himself to landscapes, and José Jiménez Aranda, famous during his own period as a painter of anecdotal genre works but who also composed landscapes which might seem to anticipate the 'superrealism' of the twentieth century.

Mariano Fortuny was a painter who enjoyed a considerable reputation during his short and brilliant career. Although the critics of the first wave of French Impressionism reproached him for his involvement with the new style, Fortuny was not in any real sense an Impressionist. However, his work displays many enjoyable characteristics including a joy in the effects of sunlight, a fluent technique unconstricted by rigorous draughtsmanship, and a palette in harmony with its subject whether it be dark or light. Of the many examples of Fortuny's varied *œuvre* which are exhibited in the Casón, certain sections of the painting of his sons in the Japanese room perhaps illustrate best the modernity and virtuosity of this artist's work. Despite his extreme realism, Fortuny's brother-in-law, Raimundo de Madrazo (son of the painter Federico de Madrazo), is also an attractive painter.

In the canon of Spanish art history, Eduardo Rosales is regarded as a figure of equal importance to Fortuny. In contrast to the uninhibited lightness of Fortuny's style, Rosales' work has a stately gravity which reflects something of the humanity and creativity that lies at the heart of the Spanish temperament. Rosales places himself con-

sciously within the tradition of Spanish history as can be seen in his monumental composition, *The Testament of Queen Isabella the Catholic*.

Two other interesting artists, who were close contemporaries of Rosales and Fortuny, are Vicente Palmaroli and José Casado del Alisal. Palmaroli is a painter with two contradictory sides. On the one hand he produced work displaying scrupulous draughtsmanship and modelling; on the other he cultivated a very fluent style, using an uneven palette in which dark and sober tones predominate. For many years Casado del Alisal was known to the general public mainly through his big historical painting *The Surrender of Bailen*, which ceased to be exhibited in the Casón in 1981 because of the space required to display Picasso's *Guernica*. However, like most painters of his generation, he also produced anecdotal genre works and portraits.

Three Valencian artists, Francisco Domingo Marqués, Ignacio Pinazo and Joaquín Sorolla, became highly significant figures in Spanish art towards the end of the nineteenth century and during the early years of the twentieth. All these artists greatly developed nineteenth-century realism with their rich and fluent styles. In the case of Marqués and Pinazo, this was done without departing from an uneven and frequently dark palette; they show an interest in the material quality of the paint itself, and depict the natural world with great skill. While Sorolla never entirely abandoned the use of a dark palette, with which the Spanish temperament seems to have so much affinity, he did develop a greater use of lighter tones.

The last room in the Casón contains landscapes from the end of the nineteenth and the beginning of the twentieth centuries, along with some other examples of twentieth-century painting. There is an extensive series of pictures by Aureliano de Beruete, giving a comprehensive view of his impressionistic work with its keen perception of light, atmosphere and form. There are also some works by Agustín Riancho who, like Beruete, was a follower of Carlos de Haes; Riancho ended his career as a realist painter when his work underwent a sudden and individual transformation into an intense, almost 'fauvre' mode of pictorial expression. Also exhibited are works by the following Catalonian artists: Francesco Gimeno, who was deeply influenced by his origins in nineteenth-century realism; Santiago Rusiñol, whose work enjoys a considerable reputation; and the fiery colourist, Joaquín Mir.

It should be mentioned in this brief summary of nineteenth-century art belonging to the Prado, that whilst the collection as a whole is extensive much of it has been distributed to various museums all over Spain. The collection is largely composed of leading works from The National Exhibitions of the Fine Arts which were inaugurated in 1856. A considerable number of works of better quality also came from donations and bequests made to the museum. The collection, having previously belonged to the Prado and the Museum of the Trinity, was kept in the National Museum of Modern Art in Madrid from 1894 until 1968. When the museum closed the collection was transferred to the Museum of Contemporary Art in Madrid where it was kept until 1971.

The arrival in Madrid of Picasso's *Guernica* in October 1981, after it had been kept for many years in the Museum of Modern Art in New York, was an international event. The great significance of this work, and of Picasso himself, to the art of this century is only too well known. However, it should also be mentioned that, alongside the *Guernica* in the Casón, there is a large body of work, including preparatory and later sketches related to the composition of the vast canvas, which Picasso donated to the Prado in 1971, two years before his death. The collection of Picasso's work also includes the *Minotaur* engravings, executed two years before *Guernica*. These form a valuable iconographical antecedent to *Guernica*, and the Spanish state considered it important to acquire these engravings in 1981 in order to complete the 'Picasso-Guernica' exhibit in the Casón del Buen Retiro. In addition to *Guernica*, a number of important works by other great masters of contemporary Spanish art can be seen at the Prado. These symbolize the Museum's continuing rôle as the ideal centre for all Spanish art.

It is thanks to the generosity of the critic and historian Douglas Cooper that the Prado now possesses not only two important works by Juan Gris, *Portrait of Josette* and *Violin and guitar*, but also a superb *Still life* by Picasso. Furthermore, a donation by the widow of Joan Miró endowed the Prado with two of his most important works: *Snail, woman, flower and star* and *Dragonfly with red wings chasing a serpent which slips away in a spiral towards the comet-star*.

1
José de Madrazo
Santander, 1781 – Madrid, 1859
The Death of the Spanish Rebel Viriathus,
c.1808/18
Canvas, 307 × 462 cm
In the Royal Collection in the nineteenth
century; Cat No. 4469

2
Vicente López
Valencia, 1772 – Madrid, 1850
Sketch for a ceiling painting, *The Institu-*
tion of the Order of Charles III
Canvas, 113 × 106 cm
Purchased in 1879; Cat No. 3804

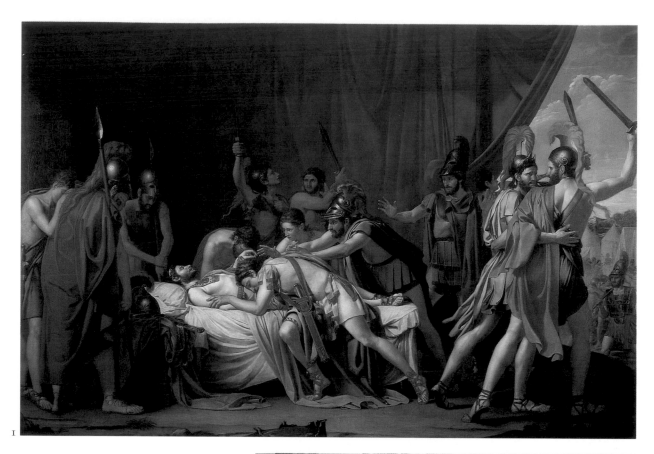

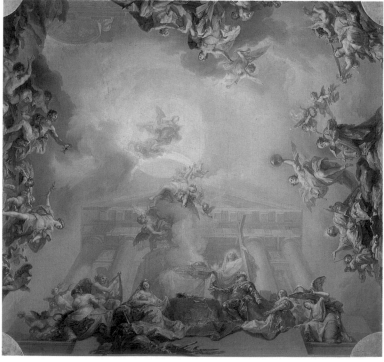

Vicente López
Valencia, 1772 – Madrid, 1850
Francisco José de Goya, 1826
Canvas, 93 × 77 cm
In the Royal Collection in the nineteenth
century; Cat No. 864

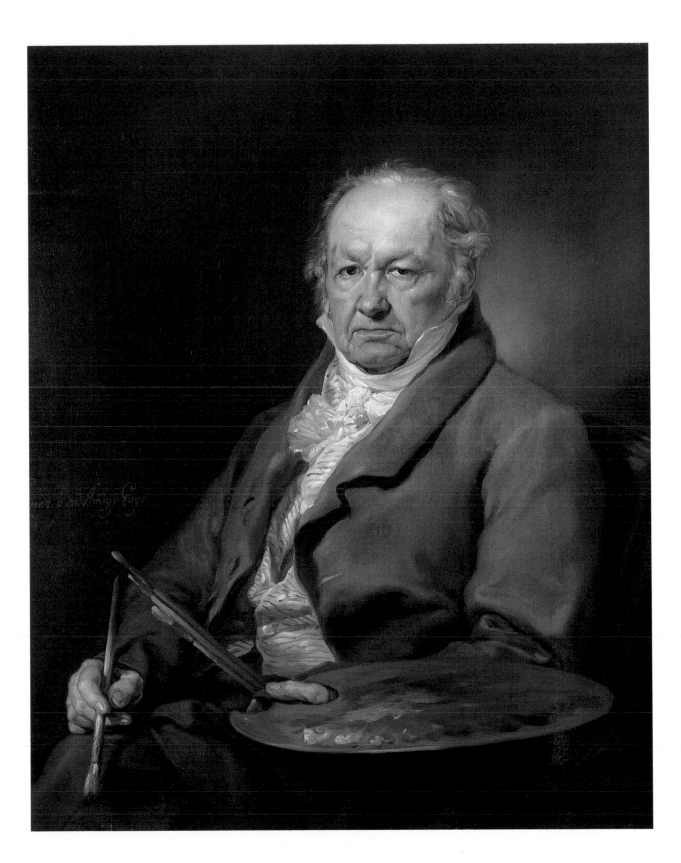

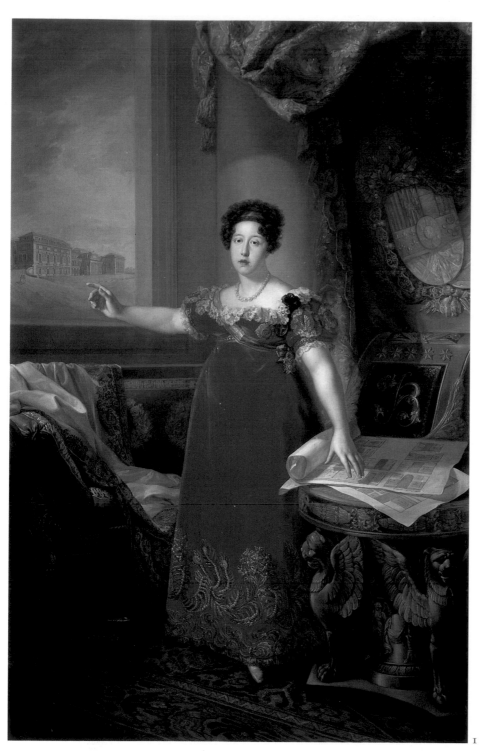

1
Bernardo López
Valencia, 1800 – Madrid, 1874
Queen Doña María Isabel de Braganza, 182
Canvas, 254 × 172 cm
In the Royal Collection in the nineteenth
century; Cat No. 863

Bernardo López, son of the more famous
Vicente López, did not develop his own
style in any significant way, but remaine
his father's close follower. The sitter, bor
in 1797 but dying young in 1818,
daughter of John VI of Portugal and
Carlota Joaquina de Borbón, was the
second wife of King Ferdinand VII of
Spain. She is commemorated in the paint
ing as the co-founder of the Prado.

2
Ascensio Juliá
Valencia, 1767 – Madrid, c.1830
A scene from a comedy
Canvas, 42 × 56 cm
Purchased in 1934; Cat No. 2573

3
Eugenio Lucas
Alcala de Henares, 1824 – Madrid, 1870
A huntsman
Canvas, 216 × 153 cm
Purchased in 1931; Cat No. 4424

4
Eugenio Lucas
Alcala de Henares, 1824 – Madrid, 1870
'Majas' on a balcony, 1862
Canvas, 107 × 81 cm
From the Vitórica Bequest of 1969; Cat
No. 4427

I

2

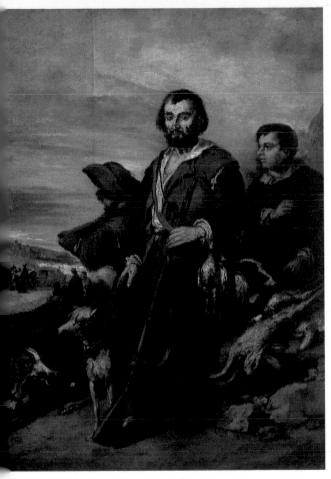

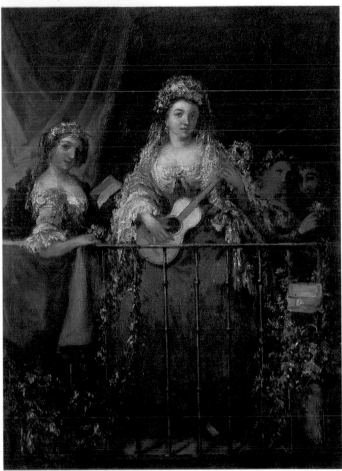

4

1
Antonio María Esquivel
Seville, 1806 – Madrid, 1857
The Gathering of the Poets, 1846
Canvas, 144 × 217 cm
Donated in 1866 by the Ministry of
Development; Cat No. 4299

2
Leonardo Alenza
Madrid, 1807 – Madrid, 1845
'El gallego de los curritos'
Canvas, 35 × 25 cm
From the Modern Art Museum; Cat No.
4205

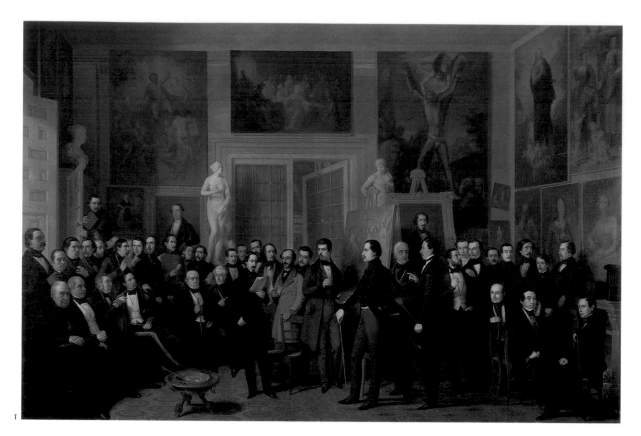

3
Valeriano Dominguez Bécquer
Seville, 1834 – Madrid, 1870
Sorian peasants dancing, 1866
Canvas, 65 × 101 cm
Presented by the artist on the receipt of a
government pension; Cat No. 4324

4
Francisco Lameyer
Puerto de Santa Maria, 1825 – Madrid,
1877
A group of Moors
Panel, 38 × 54 cm
From the Laffitte Bequest of 1942; Cat No.
4394

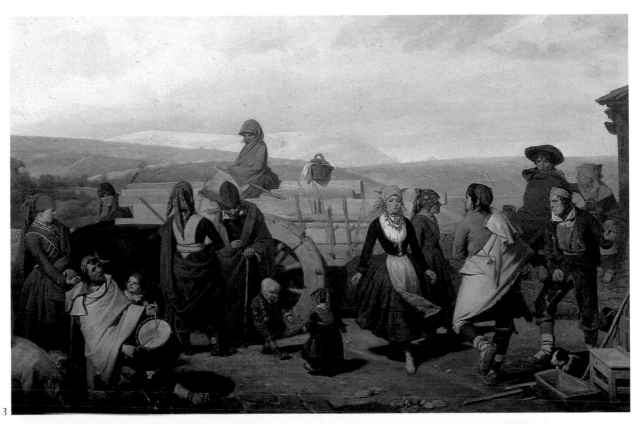

3

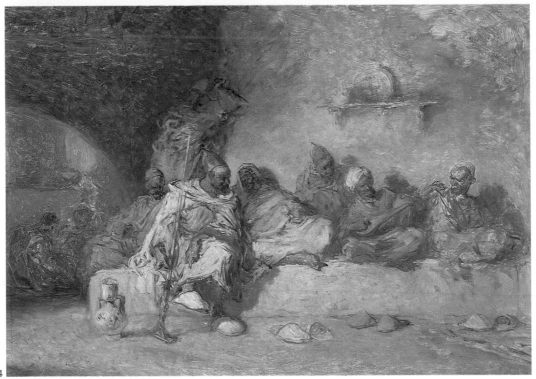

4

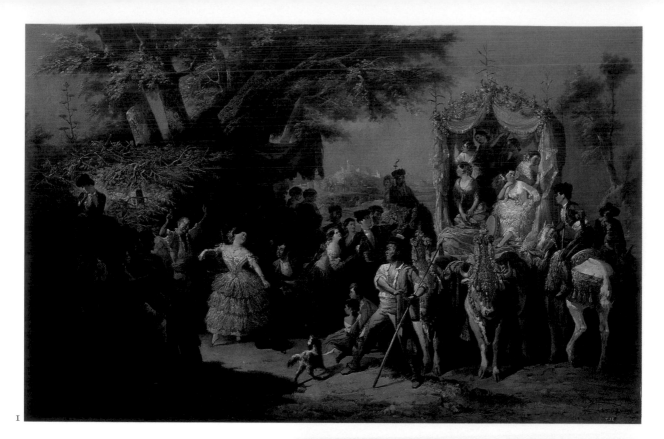

1

Manuel Rodríguez de Guzmán
Madrid, 1818 – Madrid, c.1866/67
The Santiponce Fair, 1855
Canvas, 125 × 196 cm
Purchased in 1856; Cat No. 4604

2

Federico de Madrazo
Rome, 1815 – Madrid, 1894
The Countess of Vilches, 1853
Canvas, 126 × 89 cm
Bequeathed in 1944 by the Count of La
Cimera; Cat No. 2878

Federico de Madrazo was twice appointed
Director of the Prado, from 1860 to 1868
and from 1881 to his death; he was the
son of the painter José de Madrazo, who
had also been Director of the Prado. His
portraits show great refinement and
sensitivity, a delicate harmony of colour
and texture, and the clear influence of the
French painter Ingres. The subject of this
portrait, with its appealing combination of
the aristocratic and the familiar, is the
Countess of Vilches (1821–74), a promin-
ent writer and *salon* personality in her
day.

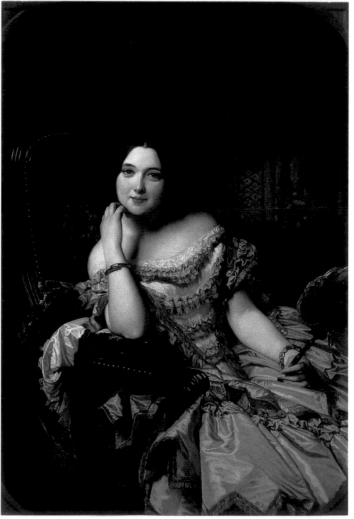

2

3
Eduardo Rosales
Madrid, 1837 – Madrid, 1873
The Testament of Queen Isabella the Catholic,
1864
Canvas, 287 × 398 cm
Purchased in 1865; Cat No. 4625

4
Luis Rigalt
Barcelona, 1814 – Barcelona, 1894
Landscape with a prominent rock
Canvas, 62 × 98 cm
Purchased in 1974; Cat No. 4601

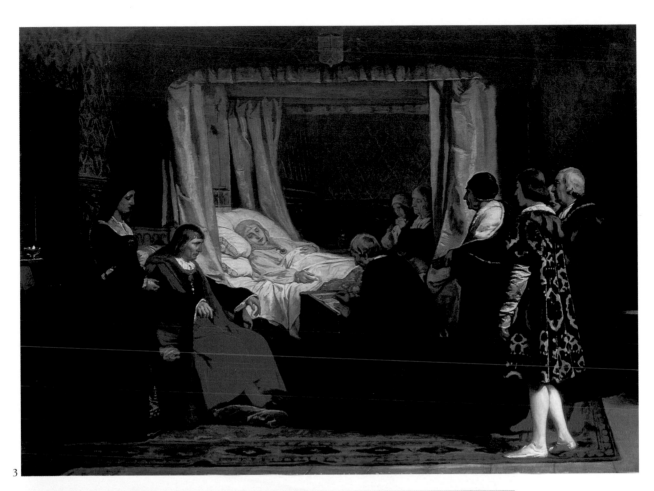

3

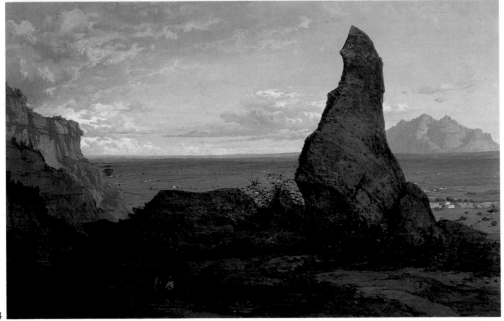

4

Eduardo Rosales
Madrid, 1837 – Madrid, 1873
The Testament of Queen Isabella the Catholic,
1864

Luis Rigalt
Barcelona, 1814 – Barcelona, 1894
Landscape with a prominent rock

1
Eduardo Rosales
Madrid, 1837 – Madrid, 1873
The Countess of Santovenia, 1871
Canvas, 163 × 106 cm
Presented in 1982 by the Friends of the
Prado Museum; Cat No. 6711

2
Vicente Palmaroli
Zarzalejo, 1834 – Madrid, 1896
Confidences on the Beach, c.1883
Panel, 137 × 63 cm
In the Bauer collection until 1930;
bequeathed by the artist's son; Cat No.
4537

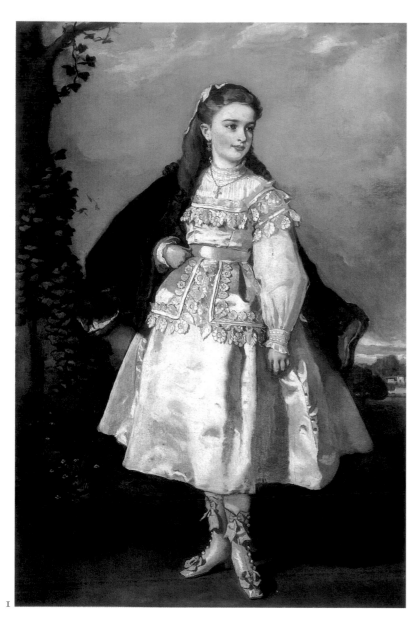

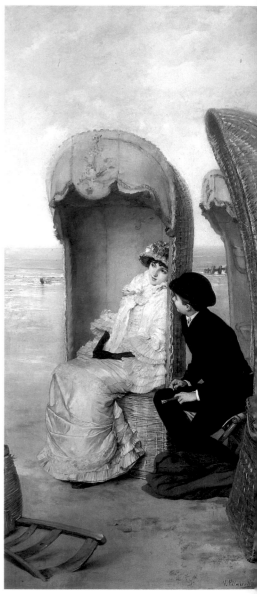

1

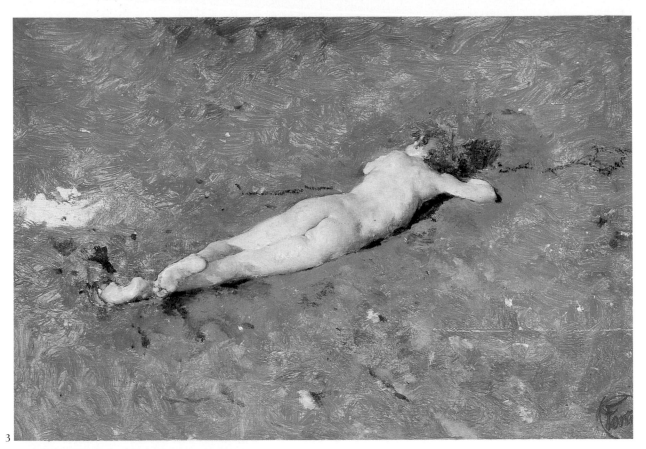

3

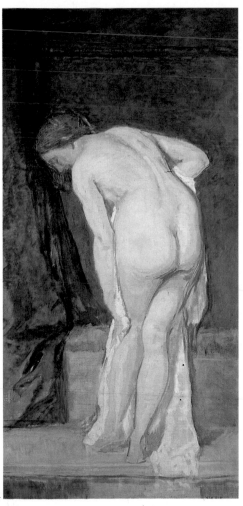

3
Mariano Fortuny
Reus, 1838 – Rome, 1874
A Nude on the Beach at Portici
Canvas, 13 × 19 cm
Bequeathed in 1904 by Don Ramón de
Errazu; Cat No. 2606

4
Eduardo Rosales
Madrid, 1837 – Madrid, 1873
Leaving the Bath
Canvas, 185 × 90 cm
Purchased in 1878; Cat No. 4616

4

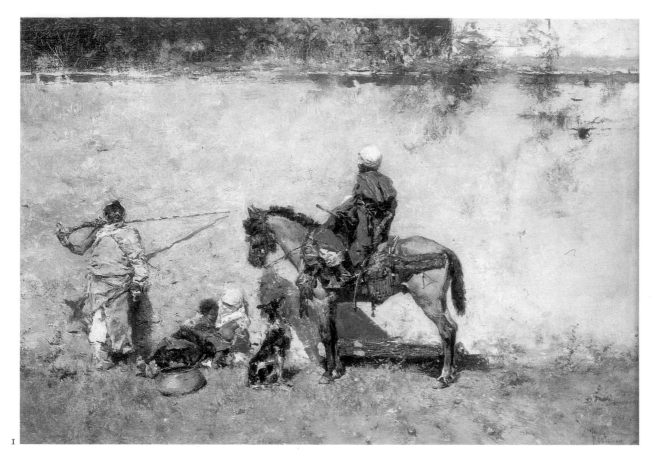

1

1
Mariano Fortuny
Reus, 1838 – Rome, 1874
'Moroccans'
Panel, 13 × 19 cm
Bequeathed in 1904 by Don Ramón de
Errazu; Cat No. 2607

2
Mariano Fortuny
Reus, 1838 – Rome, 1874
Idyll, 1868
Paper, 31 × 22 cm
Bequeathed in 1904 by Don Ramón de
Errazu; Cat No. 2609

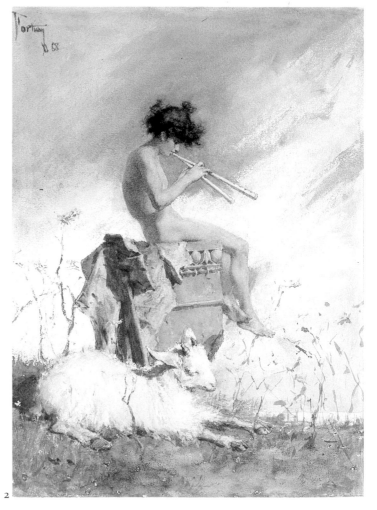

2

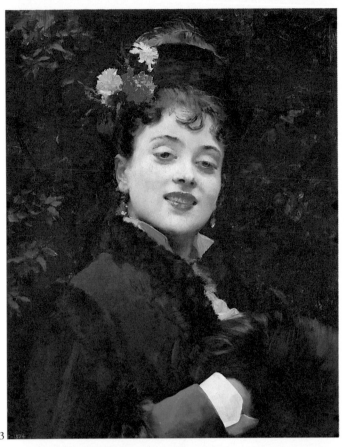

3

Raimundo de Madrazo
Rome, 1841 – Versailles, 1920
Aline Masson, the Artist's Model
Panel, 60 × 47 cm
Bequeathed in 1904 by Don Ramon de
Errazu; Cat No. 2622

4

Francisco Domingo Marqués
Valencia, 1842 – Madrid, 1920
*The Studio of Antonio Muñoz Degrain in
Valencia, 1867*
Canvas, 38 × 50 cm
Purchased in 1904; Cat No. 4484

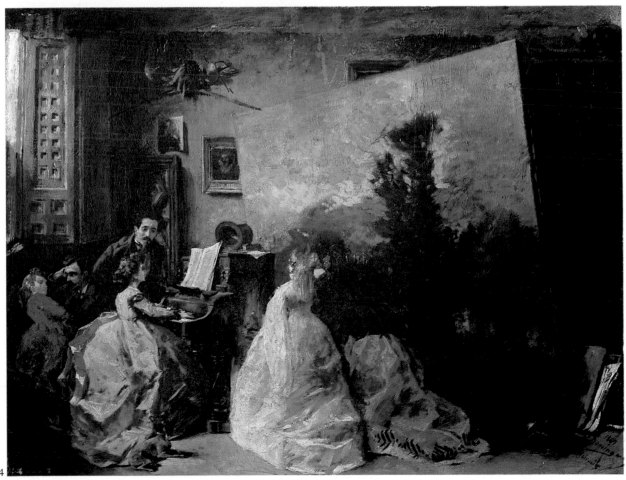

1
Aureliano de Beruete
Madrid, 1845 – Madrid, 1912
The banks of the River Manzanares
Canvas, 57 × 81 cm
Provenance unknown
Cat No. 4252

2
Ignacio Pinazo
Valencia, 1849 – Godella, 1916
Study of a nude, 1888
Panel, 10 × 18 cm
Provenance unknown
Cat No. 4578

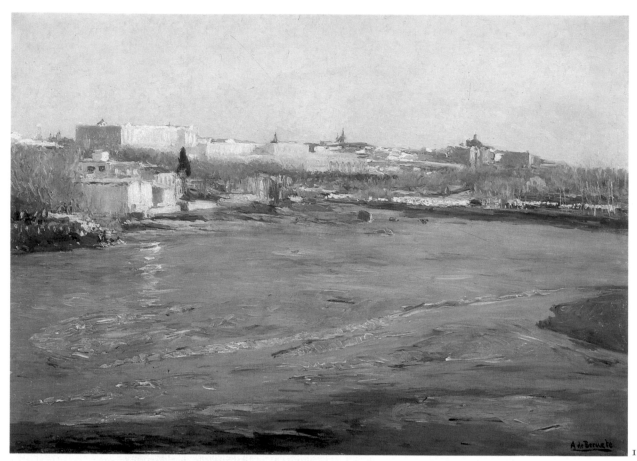

1

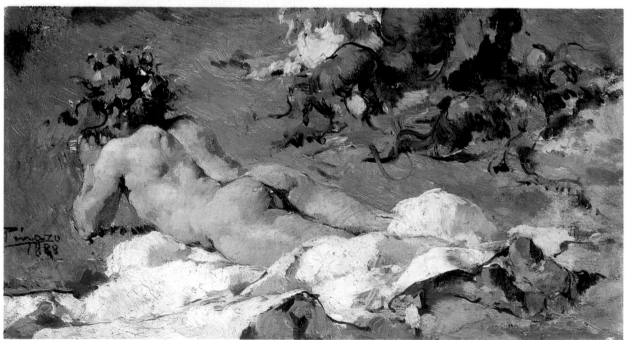

2

Carlos De Haes
Brussels, 1826 – Madrid, 1898
Los Picos de Europa, 1876
Canvas, 167 × 123 cm
Purchased in 1876; Cat No. 4391

Martín Rico
Madrid, 1835 – Venice, 1908
The Doge's Palace and the Riva degli
Schiavoni, Venice
Canvas, 41 × 71 cm
Bequeathed in 1904 by Don Ramón de
Errazu; Cat No. 2625

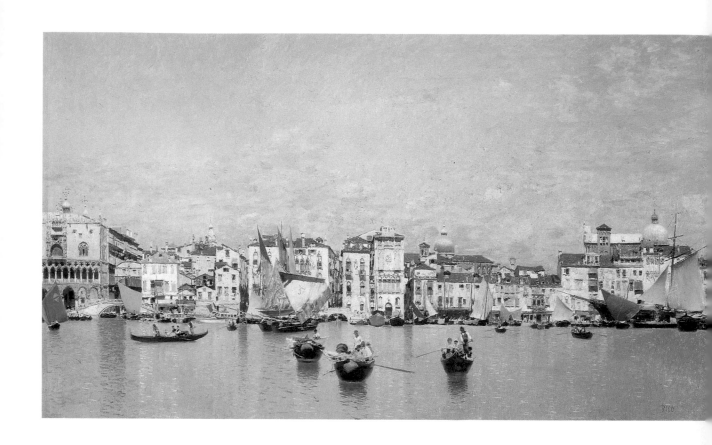

Joaquín Mir
Barcelona, 1873 – Barcelona, 1940
The waters at Naguda, 1917
Canvas, 129 × 128 cm
Purchased in 1917; Cat No. 4513

Joaquín Sorolla
Valencia, 1863 – Carcadilla, 1923
Children at the beach, 1910
Canvas, 118 × 185 cm
Presented in 1919 by the artist; Cat No.
4648

From a background in traditional
nineteenth century realism Sorolla moved
towards a more luminous and colourist
mode, reflecting more directly his sensa-
tions of the vitality and freshness of
Nature. Through contact with the Im-
pressionists in France, he developed a
technique employing long, confident
brushstrokes and a rich range of colour.

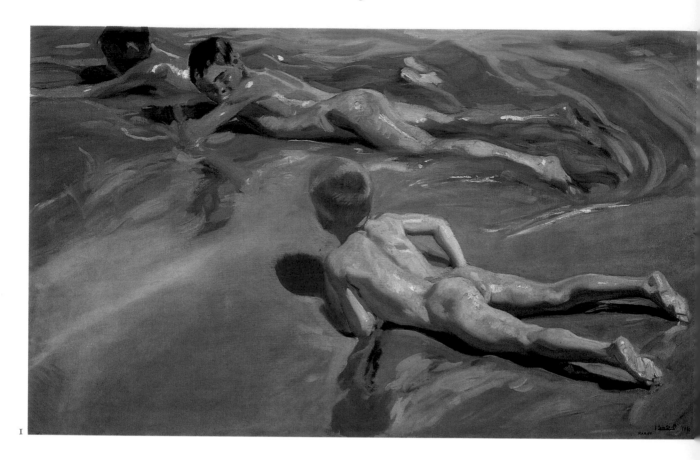

1

2
Juan Gris
Madrid, 1887 – Paris, 1927
Violin and Guitar, 1913
Canvas, 81 × 60 cm
Bequeathed in 1984 by Mr Douglas
Cooper; Cat No. 7079

3
Pablo Picasso
Malaga, 1881 – Mougins, 1973
Still life
Canvas, 46 × 65 cm
Bequeathed in 1984 by Douglas Cooper;
Cat No. 7078

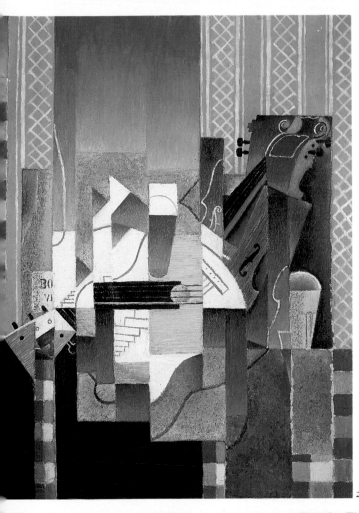

2

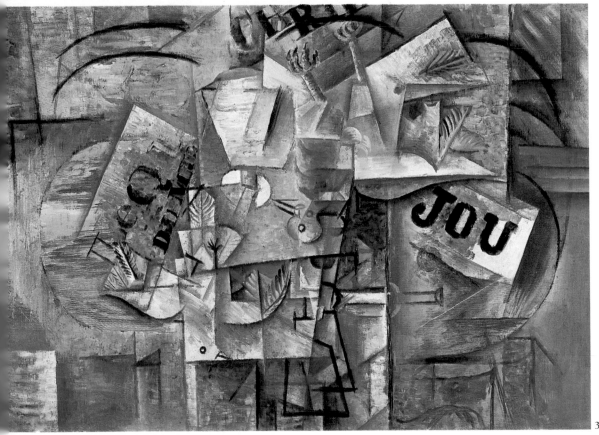

3

Joan Miró
Barcelona, 1893 – Palma de Mallorca, 1983
Dragonfly with red wings chasing a serpent which slips away in a spiral towards the comet-star, 1951
Canvas, 81 × 100 cm
Donated in 1986 by Doña Pilar Juncosa, the artist's widow; Cat No. 7145

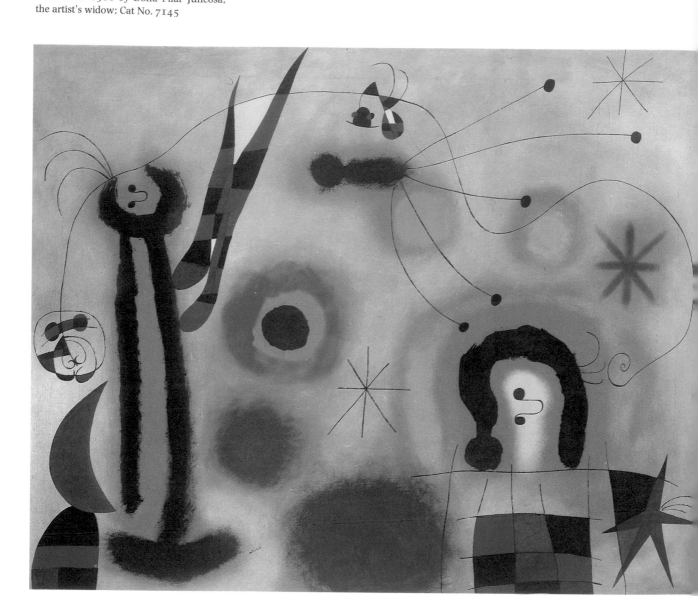

Pablo Picasso
Malaga, 1881 – Mougins, 1973
Woman crying, with a handkerchief, 1937
Canvas, 92 × 72 cm
Entered the Prado in 1981 according to
the bequest of the artist; Cat No. 6945

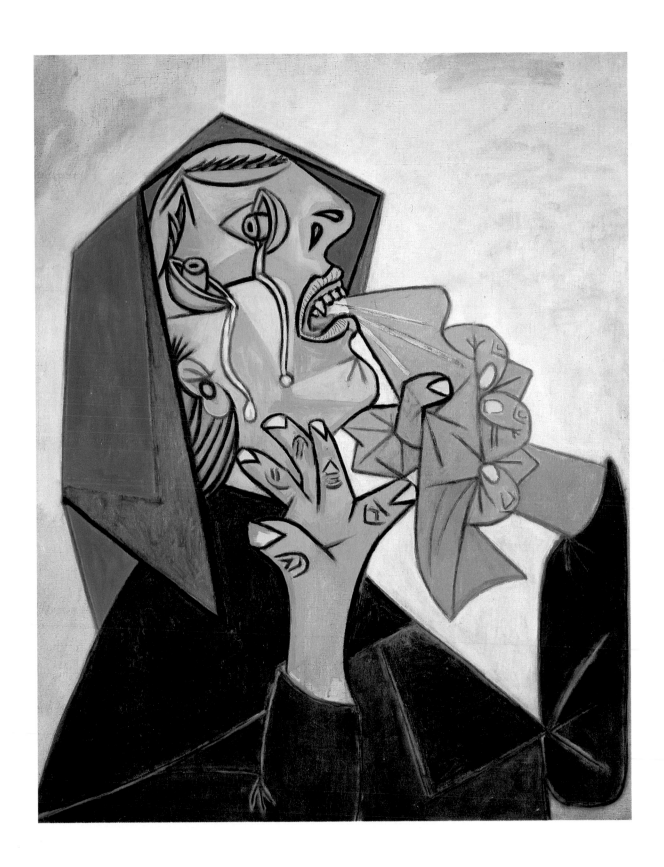

Pablo Picasso
Malaga, 1881 – Mougins, 1973
Guernica, 1937
Canvas, 349 × 776 cm
Entered the Prado in 1981 according to
the bequest of the artist; Cat No. 6479

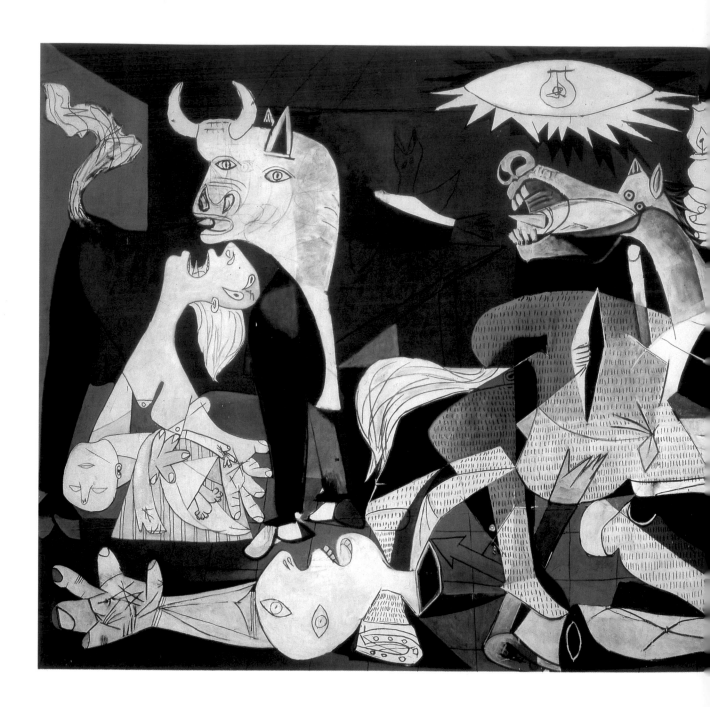

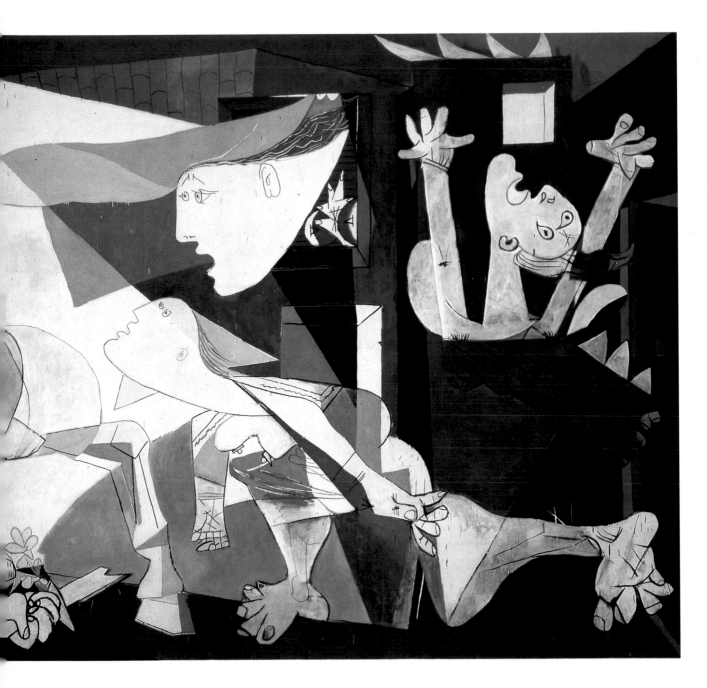

During the 1930s Picasso tried out
several different ways of painting. In
Guernica the essentially poetic contortions
of cubism were employed to convey the
agony and frustration of war. The event
to which the title refers was the bombing
of the town of Guernica in northern Spain
in 1937, during the second year of the
Spanish Civil War. This huge, didactic
work shocks and convinces by a com-
bination of massive scale, frenetic com-
position, sombre colouring and ultimately
the humanity of its inhuman forms.

However, Picasso's *Guernica* should be
seen not only as a development within the
movement of cubism but also within a
Spanish tradition of protest paintings,
going back to Goya's indictments of war
and continued also by Salvador Dali in his
cannibalistic *Premonition of Civil War*.

The Foreign Collections

Walking through the galleries of the Prado and surveying the magnificent pictures they contain, one cannot but be struck by the universal quality of this museum. The various collections clearly reflect the tastes and politics of the monarchs, courtiers and counsellors who assembled them, not the informed choice of art historians and scholars, and this should always be borne in mind.

After the close economic cooperation between Castile and the Low Countries during the Middle Ages, a succession of royal marriages and royal deaths led eventually to Charles V becoming King of both Spain and Flanders in 1517, and ruler of Austria and Holy Roman Emperor two years later. These circumstances encouraged the import of many works of Netherlandish art into Spain from the fifteenth century onwards, most of which entered the Royal Collection.

The Italian collection in the Prado is one of the most representative, and is considered by many to be indispensable for a full understanding of Italy's artistic evolution. Most of the pieces were acquired directly from Madrid. The Venetian School was traditionally the most popular with the Spanish monarchs, partly, no doubt, owing to the fact that Titian was official portraitist to both Charles V and Philip II. The latter, in particular, assembled a highly impressive group of Italian paintings, including works by Correggio and Raphael, which were hung in the palace of the Alcazar in Madrid, El Pardo and Aranjuez. Philip III, although not a keen collector, was presented by the Duke of Urbino with two magnificent canvases by Barocci, and it was during his reign that Rubens first visited the Court in Madrid when in 1603 he accompanied an embassy from Vincenzo Gonzaga, Duke of Mantua.

In contrast, Philip IV was a great patron of the arts. During his reign Spanish artists of the calibre of Velázquez, Zurbarán and Ribera were at the height of their powers yet, even so, large numbers of Flemish paintings were imported to help decorate the royal palaces. When Rubens died, Philip purchased many pictures from the sale at his studio and, after the execution of Charles I of England in 1648, the royal agents bought works from Charles' remaining estate by Mantegna, Raphael, Veronese, Andrea del Sarto, Tintoretto and Dürer. With the building of the Buen Retiro Palace in Madrid in 1630, many pieces were commissioned and sought in Italy, and the ambassadors in Rome and the Viceroys of Naples vied with each other to send the finest canvases for the decoration of the new royal residence and the old Alcazar. Queen Christina of Sweden presented two panels by Dürer, and many Spanish and Italian aristocrats also donated works; while Velázquez was responsible for making purchases for Philip in Italy.

By Philip's death in 1665 the collection was by any standards a magnificent one, and his successor, Charles II, did not greatly enlarge it – though works by Rubens and a number of Italian still-lifes by Recco, Nuzzi and Belvedere were added during his reign. In 1692 Luca Giordano arrived at Court and dominated the artistic milieu of Spain for ten years. He renewed interest in large-scale decorative schemes and his presence coincided with the last splendours of the so-called 'Golden Age' of Spanish painting (El Siglo de Oro).

With the establishment of the Bourbon dynasty in Spain in 1700 the grandson of Louis XIV of France, Philip V, ascended the throne of Spain. He and his second wife, the Italian Isabel de Farnesio, commissioned French artists such as Houasse and Ranc to paint genre scenes and portraits, and turned to Italy, to artists like Procaccini and Vaccaro, for religious and historical works. The refurbishing of the old palaces and the building of new ones, for example, La Granja, called for fresh decorations. Accordingly, family portraits by Rigaud, Largillière, De Troy, Santerre and Gobert arrived and the King's agents purchased pictures in Italy, France and the Low Countries.

Ferdinand VI contributed very little to Spain's artistic patronage, although during his reign various Italian painters executed mural decorations and minor works. Charles III, who reigned for twenty-nine years, completed the building of the new palace in Madrid and commissioned Tiepolo and Mengs to decorate it. Many of the famous paintings were acquired at this time, by various artists including Rembrandt and Tintoretto, and the Prince of Asturias, later to become Charles IV, started his own collection. By the time he lost the throne in 1808, he had assembled a sophisticated collection to be added to that of his ancestors. Among his purchases were works by contemporary artists like Pillement and Vernet, along with earlier paintings, now exhibited in the Prado, by Andrea del Sarto, Robert Campin, Raphael, Domenichino, Turchi and Cavedone.

After the disruption caused by the Napoleonic Wars and the invasion of Spain in 1808, the House of Bourbon was duly restored in the person of Ferdinand VII in 1814, and the Prado Museum was finally inaugurated in 1819. The director, Federico de Madrazo, obtained the splendid *Annunciation* altarpiece by Fra Angelico in 1860 and, five years later, the exquisite polyptych of forty animals on copper plate by Van Kessel the Elder was presented to the Prado.

Italian Painting

A large number of religious paintings were transferred to the Prado from the Museum of the Trinity in 1872, including works by Van der Weyden and Barocci. The flow of donations continued until the end of the nineteenth century, the most notable being the remarkable presentation of almost two hundred paintings by the Duchess of Pastrana.

The period between 1914 and 1936 was extremely rewarding for the Prado. Works by Andrea del Sarto, Van der Weyden, Van Kessel, Bernini, Tiepolo and Van Scorel were purchased. Since the end of the Second World War the collections have been increased in a more systematic way. An example of this is the collection of British paintings, which did not even exist at the beginning of the century but now boasts works by Reynolds, Gainsborough, Lawrence and Romney among others. The British collection now neatly rounds off the Prado's representation of foreign paintings.

Italian painting forms the third largest collection in the Prado and includes much of the Italian art which the Spanish monarchy purchased or commissioned between the sixteenth and the nineteenth centuries. Political links between Spain and Italy were one of the most important factors in the assembling of Italian collections in Spain during this period. The Royal Collection was formed through just such links, as were the private collections of the nobility, whose tastes were generally those imposed by the Court and whose visits to Italy as ambassadors permitted them to purchase important works.

The personal tastes of the Spanish monarchs obviously dictated the composition of the royal collections. They account for the presence of many paintings by the most important artists working in Rome during the middle of the seventeenth century and the great abundance of works from the Venetian School of the sixteenth century. But equally they explain the significant gaps during other periods. For example, there is a marked lack of works from Quattrocento Italy because during the time of Ferdinand and Isabella, economic and political ties with Flanders resulted in a concentration on Flemish works of art. Similarly, in the eighteenth century, the establishment of the Bourbon dynasty in Spain meant that artistic interests inclined towards French painting, at the expense of the quite active Italian schools of the period.

Amongst the earliest works in the Italian collection are two small panels from the fourteenth century which probably formed the *predella* to an altarpiece. They are attributed (although not unanimously) to Taddeo Gaddi, a Florentine artist from Giotto's circle of followers. The gilded background of the paintings serves to highlight the figures, yet the elegance and richness of the clothing does not detract from the monumental sense of form and expressive individualism derived from Giotto. Also exhibited is a panel by Giovanni del Ponte, who might be considered a rather archaic artist. Although this panel, which formed the front of a *cassone* (a linen chest) and represents the Seven Liberal Arts, has been dated around 1435, the lack of geometrical perspective, the gilded background and the elegant and elaborate attitudes of the figures suggest close contact with the International Gothic Movement of a rather earlier period, and make this work an interesting example of the state of painting immediately prior to the innovations of the first Florentine Renaissance.

The collection of Quattrocento painting proper in the Prado begins with the exquisite *Annunciation* by Fra Angelico, which comes from one of the altars of the Dominican monastery at Fiesole near Florence, and was

sold by the Dominican monks in 1611 in order to pay for the restoration of their bell tower. The work was purchased by the Duke of Lerma, the powerful favourite of Philip III, and was donated in the same year to the Monastery of the Discalced Carmelites in Madrid where it adorned one of the altars of the cloister chapels. In 1861 Federico de Madrazo, then director of the Prado, discovered this magnificent panel in an excellent state of preservation and had it moved into the museum, replacing it with one of his own works on the same theme.

Florentine painting during the late Quattrocento is represented by three panels by Botticelli which illustrate a story from Boccaccio's *Decameron*. Although typical enough of Botticelli's earlier style, they display many of the characteristics which would be associated with the mannerism of the sixteenth century.

One of the finest pieces in the entire museum is undoubtedly *The Death of the Virgin* by the Paduan artist Andrea Mantegna. It reflects well on the discernment of Philip IV and his artistic advisers that they should show an interest in early Renaissance works when prevailing taste looked towards Raphael and the contemporary baroque masters.

The paintings from Quattrocento Venice, as represented in the Prado, are situated at the threshold of the great achievements of Venetian art during the sixteenth century. Antonello da Messina's *Dead Christ supported by an Angel* is one of the artist's most beautiful creations, blending a typically Venetian play on the effects of atmosphere and light with elements of northern realism.

Melozzo da Forlì, a follower of Piero della Francesca, is represented by a fragment of a fresco depicting an angel musician. Along with Antoniazzo Romano, Melozzo is an example of the Umbrian School at the end of the fifteenth century; the school from which Perugino emerged and in which the young Raphael was trained. The relative scarcity of pieces from the fifteenth century in the Prado is more than compensated for by the magnificent collection of sixteenth century works from all the various artistic centres of Italy.

The full development of Italian classicism at the beginning of the sixteenth century is best represented in the Prado by the works of Raphael. *The Holy Family with a lamb*, a youthful picture from 1507, belongs to Raphael's Florentine period during which he came into contact with the ideas of Leonardo and Fra Bartolommeo. The composition which shows Raphael's most rigorous classicism is *The Madonna of the Fish* painted around 1514. In this work, pictorial space is determined through geometrical relations

and the figures attain a solid and monumental character. Raphael's profound psychological insight is shown in the *Portrait of a Cardinal* which embodies in the severe figure of the sitter a sense of the refinement, intelligence and indifference of the Church prelates during that period of bitter conflict with Lutheranism.

Of Andrea del Sarto, the Prado possesses an enigmatic portrait of a woman who critics recognize as Lucrezia di Baccio del Fede, the artist's wife, and *The Virgin with a Saint and an Angel*, the largest composition by Andrea del Sarto in the museum. This scene, framed within a rigid pyramidal structure, is executed in a technique which clearly recalls Leonardo's use of chiaroscuro while the expert blending of rich, warm tones – reds, greens and pure yellows – with more roseate and iridescent tones anticipates the daring colouring of the Florentine mannerists such as Pontormo and Bronzino.

Some of the best examples of the work of Niccolò dell' Abate and Parmigianino, high mannerists working during the middle of the sixteenth century, are also to be found in the Prado, while the works of Sebastiano del Piombo, Correggio and Barocci show the independent and individual tendencies of these artists within the broad sweep of mannerism. Correggio was one of the most innovative and independent artistic personalities during the first part of the century, and the Prado possesses in *The Virgin and Child with St John*, one of his most famous compositions.

Few other collections include so many works by the great sixteenth century Venetian masters, Titian, Tintoretto and Veronese, as well as works by other important Venetian artists such as Lotto, Palma, Bassano and Moroni. Almost all the Venetian paintings in the Prado come from the royal collections, and while a few were acquired during the eighteenth century, the majority arrived in Spain during the sixteenth and seventeenth centuries. Among these is the *Venus and Adonis* by Veronese, acquired in Italy by Velázquez who was expressly commissioned by Philip IV to buy any works he considered suitable for the royal collections.

The Prado also possesses *The Worship of Venus* and *The Andrians* by Titian, which together with another work, *Bacchus and Ariadne*, now in the National Gallery in London, formed a series executed between 1519 and 1525 for Alfonso d'Este, the Duke of Ferrara. These works are among the first of Titian's great mythological paintings. The collection includes important examples of Titian's later religious compositions and several excellent portraits, which had a major influence on Spanish portraiture towards the end of the sixteenth and throughout the seven-

teenth centuries. There are also the magnificent portraits of the high aristocracy of the period such as the fascinating portrayal of Federico Gonzaga, the Duke of Mantua, with its exquisite tonality and strange sense of melancholy, and Titian's self-portrait is a masterpiece of its kind. This work, the subject of a commentary by Vasari, belonged to Rubens and was bought by Philip IV at the sale of that artist's possessions after his death in 1640, possibly on the advice of Velázquez.

Almost all the paintings by Veronese which the Prado possesses were acquired during the reign of Philip IV. The work of Veronese, with its wealth of tone and form and its power of expression, might be considered to represent the culmination of the Venetian Renaissance. The sensual beauty of Veronese's female figures is comparable only to Titian's, and this quality in his work is exemplified in the exquisite *Venus and Adonis*. Similarly, features such as the almost rococo delicacy of the small version of *The Finding of Moses*, and the superb use of luminous landscape in the paintings, display the highly refined aesthetic of Veronese.

The work of Tintoretto reflects an important change in the direction of Venetian art during the second half of the sixteenth century, away from the sense of harmony so evident in the work of Titian and Veronese towards a new expressiveness which might be termed 'Venetian mannerism'. The dramatic tension in his compositions which is achieved through the elongation of the figures, the almost garish use of colour, and the violent touches of illumination which traverse the canvas like flashes of cold light, mark Tintoretto as one of the most original Venetian painters of this period. The Prado owns some of his finest works including *Christ washing the feet of His Disciples* and *The Battle between Turks and Christians*, as well as a magnificent series of portraits.

The sixteenth century Venetian collection in the Prado ends with works from the workshop of the Bassanos. The founder of this dynasty of painters, Jacopo Bassano, used Biblical subjects as a pretext for genre scenes and animal paintings. Many of these are lively and decorative works in which Bassano develops the naturalism, the sense of space and colour, and the vibrant brushwork of the Venetian masters. Francesco Bassano produced paintings in a similar vein to his father, among which the most interesting is *The Last Supper*, while the work of Leandro Bassano, another son, has similar themes.

The nucleus of the seventeenth century collection is the corpus of work commissioned by Philip IV for the decoration of the new Buen Retiro Palace, to which some of the most important painters of the age contributed. The two main trends in Italy at the beginning of the seventeenth century, classicism and 'naturalist tenebrism', are moderately well represented in the museum, although the works of the revolutionary Caravaggio do not seem to have attracted the attention of the monarchy; *David and Goliath* is the one outstanding exception. However, the Prado does possess some fine examples of the work of the Caravaggists, including *The Beheading of John the Baptist* by the Neapolitan artist, Massimo Stanzione.

The classicist movement, which originated in Bologna and became established in Rome at the beginning of the seventeenth century through the activities of Annibale Carracci and a number of his pupils, is also well represented in the Prado. The most significant works in this style are those by Carracci himself, such as *Venus and Adonis* and *The Assumption of the Virgin*, in which classicist elements are fused with a knowledge of sixteenth century Venetian painting. The immediate followers of Annibale Carracci are also extensively represented by pieces such as *The Toilet of Venus* by Francesco Albani and *Hippomenes and Atalanta* by Guido Reni. Domenichino, one of the most refined classicists of the first part of the century, is represented by various works, including the small *Triumphal Arch of Allegories*, dated between 1607 and 1610, and executed in honour of Giovan Battista Aguchi, an art theorist and friend of the classicist painters. In contrast to the highly intellectualized art of Domenichino is the fine collection of the work of his contemporary, Guercino. Yet another follower of Carracci, Giovanni Lanfranco, may be considered to have anticipated the grandiose manner of the full baroque; in *The Banquet of the Gladiators* the figures are composed in the form of a classical frieze and are thrown into relief by the use of light against a dark background.

The Neapolitan School also became active during the middle years of the seventeenth century. Originating in the influence of the works which Caravaggio executed in the city, Neapolitan art continued its individual path, curiously enough, in the work of a Spanish painter, Jusepe de Ribera, who established himself as a young man in Naples, and founded an indigenous tradition which culminated at the end of the century in the art of Luca Giordano. There is a notable collection of paintings in the Prado by all the principal Neapolitan artists, including some delicate mythological and Biblical compositions by Bernardo Cavallino and an excellent group by Stanzione, who continued the personal development of his art throughout the century, shifting from Caravaggist tenebrism towards a more luminous style. There are also several canvases by Aniello Falcone, a follower of Ribera, among them the beautiful composition

entitled *The Concert*. Mattia Preti is represented by *Christ in Glory*, and there is an outstanding landscape, *A View of the Gulf at Salerno*, by Salvator Rosa. Finally, the numerous works by Luca Giordano include *The Dream of Solomon* with its wonderful colouring and bold contrasts of brilliant metallic light.

Among the works of the Genoese School there is *Moses drawing Water from the Rock* by Gioachino Assereto, which greatly influenced Spanish painting, particularly the work of Murillo. The *St Veronica* by Bernardo Strozzi and the fascinating *Diogenes looking for a Good Man* by Giovanni Benedetto Castiglione should also be mentioned.

There are other works of great quality in the seventeenth century collection such as *The Finding of Moses* from Orazio Gentileschi's English period, and a *Pietà* by the Lombard painter Daniele Crespi. The flower paintings by the Neapolitan Andrea Belvedere are excellent examples of still-life painting during this period. Among the works of the Florentine School, which was closely connected with Spain towards the end of the sixteenth century, there is the magnificent *Lot and his daughters* by Francesco Furini, presented to Philip IV by the Duke of Tuscany who specially selected it from his collection to delight the refined taste of the Spanish monarch.

Despite Philip V's interest in French art, and the consequent influx of French painters to the Spanish Court in the eighteenth century, artistic relations with Italy were not completely cut off. There were still visits from Italian painters, among them major figures such as Corrado Giaquinto and Giambattista Tiepolo, and the Prado also has paintings by some of the late followers of the classicist Carlo Maratta, who worked in Rome in the first part of the eighteenth century. Perhaps the best example of this school in the museum is the portrait of *Cardinal Borja* by Andrea Procaccini, who was made court painter by Philip V.

The Prado possesses pictures by two important Neapolitan artists of the eighteenth century, Francesco Solimena and Sebastiano Conca, whose works were commissioned for the decoration of the royal palaces although they themselves never visited Spain. Another Neapolitan artist, Corrado Giaquinto, who collaborated with Conca, was summoned to Madrid in 1753 by Ferdinand VI to execute mural decorations for the new Royal Palace, and stayed to become Director of the Royal Academy of San Fernando. The Prado has an important series of his works, including the beautiful sketches for frescos such as *Apollo and Bacchus* (a preparatory sketch for the decorative scheme of the staircase in the Royal Palace). The rococo delicacy of the figures, the clear tonality and the freedom of technique in Giaquinto's work had an important influence on the development of the Madrid School in the second half of the eighteenth century. A number of these artists, like Bayeu and Maella, had been among Giaquinto's pupils in Rome and the influence of Giaquinto's style can be discerned even in Goya's early paintings.

Next to Rome, Venice was probably the most active centre of Italian art during the eighteenth century. The Prado does not possess any works by either Canaletto or Guardi, the two principal exponents of view-painting: this facet of Italian art is represented instead by the Roman views of Giovanni Paolo Panini and a view of Venice by the elder Vanvitelli, to which the museum has recently added a number of interesting studies of the palace at Aranjuez by Francesco Battaglioni, who was trained in Venice and worked for the Spanish Court from 1754. Another recent acquisition is a landscape entitled *Angels ministering to Christ* by Alessandro Magnasco, an important Genoese artist of the eighteenth century.

By far the most important figures in eighteenth century Venetian art were, however, the Tiepolos. Both the father, Giambattista, and his eldest son Gian Domenico travelled widely, executing a prodigious quantity of decorations in their native Venice and throughout the courts of Europe, such as those in the Kaisersaal in the Residence of the Bishop of Würzburg. Accompanied by both his sons, Giambattista Tiepolo arrived in Madrid in 1762, already an old man. At the Court he executed the frescos in the throne room of the Royal Palace, which are some of his most beautiful creations, and the Prado also possesses the outstanding series of canvasses which he painted for the Church of St Pascual in Aranjuez during 1769.

The Italian collection of eighteenth century painting in the Prado ends with three fine portraits by Pompeo Batoni, among them the masterly portrait of Charles Cecil Roberts, dated 1778.

1
Attributed to Taddeo Gaddi
Florence, *c*.1300 – Florence, 1366
*St Eligius before King Clothar, c.*1365
Panel, 35 × 39 cm
Presented by Don Francisco Cambó in
1940; Cat No. 2841

2
Giovanni dal Ponte
Florence, before 1376 – Florence, 1437
*The Seven Liberal Arts, c.*1435
Panel, 56 × 155 cm
Presented by Don Francisco Cambó in
1940; Cat No. 2844

1

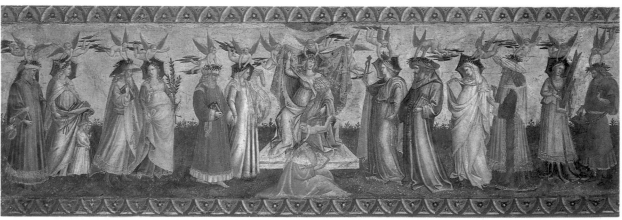

2

134

Fra Giovanni da Fiesole, called Fra Angelico
Vicchio di Mugello (?), c.1400 – Rome, 1455
The Annunciation, c.1430
Panel, 194 × 194 cm
From the Church of San Domenico in Fiesole; sold and taken to Spain in 1611. Entered the Prado in 1861; Cat No. 15

This magnificent altarpiece, with its central image of the Annunciation and its *predella* with other scenes from the Life of the Virgin, is thought to have been painted largely by the artist's workshop. The central image repeats a design Fra Angelico also used in an *Annunciation* now in Cortona and in another at the head of the stairs to the dormitory of his monastery, San Marco in Florence. The new Renaissance command of architectural perspective accompanies a continuing medieval delight in the lavish use of gilding.

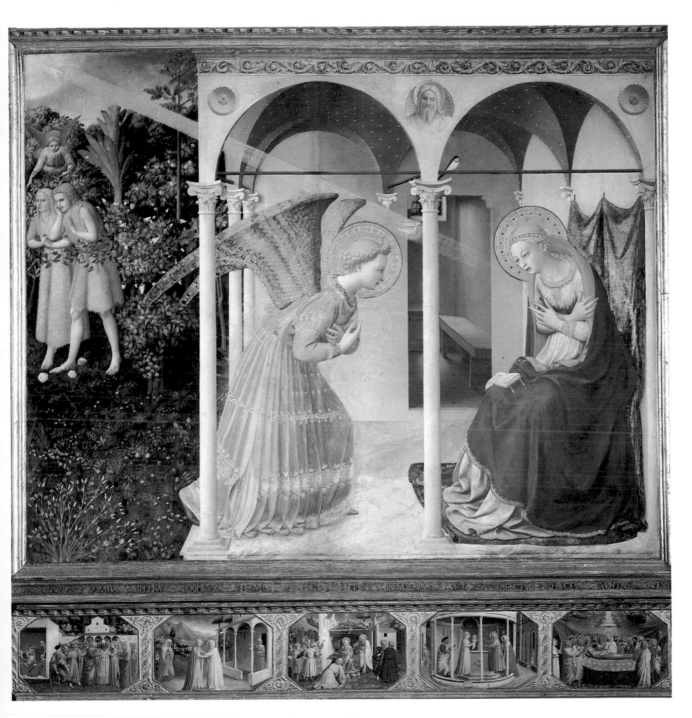

Alessandro Filipepi, called Botticelli
Florence, 1445 – Florence, 1510
The Story of Nastagio degli Onesti:
Nastagio's vision of the ghostly pursuit in the
forest, 1483
Panel, 138 × 83 cm
Presented by Don Francisco Cambó in
1940; Cat No. 2838

I

These three panels, excellent examples of the refined and elegant style of the mature Botticelli, illustrate a story from Boccaccio's *Decameron*. Nastagio, rejected by his beloved Paola Traversari, wanders alone in the forest, till he comes upon the horrifying sight of a knight and his dogs chasing, tearing and eventually disembowelling a naked woman. But he can do nothing to stop them; and when the disembowelment is complete, the woman rises again and the chase continues. The knight explains that he committed suicide for love, and this is his punishment, and that of the woman whose cruelty caused him to take his life. Nastagio invites his own beloved and her family to witness a re-enactment of the scene, as a result of which Paola relents and agrees to marry him (shown in a fourth picture by Botticelli in a private collection in Switzerland).

2
Alessandro Filipepi, called Botticelli
Florence, 1445 – Florence, 1510
The Story of Nastagio degli Onesti: the
disembowelment of the woman pursued,
1483
Panel, 138 × 83 cm
Presented by Don Francisco Cambó in
1940; Cat No. 2839

3
Alessandro Filipepi, called Botticelli
Florence, 1445 – Florence, 1510
The Story of Nastagio degli Onesti: Nastagio
arranges a feast at which the ghosts re-
appear, 1483
Panel, 138 × 83 cm
Presented by Don Francisco Cambó in
1940; Cat No. 2840

2

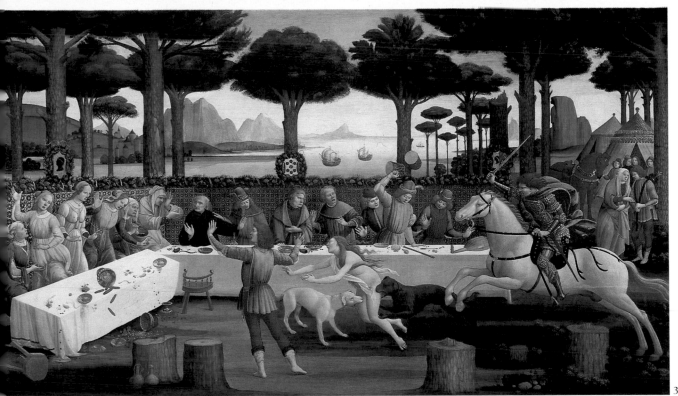

3

Antonello da Messina
Messina, *c*.1430 – Messina, 1479
The Dead Christ supported by an Angel,
c.1475/78
Panel, 74 × 51 cm
Purchased in 1965; Cat No. 3092

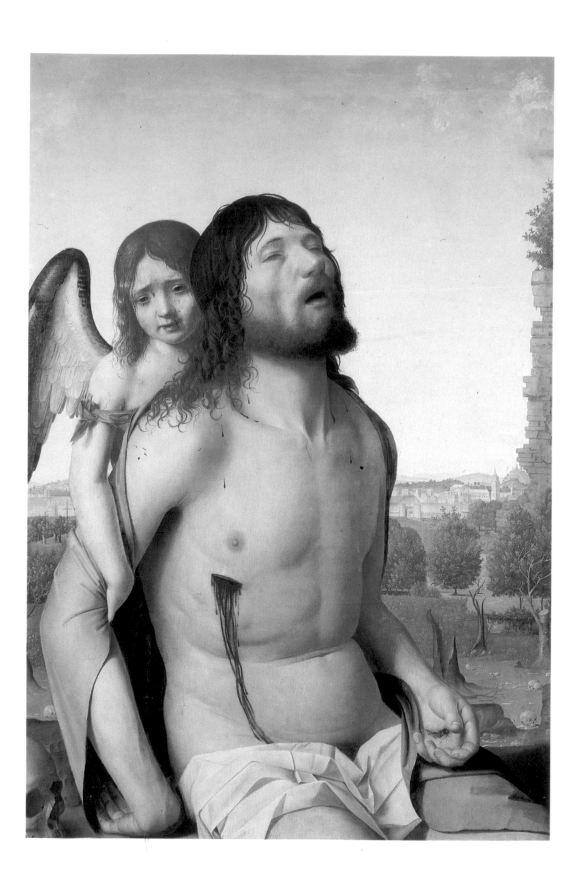

Andrea Mantegna
Isola di Caturo, *c*.1430 – Mantua, 1506
*The Death of the Virgin, c.*1461
Panel, 54 × 42 cm
From a chapel in the Ducal Palace,
Mantua (?); purchased for Charles I of
England and from his collection in 1649
for Philip IV of Spain; Cat No. 248

In a room framed by sombre pilasters, but
looking out on to a view of the lake of
Mantua, the Apostles gather round the
dying Virgin. The skilfully constructed
perspective is perfectly co-ordinated with
the precisely drawn and coloured figures.
The overall effect is severe, but its dignity
is also vivid and moving. This is justly

regarded as a masterpiece of the early
Renaissance, with its detailed naturalism,
radiant clarity and unshaken conviction.

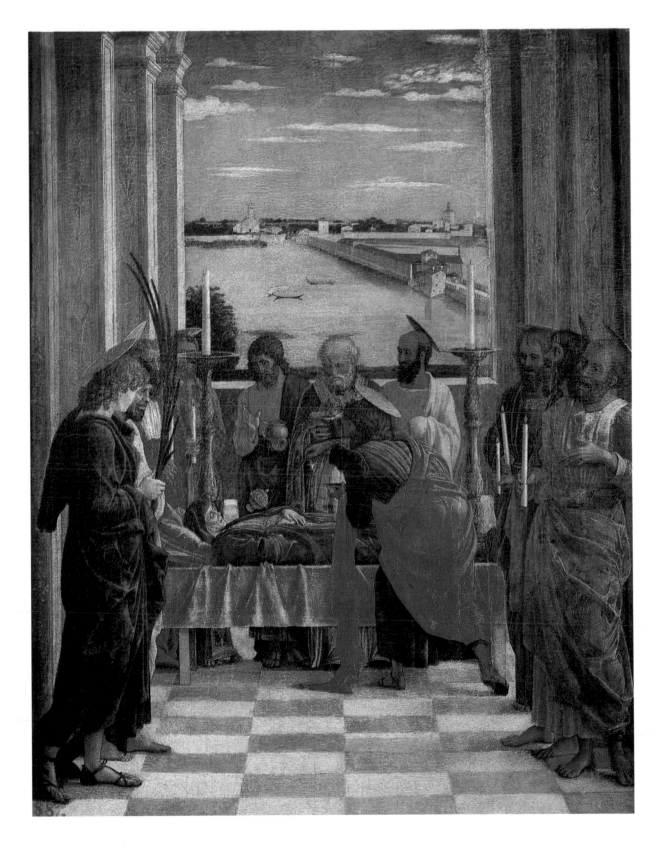

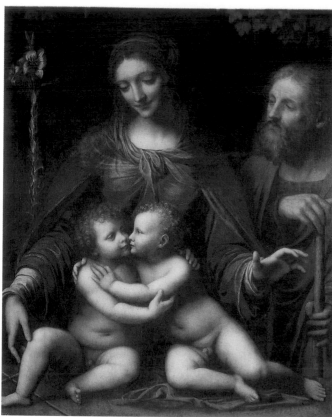

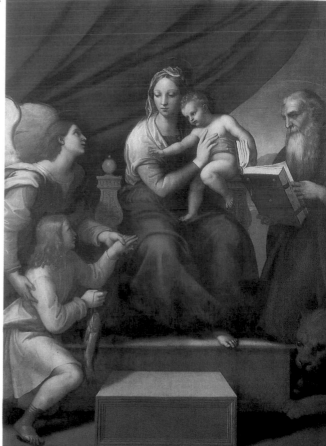

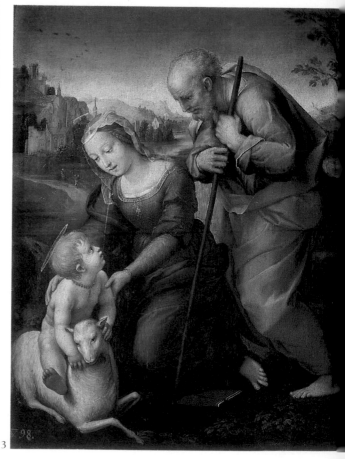

1

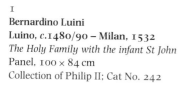

1
Bernardino Luini
Luino, *c*.1480/90 – Milan, 1532
The Holy Family with the infant St John
Panel, 100 × 84 cm
Collection of Philip II; Cat No. 242

3

Raphael (Raffaello Sanzio)
Urbino, 1483 – Rome, 1520
The Madonna of the Fish (The Madonna with
the Archangel Raphael and St Jerome),
1514
Panel transferred to canvas,
215 × 158 cm
Presented by the Duke of Medina de Las
Torres to Philip IV in 1645; Cat No. 297

Raphael (Raffaello Sanzio)
Urbino, 1483 – Rome, 1520
The Holy Family with a Lamb, 1507
Panel, 29 × 21 cm
In the Royal Collection by the eighteenth
century; Cat No. 296

This small picture for private devotion
belongs to Raphael's years in Florence,
after he had moved from Umbria but
before he went to Rome. There he was
seen to absorb the style particularly of
Leonardo, and of other artists such as the
young Michelangelo. But the miniaturist
delicacy and serenity of this work recall
his early formation under the influence of
the Umbrian master Perugino, and there
is definitely also a knowledge of Nether-
landish painting, particularly clear in the
landscape.

Raphael (Raffaello Sanzio)
Urbino, 1483 – Rome, 1520
Lo Spasimo di Sicilia (Christ falls on the
Way to Calvary), 1517
Panel transferred to canvas,
318 × 229 cm
From the Church of Santa Maria dello
Spasimo near Palermo; collection of Philip
IV; Cat No. 298

The picture takes its name from the
church for which it was commissioned
and to which it was sent by Raphael from
Rome, Santa Maria dello Spasimo near
Palermo in Sicily. The church was ded-
icated to the grief and agony ('spasimo')
of the Virgin when she witnessed the
sufferings of Christ, and the true subject of
Raphael's altarpiece is indeed the mutual
gaze of Christ, stumbling beneath the
weight of the Cross, and his distraught
mother, who reaches out her arms in
vain.

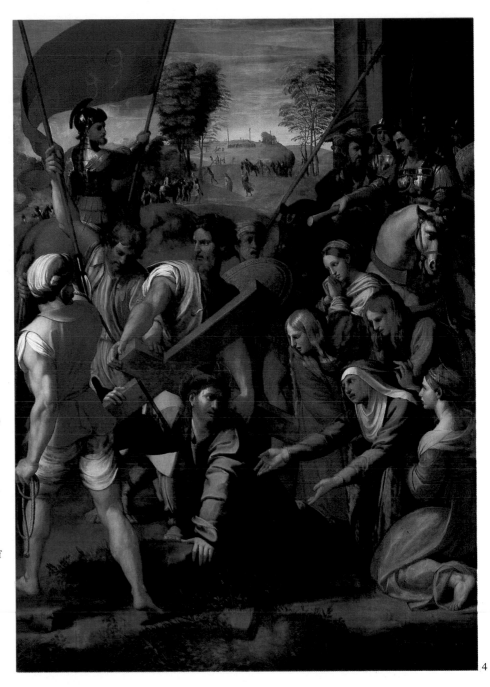

4

Raphael (Raffaello Sanzio)
Urbino, 1483 – Rome, 1520
Portrait of a Cardinal, c.1510/12
Panel, 79 × 61 cm
Collection of Charles IV; Cat No. 299

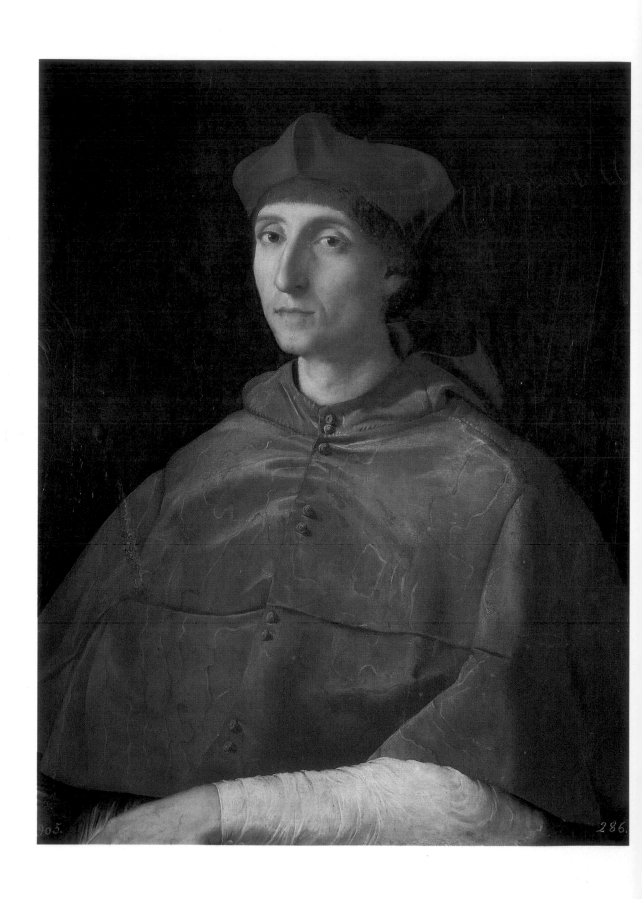

Andrea del Sarto
Florence, 1486 – Florence, 1530
Lucrezia di Baccio del Fede, the Artist's Wife,
c.1513/14
Panel, 73 × 56 cm
In the Royal Collection by the eighteenth
century; Cat No. 332

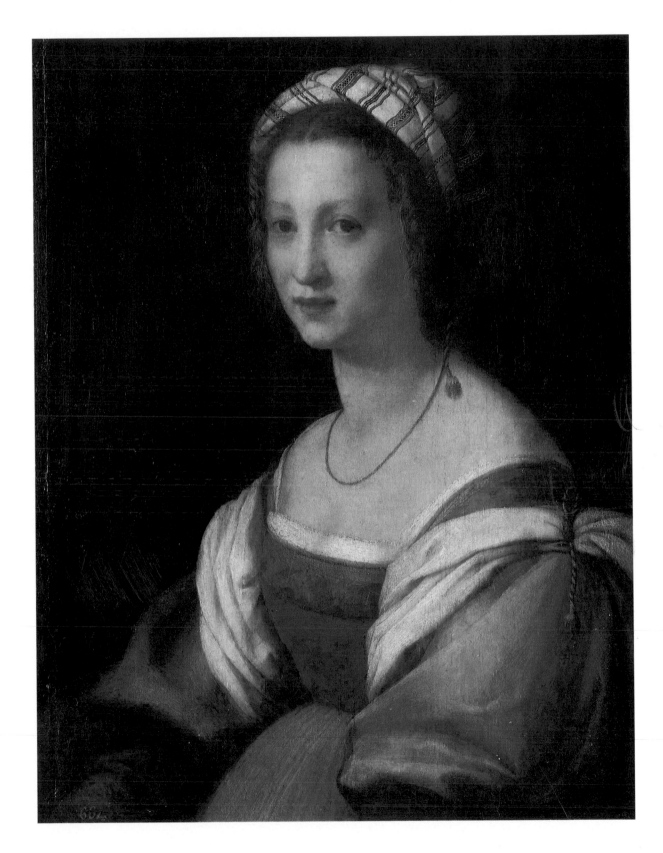

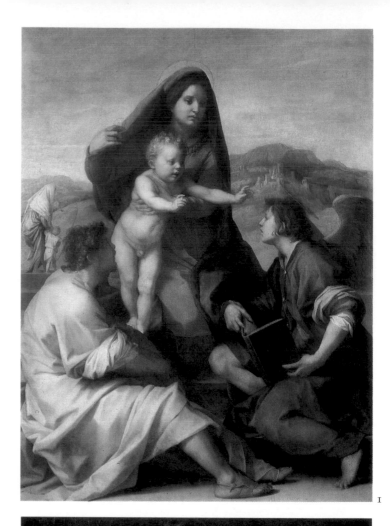

1

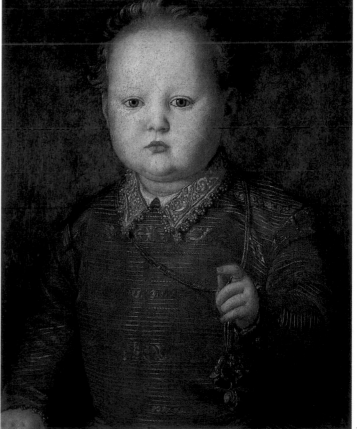

2

1
Andrea del Sarto
Florence, 1486 – Florence, 1530
The Virgin with a Saint and an Angel,
c.1522/23
Purchased for Philip IV from the sale of
the collection of Charles I of England in
1649; Cat No. 334

2
Agnolo di Cosimo Mariano, called
Bronzino
Florence, 1503 – Florence, 1572
Don Garcia de Medici (?), c.1550
Panel, 42 × 38 cm
Royal Collection; Cat No. 5

3
Antonio Allegri, called Correggio
Correggio, 1489 – Correggio, 1534
Noli Me Tangere, c.1534
Panel transferred to canvas,
130 × 103 cm
Presented by the Duke of Medina de las
Torres to Philip IV, who sent it to the
Escorial. Entered the Prado in 1839;
Cat No. 111

Untempted by Rome, Florence or Venice,
Correggio, working in the North Italian
city of Parma, maintained his originality
throughout the High Renaissance and
became one of the most important in-
fluences on seventeenth-century baroque
painting. However, he was receptive to
the art particularly of Raphael and
Leonardo: his sense of ideal beauty and
the structure of his compositions owe
much to Raphael, while his handling of
textures and light presupposes Leonardo.
In this work he uses a pyramidal com-
position of classic High Renaissance kind
and a diagonal movement anticipating
the baroque. The beautiful landscape
evokes the light of dawn, the time when
Mary Magdalene met Christ by the tomb.

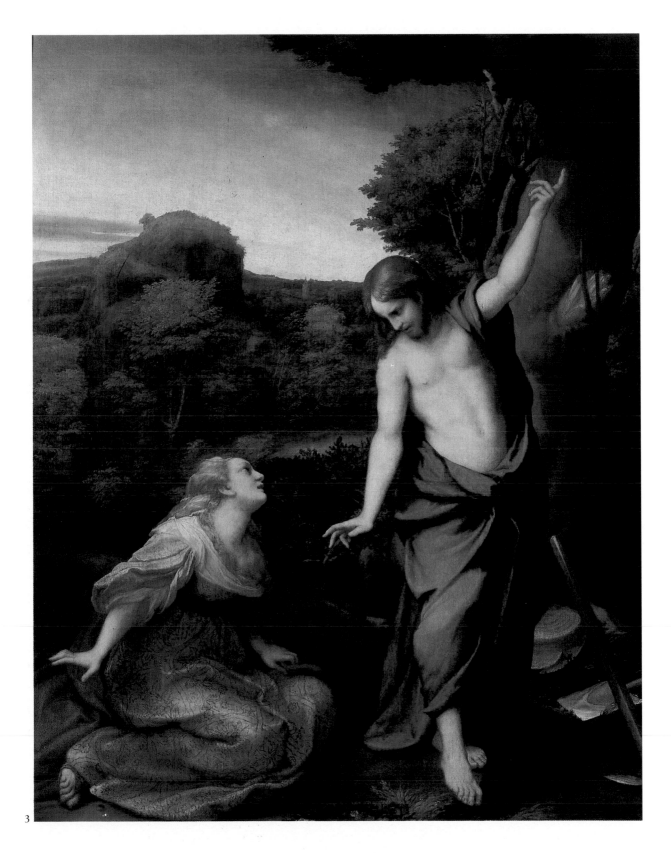

3

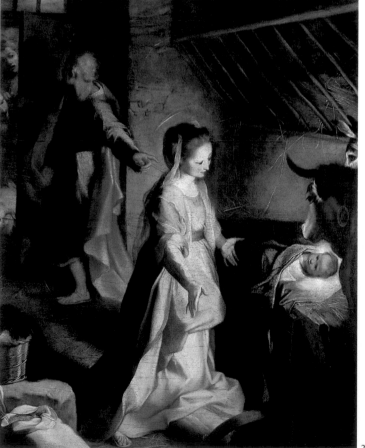

1

Francesco Mazzola, called Parmigianino
Parma, 1503 – Casalmaggiore, 1540
*The Holy family (Rest on the Flight to
Egypt)*, 1524
Panel, 110 × 89 cm
Royal Collection; Cat No. 283

2

Federico Fiori, called Barocci
Urbino, 1535 – Urbino, 1612
The Adoration of the Child, 1597
Canvas, 134 × 105 cm
Presented by the Duke of Urbino to Queen
Margarita of Austria, wife of Philip III; Cat
No. 18

3

Giovanni Bellini
Venice, c.1430 – Venice, 1516
The Virgin and Child with two female saints,
c.1490
Panel, 77 × 104 cm
Collection of Philip IV; Cat No. 50

4

Attributed to Giorgione da Castelfranco
Born in Castelfranco Veneto (?); died in
Venice in 1510
*The Virgin and Child and Sts Anthony of
Padua and Roch*
Canvas, 92 × 133 cm
Presented by the Duke of Medina de Las
Torres to Philip IV; Cat No. 288

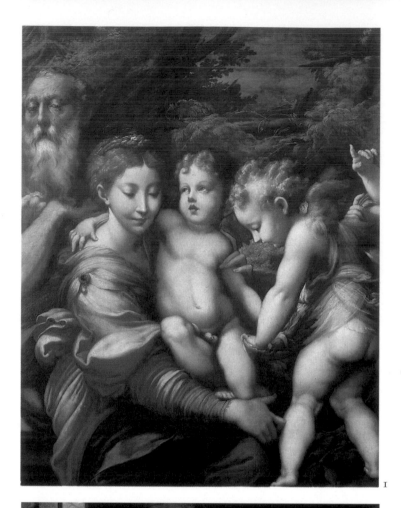

2

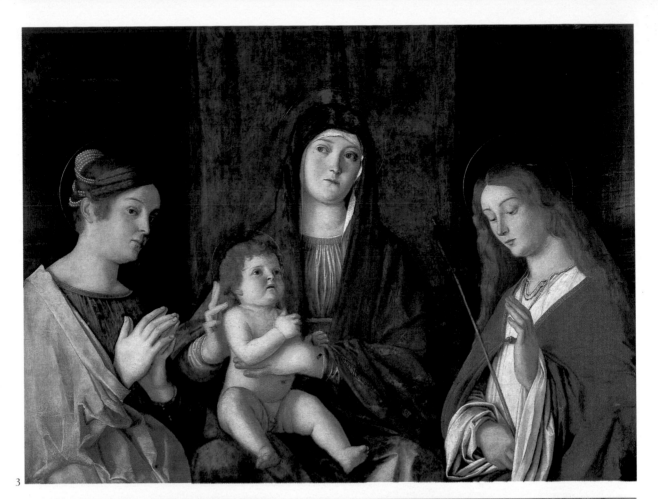

3

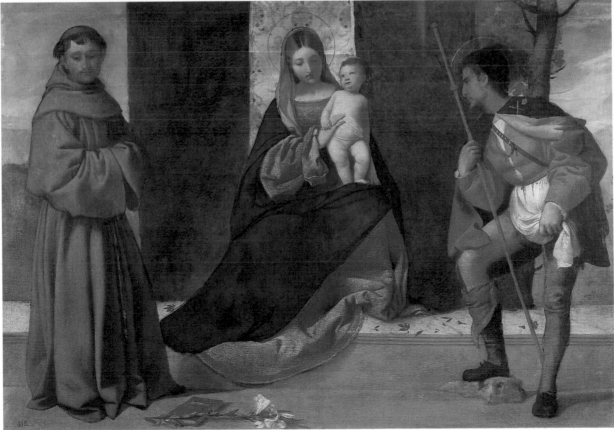

4

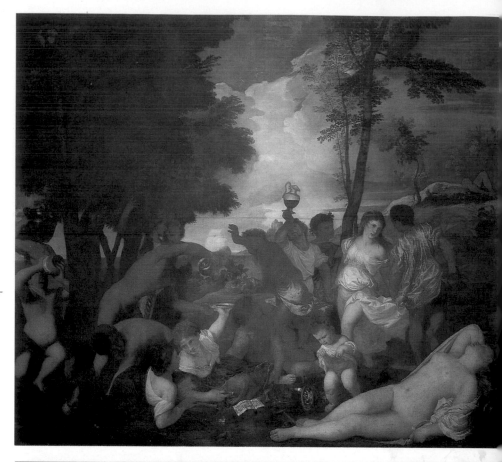

1

Titian (Tiziano Vecellio)
**Pieve di Cadore, *c*.1488/90 – Venice,
1576**
*The Andrians, c.*1525
Canvas, 175 × 193 cm
From the Castle of Ferrara; presented
to Philip IV by Nicolás Ludovisi;
Cat No. 418

This was the last in a series of magnifi-
cent paintings painted by Titian for
Alfonso d'Este, Duke of Ferrara; ano-
ther, also in the Prado, was *The Wor-
ship of Venus*; a third, *Bacchus and
Ariadne*, is in the National Gallery,
London. The subjects are taken from
classical descriptions of works of art:
here Titian reproduces a picture the
writer Philostratus saw in Naples in
the second century AD, representing
the people of the Greek Island of
Andros making merry on the river of
wine that Dionysus had created. This
splendid opportunity to emulate the
past was not lost on Titian, whose
brilliant naturalism and marvellous
colour declare him the equal of
Apelles.

2

Titian (Tiziano Vecellio)
**Pieve di Cadore, *c*.1488/90 – Venice,
1576**
The Worship of Venus, 1519
Canvas, 172 × 175 cm
From the Castle of Ferrara; presented
to Philip IV by Nicolás Ludovisi; Cat
No. 419

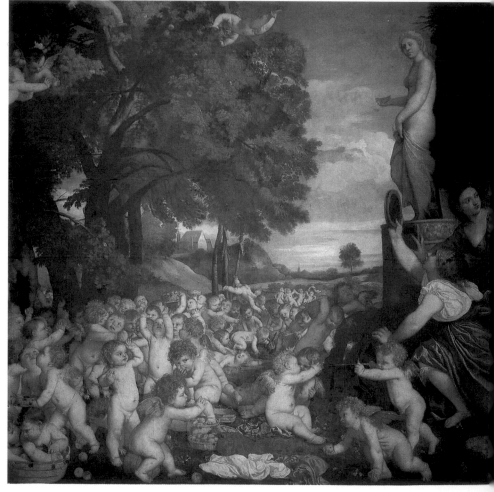

Titian (Tiziano Vecellio)
Pieve di Cadore, *c*.1488/90 – Venice,
1576
The Emperor Charles V at Mühlberg, 1548
Canvas, 332 × 279 cm
Collection of Charles V; Cat No. 410

This is one of Titian's most dramatic and monumental portraits, conveying not so much the personality of the sitter as the high ideals of his imperial office. At the Battle of Mühlberg the Emperor had defeated the Schmalkadic League of Protestant princes, and in Titian's picture he is portrayed as the archetypal Chris-tian knight victorious against heresy – a kind of modern St George. Apart from the brilliant creation of a memorable image, Titian shows his skill in the consummate handling of textures, such as the diffusion of the evening sunlight through the landscape and the captivating sheen of the armour.

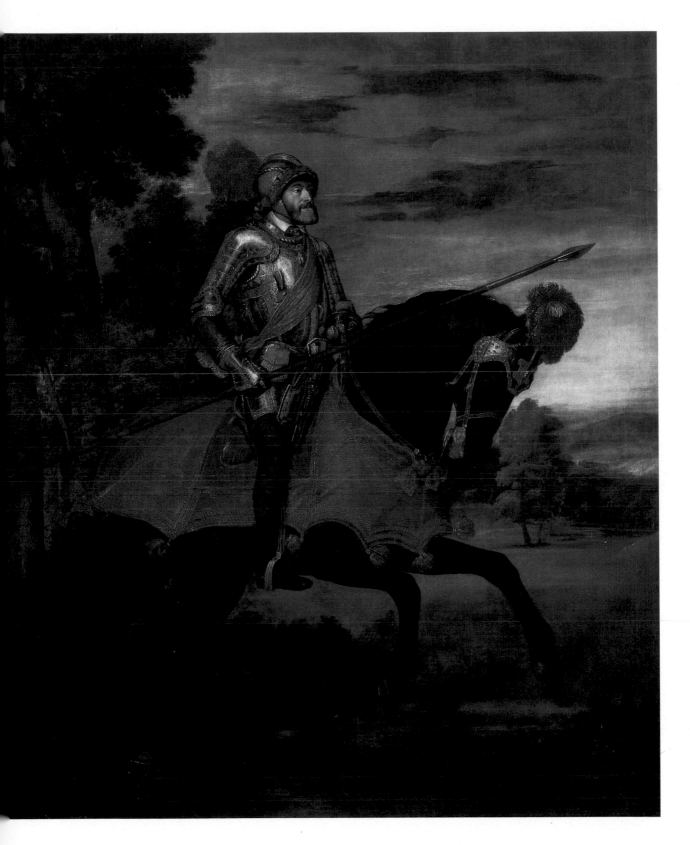

1

3

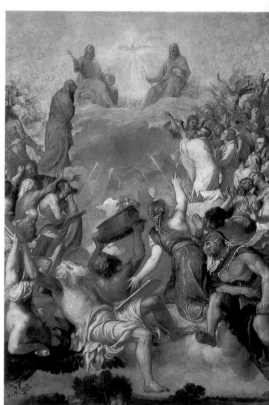

1
Titian (Tiziano Vecellio)
Pieve di Cadore, *c.*1488/90 **– Venice,**
1576
Federigo Gonzaga, Duke of Mantua,
*c.*1525/30
Panel, 125 × 99 cm
Collection of Philip IV; Cat No. 408

2
Titian (Tiziano Vecellio)
Pieve di Cadore, *c.*1488/90 **– Venice,**
1576
King Philip II, 1551
Canvas, 193 × 111 cm
Collection of Philip II; Cat No. 411

3
Titian (Tiziano Vecellio)
Pieve di Cadore, *c.*1488/90 **– Venice,**
1576
Venus and Adonis, 1554
Canvas, 186 × 207 cm
Collection of Philip II; Cat No. 422

4
Titian (Tiziano Vecellio)
Pieve di Cadore, *c.*1488/90 **– Venice,**
1576
*La Gloria (The Trinity), c.*1553/54
Canvas, 346 × 240 cm
Collection of Charles V; Cat No. 432

5
Titian (Tiziano Vecellio)
Pieve di Cadore, *c.*1488/90 **– Venice,**
1576
Venus and an organ-player, 1545
Canvas, 148 × 217 cm
Presented to Philip III by the Emperor
Rudolf II(?); Cat No. 421

6
Titian (Tiziano Vecellio)
Pieve di Cadore, *c.*1488/90 **– Venice,**
1576
Danae, 1553
Canvas, 129 × 180 cm
Collection of Philip II; Cat No. 425

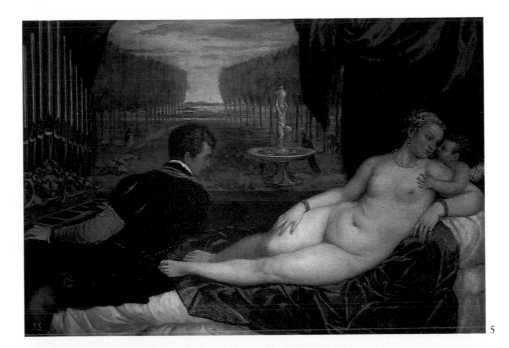

5

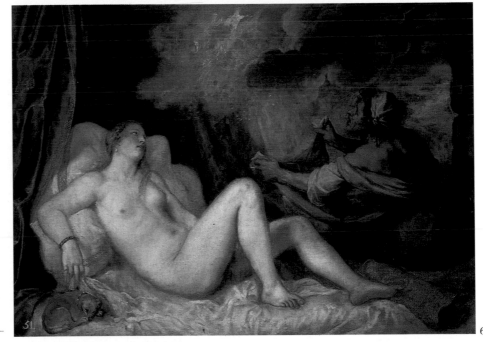

6

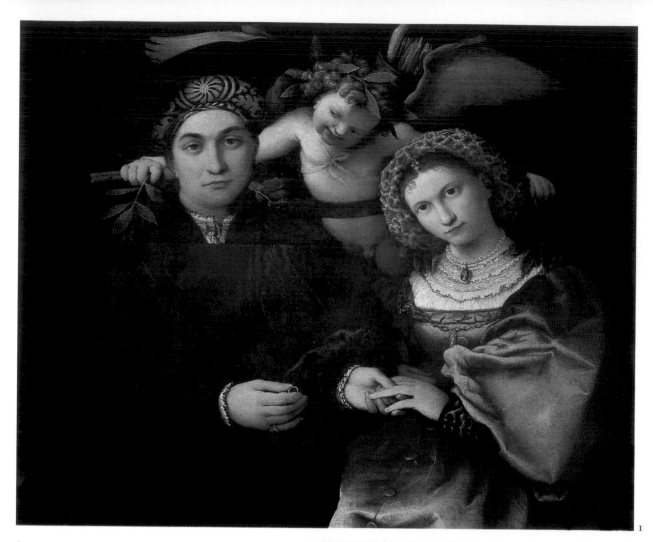

1

Lorenzo Lotto
Venice, c.1480 – Loreto, 1556
Signor Marsilio and his wife, 1523
Canvas, 71 × 84 cm
Collection of Philip IV; Cat No. 240

2

Sebastiano Luciani, called Sebastiano del Piombo
Venice, c.1485 – Rome, 1547
Christ on the road to Calvary, c.1528/30
Canvas, 121 × 100 cm
In the Royal Collection by the sixteenth
century; Cat No. 345

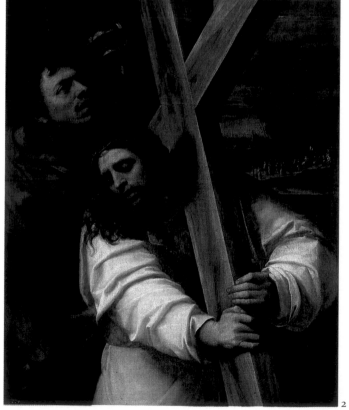

3
Paolo Caliari, called Veronese
Verona, 1528 – Venice, 1588
Jesus among the Doctors in the Temple,
1558(?)
Canvas, 236 × 430 cm
Collection of Philip IV; Cat No. 491

4
Paolo Caliari, called Veronese
Verona, 1528 – Venice, 1588
*Venus and Adonis, c.*1580
Canvas, 212 × 191 cm
Collection of Philip IV; Cat No. 482

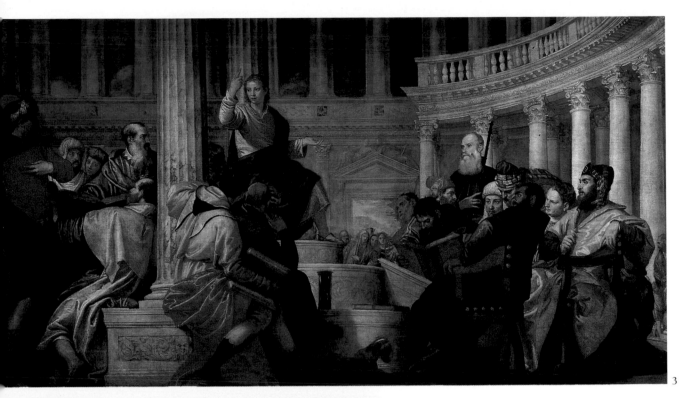

3

4

691.

Paolo Caliari, called Veronese
Verona, 1528 – Venice, 1588
The Finding of Moses, c.1580
Canvas, 50 × 43 cm
Collection of Philip IV; Cat No. 502,

This exquisite work of Veronese's mature
style shows all the elegance and refine-
ment for which the painter was famous,
and above all his superb colour – in the
rich dresses of the women and the silvery
background. The wonderful effects of
luminosity are achieved by a delicate and
subtle juxtaposition of cold and warm,
bright and dark.

Jacopo Robusti, called Tintoretto
Venice, 1519 – Venice, 1594
Christ washing the feet of His disciples,
1547
Canvas, 210 × 533 cm
Collection of Philip IV. Purchased in
London in 1649 from the collection of
Charles I of England; Cat No. 2824

It was long supposed that this work was
executed for the church of San Marcuola
in Venice, but the copy still in the church
better accords with another version of the
subject now in Newcastle. However, there
is no doubt about Tintoretto's autograph
authorship of the Prado painting, which
was almost certainly painted at about the
same time.

Typical of Tintoretto throughout his
career is the dramatic setting for the
scene, the long diagonal vistas serving to
transform the humble event into an
apocalyptic vision. The colouring, how-
ever, is bright and sumptuous, the model-
ling firm, and the space and light clear
and still – a sign of the fairly early date
of the work in the artist's career.

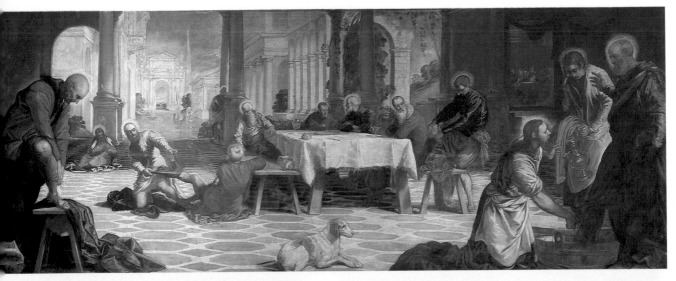

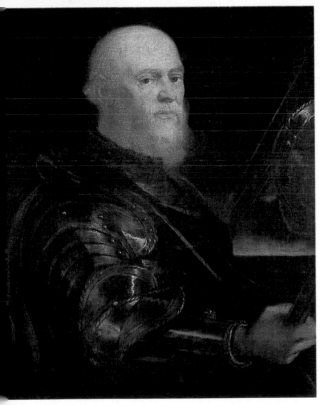

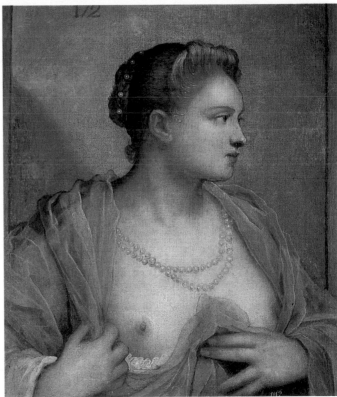

3

Jacopo Robusti, called Tintoretto
Venice, 1519 – Venice, 1594
*Portrait of a Venetian general, c.*1570/75
Canvas, 82 × 67 cm
Presented to Philip IV by the Marquis of
Leganés; Cat No. 366

3
Jacopo Robusti, called Tintoretto
Venice, 1519 – Venice, 1594
*Portrait (?) of a woman revealing her
breasts, c.*1570
Canvas, 61 × 55 cm
Royal Collection; Cat No. 382

1
Jacopo Robusti, called Tintoretto
Venice, 1519 – Venice, 1594
Battle between Turks and Christians (?),
*c.*1588/89
Canvas, 189 × 307 cm
Collection of Philip IV; Cat No. 399

2
Jacopo Robusti, called Tintoretto
Venice, 1519 – Venice, 1594
*Joseph and Potiphar's Wife, c.*1555
Canvas, 189 × 307 cm
Collection of Philip IV; Cat No. 395

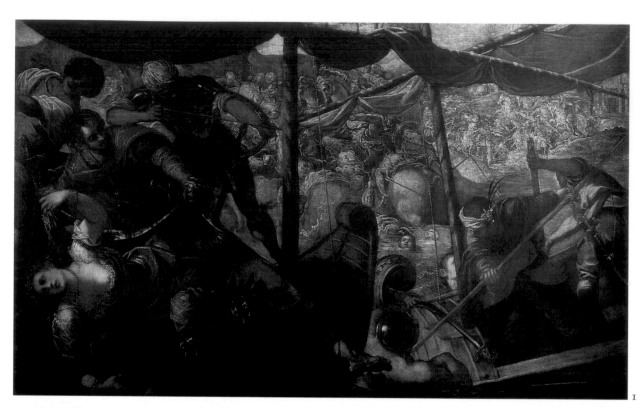

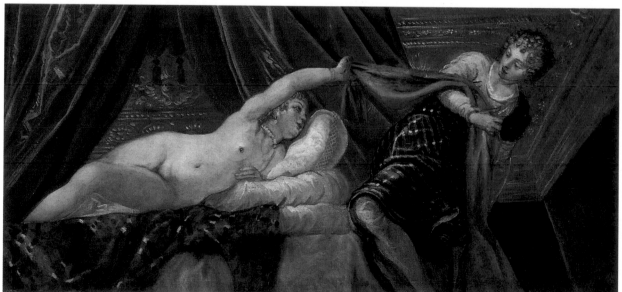

3

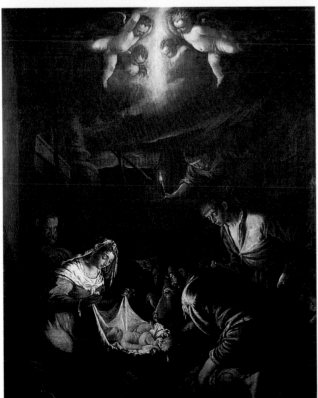

3
Jacopo da Ponte, called Jacopo Bassano
Dal Ponte, *c*.1510 – Bassano, 1592
The Animals entering the Ark
Canvas, 207 × 265 cm
Royal Collection; Cat No. 22

4
Jacopo da Ponte, called Jacopo Bassano,
or Francesco da Ponte, called Francesco
Bassano
Dal Ponte, *c*.1510 – Bassano, 1592
Bassano, *c*.1549 – Venice, 1592
The Adoration of the Shepherds
Canvas, 128 × 104 cm
In the collection of Queen Isabel de
Farnesio by 1746; Cat No. 26

4

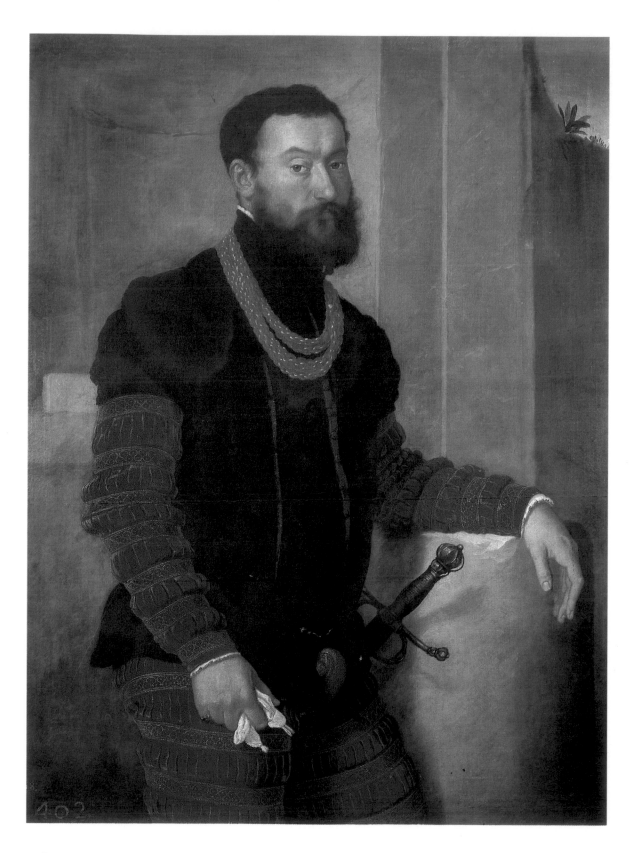

Michelangelo Merisi, called Caravaggio
Caravaggio, c.1570/71 – Porto Ercole,
1610
David and Goliath, c.1599/1600
Canvas, 110 × 91 cm
In the Royal Collection by the eighteenth
century; Cat No. 65

Caravaggio has a particular importance
for Spain, for he originated the realist and
'tenebrist' style of painting that enjoyed
such development and popularity there in
the work of such artists as Ribera and
Zurbarán. This mature work demon-
strates the fundamentals of his art: an
emphatic solidity created by a harsh
contrast of light and shade; the im-
mediacy created by staging the action
right in the foreground, and eliminating
all superfluous space around it (conven-
tionally, David would have been given
room to stand up, so to speak); the elimin-
ation of decoration, such as colour or
elegant posture, in order to concentrate
on the drama alone.

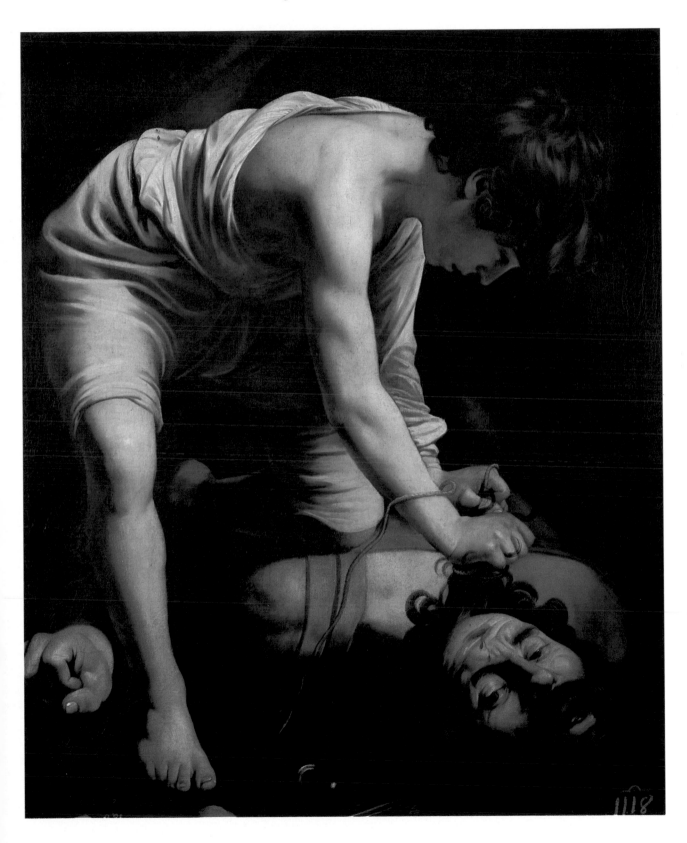

1
Massimo Stanzione
Orta di Antilla, 1585 – Naples, 1656
The Beheading of St John the Baptist, c.1634
Canvas, 184 × 258 cm
Collection of Philip IV (?); Cat No. 258

2
Aniello Falcone
Naples, 1607 – Naples, 1656
The Concert
Canvas, 109 × 127 cm
In the Royal Collection by the eighteenth
century; Cat No. 87

3
Guido Reni
Bologna, 1575 – Bologna, 1642
Atalanta and Hippomenes, c.1612
Canvas, 206 × 297 cm
Collection of Philip IV; Cat No. 3090

4
Simone Cantarini
Pesaro, 1612 – Pesaro, 1648
The Holy Family
Canvas, 72 × 55 cm
Collection of Charles IV; Cat No. 63

1

2

160

3

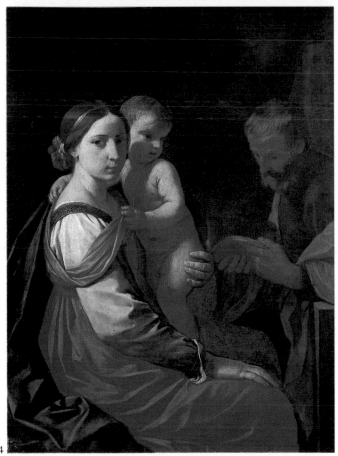

4

1
Mattia Preti
Taverna Calabria, 1613 – La Valleta,
1699
*Christ in Glory, c.*1660
Canvas, 220 × 253 cm
Purchased in 1969; Cat No. 3146

2
Paolo Porpora
Naples, 1617 – Naples, 1673
Vase of Flowers
Canvas, 77 × 65 cm
Collection of Philip IV (?); Cat No. 569

3
Orazio Gentileschi
Pisa, 1563 – London, 1639
*The Finding of Moses, c.*1630/33
Canvas, 242 × 281 cm
Collection of Philip IV; Cat No. 147

4
Francesco Albani
Bologna, 1578 – Bologna, 1660
Venus attended by nymphs and cupids, 1633
Canvas, 114 × 171 cm
Collection of Philip IV; Cat No. 1

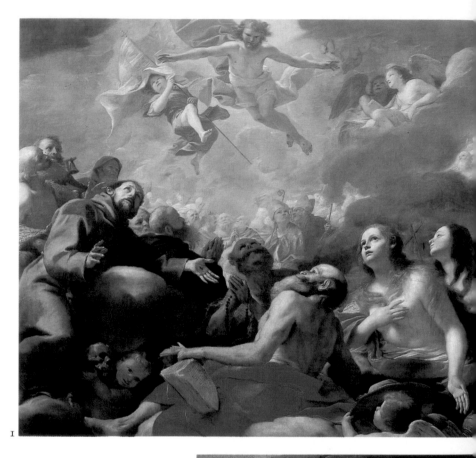

1

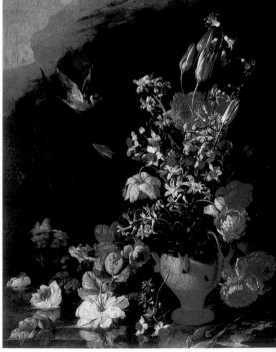

2

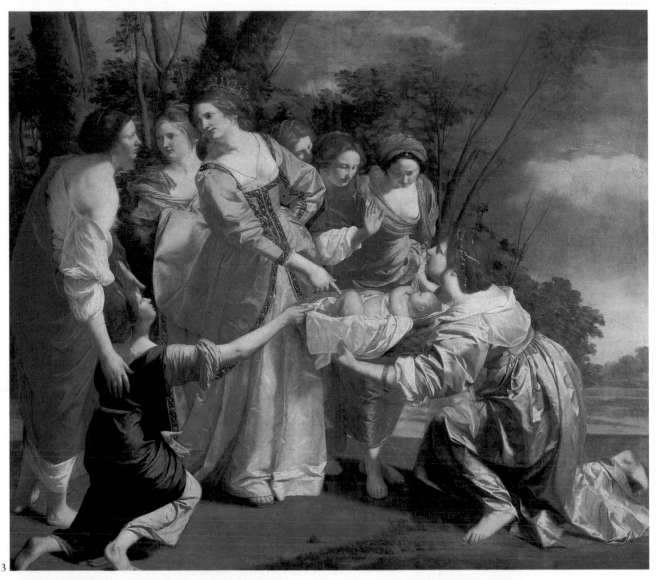

3

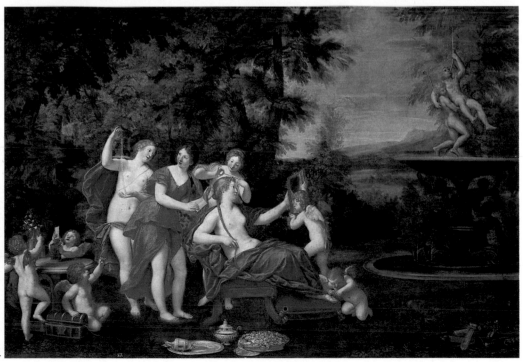

4

1
Annibale Carracci
Bologna, 1560 – Rome, 1609
*The Assumption of the Virgin, c.*1590
Canvas, 130 × 97 cm
Presented to Philip IV by the Count of
Monterrey. Entered the Prado in 1839;
Cat No. 75

2
Annibale Carracci
Bologna, 1560 – Rome, 1609
*Landscape, c.*1602
Canvas, 47 × 59 cm
In the collection of Philip V by 1746; Cat
No. 132

3
Guido Reni
Bologna, 1575 – Bologna, 1642
A girl with a rose
Canvas, 81 × 62 cm
Collection of Philip IV; Cat No. 218

4
**Giovanni Francesco Barbieri, called
Guercino**
Canto, 1591 – Bologna, 1666
Mary Magdalene in Penitence
Canvas, 121 × 102 cm
In the collection of Queen Isabel de
Farnesio by 1746; Cat No. 203

5
Domenico Zampieri, called Domenichino
Bologna, 1581 – Naples, 1641
The Sacrifice of Isaac
Canvas, 147 × 140 cm
Collection of Philip IV; Cat No. 131

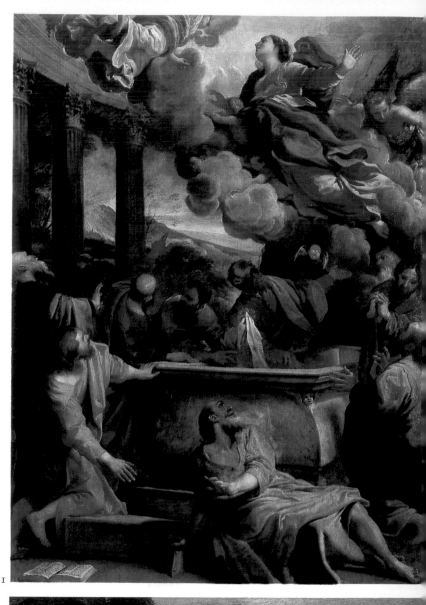
1

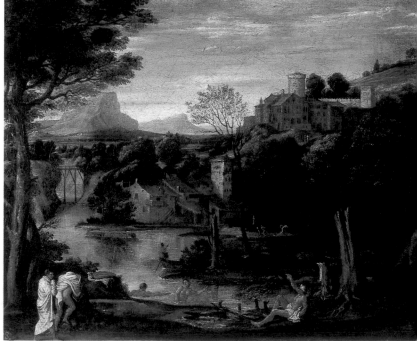
2

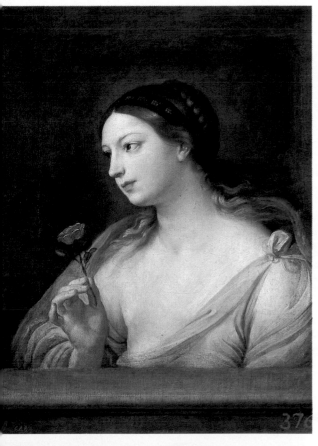

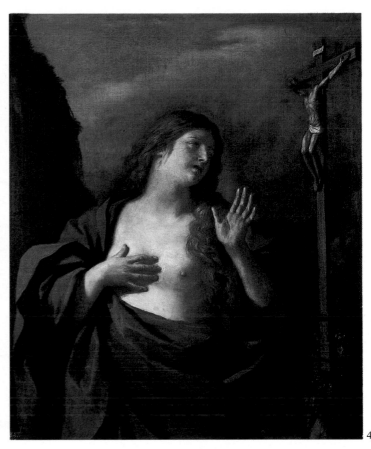

4

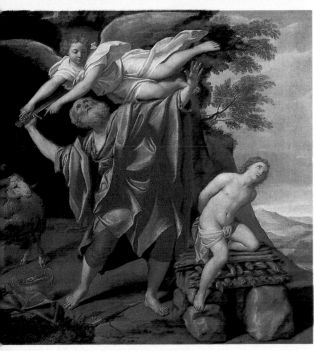

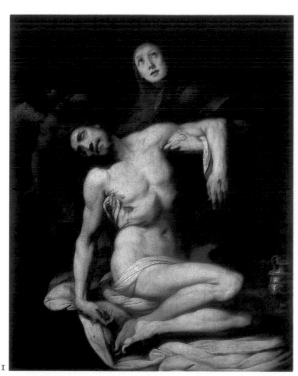

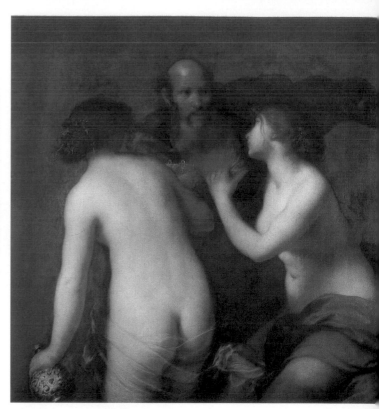

1

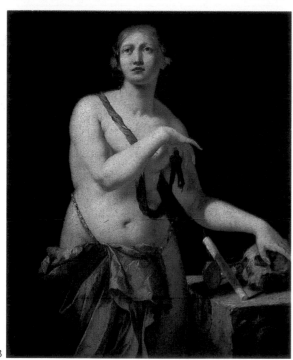

3

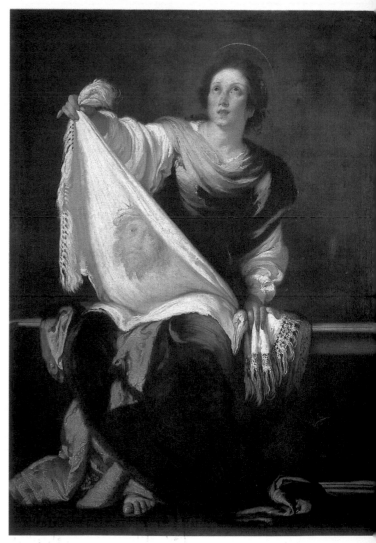

1
Daniele Crespi
Busto Arsizio, 1597 – Milan, 1630
Pietà, c.1626
Canvas, 175 × 114 cm
Collection of Charles II. Purchased in
1689 from the collection of the Marquis of
El Carpio; Cat No. 128

2
Francesco Furini
Florence, 1600 – Florence, 1646
Lot and his Daughters
Canvas, 123 × 120 cm
Presented to Philip IV by the Duke of
Tuscany; Cat No. 144

3
Antonio Zanchi
Este, 1631 – Venice, 1722
Mary Magdalene in Penitence
Canvas, 112 × 95 cm
Presented in 1915 by Don Pablo Bosch;
Cat No. 2711

4
Bernardo Strozzi
Genoa, 1581 – Venice, 1644
St Veronica, c.1625/30
Canvas, 168 × 118 cm
In the collection of Queen Isabel de
Farnesio by 1746; Cat No. 354

5
Gioachino Assereto
Genoa, 1600 – Genoa, 1649
Moses drawing Water from the Rock
Canvas, 245 × 300 cm
In the collection of Queen Isabel de
Farnesio by 1746; Cat No. 1134

6
Giovanni Benedetto Castiglione
Genoa, 1610 – Mantua, 1670
*The Fable of Diogenes, looking with a lantern
for a good man*
Canvas, 97 × 145 cm
Purchased from the collection of Carlo
Maratta. In the collection of Philip V by
1746; Cat No. 88

5

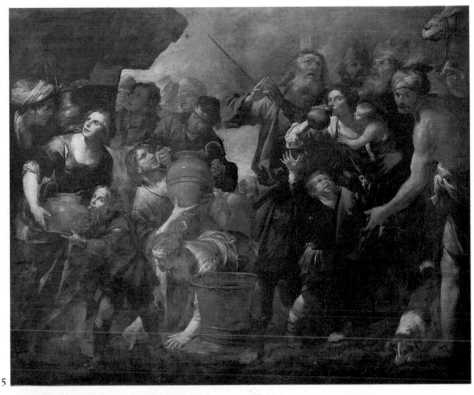

6

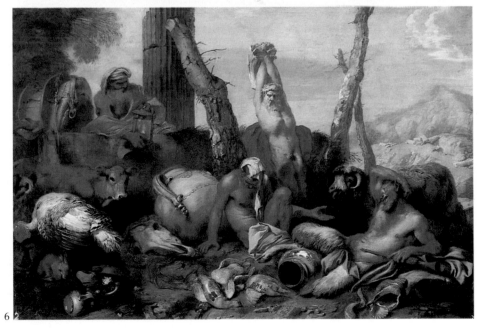

1
Domenico Zampieri, called Domenichino
Bologna, 1581 – Naples, 1641
A Triumphal Arch of Allegories, c.1607/10
Canvas, 70 × 60 cm
Purchased from the collection of Carlo
Maratta. In the collection of Philip V by
1746; Cat No. 540

2
Salvatore Rosa
Naples, 1615 – Naples, 1673
View of the Gulf of Salerno, c.1640/45
Canvas, 170 × 260 cm
In the Royal Collection by the eighteenth
century; Cat No. 324

3
Viviano Codazzi
Bergamo, 1604 – Rome, 1670
*St Peter's, Rome, with the obelisk and part of
the Vatican Palace, c.1630*
Canvas, 168 × 220 cm
Collection of Philip IV; Cat No. 510

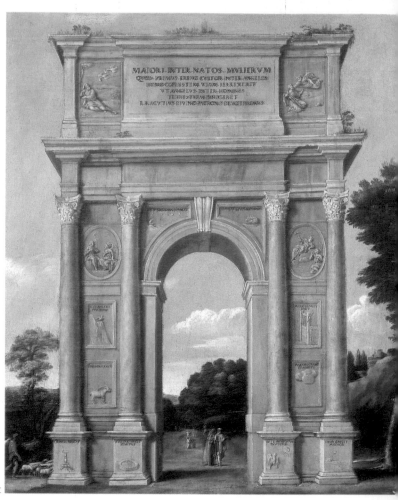

1

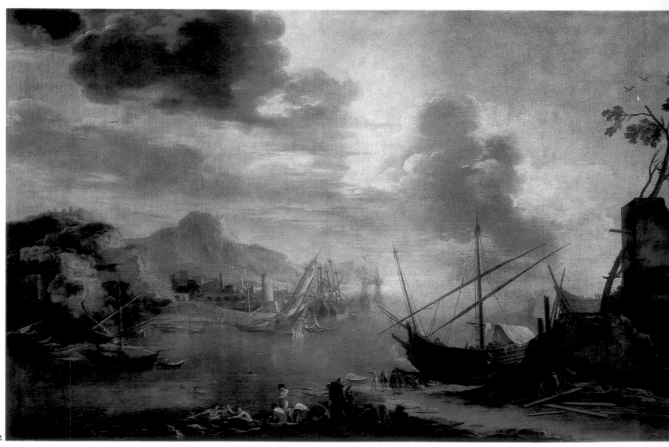

2

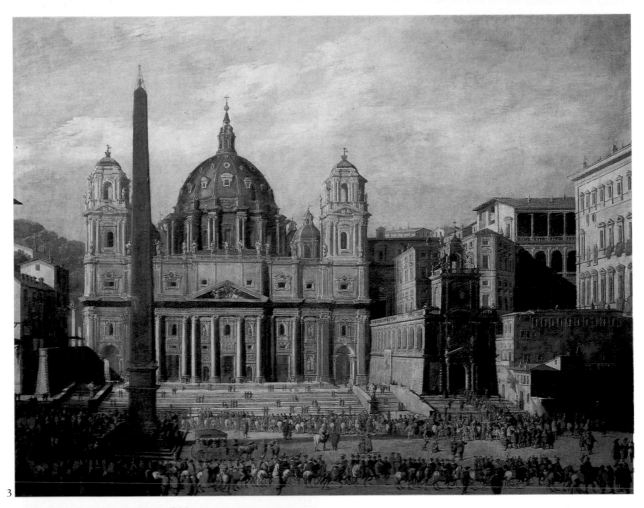

3

4

4
Andrea Procaccini
Rome, 1671 – La Granja, 1734
Cardinal Borja, c.1721
Canvas, 245 × 174 cm
Bequeathed by the Count of La Cimera in
1944; Cat No. 2882

Throughout the eighteenth century
Italian painters were employed by Spanish
patrons, and many spent their working
lives in Spain. There is indeed an
enormous collection of Italian paintings of
that period, including frescos, to be found
in the Royal residences. Andrea Procac-
cini became not only court painter but art
adviser to the first Bourbon king of Spain,
Philip V, and suggested the purchase of
many of the works now in the Prado or
the Royal Palace.

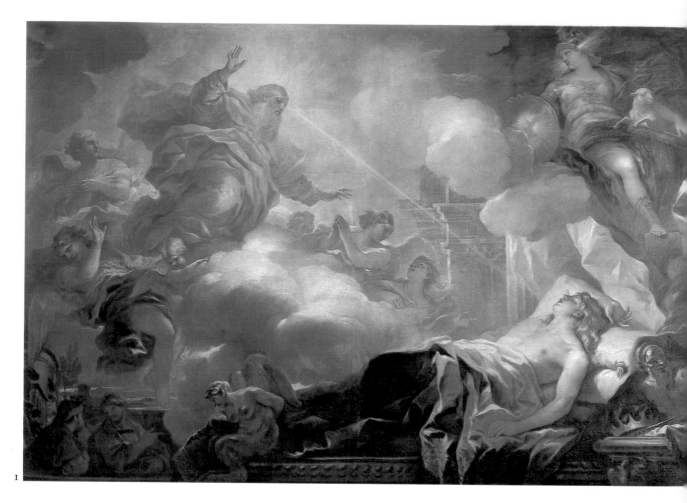

1

1

Luca Giordano

Naples, 1634 – Naples, 1705

*The Dream of Solomon, c.*1693

Canvas, 245 × 361 cm

Collection of Charles II of Spain; Cat No.
3179

Luca Giordano was one of the most important painters of the late baroque period, practising a heroic, monumental style seasoned with decorative colour. Invited to Spain by King Charles II in 1692, he was soon established as the leading painter at the Spanish Court. For the crown, he painted in particular the biblical stories of Solomon and David in a spectacular series now divided between the Prado and the Royal Palace in Madrid.

2

Sebastiano Conca

Gaeta, 1680 – Gaeta, 1764

*King Solomon's Idolatry, c.*1735

Canvas, 54 × 71 cm

Collection of Philip V (?); Cat No. 102

3

Corrado Giaquinto

Molfetta, 1703 – Naples, 1766

*Apollo and Bacchus, c.*1761

Canvas, 168 × 140 cm

Collection of Charles III; Cat No. 103

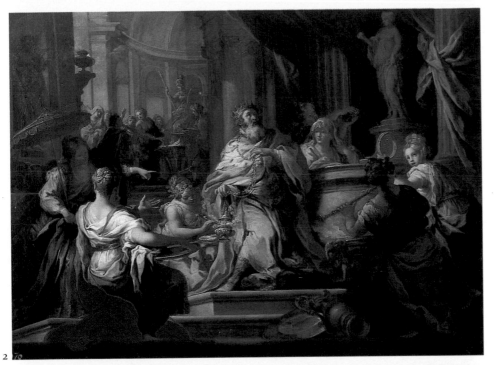

2

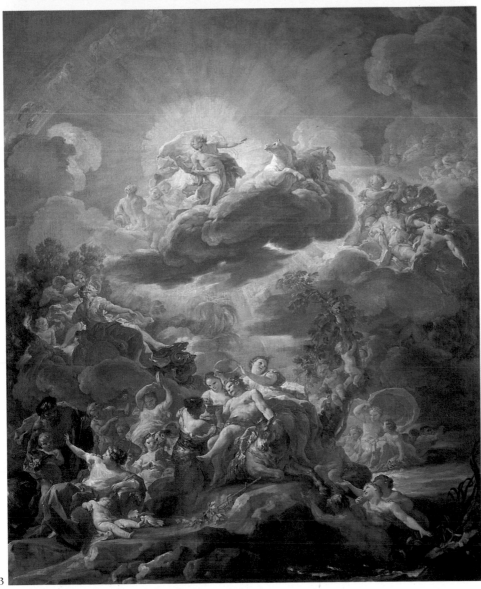

3

Alessandro Magnasco
Genoa, 1677 – Genoa, 1749
Angels minister to Christ, c.1725/30
Canvas, 193 × 142 cm
Purchased in 1967; Cat No. 3124

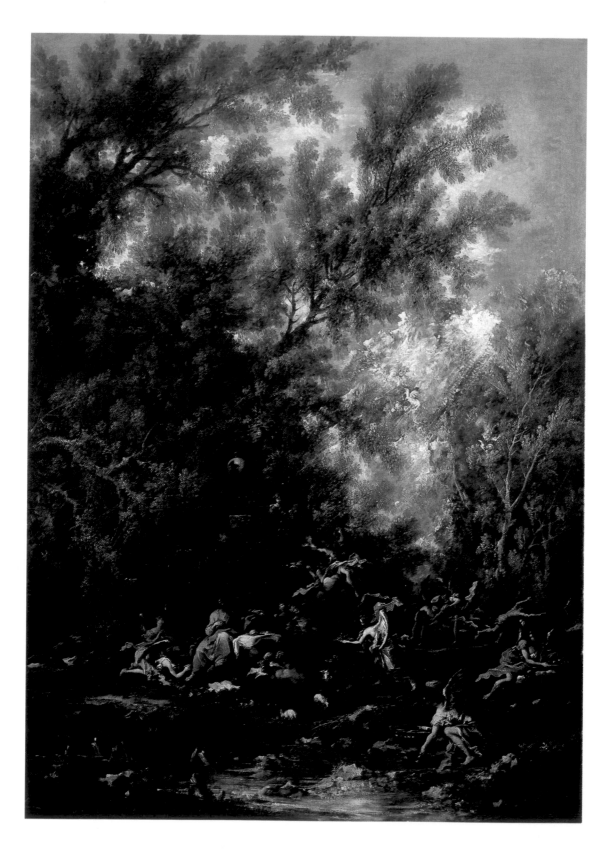

1

Gaspard van Wittel, called Gasparo Vanvitelli
Amersfoort, 1653 – Rome, 1736
View of the Piazzetta, Venice, from San Giorgio, 1697
Canvas, 98 × 174 cm
In the collection of Queen Isabel de Farnesio by 1746; Cat No. 475

2

Francesco Battaglioli
Modena, c.1725 – Venice, c.1790
The Palace of Aranjuez, 1756
Canvas, 86 × 112 cm
Purchased in 1979; Cat No. 4180

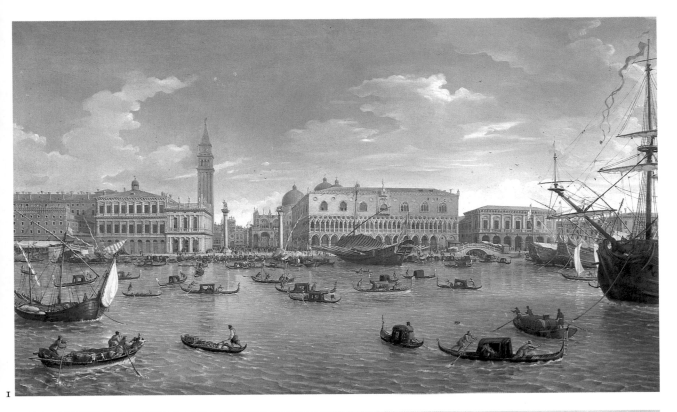

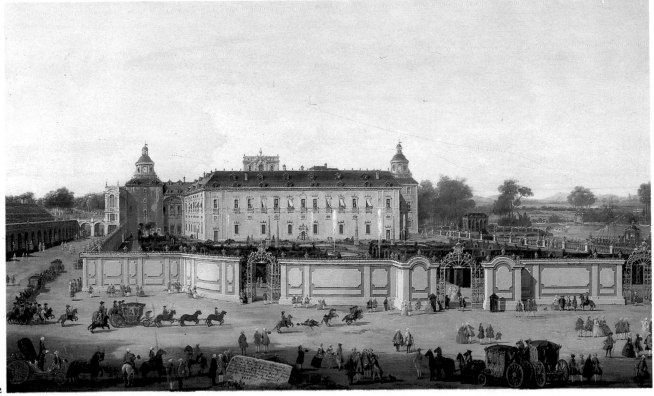

I

Giambattista Tiepolo
Venice, 1696 – Madrid, 1770
Two fragments of an altarpiece, *St Pascual*
Baylón's vision of the Eucharist borne by an
Angel, 1769
Canvas, 185 × 188 cm and 153 × 112 cm
Collection of Charles III; Cat No. 364

According to the inscription on the en-
graving published by his son (displayed
beside the fragments), Tiepolo painted the
altarpiece in 1770, which would make it
his last work. However, in a letter of 1769
Tiepolo himself refers to it as finished. He
had arrived in Spain in 1762, to complete
the decoration of the Royal Palace in
Madrid for King Charles III. In 1767 he
wrote declaring that the decoration was
finished and asking for further employ-
ment. Despite opposition to him at court,
he received the commission for a series of
seven canvases for the new church of San
Pascual Baylón, of which this was one.
But the tide of taste was running against
the old master's late baroque style, and no
sooner had the canvases been completed
than they were ripped out and replaced
with works in the new Neoclassical style
by Mengs and others.

2

Giambattista Tiepolo
Venice, 1696 – Madrid, 1770
The Temperance of Scipio, c.1722/23
Canvas, 250 × 500 cm
Purchased in 1975; Cat No. 3243

3

Giuseppe Bonito
Castellamare di Stabia, 1701 – Naples,
1789
The Turkish Ambassador to the Court of
Naples, and his entourage, 1741
Canvas, 207 × 170 cm
In the collection of Queen Isabel de
Farnesio by 1746; Cat No. 54

I

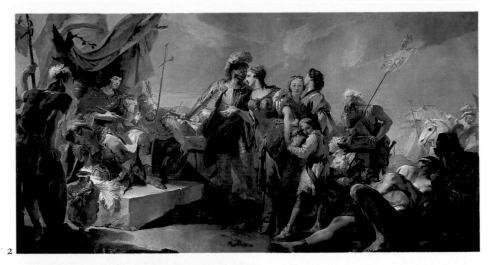

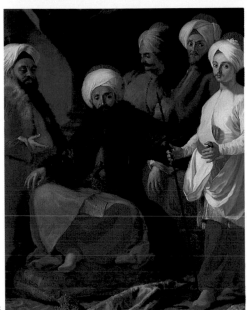

4
Gian Domenico Tiepolo
Venice, 1727 – Venice, 1804
Christ's Fall on the Way to Calvary, 1772
Canvas, 124 × 144 cm
From the Church of St Philip Neri,
Madrid. Entered the Museum of the Trinity in 1836, thence to the Prado; Cat No.
358

5
Pompeo Batoni
Lucca, 1708 – Rome, 1787
Charles Cecil Roberts, 1778
Canvas, 221 × 157 cm
In the Royal Collection by the eighteenth
century; Cat No. 49

Early Netherlandish and Flemish Painting

Along with the collections of Spanish and Italian painting, the Netherlandish and Flemish collections occupy a place of particular distinction in the Prado. The Early Netherlandish collection includes works from both Flanders and Holland, since until the beginning of the seventeenth century there was really no distinction between the Flemish and Dutch schools. After this date, however, as a result of the political and aesthetic autonomy established by those regions which took the name of Holland, Dutch art followed a defiantly separate course.

Owing to its peculiar history, Spain has always been recognized for its fabulous wealth of Flemish art, especially painting and tapestries, with a heritage running from the Primitive School of the fifteenth century to the height of baroque. This heritage can be admired in the royal palaces, the cathedrals and the monasteries, as well as in public and private collections, throughout the Iberian peninsula. The Prado, with its great assembly of Flemish paintings, ranging from masterpieces to minor works, exhibits the splendour of this legacy to the full.

Throughout the early Middle Ages the Iberian peninsula maintained close connections with the countries around the North Sea and with Flanders in particular. Contacts were generated through trade links with Castile, and this resulted in political collaboration which in turn culminated in matrimonial alliances made during the reign of Ferdinand and Isabella. The Duke of Burgundy and ruler of Flanders, Philip 'the Fair', son of the Emperor Maximilian of Austria and Maria Borgia, married the Infanta Dona Joanna 'the Mad', daughter of the Spanish sovereigns and later heir to their estates, while Don Juan, the Prince of Asturias, heir to Castile and Aragon, married Margaret of Burgundy, the sister of Philip. On account of various historical and family coincidences, this vast territorial legacy fell in its entirety to Charles of Ghent, elder son of Philip 'the Fair', who became Charles I of Spain in 1517 and Charles V of the Holy Roman Empire in 1519.

As a result of the numerous contacts between the Spanish and Flemish worlds until 1700, it is not surprising to find a similarly close relationship in the artistic sphere. Flemish artists such as Van Eyck and Rubens visited the Peninsula, while Spanish artists such as Dalmau and Sánchez Coello travelled to the north. The most important factor which helped to strengthen the artistic ties between the two regions and did most to influence Spain's pictorial tradition was the enormous number of paintings which were purchased from the Netherlands by the various social sectors – the Church, the nobility and the mercantile class – many of which were specifically commissioned to decorate palaces, shrines and residences while others were simply purchased on the art market.

The social and religious convulsions which occurred in the Low Countries during the second half of the sixteenth century and the War of Independence in the northern provinces which persisted throughout much of the seventeenth century (with the notable exception of the Twelve Year Truce), culminated in the Thirty Years War, which ended with the Peace of Westphalia in 1648 and in which the total autonomy of Holland was recognized. As a result, from the end of the sixteenth century onwards, it is possible to speak for the first time of two clearly distinct schools, the Flemish and the Dutch.

It was during the reign of Philip II that the great influx of fifteenth and sixteenth century Flemish masterpieces began, with the King ordering the acquisition of numerous works from a variety of schools. Gifts were received as well, including a panel attributed to Gossaert (although some critics detect the hand of Van Orley), entitled *The Virgin of Louvain*, which was given to Philip by the city in 1588 as a token of their gratitude for his aid during the plague ten years earlier.

It is thanks to Philip II that the Prado possesses the most important collection of the works of Bosch in the world. The sovereign achieved this by waiting patiently to purchase the panels of Bosch as they became available one by one. *The Cure of Folly* and *The Seven Deadly Sins* were obtained in 1560 from the heirs of Don Philip of Guevara, and the unparalleled *Garden of Earthly Delights* – the famous and enigmatic triptych which is a *pièce de résistance* of symbolic art – was obtained from the sale of the possessions of a natural son of the Duke of Alba. Two more triptychs, *The Adoration of the Magi* and *The Hay Wain*, were added to this group as was a later work, *The Temptation of St Anthony*.

During the seventeenth century the Spanish monarchy maintained close cultural contacts with the Flemish world. These were intensified by constant political intervention by Spain and the personal interests of Spanish rulers, such as Philip IV and the Archduke Isabella Clara Eugenia and Albert of Austria. Between them these patrons were responsible for commissioning numerous Flemish painters. The most powerful and wealthy sought works by Rubens who had established a large workshop which not only influenced the development of the Flemish School but which also affected the course of European baroque. As a result of this patronage, the collection of his works in the Prado is particularly extensive and of exceptional quality. The same applies to the collection of the work of Rubens'

collaborators, followers, pupils and other painters influenced by his personality and artistic manner.

The desire to decorate the palaces, residences and religious centres of the House of Austria with paintings from these regions led to an uninterrupted flow of canvases into Spain for many years. Among the outstanding artists who executed works were, of course, Rubens and after him Van Dyck and Jordaens. In the art of this period one can admire the burgeoning richness of the great still lifes, the brilliant and distant landscapes, the spectacular religious compositions, the great historical events, along with the grandeur of classical mythology and allegory, the pomp of the portraits with their profound psychological penetration, the grace and elegance of the genre paintings and the decorative vivacity of animal paintings.

Rubens came to Spain twice. The first visit was in 1603 in the reign of Philip III, during which he signed a contract with the Court in Madrid and executed the series of panels known as *The Apostles* for the Duke of Lerma. Years later, in 1628, when Philip IV was on the throne, the artist returned in the fullness of his maturity and executed important commissions for the King including *Philip IV on Horseback*. Many works were also executed by Rubens' workshop for the Spanish Court, although it is sometimes difficult to assess how much Rubens himself contributed to these.

A great number of works were acquired by the Crown at the sale of the contents of Rubens' studio after his death in 1640. Among them are *The Supper at Emmaus*, *St George and the Dragon* and *The Peasants' Dance*. Rubens was also employed in the decoration of the hunting pavilion of the Torre de La Parada and produced such notable works as *The Rape of Deidania*, *Heraclitus* and *Orpheus* and *Eurydice*. He also prepared many of the sketches for paintings executed by his followers, such as Cossiers, Symons and Jordaens, for this ambitious decorative scheme. Rubens would often collaborate directly in the composition of his paintings and examples in the Prado are *Achilles discovered*, painted with Van Dyck, *Ceres and her nymphs* with Snyders, and the *Devotions of Rudolf I of Habsburg* with Jan Wildens. It is appropriate that the Prado should also contain the last work Rubens executed before his death, *Perseus and Andromeda*, which was left unfinished but completed skilfully by Jordaens.

To this extensive collection Philip IV added many hunting scenes by Paul de Vos and Snyders, as well as exquisite works by Jan 'Velvet' Bruegel. Particularly outstanding are the series depicting the *Five Senses*, presented by the Duke of Medina de Las Torres, works by Van Dyck such as the two portraits *The Cardinal Infante* and *Martin Ryckaert*,

religious scenes including *St Jerome*, *The Crown of Thorns* and *Christ's Arrest in the Garden* (these last three works came from the sale of the contents of Rubens' studio) and further significant pieces by Rombouts, Teniers, Crayer, Jordaens and the Bruegels.

During the reign of Charles II the royal collections continued to grow. It was during this period that the precious panels with the sketches of the tapestry cartoons, of which two are by Rubens, and *The Holy Family* were acquired from the collection of the Marquis of Carpio, as well as the *Christchild with St John* by Van Dyck.

Throughout the following century Philip V and especially his wife Isabel de Farnesio, collected with great interest and success. The Queen acquired the series known as *The Apostles* by Rubens and various works by Van Dyck including *St Francis* and *The Mystic Marriage of St Catherine*. Also acquired was the famous *Self-portrait with Sir Endymion Porter*, along with important works by Jordaens, Arthois, Snayers, Teniers, Bril and the Bruegels.

Charles III made several acquisitions but it was left to his son, Charles IV, to gather new pieces for the collection by Bloemen, Seghers, Teniers, Van Kessel the Elder, Bruegel and Craesbeeck. The French invasion was responsible for the loss of many works, of which some were taken by Joseph Bonaparte and subsequently lost in the Battle of Vitoria (some can be found in the Wellington Museum in London), while others were sold in England and America during the nineteenth century.

Since the foundation of the Prado in 1819 the Flemish School of the seventeenth century has gained some important additions. In 1865 Count Hugo donated the *Triptych of the Animals* by Van Kessel the Elder, and the Duchess of Pastrana presented the sketches by Rubens for the Torre de La Parada among other pieces in 1889. The magnificent bequest by Don Pablo Bosch made several valuable additions to the collection: *The Holy Family* by Van Orley, the exquisite *Rest on the Flight to Egypt* by Gerard David and the strange *Head of a Bowman* by Bosch. In 1928 *Portrait of a Family* by Van Kessel the Younger was acquired and, in 1930, the large series of copper plates on religious themes by Francken entered the museum with the bequest of Don Pedro Fernández Durán, as well as two copper plates on military themes by Meulener. In the more recent past Rubens' equestrian portrait of the *Duke of Lerma* was obtained in 1969 and a *Pietà* by Jordaens in 1981.

The Prado is thus able to give visitors a splendid overall view of this most remarkable of national schools in all its major stages of development from the Gothic to the baroque.

1

Attributed to Robert Campin
Tournai, *c*.1378/79 – Tournai, 1444
Left wing of the Werl altarpiece, showing
*St John the Baptist and the donor, Heinrich
von Werl*, 1438
Panel, 101 × 47 cm
Collection of Charles IV. Entered the Prado
in 1827; Cat No. 1513

2

Attributed to Robert Campin
Tournai, *c*.1378/79 – Tournai, 1444
Right wing of the Werl altarpiece, show-
ing *St Barbara*, 1438
Panel, 101 × 47 cm
Collection of Charles IV. Entered the Prado
in 1827; Cat No. 1514

The central panel of the triptych to which
these wings belonged has been lost.
Though long regarded as an authentic
work by Robert Campin, master of Rogier
van der Weyden, the altarpiece is now
usually thought to be a pastiche by a
follower. The bench on which St Barbara
sits and the perspective of the whole room

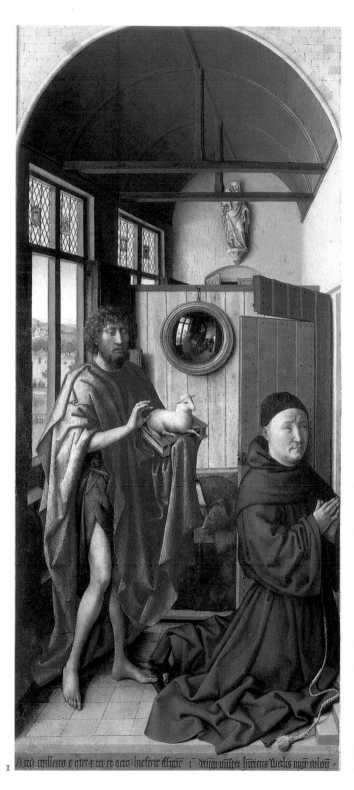

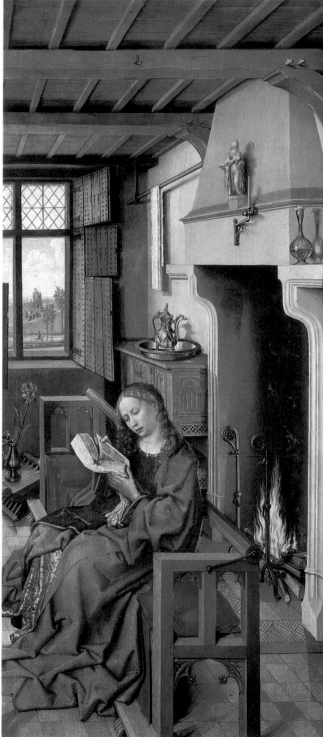

1

is taken over from Campin's *Annunciation* in The Cloisters, New York: even the white towel and the ewer of water, symbolizing the Virgin's chastity, have been copied, though they are not the attributes of St Barbara. Her attribute, the tower in which she was imprisoned, is shown outside the window – typical of the way the early Netherlandish school rationalized abstract symbols naturalistically. In the left wing, the mirror on the wall is borrowed from Jan van Eyck's *Arnolfini Marriage* in the National Gallery in London, painted four years earlier.

3
Franck van der Stockt
Brussels, 1420 (?) – Brussels, 1495
Central panel of a triptych, showing *The Crucifixion*
Panel, 195 × 172 cm
From the Convent of the Angels, Madrid;
Cat No. 1888

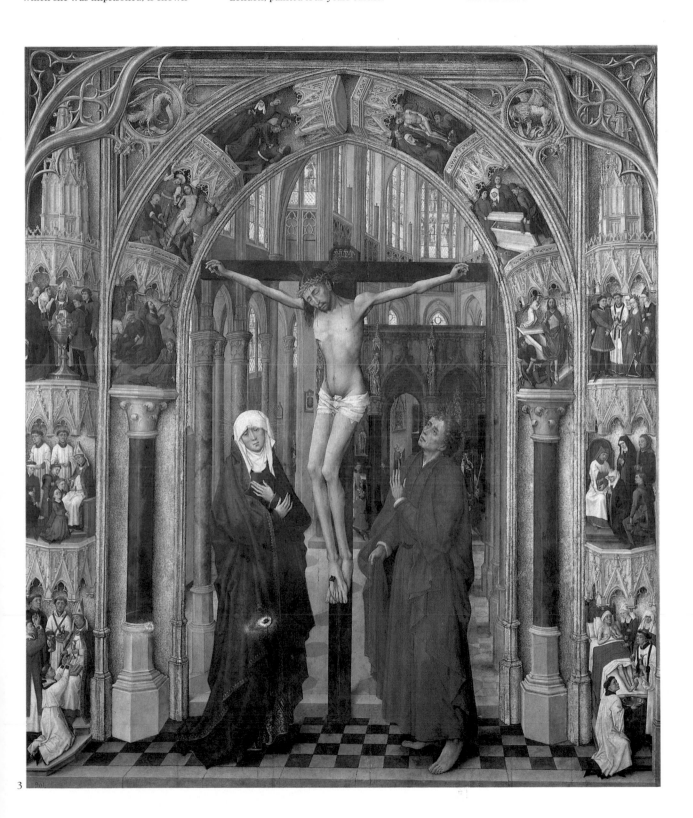

1

Rogier van der Weyden
Tournai, *c.*1399/1400 – Brussels, 1464
The Virgin and Child
Panel, 100 × 52 cm
Purchased from the Palace of Boadilla in
1899. Bequeathed to the Prado by Don
Pedro Fernández Durán in 1938; Cat No.
2722

2

Rogier van der Weyden
Tournai, *c.*1399/1400 – Brussels, 1464
*The Descent from the Cross, c.*1435
Panel, 220 × 262 cm
Collection of Philip II; Cat No. 2825

After training in the workshop of Robert
Campin, Rogier van der Weyden moved to
Brussels in 1435 and shortly afterwards
won official commissions in the city. By
about 1450, when he is reported to have
visited Italy, he had acquired an inter-
national reputation, and his figure types
and compositions were repeated and
varied upon all over northern Europe
until the end of the fifteenth century.

This is one of his most copied and
influential works. The moving scene of
the Deposition, or taking down of Christ's
dead body from the Cross, is compressed
into a shallow box to imitate the effect of
more expensive painted wooden sculp-
ture. But to modern eyes the elimination
of distraction and the monumental figures
enhance the pathos. Then and today the
painting was and is extraordinary for
the exactitude with which surfaces are
rendered, and the eloquent and memor-
able expression of the participants' grief.

3

Adriaen Isenbrandt
Active after 1510; died in Bruges in 1551
The Mass of St Gregory
Canvas, 72 × 56 cm
Entered the Prado from the Royal Palace
in Madrid in 1822; Cat No. 1943

4

Attributed to Gerard David
Oudewater, *c.*1450/60 – Bruges, 1523
The Virgin and Child
Panel, 45 × 34 cm
Entered the Prado from the Escorial in
1839; Cat No. 1537

After the death of Memling in 1494,
Gerard David became the leading artist in
Bruges. This small panel, though perhaps
not by the master himself, shows the
delicacy and softness of his work. The
framing device, creating the pretence that
the Madonna is behind the sill of a
window, has a long tradition in early
Netherlandish painting. Through the
window is shown an exquisite country-
side, and on the sill there is a meticulously
painted vase of flowers – landscape and
still life, specialities of this school.

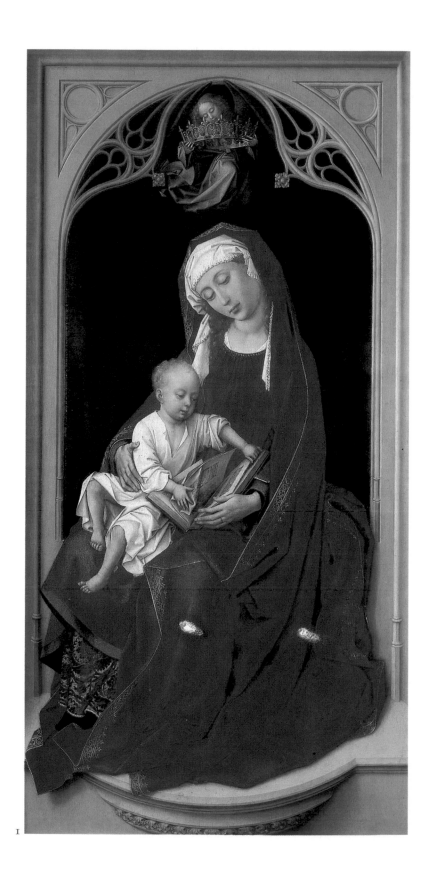

I

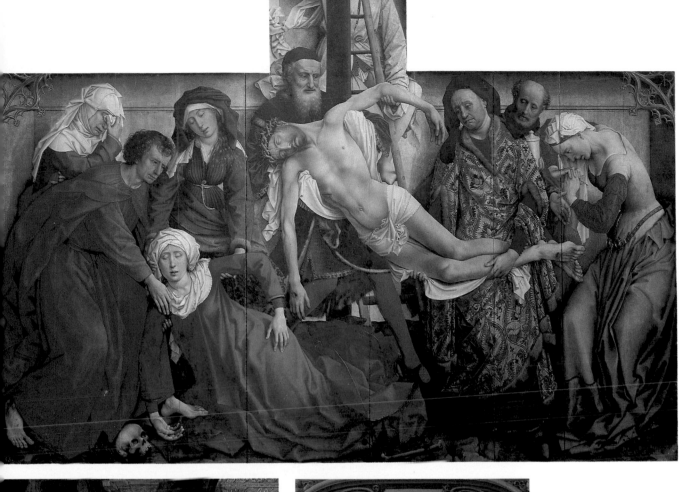

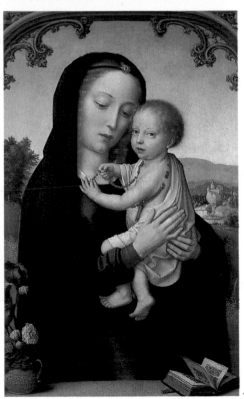

4

1

Dieric Bouts

Haarlem, *c*.1420 – Louvain, 1475

Detail of a polyptych, showing *The Adoration of the Kings*, *c*.1445

Panel, 80 × 56 cm

Entered the Prado from the Escorial in 1839; Cat No. 1461

2

Hans Memling

Mömling, *c*.1433 – Bruges, 1494

Left and right wings of triptych, showing *The Nativity* and *The Purification in the Temple*, *c*.1470

Panels, 95 × 63 cm (each wing)

Collection of Charles V. Entered the Prado in 1847; Cat No. 1557

Hans Memling trained in the workshop of Rogier van der Weyden in Brussels and then settled in Bruges. He practised a highly competent, richly coloured, clearly articulated style, lacking the emotional power of his master Rogier or the exquisite technical detail of Jan van Eyck. The compositions of this triptych are based on types established by Rogier, but typically are quieter and less monumental.

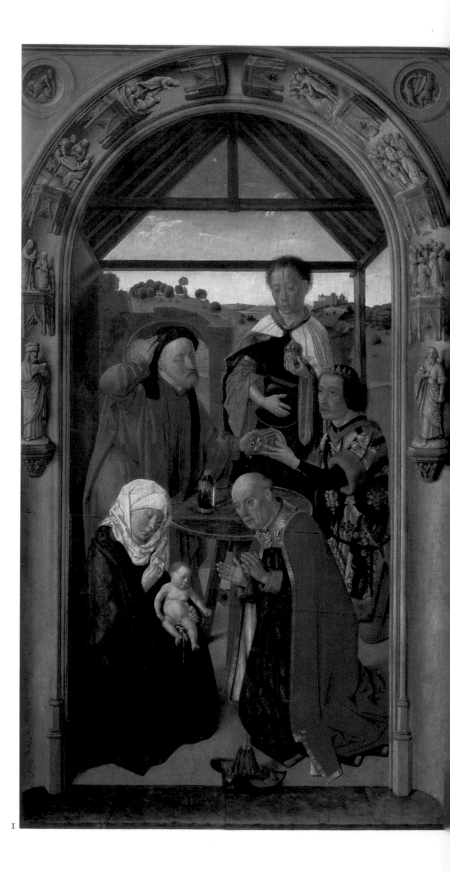

1

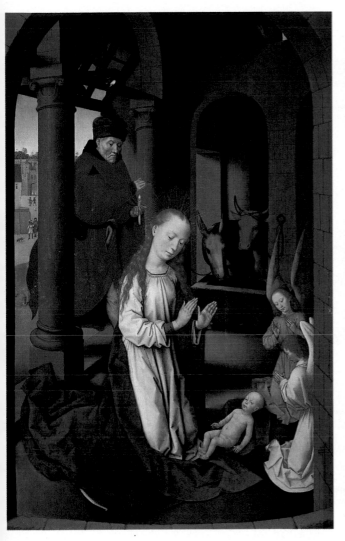

3

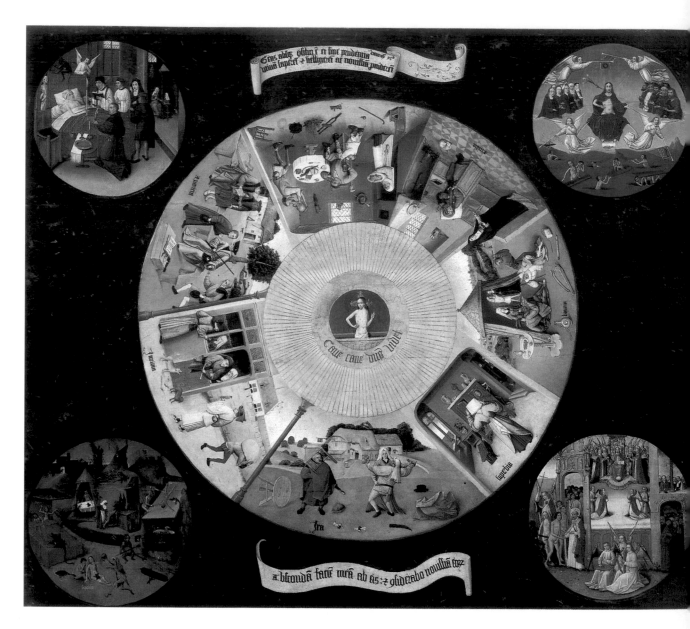

Jerome van Aken, called Bosch
's Hertogenbosch, *c.*1450 – 's Hertogen-
bosch, 1516
*The Seven Deadly Sins, c.*1480
Panel, 120 × 150 cm
Collection of Philip II; Cat No. 2822

This is one of Bosch's earliest known
works and reflects the style and preoc-
cupations which would later come to be
considered characteristic of him. It be-
longed to Philip II, who kept it in his
apartments at the Monastery of the
Escorial.

In the centre, fanned out around the
figure of Christ, appear seven scenes each
illustrating one of the Seven Deadly Sins,
bearing the appropriate inscription and
composed with the painter's usual viv-
acity and sense of the fantastic. Anger
presents a scene of jealousy and conflict;
in Pride, a demon presents a woman with
a mirror; in Lust, two sets of lovers speak
within the confines of an open tent,
entertained by a buffoon, while on the
ground outside lie various musical instru-
ments, including a harp which will reap-
pear in the *Garden of Earthly Delights*;

Idleness is represented by a woman
dressed up for church and trying to wake
a man deep in slumber; Gluttony shows a
table spread with food and around it
figures eating voraciously; Avarice dis-
plays a judge allowing himself to be
bribed; and Envy depicts the Flemish
proverb 'Two dogs with one bone seldom
reach agreement'. The corners of the table
portray the last four stages of life: Death,
the Final Judgement, Hell and Glory.

Jerome van Aken, called Bosch
's Hertogenbosch, *c.*1450 – 's Hertogen-
bosch, 1516
*The Cure for Folly: Trepanning, c.*1490
Panel, 48 × 35 cm
Collection of Philip II; Cat No. 2056

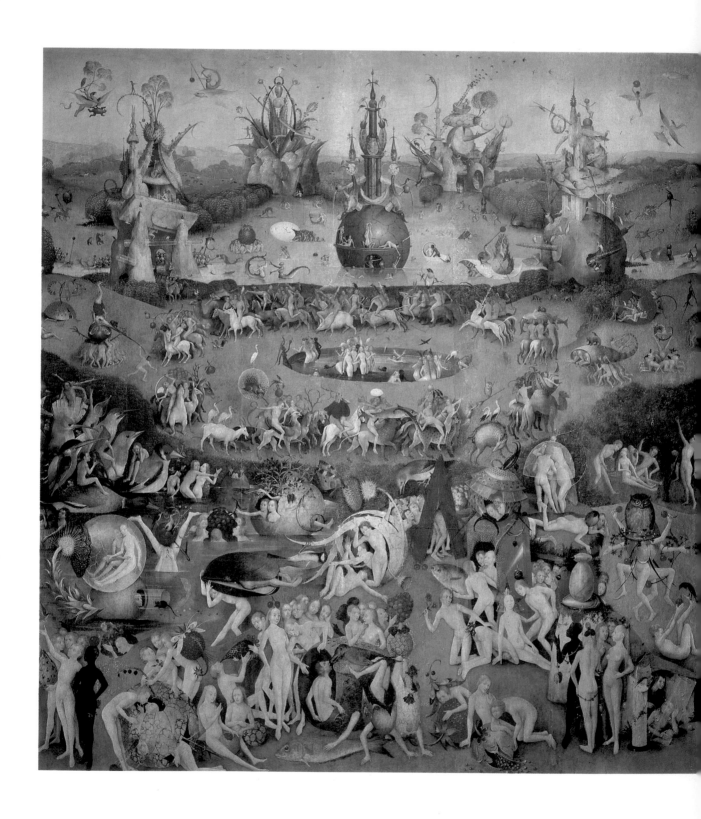

Jerome van Aken, called Bosch
's Hertogenbosch, *c.*1450 – 's Hertogen-
bosch, 1516
*The Garden of Earthly Delights, c.*1510
Facing page: Panel, 220 × 195 cm (central
panel of triptych)
This page: Panel, 220 × 97 cm (right wing
of triptych)
Collection of Philip II; Cat No. 2823

The enigmatic and strange fantasies that
people the work of Jerome Bosch earned
him enormous fame even in his own
lifetime, and his creations were widely
imitated. But nothing either in his own or
in his contemporaries' work equals the
invention of the *Garden of Delights* trip-
tych, justly his most famous painting.

Various attempts have been made to
relate these fantasies to the realities of his
own day. For instance, some of the sex-
ually related visions have been related to
the creed of the Adamites, a heretical sect
of the day advocating, at least in theory,
sexual freedom like that in Eden. But the
most promising line has been to recognize
many of them as illustrations of proverbs:
for instance, the pair of lovers in the glass
bubble would recall the proverb, 'Pleasure
is as fragile as glass'. This approach also
provides a link between these fantasies
and Bosch's other work, such as *The Cure
of Folly* or *The Haywain*, and between
Bosch's later work and Breugel's in the
middle of the sixteenth century: though
without Bosch's satanic profusion, Bre-
ugel also made illustrations of proverbs in
this way.

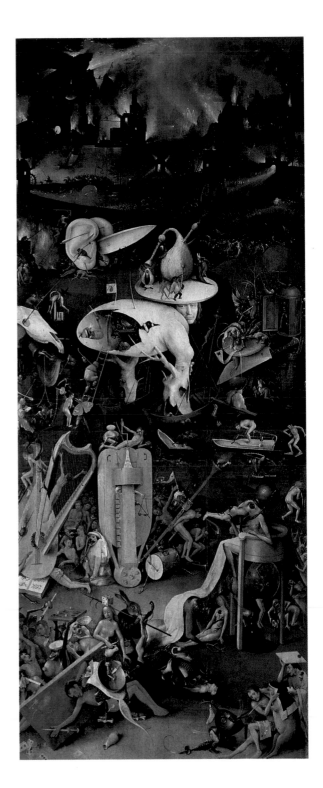

Jerome van Aken, called Bosch
's Hertogenbosch, c.1450 – 's Hertogen-
bosch, 1516
The Haywain, c.1495/1500
Panel, 135 × 100 cm (centre),
135 × 45 cm (each wing)
Collection of Philip II; Cat No. 2052

In 1486 Bosch joined the devout society of The Brethren of Our Lady, who had close connections with the extremely ascetic Brotherhood of the Common Life, founded at the end of the fourteenth century. One of the reforming movements of the late Middle Ages, the Brothers of the Common Life particularly attacked the corruption of the clergy and sought Salvation through a strict avoidance of earthly pleasures. When this triptych is closed, the outer doors carry the image of Everyman, walking the Path of Life, which perhaps alludes to the ideals of the Brotherhood.

The main panel of the triptych is based on the proverb, 'The world is a haywain from you take what you can'. All sorts of people are represented taking what they

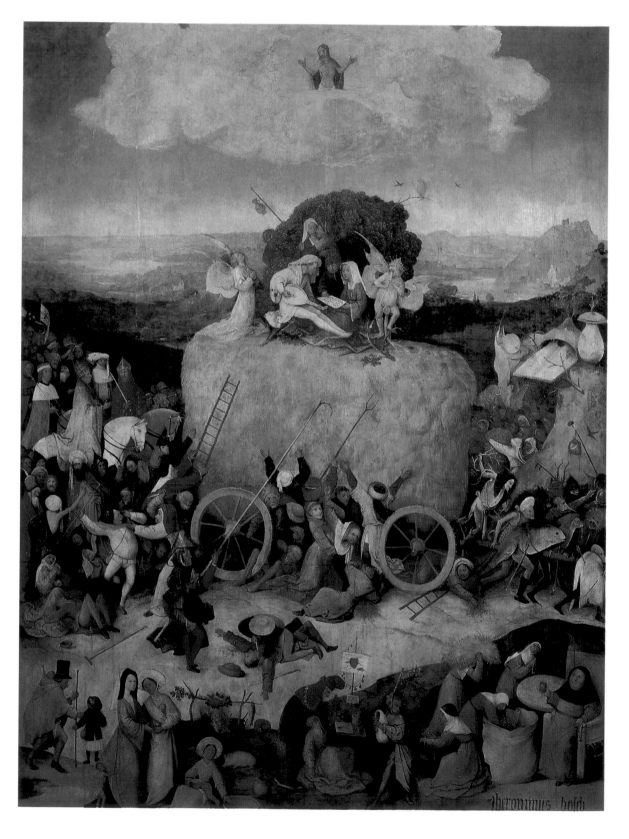

an, from the pope (on the left, on a [h]orse) to a palm-reading gypsy (fore[g]round), sweet-talking a gullible young [w]oman while the gypsy's child steals her [p]urse. In the composition, there are many [e]choes of a scene of Crucifixion: but the [p]leasure-taking lovers above the haywain [h]ave replaced Christ (and the pope on his [h]orse is in the usual position of the [R]oman executioners). The picture is a [v]icious satire on the world's turning away [fr]om God.

Jerome van Aken, called Bosch
's Hertogenbosch, c.1450 – 's Hertogen-
bosch, 1516
The Adoration of the Magi, c.1510
Panel, 138 × 72 cm (centre); 138 × 34 cm
(each wing)
Collection of Philip II. Entered the Prado
in 1839; Cat No. 2048

This late work, with donors, husband and
wife, in the left and right wings, is an

altarpiece of traditional format and sub-
ject matter. However, there are a few
Bosch intrusions – not so much the rather
charming peasants who have clambered
on the thatch to see the Child, as the
strangely robed king who peeps round
from the back of the stable. It is not
obvious who he is: is he Herod, or the
Antichrist, or a deluded fool mocking or
brought to his senses by the miraculous
advent?

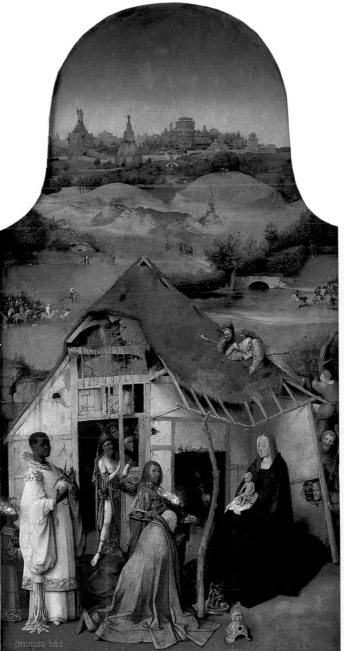

1
Jan Gossaert, called Mabuse
Maubege, *c.*1478 – Middlebourg,
*c.*1533/36
'The Virgin of Louvain'
Panel, 45 × 49 cm
Presented by the City of Louvain to Philip
II in 1588. Entered the Prado in 1839;
Cat No. 1536

2
Jan Gossaert, called Mabuse
Maubege, *c.*1478 – Middlebourg,
*c.*1533/36
*The Virgin and Child, c.*1527
Panel, 63 × 50 cm
Collection of Philip II; Cat No. 1930

3
Joachim Patenier
Bouvignes, *c.*1480 – Antwerp, 1530
The Temptation of St Anthony
Panel, 155 × 173 cm
Collection of Philip II; Cat No. 1615

4
Joachim Patenier
Bouvignes, *c.*1480 – Antwerp, 1530
Charon
Panel, 64 × 103 cm
In the Royal Collection by the eighteenth
century; Cat No. 1616

Joachim Patenier, working in Antwerp,
was a landscape specialist, often providing
the backgrounds to the figures of other
masters such as Massys or Isenbrandt. In
his own work the landscape becomes the
dominant element, so that the figure
subject which justifies it becomes some-
times no more than a tiny incident in the
foreground. The impression is sought of
vast panoramic vistas, which are seen not
from a natural but from an artificially
high viewpoint. Typically the landscape is
enlivened by dramatic effects of weather
or the outbreak of fire, in a manner in-
fluenced by Bosch.

1

2

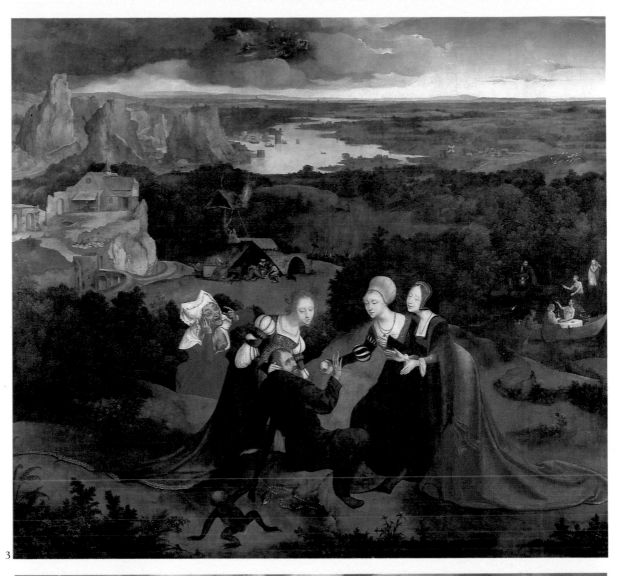

3

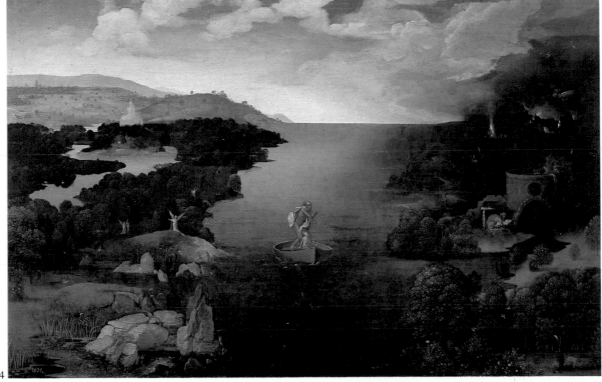

4

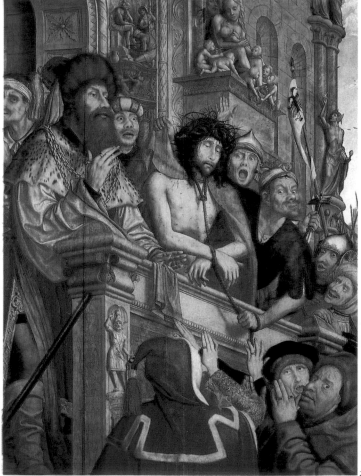

1

Bernard van Orley
Brussels, *c*.1491 – Brussels, 1542
The Holy Family, 1522
Panel, 90 × 74 cm
From the Convent of Las Huelgas in
Burgos. Bequeathed by Don Pablo Bosch
in 1915; Cat No. 2692

2

Quentin Massys
Louvain, *c*.1465/66 – Antwerp, 1530
Ecce Homo, *c*.1515
Panel, 160 × 120 cm
Bequeathed in 1936 by Don Mariano
Lanuza. Entered the Prado in 1940; Cat
No. 2801

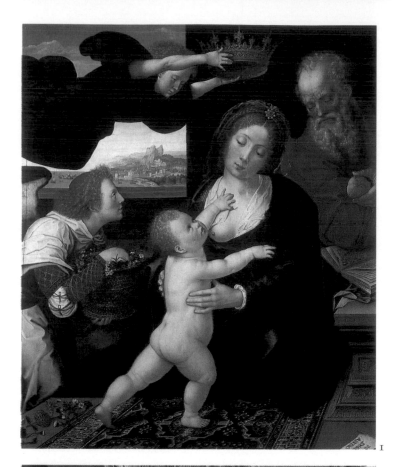

Anthonis Mor van Dashorst, called
Antonio Moro in Spain
Utrecht, 1519 – Antwerp, 1575
Queen Mary Tudor of England, Bride of
Philip II, 1554
Panel, 109 × 84 cm
Collection of Charles V; Cat No. 2108

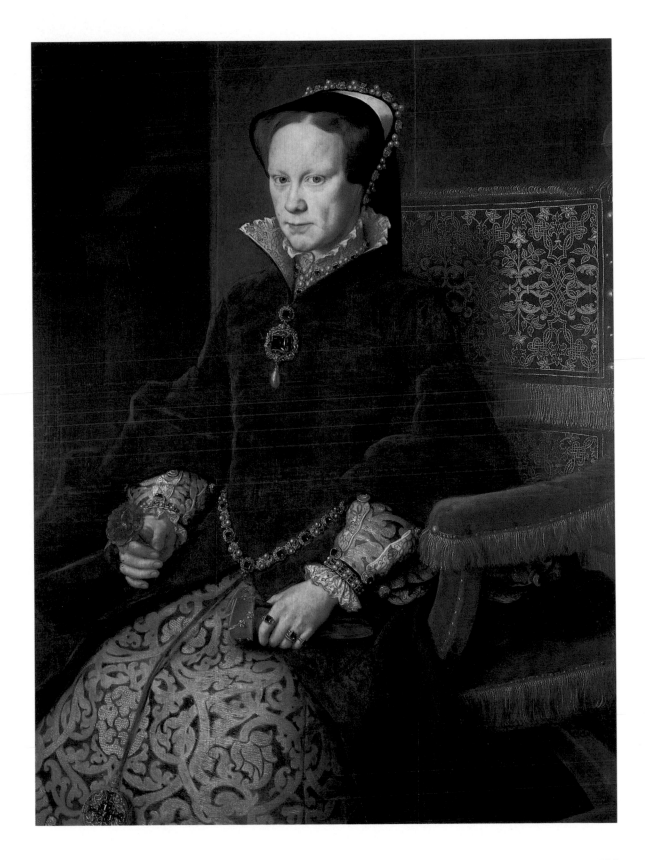

Marinus Claeszon van Reymerswaele
Roemeswaele, *c.*1497 – Roemeswaele,
after 1567
The Money-Changer and his Wife, 1539
83 × 97 cm
Bequeathed by the Duke of Tarifa in
1934; Cat No. 2567

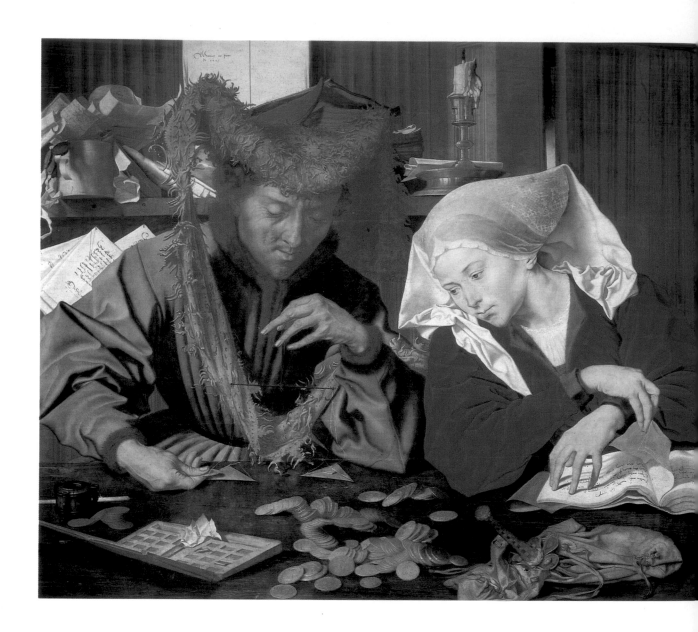

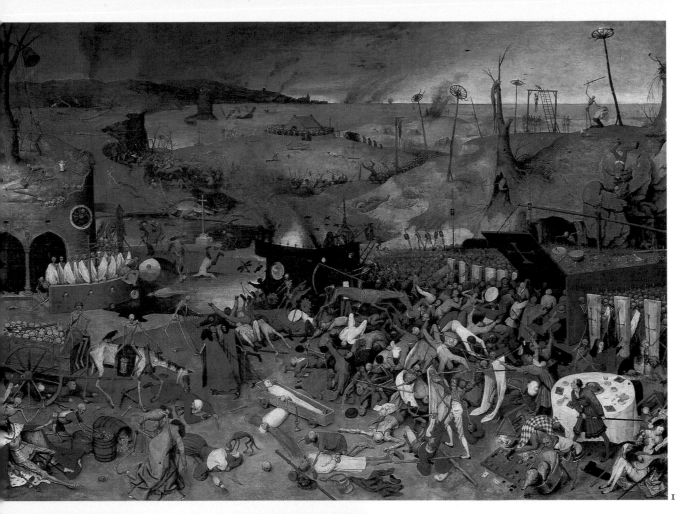

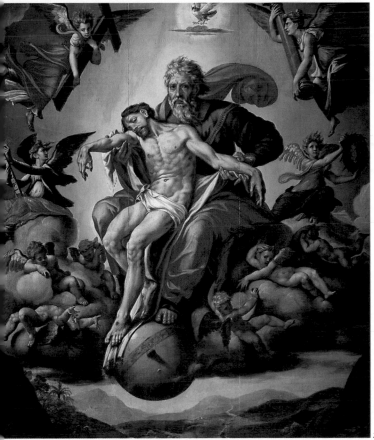

1
Pieter Bruegel the Elder
Breda (?), c.1525/30 Brussels, 1569
*The Triumph of Death, c.*1562
Panel, 117 × 162 cm
In the Royal Collection by the eighteenth
century; Cat No. 1393

2
Pieter Coecke van Aelst
Aelst, 1502 – Brussels, 1556
The Holy Trinity
Panel, 98 × 84 cm
Purchased in 1970; Cat No. 3210

Frans Francken the Younger
Antwerp, 1581 – Antwerp, 1642
The Triumph of Amphitrite
Copper, 30 × 41 cm
In the Royal Collection by the eighteenth
century; at the Quinta del Duque del Arco
in 1794; Cat No. 1523

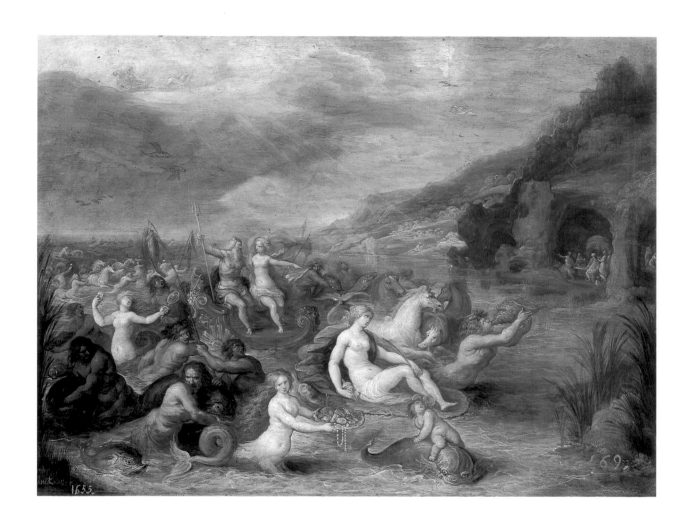

Sir Peter Paul Rubens
Siegen, 1577 – Antwerp, 1640
*The Duke of Lerma, c.*1603
Canvas, 283 × 200 cm
Purchased in 1969; Cat No. 3137

When he visited the Spanish Court for the
first time in 1603, Rubens used this
picture to display his talents and to make
his mark. It has already many elements of
his mature baroque style, which would
have been novel and striking to his
viewers. The way in which the horse

seems to surge forward towards the
spectator – an effect engineered by the
low viewpoint and lack of balancing
elements in the foreground, and recalling
the techniques of Caravaggio – was
spectacular, and broke with the tra-
ditional profile of equestrian portraits.
Other devices used to enhance the spec-
tacle were the eccentric colouring, the
tempestuous lighting, and the rather
disquieting energy of the horse's hair and
the trees' foliage.

196

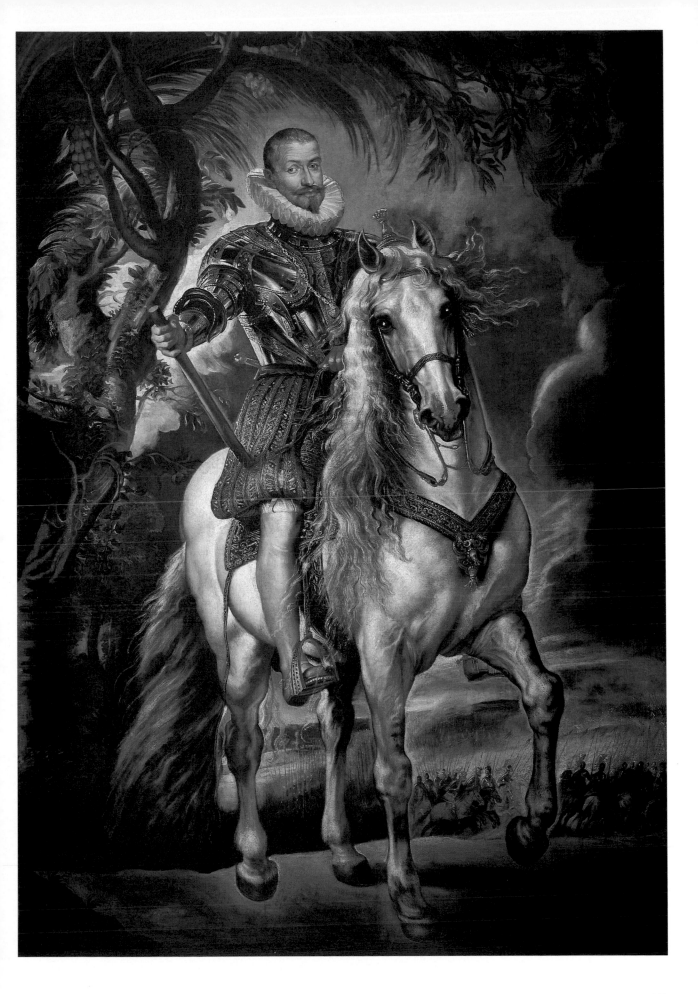

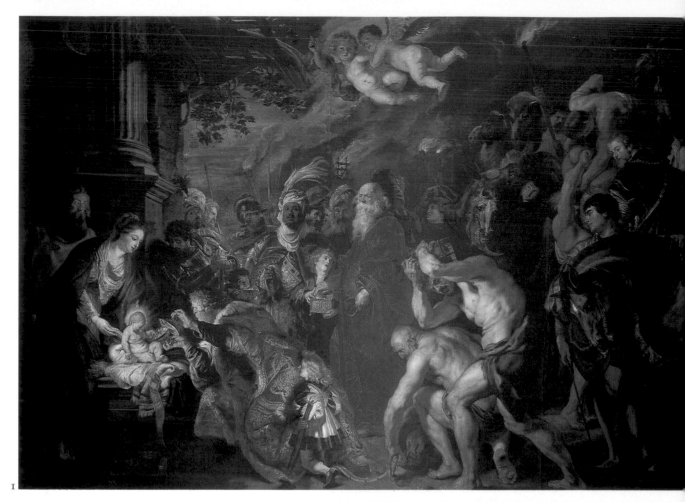

1

Sir Peter Paul Rubens
Siegen, 1577 – Antwerp, 1640
*The Adoration of the Kings, c.*1609, re-
worked 1628
Canvas, 345 × 438 cm
Collection of Philip IV; Cat No. 1638

2

Sir Peter Paul Rubens
Siegen, 1577 – Antwerp, 1640
*St George and the Dragon, c.*1606
Canvas, 304 × 256 cm
Purchased in 1656 from the artist's estate
by Philip IV; Cat No. 1644

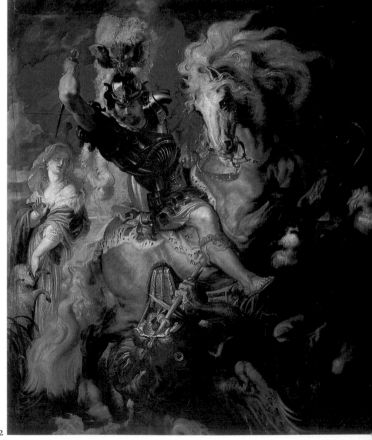

Sir Peter Paul Rubens
Siegen, 1577 – Antwerp, 1640
The Triumph of the Church over Fury,
*Discord and Hatred, c.*1628
Sketch on panel for a tapestry,
86 × 105 cm
Collection of Philip IV; Cat No. 1698

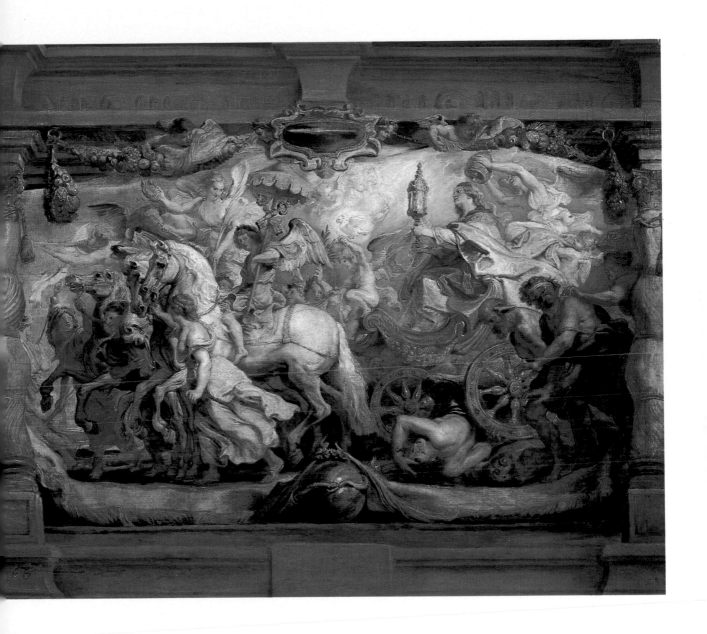

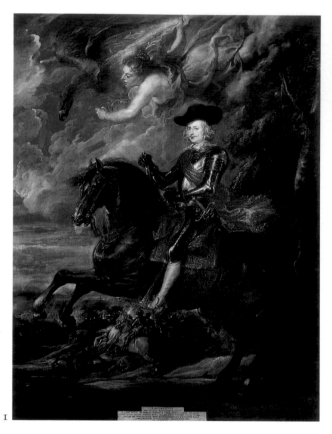

I

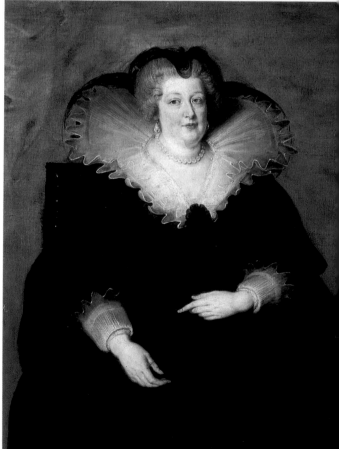

I
Sir Peter Paul Rubens
Siegen, 1577 – Antwerp, 1640
*The Cardinal Infante, c.*1634
Canvas, 335 × 258 cm
Collection of Philip IV; Cat No. 1687

2
Sir Peter Paul Rubens
Siegen, 1577 – Antwerp, 1640
*St James the Apostle, c.*1612/13
Panel, 108 × 84 cm
In the collection of Queen Isabel·de
Farnesio by 1746. Entered the Prado in
1829; Cat No. 1648

3
Sir Peter Paul Rubens
Siegen, 1577 – Antwerp, 1640
*Marie des Médici, Queen of France, c.*1622
Canvas, 130 × 108 cm
Purchased in 1656 from the estate of the
artist by Philip IV; Cat No. 1685

3

Sir Peter Paul Rubens
Siegen, 1577 – Antwerp, 1640
The Three Graces, c.1636/38
Panel, 221 × 181 cm
Purchased in 1656 from the estate of the
artist by Philip IV; Cat No. 1670

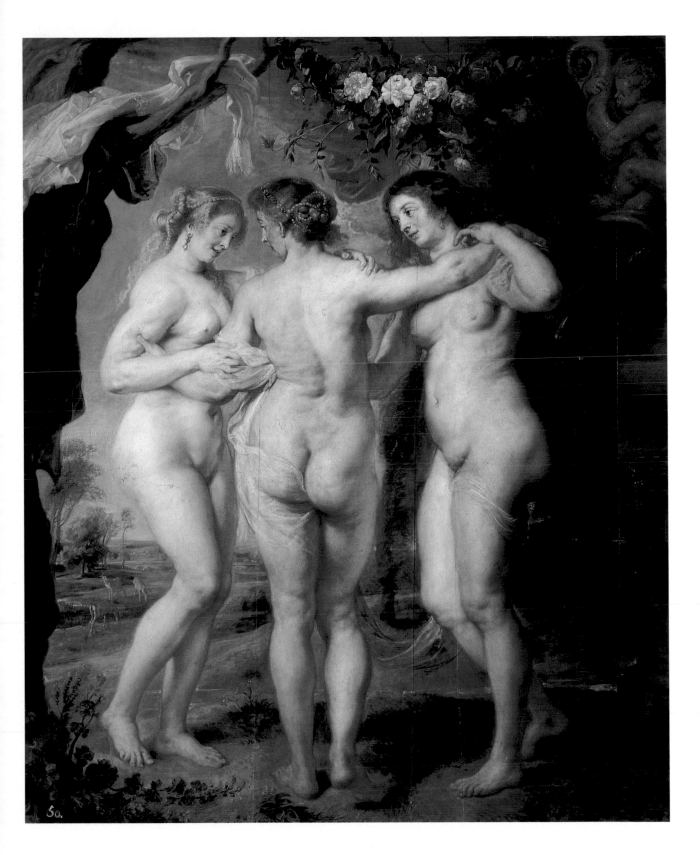

50.

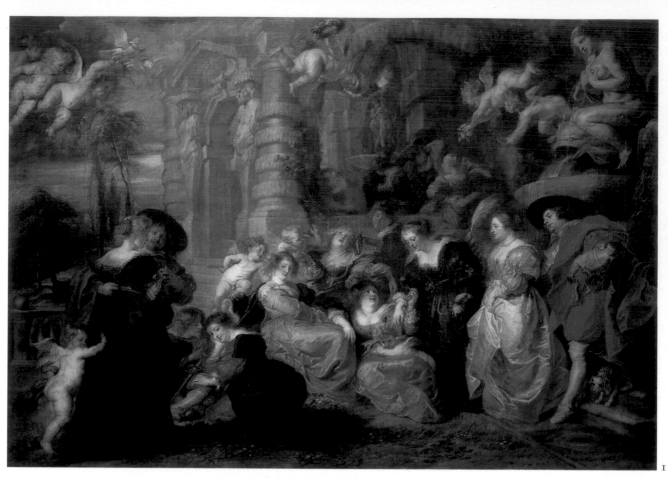

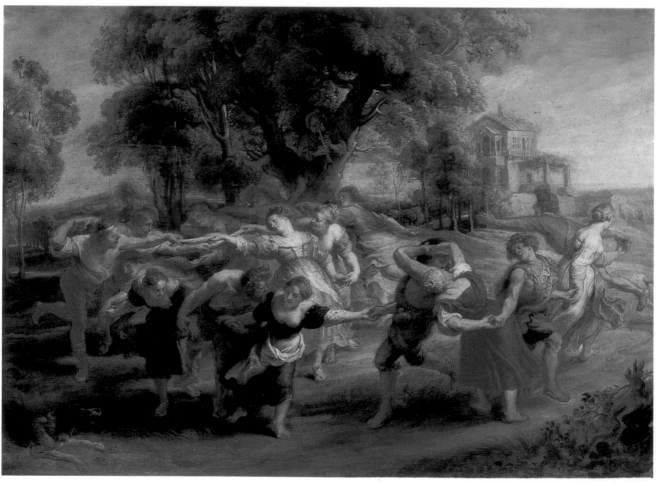

Sir Peter Paul Rubens
Siegen, 1577 – Antwerp, 1640
The Garden of Love, c.1633
Canvas, 198 × 283 cm
Collection of Philip IV; Cat No. 1690

This splendid vision of sensual dalliance
once hung in Philip IV's bedchamber. The
subject is a traditional medieval one, in
which lovers were shown conventionally
in a garden, sometimes with moral
messages or symbols accompanying them.
In the Italian Renaissance the theme had
been represented in *fêtes champêtres*, such
as the one attributed to Giorgione or
Titian in the Louvre. This picture by
Rubens is an important link in the tra-
dition running from those works to the
scenes of Watteau and Pater in the eight-
eenth century.

Sir Peter Paul Rubens
Siegen, 1577 – Antwerp, 1640
A peasant dance
Panel, 73 × 106 cm
Purchased in 1656 from the estate of the
artist by Philip IV; Cat No. 1691

Sir Peter Paul Rubens
Siegen, 1577 – Antwerp, 1640
*Landscape with the Hunt of the Calydonin
Boar*, before 1636
Canvas, 160 × 260 cm
Collection of Philip IV; Cat No. 1622

Sir Peter Paul Rubens
Siegen, 1577 – Antwerp, 1640
Saturn devouring a son, c.1636/38
Canvas, 180 × 87 cm
Commissioned by Philip IV for the Torre
de La Parada; Cat No. 1678

Sir Peter Paul Rubens
Siegen, 1577 – Antwerp, 1640
(finished by Jacob Jordaens)
Perseus and Andromeda, c.1640
Canvas, 265 × 160 cm
Collection of Philip IV; Cat No. 1663

3

4

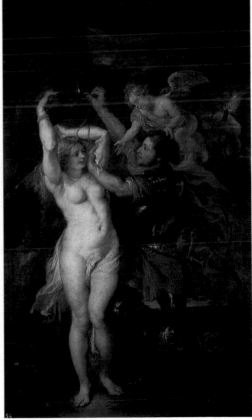

5

1
Sir Peter Paul Rubens
Siegen, 1577 – Antwerp, 1640
The Judgement of Paris, c.1639
Panel, 199 × 379 cm
Collection of Philip IV. Entered the Prado
in 1839; Cat No. 1669

2
Sir Peter Paul Rubens
Siegen, 1577 – Antwerp, 1640
Tereus confronted with the head of his son
Itylus, whose flesh he has just devoured,
c.1636/38
Panel, 195 × 267 cm
Commissioned by Philip IV for the Torre
de La Parada; Cat No. 1660

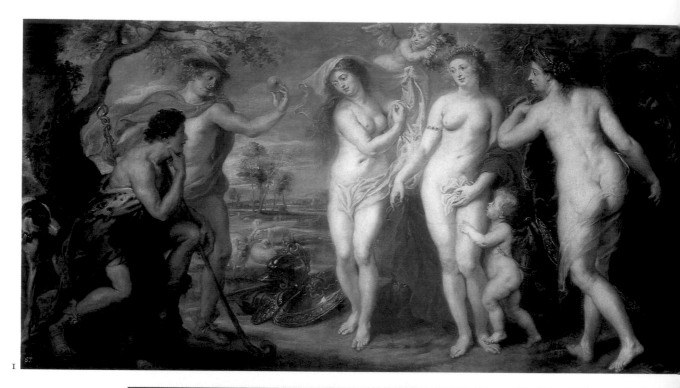

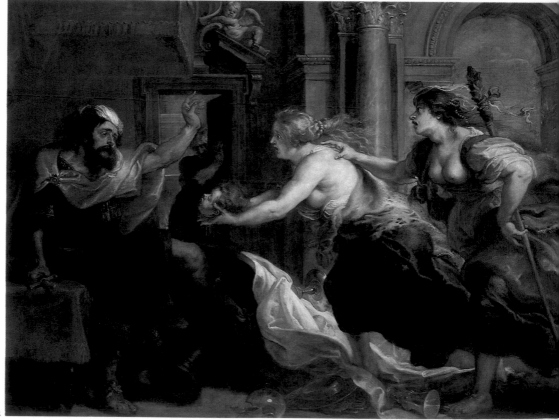

204

3

4

3
Jacob Jordaens
Antwerp, 1593 – Antwerp, 1678
The Artist and his Family, c.1620/22
Canvas, 181 × 187 cm
Collection of Philip V. Entered the Prado
in 1829; Cat No. 1549

4
Jacob Jordaens
Antwerp, 1593 – Antwerp, 1678
An Offering to Ceres, Goddess of the Harvest,
c.1618/20
Canvas, 165 × 112 cm
In the Royal Collection by the eighteenth
century; Cat No. 1547

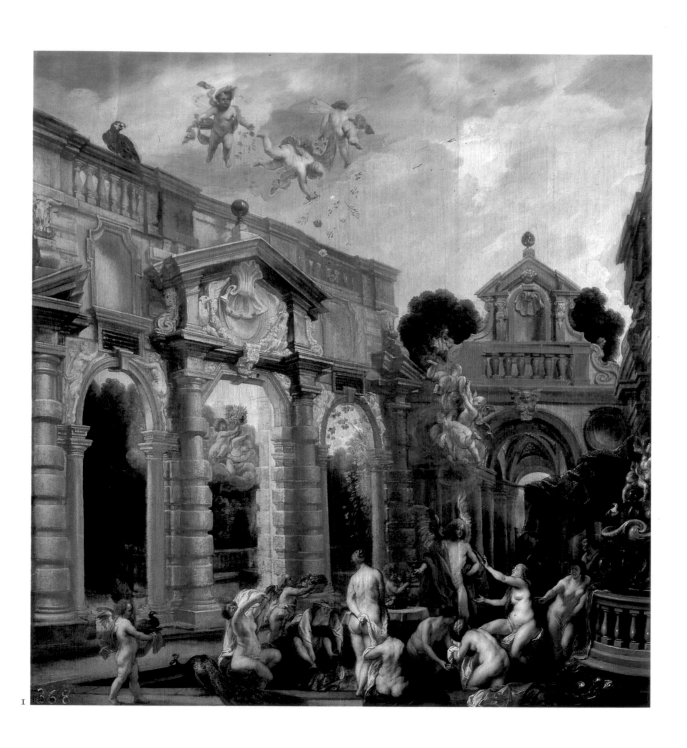

1

4
Gaspard de Crayer
Antwerp, 1584 – Ghent, 1669
The Cardinal Infante, 1639
Canvas, 219 × 125 cm
Collection of Philip IV; Cat No. 1472

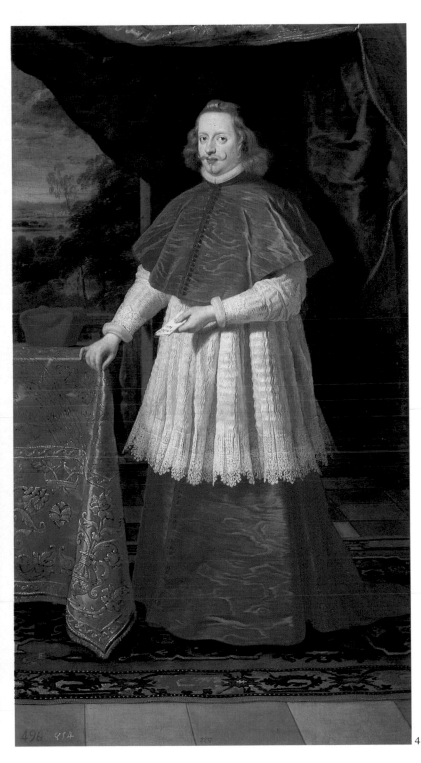

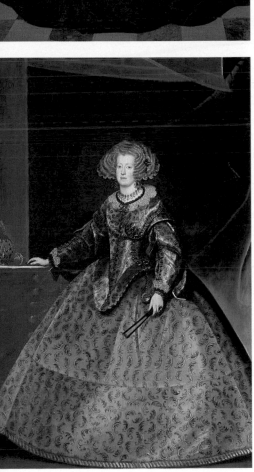

4

207

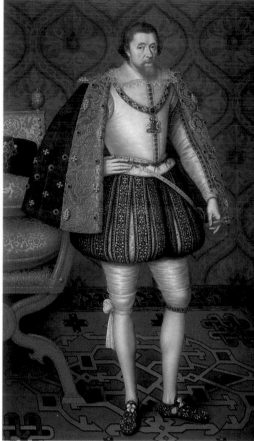

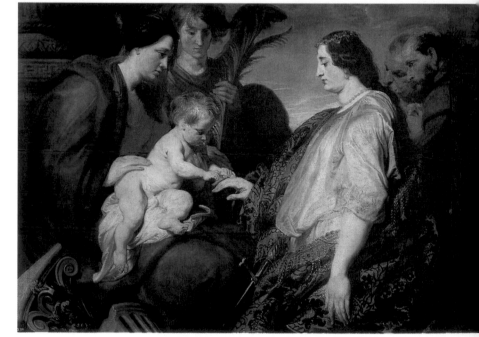

1
Jan van Kessel the Younger
Antwerp, 1654 – Madrid, c.1708
Portrait of a family, 1680
Canvas, 127 × 167 cm
Purchased in 1928; Cat No. 2525

2
Paulus van Somer
Antwerp, c.1576 – London, 1621
King James I of England
Canvas, 196 × 120 cm
Collection of Philip IV; Cat No. 1954

3
Sir Anthony Van Dyck
Antwerp, 1599 – London, 1641
The Mystic Marriage of St Catherine,
c.1618/20
Canvas, 121 × 173 cm
In the Royal Collection by the eighteenth
century; Cat No. 1544

4
Sir Anthony Van Dyck
Antwerp, 1599 – London, 1641
Christ's Arrest in the Garden, c.1618/20
Canvas, 344 × 249 cm
Purchased in 1656 by Philip IV from the
estate of Peter Paul Rubens; Cat No. 1477

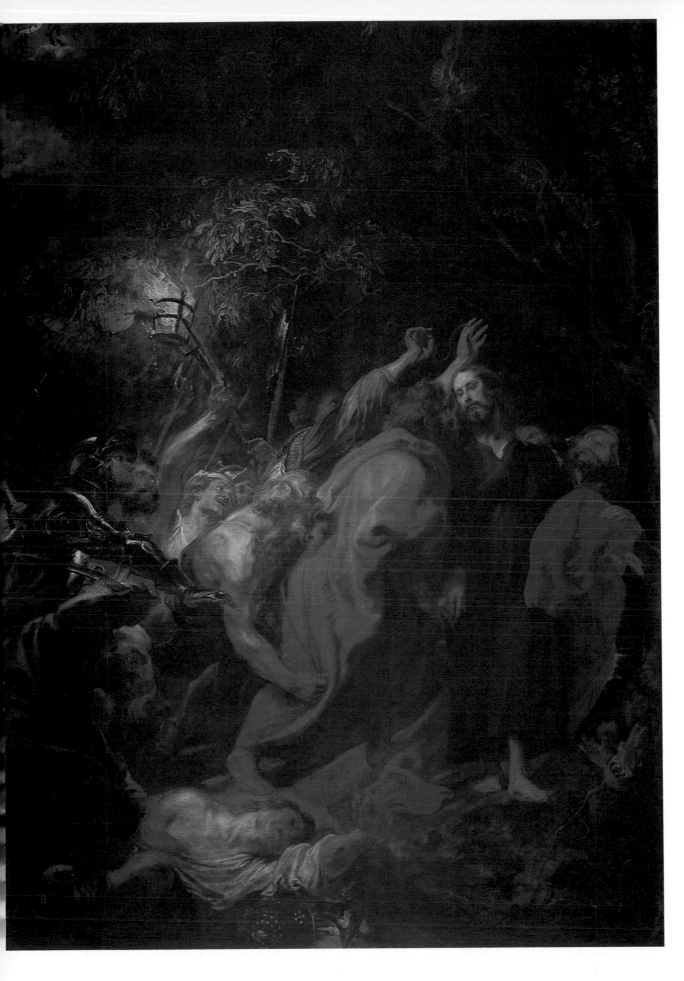

209

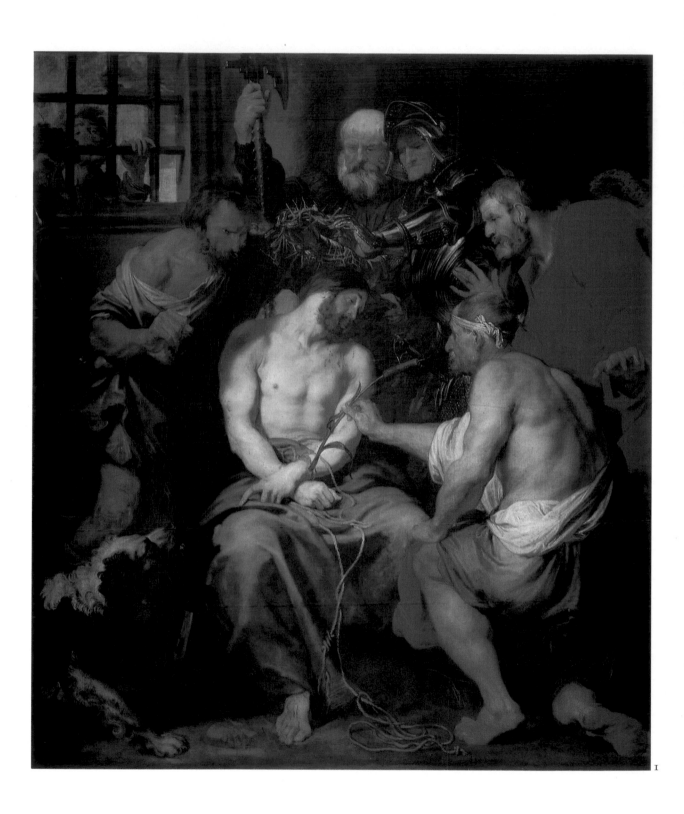

I

Sir Anthony Van Dyck
Antwerp, 1599 – London, 1641
The Crowning with Thorns, c.1618/20
Canvas, 223 × 196 cm
Collection of Philip IV. Entered the Prado
in 1839; Cat No. 1474

The contrast between the serenity of
Christ and the villainy of his captors is
vigorously conveyed in this early work by
Van Dyck. The composition, as so often, is
based on a prototype by Titian, of whom
Van Dyck was a passionate admirer. But
the influence of Rubens is also crucial,
and the presentation is typically baroque:
the viewer is forced into the rôle of a close
but helpless witness of the violence
enacted. The effect is reinforced by Van
Dyck's textures – for instance, the exposed
and brilliant chest of Christ against the
gleaming precision of the axe above or the
laid musculature of the tormentor beside

Sir Anthony Van Dyck
Antwerp, 1599 – London, 1641
Sir Endymion Porter and the Artist,
1632/41
Canvas, 110 × 114 cm
In the collection of Queen Isabel de
Farnesio by 1746; Cat No. 1489

Sir Anthony Van Dyck
Antwerp, 1599 – London, 1641
Martin Ryckaert, c.1627/32
Canvas, 148 × 113 cm
Collection of Philip IV; Cat No. 1479

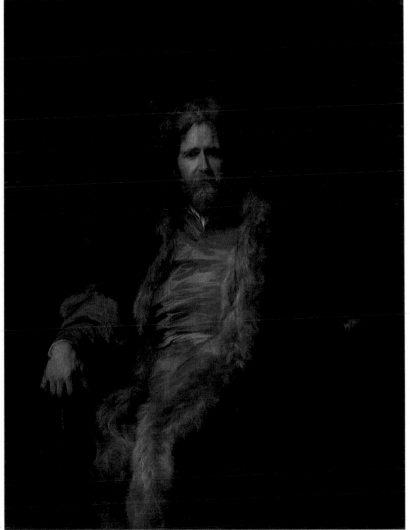

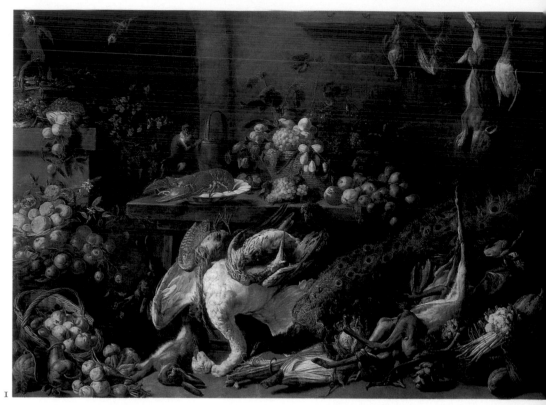

I

2 178

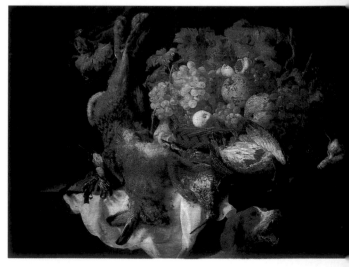

5
Denis van Alsloot
Mechlin, 1570 – Brussels, 1628
*Skating during Carnival, c.*1620
Panel, 57 × 100 cm
In the collection of Queen Isabel de
Farnesio by 1746; Cat No. 1346

6
Alexander van Adriaessen
Antwerp, 1587 – Antwerp, 1661
Still life
Panel, 60 × 91 cm
Bequeathed to Philip IV by the Marquis of
Leganés in 1652; Cat No. 1343

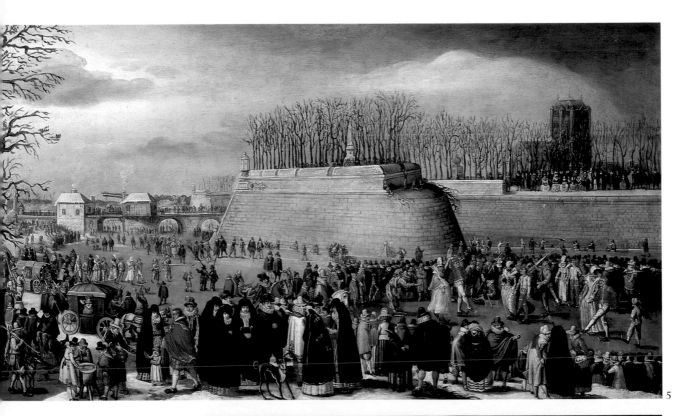

5

Adriaen van Utrecht
Antwerp, 1599 – Antwerp, 1653
Still Life: A pantry, 1642
Canvas, 221 × 307 cm
In the collection of Queen Isabel de
Farnesio by 1746; Cat No. 1852

osias Beert
Antwerp, *c.*1580 – Antwerp, 1624
Still life
Panel, 43 × 54 cm
In the collection of Queen Isabel de
Farnesio by 1746; Cat No. 1606

Clara Peeters
Antwerp, 1594 – Antwerp, 1659
Still life, 1611
Panel, 52 × 73 cm
In the collection of Queen Isabel de
Farnesio by 1746; Cat No. 1620

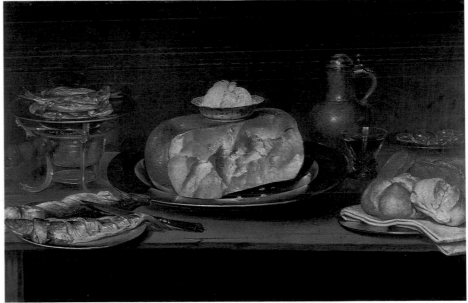

6

an Fyt
Antwerp, 1611 – Antwerp, 1661
Still life, with dog
Panel, 77 × 112 cm
In the Royal Collection by the eighteenth
century; Cat No. 1529

1

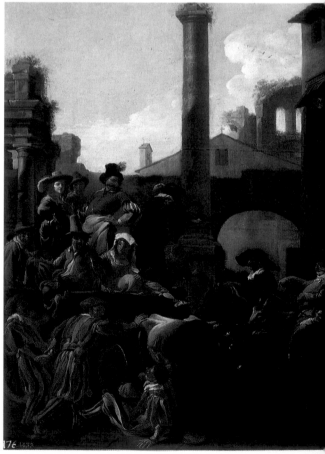

1
Pieter Bruegel the Younger
Brussels, 1564 – Antwerp, 1638
Winter landscape with a bird-trap
Panel, 40 × 57 cm
In the collection of Queen Isabel de
Farnesio by 1746; Cat No. 2045

2
Jan Miel
Beveren-Was, 1599 – Turin, 1663
Carnival time in Rome, 1653
Canvas, 68 × 50 cm
Collection of Philip IV; Cat No. 1577

2

Gillis van Coninxloo III
Antwerp, 1544 – Antwerp, 1607
Landscape
Copper, 24 × 19 cm
Provenance unknown
Cat No. 1385

1
Jan Bruegel the Elder
Antwerp, 1568 – Antwerp, 1625
A wedding banquet
Canvas, 84 × 126 cm
Collection of Philip IV; Cat No. 1442

2
Jan Bruegel the Elder
Antwerp, 1568 – Antwerp, 1625
A gathering of gypsies in a wood
Panel, 35 × 43 cm
In the collection of Philip V by 1746; Cat No. 1432

3
Jan Bruegel the Elder and Sir Peter Paul Rubens
Antwerp, 1568 – Antwerp, 1625; Siegen, 1577 – Antwerp, 1640
The Vision of St Hubert, c.1620
Panel, 63 × 100 cm
Bequeathed to Philip IV by the Marquis of Leganés; Cat No. 1411

216

4
Joost de Momper
Antwerp, 1564 – Antwerp, 1635
Landscape
Canvas, 174 × 256 cm
Provenance unknown; Cat No. 1592

Joost de Momper followed in the tradition of panoramic landscape established by Patenier and Pieter Bruegel the Elder. The familiar formula of placing browns in the foreground, greens in the middle and light blues in the background establishes the sense of aerial space; also the dark shapes of flying birds against the hazy blues and whites of the sky compound the effect. In the foreground comes the usual picturesque group of figures.

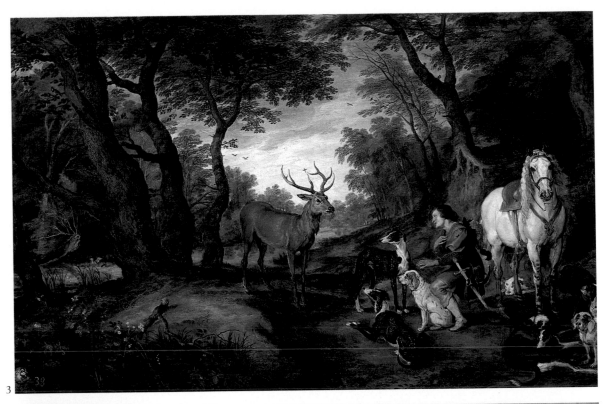

3

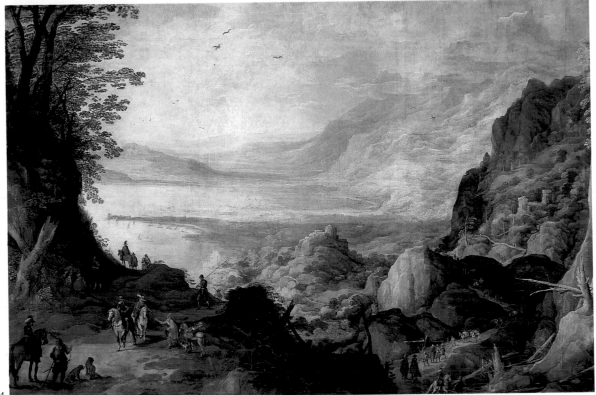

4

217

1
Joost de Momper
Antwerp, 1564 – Antwerp, 1635
A Flemish market and washing-place
Canvas, 166 × 194 cm
In the Royal Collection by the eighteenth
century; Cat No. 1443

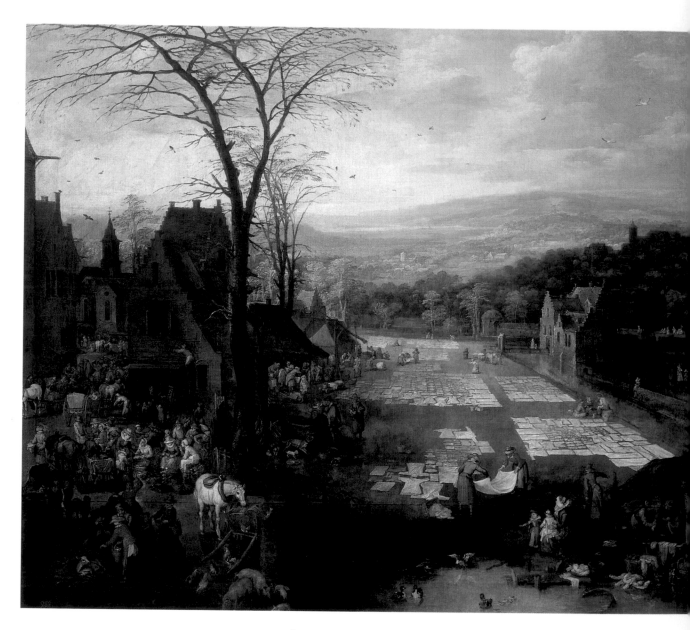

2
**Jan Bruegel the Elder and Sir Peter Paul
Rubens**
Antwerp, 1568 – Antwerp, 1625; Siegen,
1577 – Antwerp, 1640
The Sense of Sight, 1617
Panel, 65 × 109 cm
Presented by the Duke of Medina-Sidonia
to Philip IV in 1635; Cat No. 1394

3
**Jan Bruegel the Elder and Sir Peter Paul
Rubens**
Antwerp, 1568 – Antwerp, 1625; Siegen,
1577 – Antwerp, 1640
*The Virgin and child in a garland of fruit and
flowers*, c.1614/18
Panel, 79 × 65 cm
Collection of Philip IV; Cat No. 1418

4
Jan Bruegel the Elder
Antwerp, 1568 – Antwerp, 1625
Flowers
Panel, 49 × 39 cm
Royal Collection; Cat No. 1423

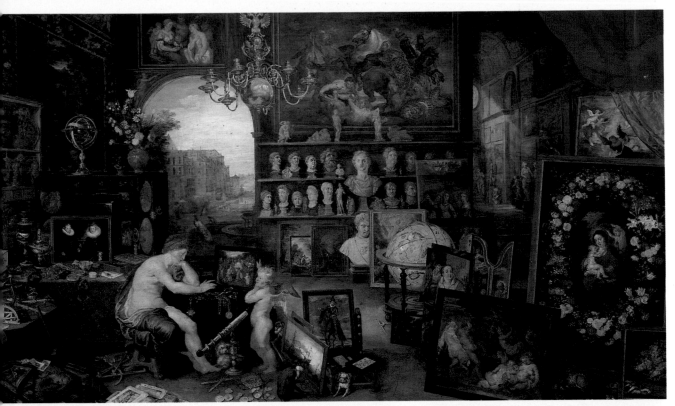

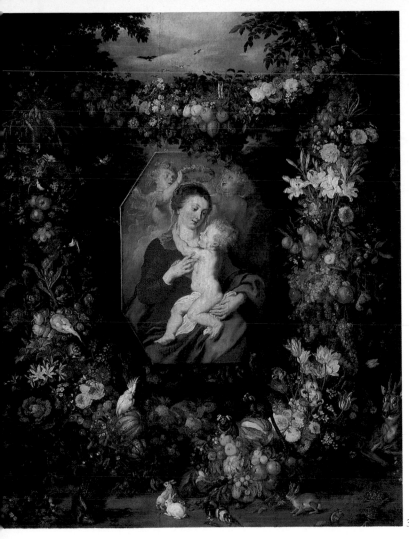

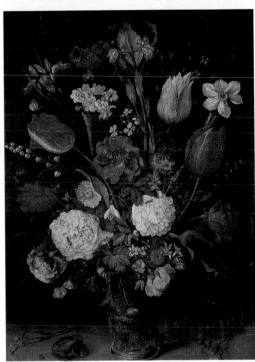

3

4

Paul Bril and Sir Peter Paul Rubens
Antwerp, 1554 – Rome, 1626; Siegen,
1577 – Antwerp, 1640
Landscape with Jupiter visiting Psyche, 1610
Canvas, 93 × 128 cm
Collection of Philip IV; Cat No. 1849

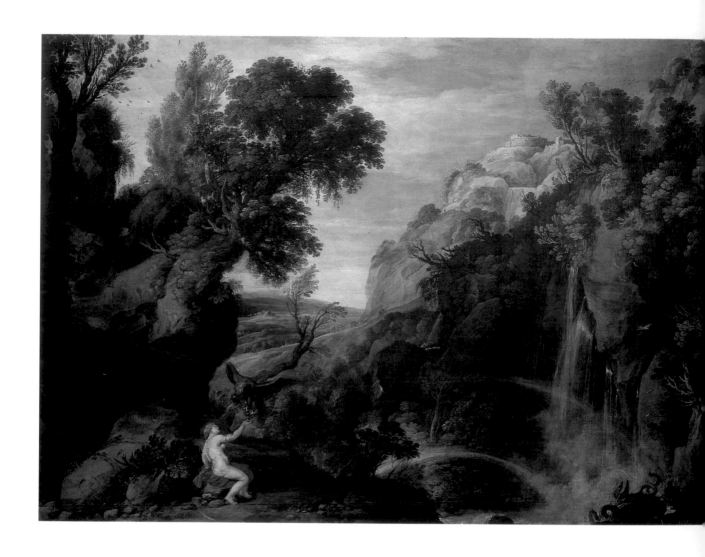

n Bruegel the Elder and Hendrick de
erck
ntwerp, 1568 – Antwerp, 1625; born in
russels, died there in 1630
bundance and the Four Elements, c.1606
pper, 51 × 64 cm
ollection of Philip V. Entered the Prado
, 1824; Cat No. 1401

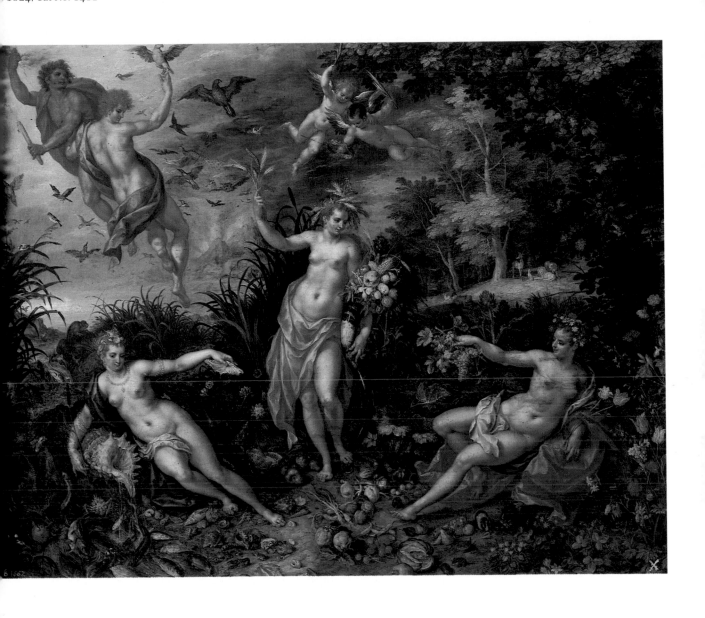

1
David Teniers the Younger
Antwerp, 1610 – Brussels, 1690
Peasants merry-making, c.1650
Canvas, 69 × 86 cm
Collection of Charles IV; Cat No. 1785

2
David Teniers the Younger
Antwerp, 1610 – Brussels, 1690
Carnival: 'Le Roi Boit'
Copper, 58 × 70 cm
In the Royal Collection by the eighteenth
century; Cat No. 1797

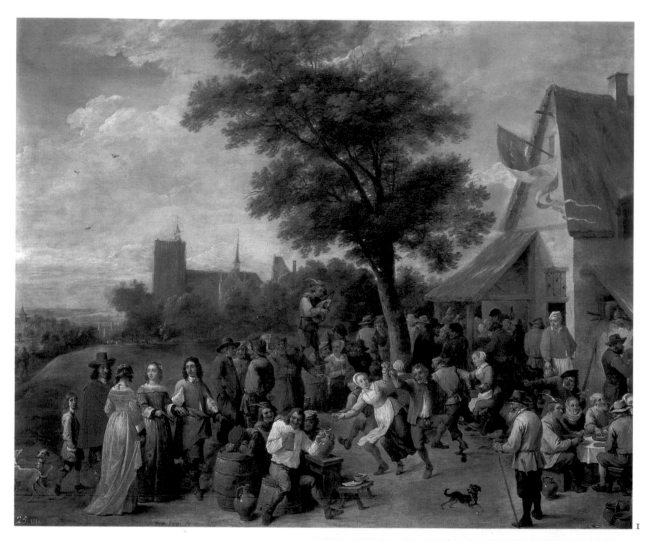

avid Teniers the Younger
ntwerp, 1610 – Brussels, 1690
he Archduke Leopold Wilhelm in his Gal-
ry, c.1647
opper, 106 × 129 cm
resented to Philip IV by Archduke
eopold Wilhelm before 1653; Cat No.
813

avid Teniers, court painter to Archduke
eopold Wilhelm Hapsburg, the Governor

of Flanders, and keeper of his very fine
collection of painting and sculpture, made
several of these gallery portraits. The
Archduke (in tall hat) is depicted showing
to visitors the wealth of his pictures, most
of them Venetian, almost half of them by
Titian. Other Venetians represented are
Giorgione, Antonello da Messina, Palma
Vecchio, Tintoretto, Bassano and
Veronese; also there are Mabuse, Holbein,
Bernardo Strozzi, Guido Reni and Rubens.

The sculpture supporting the table, repres-
enting Ganymede, is a bronze by Duques-
noy the Younger. Teniers himself is repre-
sented as the figure on the far left. It has
been suggested that Velázquez borrowed
the device of the half-open door at the
back of this picture for his *Las Meninas*; at
least *Las Meninas* can be understood as a
similar picture, designed to illustrate the
enlightened patronage of the patron and
the corresponding pride of the court artist.

French Painting

The collection of French painting consists of more than three hundred pictures and offers an incomplete but highly representative survey from the sixteenth until well into the nineteenth century, with the seventeenth and eighteenth centuries particularly well represented.

Curiously enough, the seventeenth century, which witnessed the rise of the Bourbons and the decline of the Austrian Habsburgs, as well as the long period of the Thirty Years War and the campaigns of Louis XIV, saw numerous matrimonial alliances between the French and Spanish royal families. Although these dynastic relations did not impede the armed conflict, they did occasionally lead to the exchange of portraits and other gifts – though in general the hostilities between Spain and France constituted a major obstacle to mutual understanding at an aesthetic level.

It is true that, in spite of this lack of communication, certain groups with access to both countries – merchants, pedlars, sailors and travellers from other countries – seem to have introduced considerable numbers of prints of French paintings into Spain, which were later to influence, in some degree, artists of the period from Zurbarán to Goya. Nevertheless, it was Italian and Flemish art which was acquired on an official basis in Spain during this century. French art was anyhow not particularly well known in Europe at this period; it had no long, indigenous tradition, nor any famous exponents in the first part of the century whose reputations might have caused their works to be sought by collectors. In a few cases, however, a number of French paintings did manage to enter Spain from Italy, where there was an active colony of French artists, centred in Rome. These pictures were apparently not bought as the work of French painters and never carried the names of the real artists; they were passed off as Italian or Flemish works, and in fact modern research has identified as French many canvases in the royal collections which until recently were catalogued as anonymous. One example of this form of misattribution is *The Martyrdom of St Lawrence* by Valentin which, along with other works by the same artist, were catalogued in the Royal Collection in the Alcazar under the names of various Italian artists. A similar example is a work entitled *The Poultry-Seller* by the anonymous French artist known today as Pensionante de Saraceni, which was long thought to be an Italian picture.

The completion of the Buen Retiro Palace in Madrid in 1634 called for a series of grand decorative projects to reflect the power of the monarchy; accordingly numerous foreign paintings with religious subjects were commissioned from Rome: the project was probably organized through the agency of the Marquis of Castel Rodrigo, Spanish ambassador to the Papal Court, and French artists such as Claude Lorraine, Nicolas Poussin, Jean Lemaine and Gaspard Dughet, along with many Dutch and Flemish artists, all contributed to this famous series. Apart from his collaboration in this decorative series, Claude Lorraine later produced four more works for the Buen Retiro Palace. These various commissions constitute the nucleus of the French collection which is now in the Prado, although under the Bourbons more paintings by some of these artists were added to the collections.

A number of the portraits in the French collection were originally sent to Madrid from the courts of other European monarchs who had French artists in their service. The splendid equestrian portrait of Queen Christina of Sweden by Bourdon, for example, was sent from Sweden to Philip IV. Similarly the Duke of Savoy, Charles Manuel II, sent Charles II on his accession a large family portrait painted by Dauphin which included the Duke's new-born heir. Charles II also received, as a perhaps more disinterested gift, an outstanding painting of *John the Baptist* by Pierre Mignard from his father-in-law, the Duke of Orléans. Another example of an exchange between European courts is the consignment of portraits of the French royal family by Philippe de Champaigne, Jean Nocret and Charles and Henri Beaubrun, which were sent in 1655 by Anne of Austria (then Regent of France) as part of the bargaining process leading to the marriage between her son, Louis XIV and the Infanta Maria Teresa, daughter of Philip IV.

The prospect of the last Austrian monarch of Spain dying without a successor precipitated a series of major European crises between 1700 and 1713 which were concluded by the Treaty of Utrecht. The claims of Louis XIV of France to the Spanish throne, based on the dynastic ties established during the seventeenth century, were recognized and on the death of Charles II Louis XIV's grandson, the Duke of Anjou, ascended the Spanish throne with the title of Philip V. So began the long period of Bourbon monarchy in Spain which lasted, with certain interruptions, for almost two centuries. The establishment of the new monarchy did not immediately alter the aesthetic orientation towards Italian and Flemish art and, particularly as a result of the artistic sympathies of Philip's second wife, Isabel de Farnesio, the Royal Collection continued to acquire Italian works. However, this did not preclude an interest in French art, particularly portraiture, and various French artists took up positions at the Spanish Court. Among these were Michel-Ange Houasse, a mediocre portraitist but an exceptional landscape and genre painter, and Jean Ranc and Louis-

Michel Van Loo, both distinguished portraitists, who painted likenesses of the sovereigns and their children until the reign of Ferdinand VI.

There were three special factors, during the reign of Philip V, which contributed to heighten the King's interest in art. The inheritance of paintings from his father Le Grand Dauphin added many important works to the Royal Collection; the construction of the new Palace of La Granja at Segovia ensured that many new works would be commissioned; and the destruction of the Alcazar, despite its terrible consequences and the loss of a great number of paintings, provided a stimulus for the reacquisition of lost artistic wealth which was to be a constant preoccupation for the monarchy throughout the eighteenth century.

Philip V was able to acquire some important Poussins in Rotterdam, while other significant examples of classical French art came his way from the sale of the collection belonging to the heirs of the painter Maratta in Rome. At the same time, the arrival of magnificent portraits of the Bourbons from Paris exposed the Spanish Court to the work of some of the greatest portraitists of the period: Rigaud's famous picture of *Louis XIV* in armour and Largillière's of *Maria Anna Victoria*. Two exquisite pieces by Watteau were chosen by Isabel de Farnesio, and *The Rest on the Flight to Egypt* by Stella, also acquired at this time, is an interesting work which represents the essential classicism of the previous century.

The reign of Philip V transformed Madrid into a centre for new artists, all of whom contributed towards the rebuilding of the artistic traditions of the Court. Numerous landscape paintings of the royal grounds and genre scenes by Michel-Ange Houasse survive from this period, as do some of his religious works, portraits and mythological compositions. Jean Ranc and Louis-Michel van Loo, who succeeded Houasse as official Court portraitist to the Bourbon royal family, provided such an abundance of paintings that the Court in Madrid, which had previously been exclusively a recipient of French portraits, now began to distribute portraits of its own. Ranc, a dedicated but rather dry painter with an eye for detail, portrayed the monarchy in a dignified style anchored in the aesthetic principles of the last years of the reign of Louis XIV, and mainly derived from the work of his master, Rigaud. In contrast, Louis-Michel Van Loo, who was summoned to Madrid to take over Ranc's position on his death, brought a spacious and decorative style to royal portraiture and developed forms in which the subjects were represented in a more spectacular yet more direct manner, in some ways archaic for its time. Van Loo's greatest achievement is the enormous *Family of*

Philip V, in which the monarch is seen surrounded by his wife and children rather in the manner of a public institution. After the death of Philip V in 1746, Van Loo remained in Spain for six more years under his successor, Ferdinand VI, working on the Royal Academy of Fine Arts which was finally opened in 1752.

There was an absence of French artists in Madrid during the reign of Ferdinand VI, the exception being Charles-Joseph Flipart, who spent nearly thirty years in Spain and produced a great many paintings, drawings and decorations. However, during the reign of Charles III, a number of portraits arrived from other European courts and the Prince of Asturias, the future Charles IV, who was a distinguished collector, commissioned many foreign works and also bought paintings from French artists travelling in Spain. Unfortunately, this carefully chosen collection was not to be kept intact for any length of time; the Napoleonic invasion and the subsequent War of Independence brought the inevitable looting, and it was in a large measure dispersed. However, the most numerous surviving single group, the five landscapes by Vernet, testify to the excellent taste and aesthetic sense of Charles IV; another group of works from his collection is preserved in the Casita del Principe at the Escorial.

The foundation of the Prado in 1819 raised the hope of new acquisitions, but although the Royal Museum received the contents of the palaces which formed the nucleus of its exceptional collection, the Prado did not preoccupy itself with additions and, as a result, the great French names of the nineteenth century are almost entirely absent.

The twentieth century has fared better. Two outstanding portraits by Oudry entered the museum in 1930 and other important works have been added in the second half of the century such as *A Gallery of the Colosseum of Rome* by Hubert Robert in 1944, *Time Overcome by Hope, Love and Beauty* by Vouet in 1955, and a *Vanitas* by Linard in 1962.

Since 1920 there have been purchases in other periods, such as an anonymous masterpiece from the sixteenth century, which shows the influence of the School of Fontainebleau, two mythological compositions by Jean-Baptiste Pierre, and various works by Beaufort including the exquisite sketch entitled *The Death of Calanus*.

Considering the French collection as a whole, the seventeenth-century canvases form perhaps the most important section, especially for French painting in Italy, while the eighteenth-century section is essential to an understanding of the work of French artists in Spain during this period. A final and important aspect that should be emphasized is the unique collection of portraits.

1
Valentin de Boulogne
Coulommiers-en-Brie, 1591 – Rome,
1632
The Martyrdom of St Lawrence, c.1621/22
Canvas, 195 × 261 cm
Collection of Philip IV; Cat No. 2346

2
Anonymous master, known as the Pen-
sionante de Saraceni
Active in Rome between 1610 and 1620
The poultry-seller
Canvas, 95 × 71 cm
In the Royal Collection by the end of the
eighteenth century; Cat No. 2235

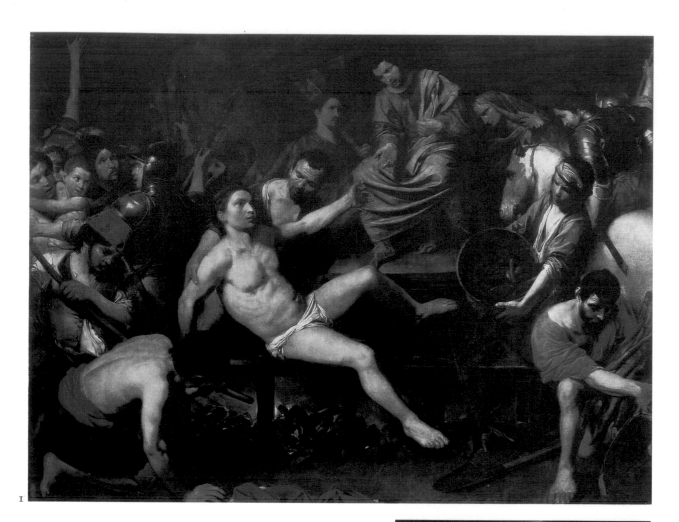

1

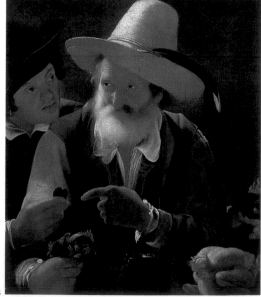

2

3
Simon Vouet
Paris, 1590 – Paris, 1649
*Father Time overcome by Love, Hope and
Beauty*, 1627
Canvas, 107 × 142 cm
Purchased in London in 1954; Cat No.
2987

4
Nicolas Tournier
Montbéliard, 1590 – Toulouse, 1638 or
1639
*The Denial of St Peter, c.*1625
Canvas, 171 × 252 cm
Bequeathed to the Prado by Don Pedro
Fernández Durán in 1930; Cat No. 2788

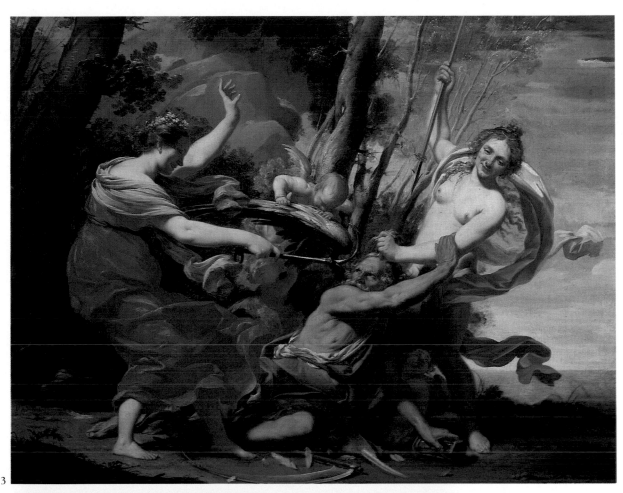

3

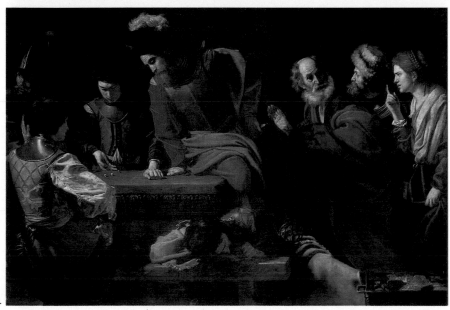

4

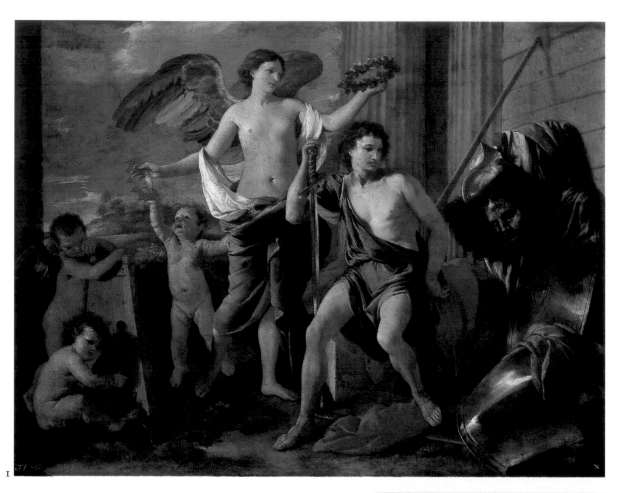

1

Nicolas Poussin was undoubtedly the
most important French artist of the seven-
teenth century, and the major exponent
of baroque classicism. Though he worked
in Rome most of his life, his influence not
only in Italy but also on French painting
was profound. His art was richly informed
by prolonged study both of the classical
past and of the High Renaissance – both
of classical sculpture and of Raphael and
Titian. He created an extraordinarily
controlled, balanced and also various
blend from these and other sources,
evolving original solutions to traditional
problems. His narration here of a biblical
story in a classical convention (Fame
delivering a wreath) is one example.

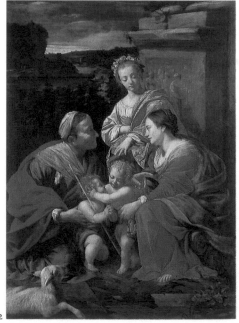

2

3
Nicolas Poussin
Les Andelys, 1594 – Rome, 1665
Parnassus
Canvas, 145 × 197 cm
Collection of Philip V. Acquired in Rotterdam in 1714; Cat No. 2313

4
Jacques Courtois called Il Borgognone
St-Hippolyte, 1621 – Rome, 1676
A battle between Turks and Christians
Canvas, 96 × 152 cm
Provenance unknown; Cat No. 2242

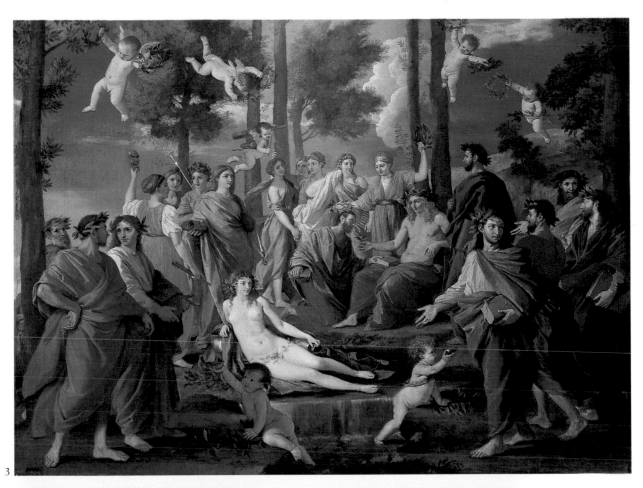

3

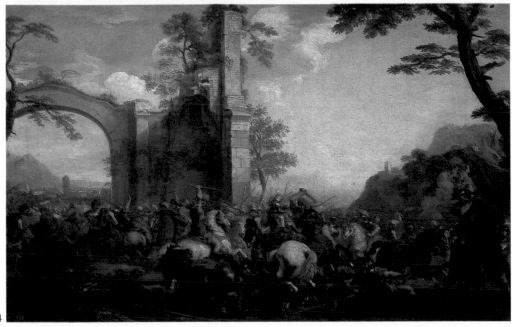

4

Claude Gellée, called Claude Lorraine
Chamagne, 1600 – Rome, 1682
Landscape with the Finding of Moses,
c.1637/39
Canvas, 209 × 138 cm
Collection of Philip IV; Cat No. 2253

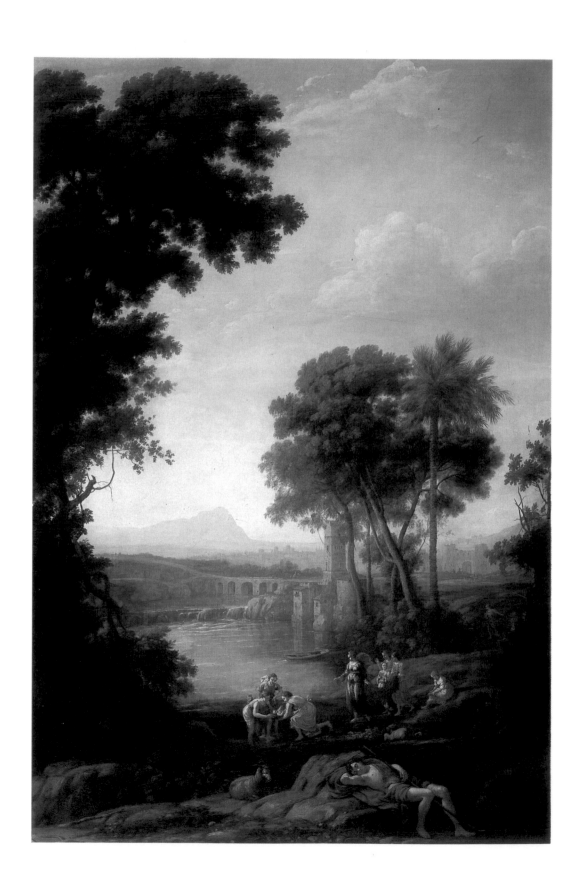

Claude Gellée, called Claude Lorraine
Chamagne, 1600 – Rome, 1682
The Embarkation of St Paula Romana at
*Ostia, c.*1637/39
Canvas, 211 × 145 cm
Collection of Philip IV; Cat No. 2254

Claude Lorraine, sometimes also known
simply as Claude, perfected the creation of
ideal landscapes, placed in a golden
classical antiquity of harmonious archi-
tecture, weather, landscape and society.
This work so typical of his style was
commissioned by Philip IV for the decora-
tion of one of the galleries in the Buen
Retiro Palace. The act of embarkation is
transformed by the theatrical setting into
an act of Roman dignity, a heroic ven-
ture, a glorious example to posterity.

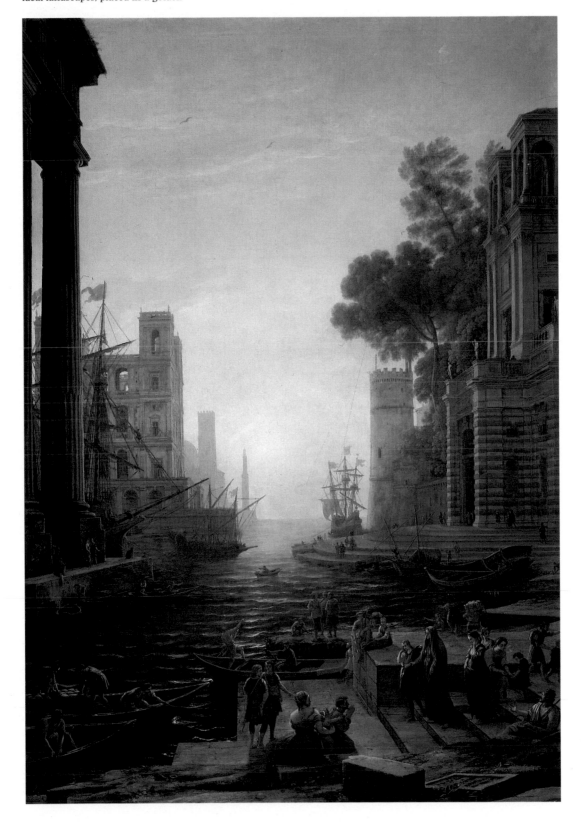

1
Philippe de Champaigne
Brussels, 1602 – Paris, 1674
King Louis XIII, 1655
Canvas, 108 × 86 cm
Sent to Philip IV by his sister Anne of
Austria, Queen of France; Cat No. 2240

2
Sébastien Bourdon
Montpellier, 1616 – Paris, 1671
Queen Christina of Sweden on horseback,
1653
Canvas, 383 × 291 cm
Presented by Queen Christina of Sweden
to Philip IV; Cat No. 1503

3
Jean Le Maire
Dammartin, 1598 – Gaillon, 1659
A hermit amid the ruins of the past,
*c.*1635/36
Canvas, 162 × 240 cm
Collection of Philip IV; Cat No. 2316

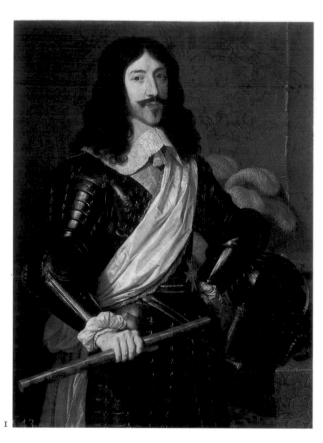

1

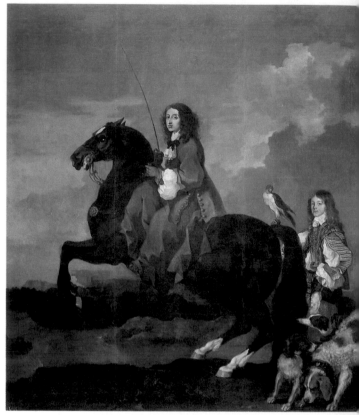

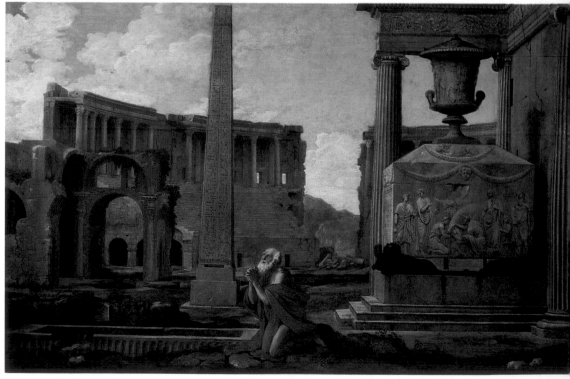

3

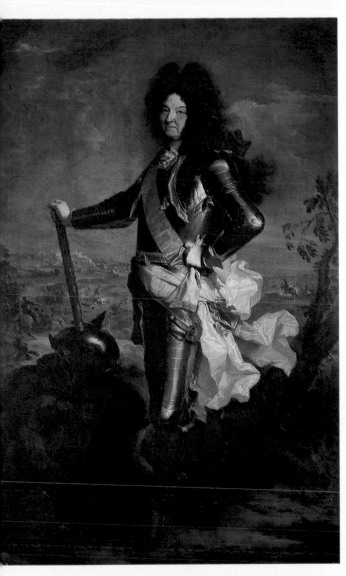

4
Hyacinthe Rigaud
Perpignan, 1659 – Paris, 1743
King Louis XIV, 1701
Canvas, 238 × 149 cm
Collection of Philip V; Cat No. 2343

5
Jacques Linard
Paris, c.1600 – Paris, 1645
Vanitas, c.1644
Canvas, 31 × 39 cm
Purchased in 1862; Cat No. 3049

6
Sébastien Bourdon
Montpellier, 1616 – Paris, 1671
Moses and the Brazen Serpent, c.1653/54
Canvas, 105 × 89 cm
Bequeathed by Mrs Katy Brunov in 1979;
Cat No. 4717

5

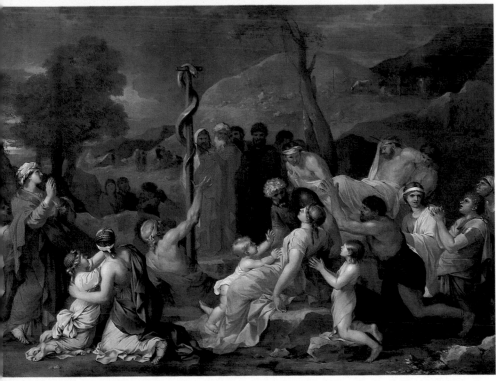

233

I

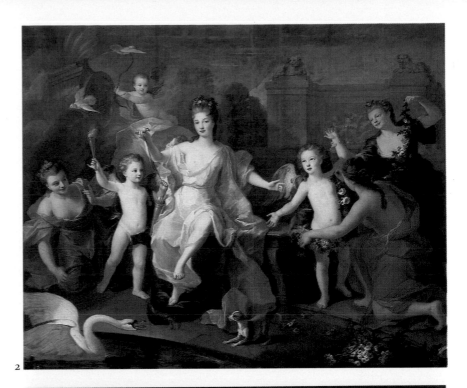

2

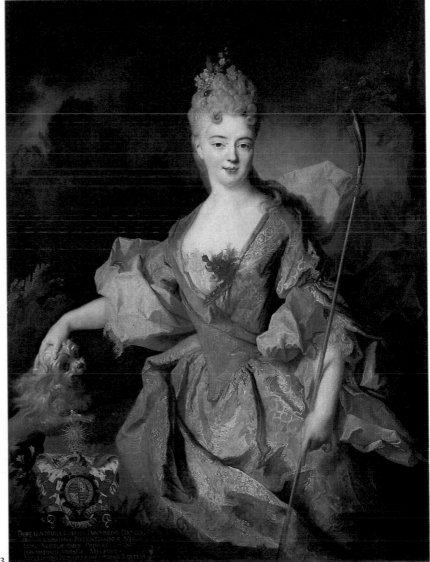

Nicolas de Largillière
Paris, 1656 – Paris, 1746
The Infanta Maria Anna Victoria de
Bourbón, 1724
Canvas, 184 × 125 cm
Collection of Philip V; Cat No. 2277

Largillière was one of the leading portraitists in Europe at the end of the seventeenth century and the beginning of the eighteenth. His works combine the best of the French, Flemish and English schools; besides portraits, he also specialized in landscapes and still lifes. He has skilfully endowed Maria Anna with royal dignity: the little child was the daughter of Philip V and the fiancée of Louis XV of France; in fact she became Queen of Portugal.

2
Pierre Gobert
Fontainebleau, 1662 – Paris, 1744
The Duchess of Burgundy and her children,
c.1722
Canvas, 216 × 168 cm
Collection of Philip V; Cat No. 2274

3
Jean-Baptiste Oudry
Paris, 1686 – Beauvais, 1755
Lady Mary Josephine Drummond, Countess
of Castelblanco, c.1716
Canvas, 137 × 105 cm
Bequeathed by Don Pedro Fernández
Durán in 1930; Cat No. 2793

3

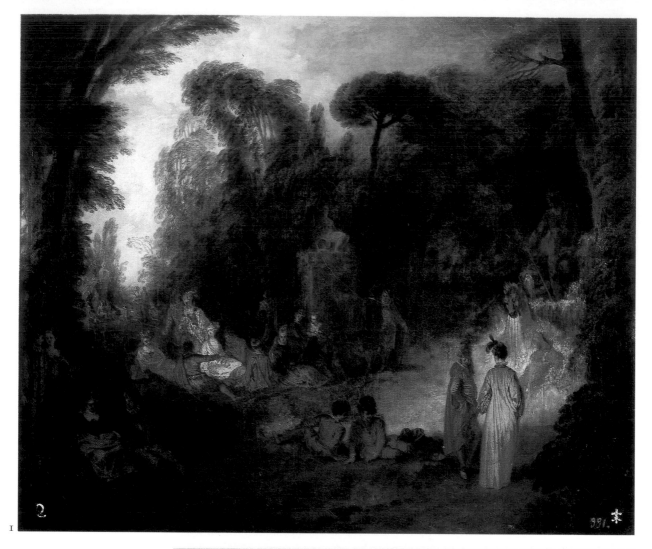

1

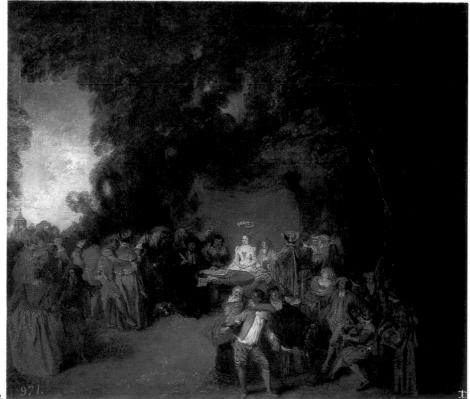

2

Jean-Antoine Watteau
Valenciennes, 1684 – Nogent-sur-Marne,
1721
Courtly gathering in a park, c.1712/13
Canvas, 48 × 55 cm
In the collection of Queen Isabel de
Farnesio by 1746; Cat No. 2354

Jean-Antoine Watteau
Valenciennes, 1684 – Nogent-sur-Marne,
1721
The Marriage Contract, c.1712/13
Canvas, 47 × 55 cm
In the collection of Queen Isabel de
Farnesio by 1746; Cat No. 2353

Antoine Watteau was the inventor of a
new spirit or current within what is called
Rococo. He presented dreamy glimpses
into a vivacious, sensual world as fresh
and as distant as yesterday.

Michel-Ange Houasse
Paris, 1680 – Arpajon, 1730
View of the Escorial Monastery, c.1720/30
Canvas, 50 × 82 cm
Collection of Philip V; Cat No. 2269

Jean Ranc
Montpellier, 1674 – Madrid, 1735
King Charles III when a child, c.1723/24
Canvas, 142 × 115 cm
Collection of Philip V; Cat No. 2334

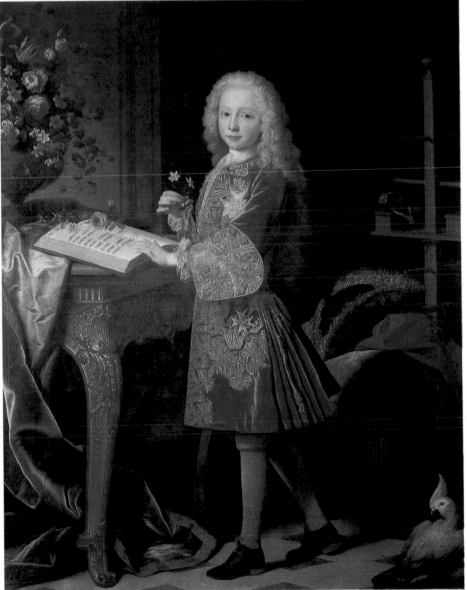

1
Michel-Ange Houasse
Paris, 1680 – Arpajon, 1730
Bacchanal, 1719
Canvas, 125 × 180 cm
Collection of Philip V. Entered the Prado
in 1820; Cat No. 2267

2
Jean Ranc
Montpellier, 1674 – Madrid, 1735
*King Philip V and his Family, c.*1723
Canvas, 44 × 65 cm
Collection of Philip V; Cat No. 2376

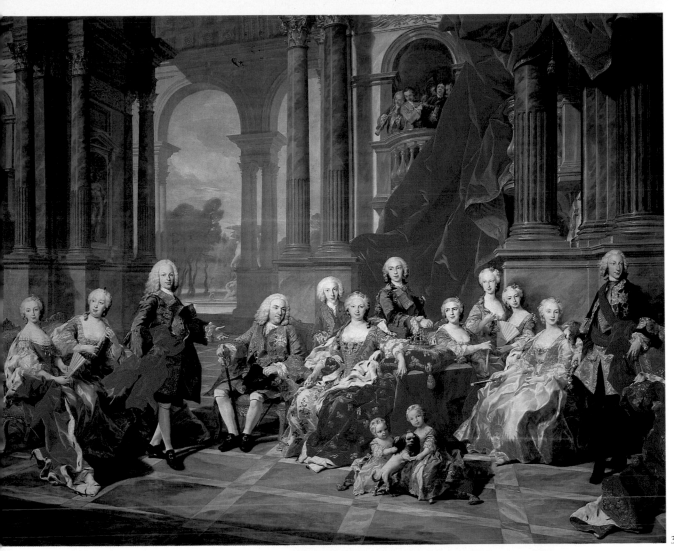

3

Louis-Michel Van Loo
Toulon, 1707 – Paris, 1771
King Philip V and his Family, 1743
Canvas, 406 × 511 cm
Collection of Philip V; Cat No. 2283

Philip V, the first Bourbon king of Spain,
commissioned portraits from the French
painters then most in vogue. Louis-Michel
Van Loo, one of a family of painters, soon
became his favourite. This is a typical
work by Van Loo, in which the sitters are
presented almost as effigies, decked out in
a rich display of finery complemented by
colossal architecture – all to a high degree
of finish that is almost brittle.

Charles-Joseph Flipart
Paris, 1721 – Madrid, 1797
*The Surrender of Seville to St Ferdinand,
King of Spain*, c.1756/57
Canvas, 72 × 56 cm
In the Royal Collection in the eighteenth
century; Cat No. 13

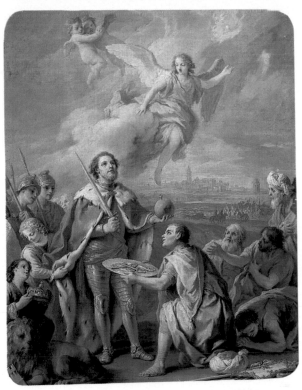

4

1

2

1
Jean Pillement
Lyons, 1728 – Lyons, 1808
Landscape, 1773
Canvas, 56 × 76 cm
Collection of Charles IV; Cat No. 2302

2
Claude-Joseph Vernet
Avignon, 1714 – Paris, 1789
View of Sorrento
Canvas, 59 × 109 cm
Collection of Charles IV; Cat No. 2350

3
Hubert Robert
Paris, 1733 – Paris, 1808
A gallery of the Colosseum, Rome
Canvas, 240 × 225 cm
Bequeathed by the Count of La Cimera in
1944; Cat No. 2883

4
Antoine-François Callet
Paris, 1741 – Paris, 1823
*King Louis XVI, c.*1783
Canvas, 273 × 193 cm
Presented by Louis XVI to the Count of
Aranda. Later purchased by Isabel II for
the Prado from the Duke of Hijar; Cat No.
2238

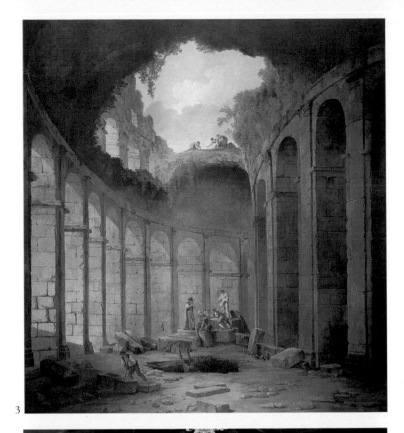

3

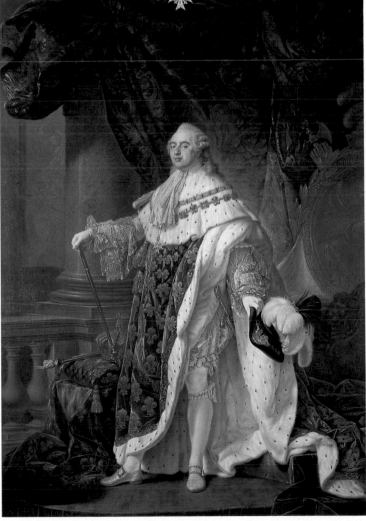

4

Dutch Painting

Throughout the early Middle Ages and for a large part of the sixteenth century the Low Countries effectively formed a single country sharing common characteristics. Under the government of Charles V the Low Countries, although maintaining their own economy, were integrated into the mosaic of states which were dominated by the House of Austria and co-ordinated from the Iberian Peninsula. However, even at this time, the difference in the modes of artistic expression of the north and south were already evident.

During the last third of the sixteenth century the Low Countries underwent major political transformations and suffered instability as a result of the diffusion of religious doctrines in the Reformation which profoundly influenced the provinces both of the north and, to a lesser extent, the south. The ensuing revolt in the northern provinces resulted in the creation of a new country – Holland – which developed independently from Spanish tutelage after its recognition in the Peace of Westphalia in 1648. Long before this critical date, however, the definitive characteristics of this society had already been formed, developing at the same time an aesthetic which tended towards an austere and concrete manner of expression little inclined towards fantasy and corresponding to the patronage of burghers, artisans and merchants. Moreover, the artists, rather than executing works for the church or the aristocracy, as was still the case in the south, worked with the smaller domestic space of their clients in mind and with a subject matter far removed from the heroic mythologies traditionally favoured by the aristocracy. Here art adapted itself to a competitive and sober capitalist environment.

The presence of Dutch painters in the Rome of Caravaggio at the beginning of the seventeenth century, and their subsequent return to re-define the realism of Dutch art, resulted in an intimate type of genre painting which depicts domestic interiors and scenes of the road and tavern in a detailed and naturalistic manner. During this period, Dutch painters developed various pictorial forms including landscapes, still life, and animal pictures, and both single and group portraiture notable for great psychological penetration. The second half of the century saw a development towards a richer, more decorative form pervaded by the baroque spirit.

Naturally, the enmity between Holland and Spain until the middle of the seventeenth century made it difficult for Dutch painters to reach Spanish collections. Throughout the second half of the century relations were still strained, despite diplomatic alliances in united opposition to France, and differences in taste and culture ensured that the lack of Dutch art in Spain continued. Almost all the pieces in the Prado date, in their acquisition, from well after this period, and it is impossible not to notice the absence of works by Frans Hals, Vermeer, Hobbema and the fastidious still lifes of Kalf.

During the seventeenth century the royal collections registered a few entries by Dutch artists, like the four panels with feminine portraits by Adriaen Cronenburch, which show great dignity and presence. From the reign of Philip IV date the splendid landscapes by Both and Swanevelt, acquired in Rome for the decoration of the Buen Retiro Palace, as were the two religious works by Steenwijck the Younger and *The Doubting Thomas* by Stomer. By the time of Philip V and Isabel de Farnesio the eighteenth century fashion for small Dutch paintings was well under way, and they made many purchases including works by Droochslott, Schoeff, Poelenburgh and a number of views by Wouwermans. However, it was Charles III who was responsible for acquiring the magnificent Rembrandt, *Artemisia*, bought in 1769 at the sale of the possession of the Marquis de la Ensenada. Charles IV also acquired many other Dutch works including pieces by Breenberg, Schalken, Bramer, J. G. Cuyp and Wtewael, *The Dead Hen* by Metsu, tavern scenes by Van Ostade and the singular *Vanitas* by Steenwyck. During the Napoleonic invasion the works of this school, which Charles had so carefully collected, were dispersed and those now in the Prado are only the remnants of the paintings which he amassed.

Since the opening of the Prado in 1819 the gaps have not been filled, with the exception of certain generous donations: for example, Potter's *Cows and goat* was acquired in 1894, as the result of a bequest by the Marquis de Cabriñana; the three still lifes by Heda and Claesz entered the museum through the Fernández Durán bequest of 1930; the portrait of a general by Backer was given by the Count of Prader in 1934, while a new Schalken was presented by the Duke of Arcos in 1935. In the years following the Civil War, and up to quite recently, several works were acquired on the art market: two portraits by Mierevelt and a landscape attributed, with certain doubts, to Van Goyen in 1953, *The Adoration of the Shepherds* by Benjamin Gerritsz Cuyp in 1954, and the excellent portrait of Petronella de Waert by Ter Borch with a still life by Rycknals in 1982.

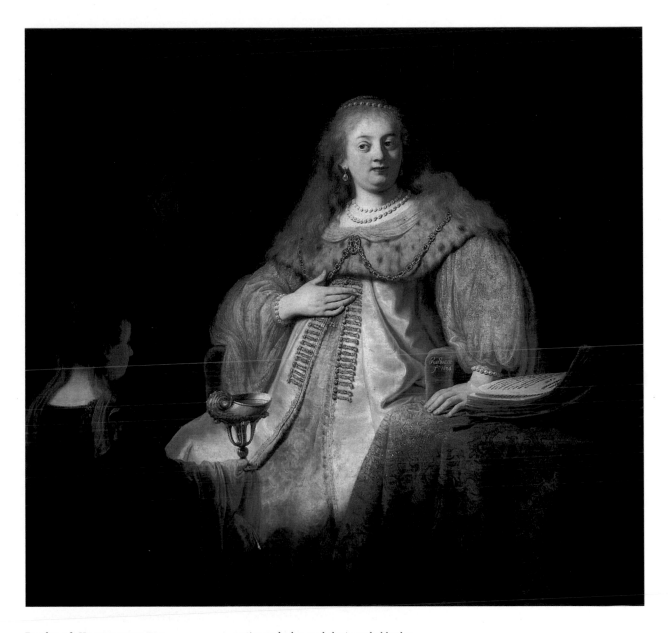

Rembrandt Harmensz van Rijn
Leyden, 1606 – Amsterdam, 1669
Artemisia, 1634
Canvas, 142 × 153 cm
Bought for Charles III by Anton Mengs in
1769 from the collection of the Marquis of
La Ensenada; Cat No. 2132

This is the only certain work by Rem-
brandt in the Prado. It was painted when
he was 28, in the year of his marriage to
Saskia, the daughter of an Amsterdam

antiques dealer, and she is probably the
sitter. Rembrandt probably learnt its
typically Caravaggesque spotlight effect
during his apprenticeship to Pieter Last-
man, who had been receptive to the new
manner. Already Rembrandt employs it to
make more of the texture, to variegate the
deeply modelled face, the servant's head,
the ghostly figure looking on in the back-
ground, but above all to dwell on the
lavish textiles and the ornate cup.

1
Jan Davisz de Heem
Utrecht, 1606 – Antwerp, 1684
Still life
Panel, 49 × 64 cm
Provenance unknown
Cat No. 2090

2
Pieter van Steenwyck
Active in Delft during the mid-
seventeenth century
Still life, or Vanitas
Panel, 34 × 46 cm
Collection of Charles IV; Cat No. 2137

3
Philips Wouwermans
Haarlem, 1619 – Haarlem, 1668
The scene in front of an inn
Panel, 37 × 47 cm
In the collection of Queen Isabel de
Farnesio by 1746; Cat No. 2151

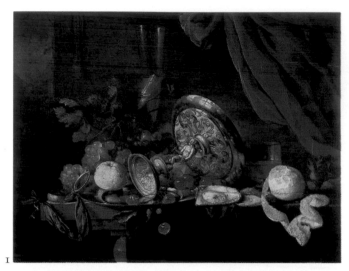

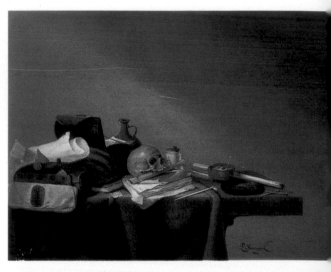

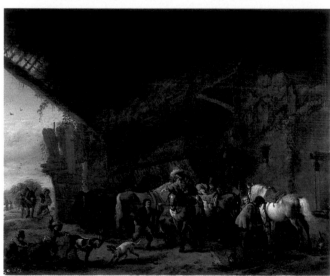

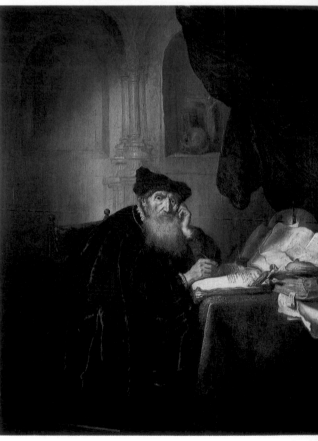

4
Solomon Koninck
Amsterdam, 1609 – Amsterdam, 1656
A Philosopher, 1635
Panel, 17 × 71 cm
Purchased in 1953; Cat No. 2974

German Painting

Turning to the German collection, it is not simply a question of the discontinuities and gaps caused by the idiosyncracies of royal collectors, but also of the almost insoluble difficulties which any museum has to face in attempting to classify and co-ordinate the aesthetic evolution of Germany as a whole. Frequent wars, traditional and political divisions, religious conflicts and all the other divisive forces of German history have contributed to the formation of a complex mosaic of artistic styles which it is difficult to represent in any limited form.

During the fifteenth century in Germany a pictorial movement developed which was influenced by the Netherlandish Primitives and represented a continuation of the achievements of the international style of the previous century which had flourished from The Hague to Bohemia and Austria. Many of the works of this period show marked expressionistic characteristics, a tendency to excessive effect and a sense of concentrated violence which endow their subjects with the tense, dramatic quality that so often reappears in later German art. However, even if a certain expressive strain can be traced through all the various phases of German art history – at the end of the Gothic period, during the baroque and at the culmination of the rococo – this sense of a common *geist* does not necessarily operate at the local level. Local traditions, the fragmentation of the states which made up the German empire, and the various degrees of assimilation of foreign influence, all contributed to the extreme complexity of the German scene, which was further accentuated by many historical forces: the Reformation, the Counter-Reformation, the dynastic crises, the personal interests of the princes, the Thirty Years War, the interference of France, the power of Austria, the expansion of Prussia and the eighteenth-century Enlightenment.

Despite the close dynastic relations between Spain and the Austrian Empire during the sixteenth and seventeenth centuries, there were no corresponding artistic relations between the two regions and the German schools are therefore not extensively represented in the Prado. The Emperor Charles V, like his son Philip II, was more inclined towards Italian pictorial novelties and the Flemish traditions, and perhaps consciously rejected German art on account of its expressionistic and pessimistic character, so contrary to the spirit of the Mediterranean world. It is also possible that he saw the anti-classical spirit of German art during this period as a reflection of the internal disintegration of Germany, encouraged by religious conflict and the emergence of Protestantism. This would explain the scarcity of German works of this period in the Royal Collection and one has to wait until the seventeenth century to see any increase, albeit a small one, in the German representation at the Prado.

Nevertheless, the estate of Queen Mary of Hungary, the sister of Charles V, contributed two panels by Lucas Cranach the Elder in collaboration with his son, which represent a hunt at the Castle of Torgau in honour of Charles V, and from the same source came two panels by Baldung Grien, the elegant *Three Graces* and the ominous *Three Ages of Man*, in the collection of Philip II. There are also four fine panels by Dürer, The two panels of *Adam* and *Eve* were presented by Christina of Sweden to Philip IV, who also acquired the incomparable Dürer *Self-portrait* at the sale of the possessions of Charles I of England – a perfect example of the masterly technical precision of the artist in portraiture. The fascinating *Portrait of a Gentleman* by Dürer was also the property of the unfortunate Charles I.

With the exception of an interesting work by Elsheimer from the seventeenth century, and various pastoral works by Rosa de Tivoli, no new pictures were acquired by the monarchy until the beginning of the eighteenth century, when Isabel de Farnesio acquired two sixteenth-century portraits attributed to Amberger, Two landscapes by Vollardt, donated by Don Pedro Fernández Durán in 1930, provide examples of German rococo. German Neoclassicism is extensively represented in the museum by the works of Anton Rafael Mengs, who was summoned by Charles III to decorate the Royal Palace in Madrid, and subsequently held a powerful position at Court. Mengs was a painter of meticulous religious scenes and exquisite, porcelain-like portraits; his works can be seen to reflect the refined courtly milieu which cultivated Neoclassicism.

To conclude there is a work by Angelica Kauffmann which entered the museum with the Errazu bequest of 1925. Here Neoclassical concepts are combined with the influence of British portraiture in an elegant and evocative feminine style appropriate to the late eighteenth century.

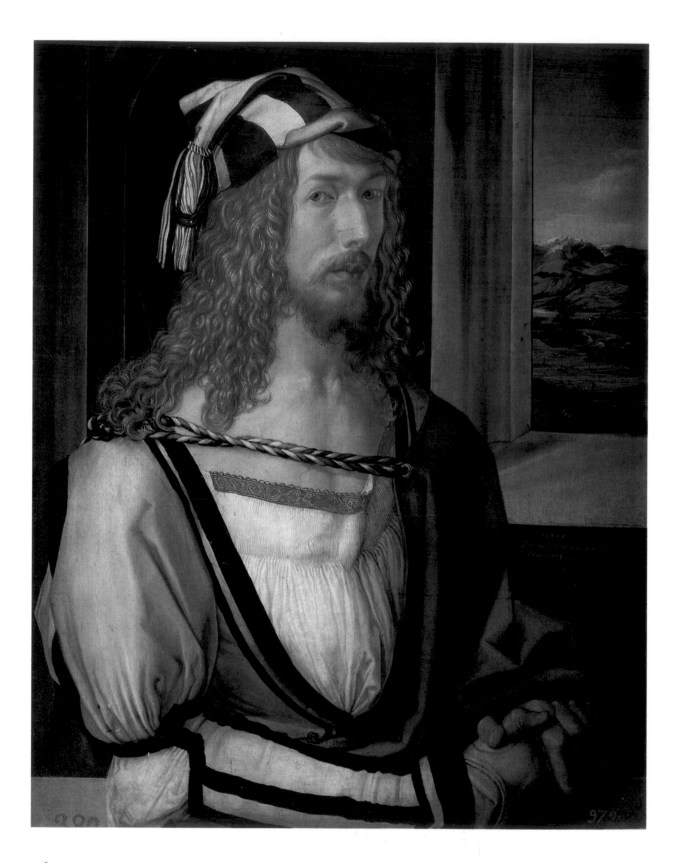

Albrecht Dürer
Nuremberg, 1471 – Nuremberg, 1528
Portrait of a gentleman, 1524
Panel, 50 × 36 cm
In the Alcazar, Madrid, in the seventeenth
century; Cat No. 2180

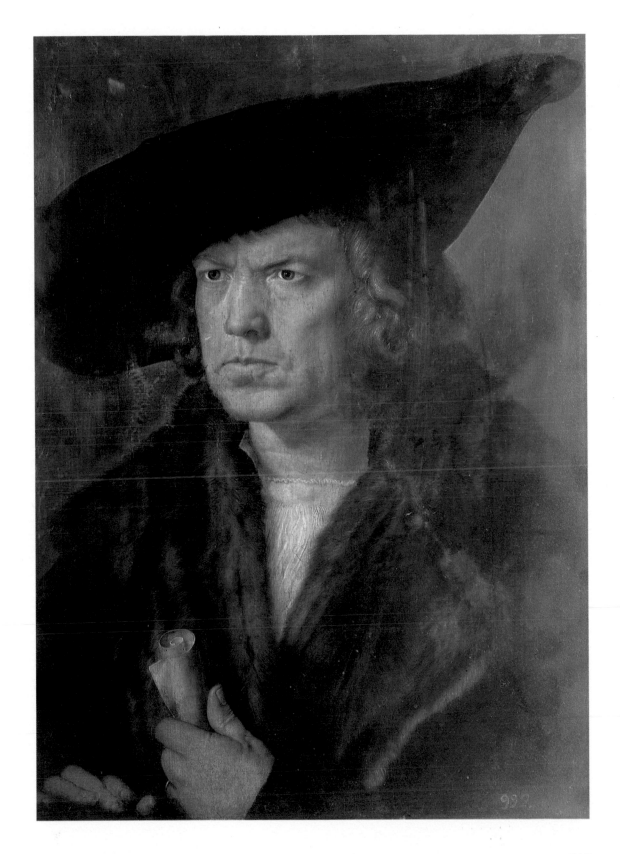

Albrecht Dürer
Nuremberg, 1471 – Nuremberg, 1528
Adam, 1507
Panel, 209 × 81 cm
Presented to Philip IV by Queen Christina
of Sweden; Cat No. 2177

Albrecht Dürer
Nuremberg, 1471 – Nuremberg, 1528
Eve, 1507
Panel, 209 × 81 cm
Presented to Philip IV by Queen Christina
of Sweden; Cat No. 2178

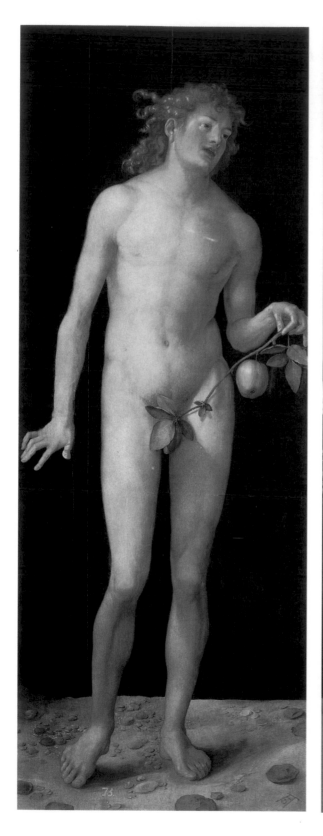
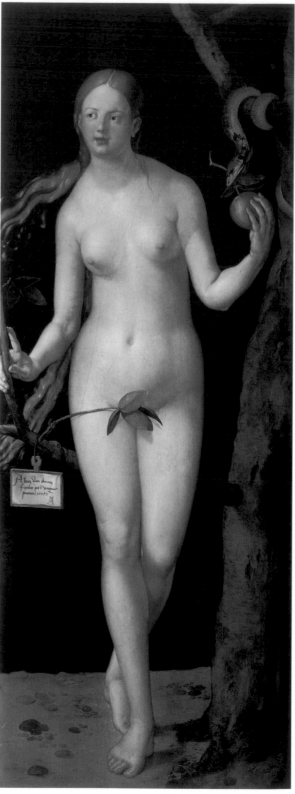

Hans Baldung Grien
Gmund, *c*.1484/85 – Strasbourg, 1545
The Three Ages of Man, 1539
Panel, 151 × 61 cm
Presented by the Count of Solns to Jean de
Ligne in 1547; later in the collection of
Philip II; Cat No. 2220

Hans Baldung Grien
Gmund, *c*.1484/85 – Strasbourg, 1545
The Three Graces, 1539
Panel, 151 × 61 cm
Presented by the Count of Solns to Jean de
Ligne in 1547; later in the collection of
Philip II; Cat No. 2219

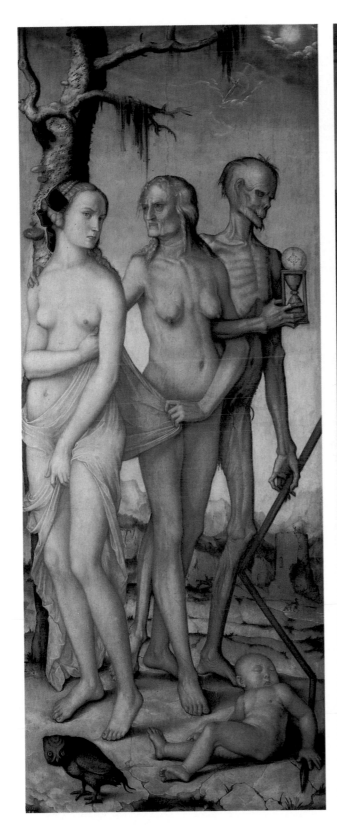

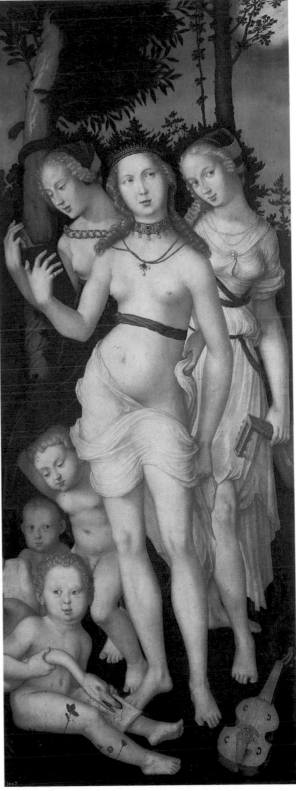

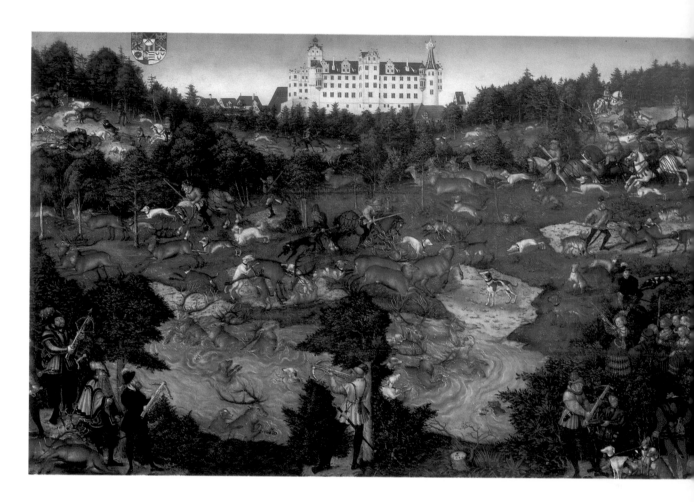

Lucas Cranach
Kronach, 1472 – Weimar, 1553
A hunt in honour of Charles V at the Castle
of Torgau, 1544
Panel, 114 × 175 cm
Inherited by Philip II from the collection
of Mary, Queen of Hungary; Cat No. 2175

Christoph Amberger
Born *c.* 1505; died in Augsburg in 1562
The goldsmith Jörg Zürer of Augsburg, 1531
Panel, 78 × 51 cm
In the collection of Queen Isabel de
Farnesio by 1746; Cat No. 2183

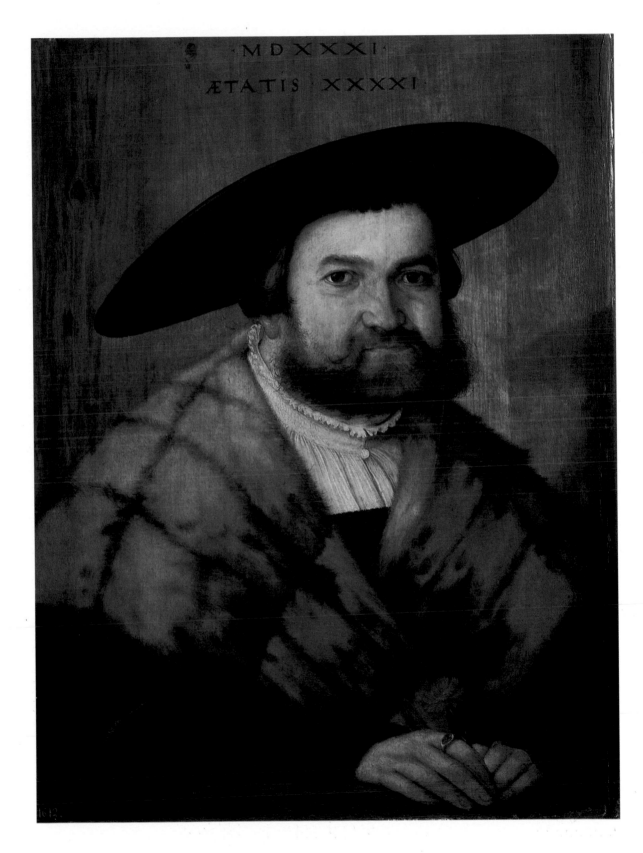

1
Adam Elsheimer
Frankfurt, 1578 – Rome, 1610
Ceres and Stellio
Copper, 30 × 25 cm
In the Alcazar, Madrid, before 1734; Cat
No. 2181

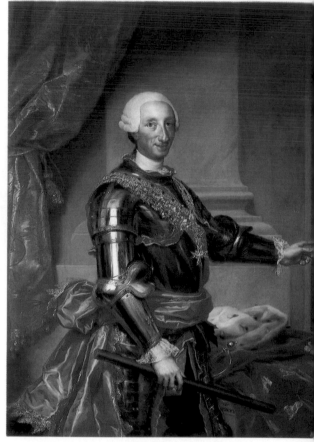

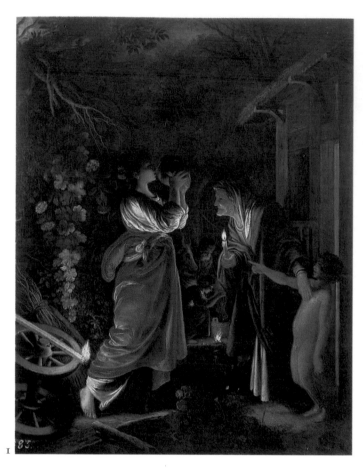

1

2
Anton Rafael Mengs
Aussig, 1728 – Rome, 1779
King Charles III, 1761
Canvas, 154 × 110 cm
Collection of Charles III; Cat No. 2200

3
Anton Rafael Mengs
Aussig, 1728 – Rome, 1779
The Archduke Ferdinand and the Archduchess
Anne of Austria, 1770
Canvas, 147 × 96 cm
Collection of Charles III; Cat No. 2192

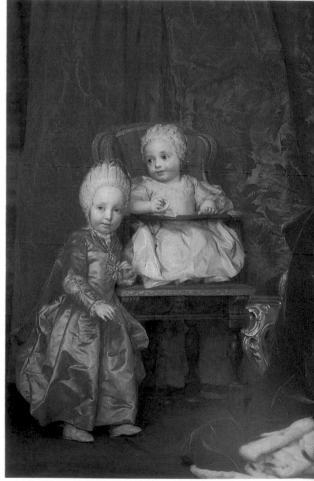

Anton Rafael Mengs
Aussig, 1728 – Rome, 1779
The Adoration of the Shepherds, 1770
Panel, 258 × 191 cm
Collection of Charles III; Cat No. 2204

Mengs is an important figure in the transition from Rococo to Neoclassicism. Emerging from a Rococo milieu, Mengs favoured more severe compositions recalling classical and High Renaissance art. In Spain, he succeeded in ousting from fashion Tiepolo, the last great painter of the baroque tradition. Yet the greatest quality of Meng's work, its enamel colours and brittle textures, is essentially Rococo. This particular picture was painted in Rome for the Spanish Royal Collection, being delivered in 1771.

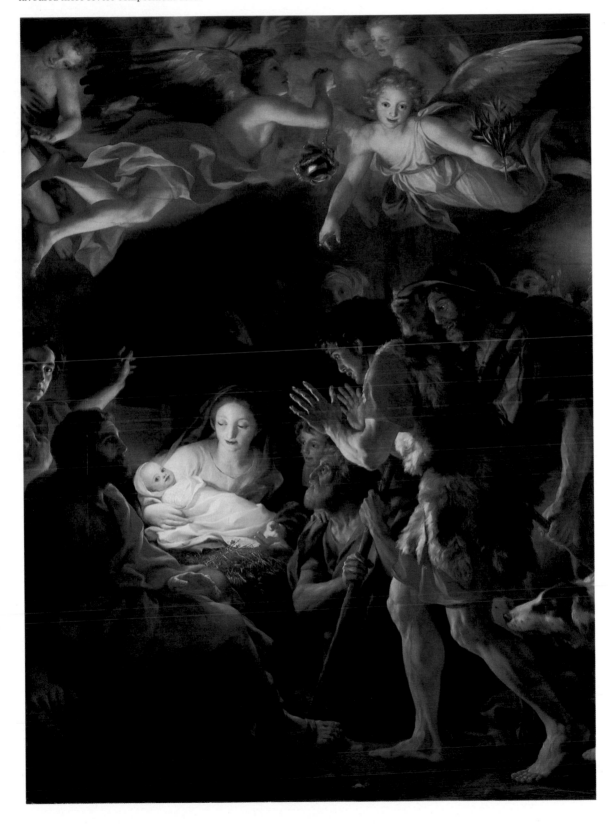

British Painting

The British collection, which also includes Irish works, is
the most recently formed collection in the Prado. When
discussing its history it has to be remembered that England
and Scotland were independent sovereign states until
1707, when the Act of Union formally marked the absorp-
tion of Scotland into the new identity of Britain. Recurring
political differences between Spain and England, which
lasted from the sixteenth century until early in the
nineteenth, and the resulting lack of matrimonial ties
between the respective royal families – a situation only
broken by the marriage of Alfonso XIII to Victoria of Bat-
tenberg in 1906 – combined with a lack of contact be-
tween the leading families of both countries to produce a
historical background essentially inimical to the dissem-
ination of British art in Spain. A more general reason is
perhaps the relative lack of popularisation of British art in
Europe until the twentieth century. As a result of these
historical circumstances no English or Scottish paintings,
except for a few anonymous works, are registered in the
inventories of the Royal Collection. Even after the founda-
tion of the Prado, in 1819, very few works entered the
royal collections apart from a number of Victorian por-
traits, and these were assigned to the royal palaces rather
than to the Prado. In fact, the main British works in the
Prado have been acquired, either through purchases or
donations, almost entirely during the course of the twen-
tieth century.

Although Britain certainly possessed important indig-
enous artistic talent, especially in the field of the English
miniature, the larger scale works commissioned during the
sixteenth and seventeenth centuries tended to be executed
by foreign artists. The Prado possesses many examples of
pictures of this type, such as the magnificent portraits from
Van Dyck's English period, and various works by Anthonis
Mor van Dashorst, Van Somer and Rubens which are to be
found in the Flemish collection, but unfortunately has no
paintings by artists like Peter Lely or Godfrey Kneller, nor
any works by their contemporaries, which would be of
value in assessing the basis from which the British art of
the eighteenth and nineteenth centuries emerged.

However, during the twentieth century a more represen-
tative and informative group of pictures has been collected
which gives some idea of the work of British artists from
the eighteenth century onwards. There are two male por-
traits by Reynolds, *An Unknown Clergyman* and *James
Bourdieu*, and portraits by his great contemporary, Gains-
borough. However, large scale single and group por-
traiture, and also female portraiture, by Reynolds and
Gainsborough is not represented. Female portraiture is

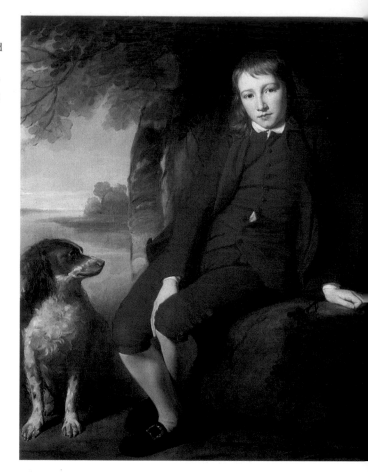

1
George Romney
Dalton-in-Furness, 1734 – Kendal,
1802
Master Ward
Canvas, 126 × 102 cm
Purchased in London in 1958;
Cat No. 3013

2
Henry Raeburn
Stockbridge, 1756 – Edinburgh,
1823
Mrs Maclean of Kinlochaline
Canvas, 75 × 63 cm
Purchased in 1966;
Cat No. 3116

represented, though, in the work of Romney, Hoppner,
Pocock, Cotes, Raeburn, Philipps and Gordon. Special men-
tion should also be made of the two works by Lawrence
which bridge the transition from the eighteenth to the
nineteenth centuries. The first is an elegant if slightly pre-
tentious portrait, *John Fane, tenth Earl of Westmorland*, and
the second the extremely delicate portrayal of Miss Martha
Carr. In addition there is a distinguished portrait by Martin
Shee of Anthony Gilbert Storer – good examples of the
sober precision of early nineteenth-century British
portraiture.

3
Sir Thomas Lawrence
Bristol, 1769 – London, 1830
Portrait of Miss Martha Carr
Canvas, 76 × 64 cm
Purchased in London in 1959;
Cat No. 3012

4
Sir Thomas Lawrence
Bristol, 1769 – London, 1830
John Fane, tenth Earl of Westmorland
Canvas, 247 × 147 cm
Purchased in London in 1958; Cat No.
3001

5
Martin Archer Shee
Dublin, 1769 – Brighton, 1850
Anthony Gilbert Storer, 1815
Canvas, 240 × 148 cm
Purchased in 1957; Cat No. 3014

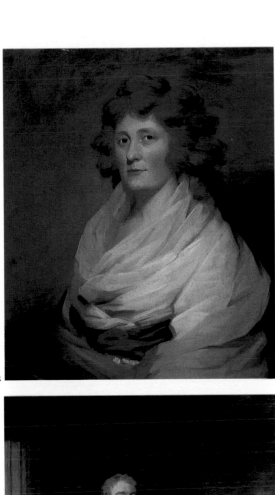

2

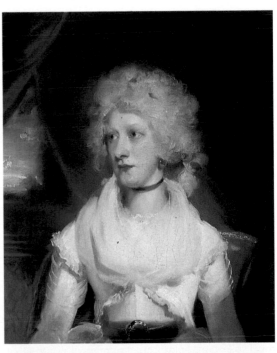

3

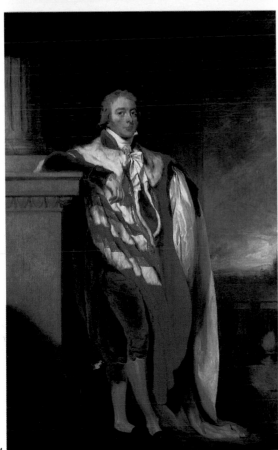

4

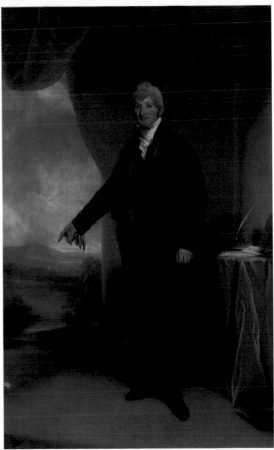

5

Index of illustrations by artist's name

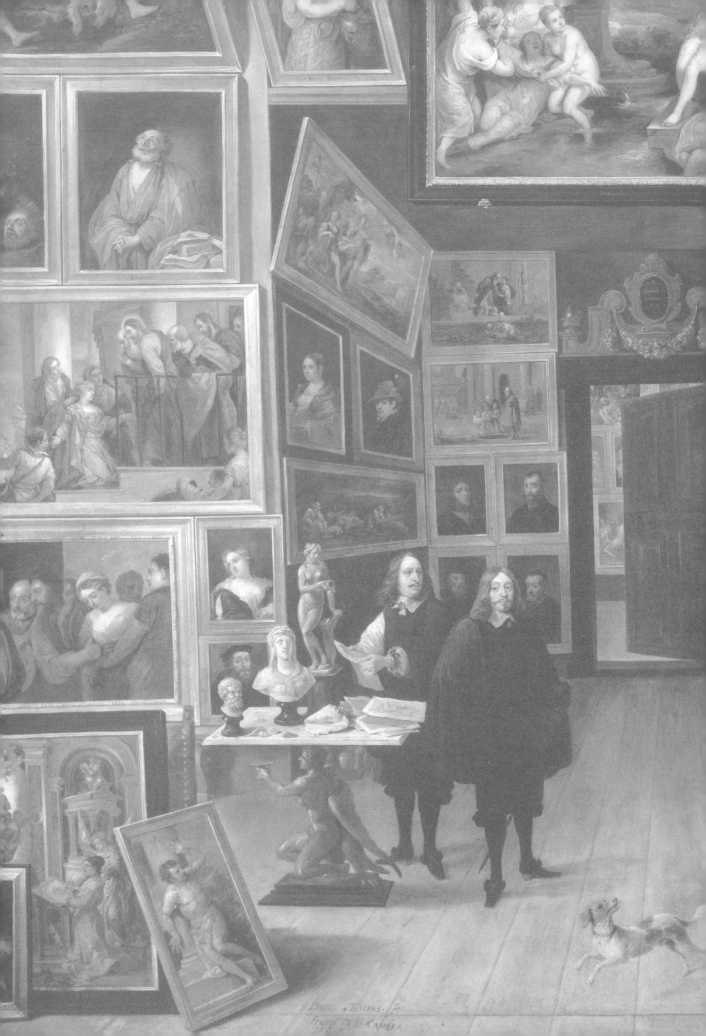